CODED CHARACTERS

media art by Jill Scott

To all the women of
power in the world
may we make a
difference! lots of luck
Jill x

Hatje Cantz

ANALOG FIGURES

WESTCOAST 1975 – 1982 | **040** parallel worlds | **048** performance art |

DIGITAL BEINGS

DOWNUNDER 1982 – 1992 | **094** pluralistic metaphors |

MEDIATED NOMADS

005 introduction – roy ascott
008 coded characters – jill scott
009 of continents, decades, bodies and technology, an interview – robert atkins
030 body memory and time zones – anne marsh

102 video art | **EUROPE 1992 – 2002** | **142** mixed realities | **150** computer art | | | | | | | | | | | | | | | |

202 video – the reflexive performance of media images – yvonne spielmann
214 progressive ideals and political engagement in jill scott's art – robert atkins
231 biographies
237 credits

D | Jill Scott hat ihre langjährige künstlerische Arbeit als einen fortschreitenden Prozess beschrieben – von "Analog Figures" über "Digital Beings" bis hin zu "Mediated Nomads" – mit Begriffen, die sowohl universelle als auch idiosynkratische Bedeutungen implizieren. Diese Entwicklung liegt sowohl im Denken wie in der künstlerischen Umsetzung. Es entstanden neue Metaphern vom Selbst und ein neues Verständnis des Interfaces. Die progressive Auslegung ihrer Arbeit fand im performativen Raum, im nicht-linearen Raum des Bildschirms und im sozialen Raum der Interaktion einen entsprechenden Ausdruck. In ihren Arbeiten manifestiert sich eine permanente Suche nach Bedeutungen dafür, was es heisst, ein Mensch zu sein, und mit welchen Methoden diese Ideen und Gefühle in das Bewusstsein des Publikums gerückt werden können.

INTRODUCTION

BY ROY ASCOTT

E | Jill Scott has defined the progression of her work as an evolution from "Analog Figures" to "Digital Beings" and finally to "Mediated Nomads" – a set of terms resonant with universal as well as idiosyncratic relevance. It is an evolution in thought as well as practice, and it is accompanied by the creation of new metaphors of self and new understandings of interface. The progressive nature of her work has brought into focus performative space, the nonlinear space of the screen, and the social space of interaction. This work has been a constant search for meanings of what it is to be human, and by what means these ideas and feelings can be brought into the consciousness of the observer.

With great sensitivity, dedicated research, and acute social awareness Jill Scott has, through her art, brought a critical view to bear on our many-sided understanding of what constitutes the body, how variously it can be represented, particularly by the use of new technologies, and what, through their mediation and intervention, it might become. Similarly

Mit großer Sensibilität und engagierter Forschung sowie einem ausgeprägten sozialen Bewusstsein hat Jill Scott einen kritischen Blick in ihrer Kunst entworfen. Dieser beleuchtet unsere komplexen Vorstellungen von einer Definition des Körpers. In welchen verschiedenen Formen lässt er sich darstellen, insbesondere durch den Einsatz von "Neuen Technologien"? Wie könnten sich diese Technologien durch mediale Vermittlung und Intervention auf den Körper auswirken? Wie verändern sich unsere Vorstellungen vom Körper durch seine mediale Vermittlung und welche Auswirkungen haben die Interventionen der neuen Technologien auf den menschlichen Körper? Auf ähnliche Weise begreift Jill Scott die Prägnanz neuer Entwicklungen in der Biologie mit ihren radikalen (Gen-) Kodierungen und thematisiert sie in ihrer Kunst die neu entstehende Transformation und Transmutation des menschlichen Körpers. Darüber hinaus hat Jill Scott ebenso radikal die narrative Form untersucht und sich mit der Frage beschäftigt, wie Narrationen neu rekonfiguriert oder rekonstruiert werden könnten, um neue Identitäten und neues Verhalten zu schaffen. Jill Scott ist in ihrer Arbeit stets mutig und phantasievoll, gleichzeitig hat sie außerordentliche technische Fachkenntnisse gesammelt und meidet vehement vorgefertigte Lösungen.

her grasp of the significance of the new biology and its radical coding informs her strategies for corporeal transformation and transmutation. Her scrutiny too has been applied to the narrative form, how this might be reconfigured or restructured both to incorporate new identities and to provide a new behavioural arena. In this she has been consistently bold and imaginative, summoning considerable technical expertise and rigorously eschewing readymade solutions.

Not only is Jill Scott's work well-known in many countries, but she has herself roamed widely, even nomadically through the world, along the way assimilating a wide range of cultural differences. Her work shows in particular the influence of those places where she has more permanently settled – the West Coast in the years 1975-82, Australia in the 1980s and Northern Europe since 1992. Together it constitutes a dynamic interplay of many influences. Since 1975, her relentless experimentation has cut an innovative pathway through the possibilities that contemporary technology and science have had to offer – from the early surveillance/performance work, to video art, through to computer-based installations and her interactive cinema of today. In this she has contributed significantly to the evolution of art in the context of technology, and to the understanding of what it might offer in the light of scientific discovery and for the creation of new human values.

CODED CHARACTERS covers these 28 years of development with essays and interviews by leading theorists from the three continents that she has traversed, whose intimate knowledge of her work and expert familiarity with contemporary practice provides the reader with a deep understanding of her approach and her achievements.

Anne Marsh reflects on Jill Scott's use of narrative in relation to time travel, dream and illusion, pointing to her skill in articulating the multiple dimensions of the self that technology can elicit, and showing how, by giving voice to others in her works, she opens up approaches to spiritual and intuitive knowledge compatible with the survival of the planet.

Das Werk von Jill Scott ist in vielen Ländern bekannt, und sie selbst hat, wie eine Nomadin, auf ihren Reisen in der ganzen Welt ein breites Spektrum von kulturellen Unterschieden kennen gelernt. Vor allem die Gegenden, in denen sie sich dauerhafter aufgehalten hat, tauchen in ihren Arbeiten wieder auf – die Westküste (Nordamerikas) in den Jahren 1975-82, Australien in den achtziger Jahren und Nord- bzw. Mitteleuropa seit 1992. Daraus resultiert ein dynamisches Zusammenspiel zahlloser verschiedener Einflüsse. Mit andauernder Experimentierfreude hat Jill Scott seit 1975 einen innovativen Weg eingeschlagen durch die sich anbietenden Möglichkeiten der Neuen Technologien und der zeitgenössischen Wissenschaft – von den frühen Performances mit Überwachungssystemen über Videokunst bis hin zu computergestützten Installationen und ihrem interaktiven Kino von heute. Mit ihren Arbeiten lieferte sie bedeutende Beiträge für eine Kunst im Kontext von Technologie und zum Verständnis davon, was Kunst zu leisten vermag hinsichtlich wissenschaftlicher Entdeckungen und einer Formulierung neuer menschlicher Werte.

CODED CHARACTERS illustriert 28 Jahre dieser Entwicklung mit Essays und Interviews von führenden TheoretikerInnen aus den drei Kontinenten, in denen Jill Scott gelebt hat. Sie sind mit den Arbeiten von Jill Scott eng vertraut. Durch ihr umfangreiches Expertenwissen in Bezug auf die Gegenwartskunst vermitteln sie den LeserInnen tiefe Einblicke in die Herangehensweise und die Ergebnisse des langjährigen Schaffens der Künstlerin.

Anne Marsh beschreibt, in welcher Form Jill Scott narrative Elemente mit Themen wie Zeitreise, Traum und Illusion verknüpft. Marsh stellt heraus, wie geschickt die Künstlerin multiple Dimensionen des Selbst durch ihren kreativen Einsatz der Medientechnologien zu artikulieren vermag. Sie argumentiert, dass Jill Scott, indem sie andere Personen in ihren Arbeiten zu Wort kommen lässt, spirituelles und intuitives Wissen zugänglich macht, Erfahrungen, die sich auf das Überleben der Erde übertragen lassen.

Robert Atkins untersucht die sozialen und politischen Haltungen, die ihre gesamte künstlerische Laufbahn begleiten; die unauslöschlichen Spuren, die die Avantgarde der Bay Area in den siebziger Jahren hinterlassen hat, und wie sich der Zusammenhang zwischen philosophischen und thematischen Ansätzen in ihren Arbeiten behaupten konnte, trotz aller Umformungen und Verschiebungen von der Moderne zur Post-

Robert Atkins examines the social and political attitudes that permeate her entire career; the indelible mark left by the late seventies' Bay Area avant-garde, and how, throughout the shifts and slides from modernism to the post-modern condition, the consistency of her philosophical and thematic approaches has been maintained. It is in the evolution of her audience that he sees her social concerns most evident: the small, unplanned audiences of her early street works giving way to the large, mixed audiences of public-art installations in non-art museums, as well as the even wider reaches of broadcast TV.

Yvonne Spielmann traces how, by introducing video into performance, Jill Scott finds new language to express her vision of multiple bodies, while using the instability of electronic imagery to counter stereotypes of womanhood in relation to technology. Interrelating video with live action, she combines the surface image of video with the projected image of film and the digital image of simulation, providing complex interfaces where fictional characters, historical personalities and simulated figures come together in a structured flux and flow. These mixed realities involve combinatory processes which incorporate the creative interaction of the viewer. She argues that through the poetics of video, Jill Scott integrates differing images of one's own body, the body as an object in space, and finally the virtual body and its multiple parts in cyberspace.

These insights are richly amplified by Jill Scott's own original notes about the works and their related technologies, leading the reader through body-based issues that the artist places within discourses around science, idealism, media-mythology, behaviour, memory, feminism and space. With a fecundity of illustrations, the book is divided into three sections: "Analog Figures" and performance art of the 1970s, "Digital Beings" and video art of the 1980s, and "Mediated Nomads" and interactive computer-based art of the 1990s. The artist shows how through the use of different media her concepts have grown from "dualistic statements to complex social and historical paradigms with layered meanings". CODED CHARACTERS provides a challenging perspective on a singular vision, and gives access to an art that infuses its technology with humanity.

moderne. Für Robert Atkins wird ihr soziales Engagement besonders deutlich sichtbar im Entwicklungsprozess ihres Publikums: von den kleinen spontanen Zuschauergruppen der frühen Arbeiten auf der Straße über ein großes, gemischtes Publikum ihrer Installationen im öffentlichen Raum und in interdisziplinären Museen wie auch die weitere Verbreitung ihrer Arbeiten durch das Fernsehen.

Yvonne Spielmann beschreibt, wie es Jill Scott gelingt, durch die Integration von Video in die Performance-Kunst eine neuartige Sprache zu formulieren, in der sich ihre Vision des multiplen Körpers artikulieren kann. Dabei setzt sie die Instabilität elektronischer Bilder ein, um den Stereotypen von Weiblichkeit in Bezug auf Technologie entgegenzutreten. Unter Berücksichtigung der Wechselbeziehungen von Video und Live-Action kombiniert sie die Video-Bildfläche mit dem projizierten Filmbild und dem digitalen Bild von Simulationen und erzeugt auf diese Weise komplexe Interfaces, in denen fiktive Charaktere, historische Personen und simulierte Figuren in einem strukturierten Fluss von Veränderungen aufeinandertreffen. Diese vermischten Realitäten enthalten kombinatorische Prozesse, welche die kreative Interaktion der BetrachterIn miteinbeziehen. Spielmann argumentiert, dass Jill Scott die Poesie von Video einsetzt, um unterschiedliche Bilder des eigenen Körpers, des Körpers als Objekt im Raum und schließlich des virtuellen Körpers und seiner multiplen Teile im Cyberspace zu integrieren.

Diese Überlegungen werden ausführlich ergänzt von Jill Scotts Anmerkungen zu ihren Werken und den angewandten Technologien. Sie führen die LeserInnen durch einen umfangreichen, körperbezogenen Kanon von Themen, die von der Künstlerin in Diskursen über Wissenschaft, Idealismus, Medien-Mythologien, Verhaltensmuster, Erinnerung, Feminismus und Raum behandelt werden. Mit vielen Abbildungen ist das Buch in drei Kapitel unterteilt: "Analog Figures" und Performancekunst der siebziger Jahre, "Digital Beings" und Videokunst der achziger Jahre und "Mediated Nomads" und interaktive, computergestützte Kunst der neunziger Jahre. Die Künstlerin veranschaulicht, wie sich ihr Konzept durch den Einsatz unterschiedlicher Medien konsequent weiterentwickelt hat, von "dualistischen Aussagen zu komplexen gesellschaftlichen und historischen Paradigmen mit vielschichtigen Bedeutungen". Diese außergewöhnliche Vision lässt die Beschäftigung mit CODED CHARACTERS zu einem spannenden Abenteuer werden und erschließt den Zugang zu einer Kunst, die Technologie und Menschlichkeit vereint.

CODED CHARACTERS

BY JILL SCOTT

E | During the last 30 years, both the represented image of the body and the physical body of the viewer have undergone a transition linked to the codifying and mediating experience of new technologies and mass media. I interpret this shift as a type of "coding". Not a code like "Morse code", but rather a communicative set of mechanical notations, digital conversions, social behaviour patterns and genetic biological structures. In this light, coded characters have emerged. On the one hand, there are the coded characters on the screen and the stage; on the other hand, the codifiers: the artists, the scientists, and you, the audience.

I imagine these mediated codes have shifted old definitions of the human body as well as the future of its representation and its identity dramatically. For me, media art is the platform best suited to translate, interpret and communicate the body, and media theory the best way to analyse body concepts. My aim is to trace, interpret, communicate, formulate and to create the organic, mechanical and virtual changes surrounding these coded characters and their transformed stage.

D | In den letzten dreißig Jahren hat sich die bildliche Darstellung des Körpers umfassend verändert. Genauso drastisch hat sich der physische Körper der BetrachterIn verändert. Beide Entwicklungen stehen in engem Zusammenhang mit den kodifizierten und mediatisierten Erfahrungen, die wir im Umgang mit neuen (Medien-) Technologien und den Massenmedien machen. Ich persönlich interpretiere diese Veränderungen als eine neue Form von "Kodierung". Damit gemeint ist nicht ein Code wie dem "Morse Code", sondern eher ein Kommunikationssystem aus analog-materiellen Aufzeichnungen, digitalen Manipulationen, interaktiven Verhaltensmustern und genetisch biologischen Strukturen. In diesem Sinne sind kodierte Charaktere entstanden. Dabei handelt es sich einerseits um kodierte Charaktere auf Bildschirm und Bühne und andererseits um kodifizierende Charaktere, womit die KünstlerInnen, die WissenschaftlerInnen, und Sie, das Publikum, gemeint sind.

Aus meiner Sicht verwandeln die Kodierungen der Medien die herkömmlichen Konzepte und die zukünftigen Identitäten des menschlichen Körpers dramatisch. Die Medienkunst stellt für mich eine besonders geeignete Plattform für die mediale Umsetzung, Interpretation und Kommunikation des menschlichen Körpers dar, und Medientheorie die beste Methode, Körperkonzepte zu analysieren. Mein Ziel ist es, den physischen und virtuellen Veränderungen der kodierten Charaktere nachzuspüren und sie - wie auch ihre transformierte Bühne - zu interpretieren, zu kommunizieren, zu formulieren und neu zu kreieren.

OF CONTINENTS AND DECADES, BODIES AND TECHNOLOGY

AN INTERVIEW BY ROBERT ATKINS

E | ROBERT ATKINS Our last interview was conducted nearly 22 years ago in San Francisco for your first book, "Characters of Motion".

JILL SCOTT Yes, and now we're here in Zürich where I work and you live in New York.

RA We left San Francisco at the same time - in 1982 - but you've spent the intervening years in Australia and Europe. I don't think many people realize that you've had three, sometimes quite distinct phases to your life as an artist. Why did you leave Australia for California in the first place during the seventies?

JS Because I wanted to re-invent myself. We Australians are great travellers you know. We tend to feel isolated there. Let's see, I had my BFA and I was in a conceptual art show organized by Kiffy Rubbo at the Ewing and George Patton Gallery in Melbourne. The rest of the commercial art world, with their prices attached and stuffy people, made me quite sick. What's the point I thought? Remember this is back in the early seventies,

D | ROBERT ATKINS Unser letztes Interview haben wir für dein erstes Buch "Characters of Motion" vor fast 22 Jahren in San Francisco geführt.

JILL SCOTT Ja, und nun sitzen wir hier: ich arbeite in Zürich, und du lebst in New York.

RA Wir haben San Francisco nahezu gleichzeitig verlassen - 1982 - aber du hast dich die Jahre danach in Australien und Europa aufgehalten. Ich glaube, viele wissen nicht, dass du drei mitunter doch unterschiedliche Phasen als Künstlerin durchlebt hast. Warum eigentlich bist du in den siebziger Jahren von Australien nach Kalifornien gezogen?

JS Weil ich mich sozusagen neu erfinden wollte. Wie du weißt, reisen wir AustralierInnen gerne und viel. Wir fühlen uns dort irgendwie isoliert. Lass mich nachdenken. Ich hatte gerade meinen BFA (Bachelor of Fine Arts) gemacht und nahm an einer Ausstellung von Konzeptkunst teil, die Kiffy Rubbo in der Ewing & George Patton Gallery in Melbourne organisiert hatte. Die kommerzielle Kunstwelt mit ihren angeklebten Preisschildern und den spießigen Leuten machte mich ganz krank.

and so I went to do a one-year's teaching degree at university and taught teenagers at a very progressive Steiner school. We even had a black and white video portapak. I saved enough after a year to travel in India and then to Europe. I worked again in London and then toured Africa before leaving for the U.S. in 1975.

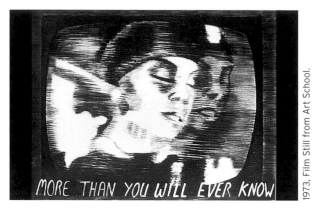

MORE THAN YOU WILL EVER KNOW

1973, Film Still from Art School.

RA What specifically attracted you to San Francisco?

JS Oh, on my travels I'd heard it was a very creative, hybrid environment. I already knew the work of Bay Area conceptualists and performers like George Coates and Terry Fox. Tom Marioni's Joseph Beuys/Terry Fox catalogue for his Museum of Conceptual Art was a real eye opener for me. Then there were the Pacific Rim connections with Australia – it was also closer to Asia.

RA So did you find this hybrid (art, theatre, sound) from the outset?

JS Yes, and it turned out that was one of the incredible things about San Francisco in the seventies: In addition to conceptual art there were avant-garde theatre artists like Snake Theatre and Jock Reynolds/Suzanne Helmuth; a fantastic electronic music scene nurtured by Paul de Marinas at Mills College, and several poetry groups. I became very close to the poets Barrett Watten and Carla Harryman.

RA Why did you return to Australia in the early eighties?

JS Probably a bad case of homesickness I'd say. Well, at the end of the seventies I'd collected video from 22 Bay Area artists and organised a lecture/screening tour throughout Australia. While on it, I collected documentation from Australian artists to show in the U.S. That show toured to five cities in the U.S. I found video an enchanting medium. Seductive in fact. All one's fantasies

Ich dachte, worum geht es hier eigentlich? Vergiss nicht, das war in den frühen siebziger Jahren, und so absolvierte ich in einem Jahr mein Examen für das Lehramt an der Universität und unterrichtete danach Teenager an einer sehr fortschrittlichen Steiner-Schule. Wir verfügten dort sogar über ein tragbares Schwarzweiß-Videogerät. Ich hatte nach diesem einen Jahr genug Geld gespart, um nach Indien reisen zu können und dann nach Europa. In London musste ich wieder arbeiten, danach war ich in Afrika unterwegs, bevor ich 1975 in die USA ging.

RA Warum hat es dich ausgerechnet nach San Francisco gezogen?

JS Ich hatte auf meinen Reisen von der überaus kreativen, hybriden Atmosphäre dort gehört. Ich kannte bereits Arbeiten von Konzept- und PerformancekünstlerInnen aus der Bay Area wie George Coates und Terry Fox. Der Joseph Beuys/Terry Fox-Katalog von Tom Marioni für sein Museum of Conceptual Art öffnete mir regelrecht die Augen. Dann waren da noch die Verbindungen zu Australien auf der anderen Seite des Pazifiks – und Asien war auch näher.

RA Hast du dieses Hybride (Kunst, Theater und Sound) gleich nach deiner Ankunft vorgefunden?

JS Ja, und was, unter anderem, richtig aufregend an San Francisco in den siebziger Jahren war: es gab dort, über die Konzeptkunst hinaus, Avantgardetheater wie das Snake Theatre und KünstlerInnen wie Jock Reynolds und Suzanne Helmuth; eine phantastische elektronische Musikszene, die maßgeblich von Paul de Marinas am Mills College beeinflusst war, und zahlreiche Gruppen von DichterInnen. Mit den DichterInnen Barrett Watten und Carla Harryman war ich eng befreundet.

RA Warum bist du in den frühen achtziger Jahren nach Australien zurückgekehrt?

JS Ich würde sagen, das war wohl ein ernster Fall von Heimweh. Nun, Ende der siebziger Jahre stellte ich Videoarbeiten von 22 KünstlerInnen aus der Bay Area zusammen und organisierte eine Ausstellungstournee mit Vorträgen und Filmaufführungen quer durch Australien. Während ich dort war, sammelte ich Dokumentationsmaterial von australischen KünstlerInnen, um sie in den USA zu zeigen. Diese Ausstellung reiste durch fünf amerikanische Städte. Video sollte sich für mich als ein wunderbares, geradezu verführerisches Medium erweisen. Durch den Einsatz synthetischer Effekte ließen sich sämtliche Phantasien direkt im Schneideraum ausleben. Ich hatte eine schöne Ausstellung zusammen mit zwei KünstlerInnen aus San Francisco, Max Almy und Judith Barry, die auf ähnliche Weise wie ich von Digitaleffekten fasziniert waren (CONSTRICTION I, 1982). Aber obwohl eigentlich einiges eher dafür sprach, in San Francisco

could be created by using synthetic effects in the editing suite. I had a nice show with two San Francisco artists, Max Almy and Judith Barry, who were similarly fascinated with digital effects (CONSTRICTION I, 1982). But even though this made it tempting to stay, nostalgia for the landscape and the cultural context made me want to go back to Australia to live. Besides, Steven Jones, an Australian artist once told me "You may as well be in Sydney as in San Francisco these days". He was building one of the first video synthesizer kits in my SF studio at the time, and well, that western digital revolution was spreading fast!

RA I know we'll be dealing directly with the work you've done in other parts of this book. So let's fast forward another decade to 1992, when you made another radical (geographical) break.

JS Sure, I moved to Germany to take advantage of an opportunity offered there. Years earlier, I'd met the artist Ulrike Rosenbach and it was she who invited me to be a guest professor in Saarbrücken. The art school wanted to develop computer graphics and animation - my obsession at the time. However, after two years there, I was asked to be an Artist in Residence at the ZKM (Zentrum für Kunst und Medientechnologie) in Karlsruhe.

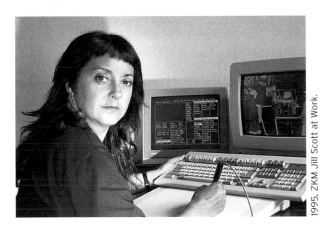

1995, ZKM Jill Scott at Work.

zu bleiben, verspürte ich doch den Wunsch, nach Australien zurückzukehren. Aus Sehnsucht nach der Landschaft und wegen des kulturellen Kontextes wollte ich wieder dort leben. Außerdem hatte mir Steven Jones, ein australischer Künstler, mal gesagt "Man kann heutzutage genauso gut in Sydney wie in San Francisco leben". Er hatte in meinem damaligen Atelier in San Francisco einen der ersten Video-Synthesizer gebaut, und die digitale Revolution im Westen breitete sich ja wirklich schnell aus!

RA Auf deine Arbeit aus dieser Zeit kommen wir ja direkt an anderer Stelle des Buches zurück. Also lass uns ganz schnell ein Jahrzehnt überspringen. 1992 hast du wieder einen radikalen (geographischen) Schritt unternommen.

JS Das stimmt, ich ging nach Deutschland, weil ich dort ein interessantes Angebot erhielt. Jahre zuvor hatte ich die Künstlerin Ulrike Rosenbach kennengelernt, und sie war es dann auch, die mich als Gastprofessorin nach Saarbrücken holte. Die Kunsthochschule plante einen Studiengang für Computergraphik und -animation einzurichten - genau das war meine Obsession damals. Zwei Jahre später wurde ich dann vom ZKM (Zentrum für Kunst und Medientechnologie) als Gastkünstlerin nach Karlsruhe eingeladen.

RA Bist du zu diesem Zeitpunkt nicht auch an die Universität zurückgekehrt?

JS Ja, stell dir das vor. Es begann alles damit, dass mich Roy Ascott anrief und mir eine Position in seinem neu gegründeten Doktorandenprogramm in Wales namens "The Centre for Advanced Inquiry into the Interactive Arts" in Aussicht stellte. Ein hochinteressantes Projekt, dass KünstlerInnen ermutigt, sich akademisch mit der eigenen Arbeit auseinanderzusetzen, auch ein Programm, das ernsthaft die wissenschaftlich künstlerische Forschung vorantreibt. Danach wurde ich für eine Professur an der Bauhaus-Universität in Weimar vorgeschlagen, wobei mich die Aussicht reizte, DoktorandInnen zu unterrichten. Jetzt stehe ich gerade vor einer weiteren Veränderung, durch die ich mich wieder neu erfinden kann - diesmal eine Forschungsstelle an einer Hochschule in der Schweiz.

RA Wasn't that when you also returned to university?

JS Yes - imagine that. It all started when Roy Ascott rang and offered me a position in his newly founded doctorate program in Wales called "The Centre for Advanced Inquiry into the Interactive Arts". An interesting program - which definitely helps artists write academically about their own research, and also for art-research to be taken seriously. Afterwards, I was offered a professorship at the Bauhaus University in Weimar and it was important for me to know how to supervise Ph. D students. Now I am in transition to re-invent myself again - this time for a research position at a technical university and at an art school in Switzerland.

RA It sure has been quite an odyssey looking back on all your work, but there's one thing that cuts across all of it and that's the body. Whether this is in the form of early works in which you were suspended from walls or stuck in shipping crates, works dealing with your breast cancer, to the more overtly social concerns to be found in your recent, didactic works about feminist history or the contemporary virtual body. You've even identified eight, body-related metaphors and thematic concerns in your work. Let's go through them one by one. The first you call "the body and the codes of science".

JS My process of making media artworks is actually scientific in nature. It flows from having an idea (hypothesis), conducting research (experiments and prototypes) and drawing conclusions (proof - the final artwork). Actually, I have often placed myself in the role of a satirical scientist - sometimes decoding and classifying information.

Sometimes, my work was connected to actual scientific and technical discoveries in relation to the human body in the early seventies. For example I was fascinated with human hearing and acoustics. I remember being surprised to learn that loss of hearing was actually a dulling of the lower and higher frequency range rather than a drop in volume. I made sound sculpture at the time and this information affected the types of sculpture I built with their low and ratcheting tones (REVOLVING DESERT SIMULATOR). I wanted people to increase their audio-perception and to experience the type of sounds that might emerge from under the crust of the earth.

RA Die Rückschau auf dein Gesamtwerk war sicher eine ziemliche Odyssee. Ein Thema zieht sich durch alle deine Arbeiten, das des Körpers. Ob es sich um die Form deiner frühen Körperaktionen handelt, bei denen du an eine Hauswand geklebt oder in eine Transportkiste verpackt wurdest, um Arbeiten, die sich mit deinem Brustkrebs beschäftigten, bis hin zu einer eher unverhohlenen gesellschaftlichen Auseinandersetzung, auf die man in deinen neueren didaktischen Arbeiten über die Geschichte des Feminismus oder den virtuellen Körper in der Gegenwart trifft. Es ist dir gelungen, acht auf den Körper bezogene Metaphern und Themenbereiche in deinem Werk zu bestimmen. Lass sie uns der Reihe nach durchgehen. Die erste Metapher nennst du "der Körper und die Codes der Wissenschaft".

JS Tatsächlich ist mein Entstehungsprozess von Medienkunstwerken von Natur aus wissenschaftlich. Er führt von der Formulierung einer Idee (Hypothese) über die Durchführung von Untersuchungen (Experimente und Prototypen) zur Schlussfolgerung (Beweis - das vollendete Kunstwerk). In der Tat habe ich häufig versuchsweise die Rolle einer ironisch-distanzierten Wissenschaftlerin angenommen und dabei gelegentlich Information decodiert und klassifiziert.

Bisweilen war meine Arbeit in den frühen siebziger Jahren an aktuelle wissenschaftliche und technische Entdeckungen geknüpft, die sich auf den menschlichen Körper bezogen. Zum Beispiel war ich vom Hören des Menschen fasziniert, von akustischer Wahrnehmung. Ich erinnere mich, wie sehr mich die Erkenntnis überrascht hat, dass Hörverlust tatsächlich eher auf der Beeinträchtigung der niedrigeren und höheren Frequenzen als auf einem Abfall der Lautstärke insgesamt beruht. Ich arbeitete zu dieser Zeit an Klangskulpturen wie dem REVOLVING DESERT SIMULATOR, mit denen ich beispielsweise leise, knarrende Geräusche, assoziierbar mit vorstellbaren Klangbildern unterhalb der Erdkruste, zu erzielen suchte. Die BesucherInnen sollten ihr akustisches Wahrnehmungsvermögen erweitern und diese Art von Geräusche neu erleben können.

Als ich in den achtziger Jahren verschiedene Aufsätze von Physikern über das Verhältnis von Zeit und Raum las, begann mir aufzufallen, dass Frauen aus der Geschichte der Astrophysik gänzlich ausgeschlossen waren. Als Reaktion darauf entstand GREAT ATTRACTOR. Australien entwickelte sich in den achtziger Jahren zu einer Art Paradies für Übertragungssysteme per Satellit und Mikrowellen, und ich stellte mir die Frage, inwieweit kulturelle Information auf die Eingeborenen in den Wüstenorten Einfluss nimmt. Was geschieht mit dem Datenfluss und den Radiowellen, die wie Müll im Raum herumschweben (MEDIA MASSAGE)? Mit Vinetta Lagzdina und ein paar anderen Frauen gründete ich die digitale Band "Dynabytes", mit der wir unsere Studien über Elektromagnetismus anwenden wollten.

RA Später hast du dich doch dann noch viel direkter mit dem physischen menschlichen Körper befasst. Inwieweit hast du dich in diesem Zusammenhang mit der Natur an sich und mit der ideologischen Konstruktion von (Natur-) Wissenschaft auseinandergesetzt?

JS In den neunziger Jahren galt meine Beschäftigung u.a. den Zellstrukturen des menschlichen Körpers sowie der Haut als Interface (A FIGURATIVE HISTORY). Heute bin ich ein Junkie von Wissenschaftsmagazinen wie "Nature's Biotechnology Special". Zu selten werden dort aber die notwendigen ethischen Fragen über die Manipulierbarkeit der Natur und die utopischen Konzepte über ästhetische Darstellungen des Körpers behandelt, und genau hier können Medienkunstwerke eingreifen (z.B. DIGITAL BODY AUTOMATA als Resultat meiner Forschungsarbeiten am ZKM). Vielleicht können sie auch eine Rolle spielen bei einer Neu-Definition von Identität im Verhältnis zur digitalen Darstellung.

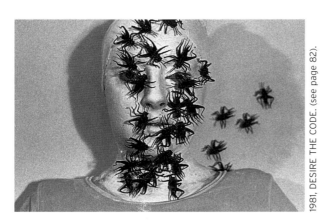

1981, DESIRE THE CODE. (see page 82).

In the 1980s, I read physics about the relationship of time and space, which led me to ponder women's exclusions from astrophysics history like in the GREAT ATTRACTOR. The eighties were a satellite and microwave transmission paradise for Australia, and it made me wonder how cultural information affects indigenous people in desert communities. What happens to the escaped data and radio waves that float around space like garbage? (MEDIA MASSAGE). With Vineta Lagzdina and a few other women I had a digital band called the "Dynabytes" where we tried to actually apply our study of electromagnetism.

RA Later on you worked more directly with the human body. What about dealing with the nature and ideological construction of science itself?

JS I guess in the nineties this led to an interest in looking at the cellular constitution of the human body and also the skin as an interface (A FIGURATIVE HISTORY). Now, I'm a junkie for science journals – like Nature's Biotechnology special. They don't always raise essential ethical questions about the manipulation of nature and the utopian concept of aesthetic representation of the body, and this is where media art might find a role (e.g. DIGITAL BODY AUTOMATA, my works from research at the ZKM). They might also find a role in the re-defining of identity in relation to digital representation.

»THE EGO IS ULTIMATELY DERIVED FROM BODILY SENSATIONS, CHIEFLY THOSE SPRINGING FROM THE SURFACE OF THE BODY.« SIGMUND FREUD. »THE REAL AND THE VIRTUAL SPACES WHICH BOTH ENCOMPASS THE BODY AND COMPRISE THE BODY ARE COMBINED IN PERPETUAL ASSOCIA- TION.« JACQUES LACAN. »THINK OF THE BODY WITHOUT ORGANS, AS THE BODY OUTSIDE ANY DETERMINATE STATE, POISED FOR ANY ACTION IN ITS REPERTORY; THIS IS THE BODY FROM THE POINT OF VIEW OF ITS POTENTIAL, OR VIRTUALITY.« GILLES DELEUZE.

ROBERT ATKINS This brings me to the next question. Can you elaborate on "the body and the codes of identity"?

JILL SCOTT I think artists are also close to the process of philosophical discourse. Both artists and the bodies they represent on any screen want to question their existence and break away from the boundaries of conventional thought, don't they? In the early seventies we had to study philosophy, psychology and sociology as part of our art course at university. We budding feminists slammed Freud; we hated being categorized only on the basis of biological difference. Marx's equality was much more appealing for us anti-capitalists, anti-imperialists. But it was Roland Barthes' work, in which identity was a land full of rich cultural mythologies. His philosophy made all the difference for me in the late seventies.

RA And suddenly modernism really ends and the whole intellectual landscape shifts like the San Andreas Fault.

JS So true. I had started reading theory and opened myself up to more variegated concepts of identity. Remember that great Lacanian analysis? He said that our true identities were based on the surrounding baggage that we drag around with us and reflect in the mirror of ourselves. And then there was Michael Foucault, whose concepts of power and control represented the New World of surveillance we witnessed being built around us. Meanwhile, Barthes continued to spin tales for a tele-literate audience. He really made it clear that the plural roles of the media artist, the audience and the image itself had to be rethought and seen as interdependent components.

ROBERT ATKINS Das bringt mich zur nächsten Frage. Kannst du mehr darüber sagen, was du mit dem "Körper und den Codes der Identität" meinst?

JILL SCOTT Ja, ich denke, auch KünstlerInnen sind mit philosophischen Diskursen durchaus vertraut. Für beide, die KünstlerInnen und die Körper, die sie in welcher Form auch immer repräsentieren, stellt sich die Frage nach ihrer Existenz, und es entsteht das Bedürfnis, die Grenzen konventionellen Denkens zu durchbrechen, oder? In den frühen siebziger Jahren mussten wir während unseres Kunststudiums an der Universität Philosophie, Psychologie und Soziologie belegen. Für uns angehende FeministInnen war Freud der Sündenbock; wir lehnten es vehement ab, ausschließlich auf der Ebene des biologischen Unterschieds beurteilt zu werden. Der Gedanke der Gleichheit bei Marx sprach uns als Anti-KapitalistInnen und Anti-ImperialistInnen viel stärker an. Aber es musste erst Roland Barthes kommen, dass wir Identität als ein Reich voller kultureller Mythologien begriffen. Seine philosophischen Gedanken waren für mich in den späten siebziger Jahren von mehr als entscheidender Bedeutung.

RA Und plötzlich endet die Moderne dann wirklich, und die gesamte intellektuelle Landschaft verschiebt sich wie der St. Andreas-Graben.

JS Ja, genau. Ich hatte damit begonnen, theoretische Texte zu lesen und mich für vielschichtigere Konzepte von Identität zu interessieren. Erinnerst du dich an die beeindruckende Analyse von Jacques Lacan? Er sagte, dass unsere wahre Identität auf dem Gepäck, das wir ständig mit uns schleppen, basiert und in einem Spiegel von uns selbst reflektiert wird. Und dann war da noch Michel Foucault, dessen Konzept von Macht und Kontrolle die Neue Welt der Überwachung darstellte, die vor unseren Augen entstand. Gleichzeitig widmete sich Barthes weiter seinen Ideen um ein tele-literarisches Publikum. Er machte mehr als deutlich, dass die vielfältigen Rollen der MedienkünstlerIn, des Publikums und auch des Bildes selbst neu überdacht und als Bestandteile in einer voneinander abhängigen Wechselwirkung betrachtet werden müssten.

Then in the nineties this evolved into a paradigm of mixed realities. Gilles Deleuze believed that new definitions of the human identity must always consider the transient aspects – those that are poised on the very edge of change. He offered a much broader concept of the term body, like Barthes incorporating the audience and the context. Currently, I find his ideas especially appealing. In fact most of my media-friends believe that his philosophies about our bodies in relation to change are most appropriate at the moment. Consequently, we are often asking: How might the body be represented by media to reflect and incorporate change? Does the concept of nature also include the extended body of the whole audience? How do new media's artificial components – the technical hardware and software – fit into the Deleuzian definition or paradigm of identity?

In den neunziger Jahren entwickelte sich daraus ein Paradigma vermischter Realitäten. Gilles Deleuze glaubte, dass neue Definitionen der menschlichen Identität immer Aspekte der Vergänglichkeit berücksichtigen müssten - gemeint sind jene exakt am Rande von Veränderungen. Er entwarf ein viel umfassenderes Konzept des Begriffs vom Körper und brachte wie Barthes Publikum und Kontext zusammen. Gerade jetzt sind seine Überlegungen für mich von besonderem Interesse. Eigentlich halten die meisten meiner MedienfreundInnen seine philosophischen Gedanken über unseren Körper in Bezug auf Veränderungen momentan für ausgesprochen zeitgemäß. Folgerichtig stellen wir uns oft die Frage: Wie könnte der Körper medial dargestellt werden, um Veränderung zu reflektieren und gleichzeitig zu verkörpern? Enthält das Konzept von Natur auch den das gesamte Publikum umfassenden Körper? Wie passen die künstlichen Komponenten der neuen Medien - technische Hardware und Software - zu der Definition von Deleuze oder zum Paradigma von Identität?

»IF THE ›REAL‹ IS MERELY A CULTURAL CONSTRUCTION, DEPENDENT ON PERCEPTION AND THEREFORE ON IDENTIFICATION, THEN ›WHO‹ WITHIN ›WHAT‹ IS THE STARTING POINT OF MYTHOLOGICAL ANALYSIS.« ROLAND BARTHES. »HUMANS WILL ALWAYS THINK AND EXIST IN VIEW OF OTHER HUMANS.« JACQUES LACAN. »NON-LINEAR NARRATIVES ALLOW FOR SEMIOTIC EXCHANGE, A REFORMATION OF CONTENT AND A RADICAL REVISION OF IDENTITY AND SOCIAL RELATIONS.« JEAN-FRANÇOIS LYOTARD.

ROBERT ATKINS Identity sure is an important issue these days. Can you talk more about what you call "the body and the codes of behavior".

JILL SCOTT Sure. Actually, audience behaviour has really been a consistent interest of mine for about 30 years. Lately it turned into a focus on cognition. I was often trying to make satires about human manipulation and therefore I used patterns or codes based on preferences or choices by the audience. Sometimes these sprung from books about psychology (IQ tests) and social order. In 1975, I started with a series of basic experiments to study audience behaviour patterns in installation environments. I wondered how I could mirror the processes of the viewer making right- and left-brain choices, and through surveillance I attempted to sketch the conceptual associations and changing reactions of the audience after they recognized themselves through video feedback. The results were rather crude, but they did give me a new role: I became a kind of decoder of didactic information and artist combined.

ROBERT ATKINS Identität ist ein wichtiger Themenbereich heutzutage. Kannst du noch etwas mehr darüber sagen. Was meinst du, wenn du vom "Körper und den Codes der Verhaltensmuster" sprichst?

JILL SCOTT Natürlich. In der Tat hat mich das Verhalten des Publikums seit ungefähr dreißig Jahren nachhaltig interessiert. Neuerdings stehen dabei auch die Erkenntnistheorien im Vordergrund. Ich habe mich versuchsweise und in ironischer Form mit der Manipulierbarkeit des Menschen auseinandergesetzt und benutzte deshalb Muster oder Codes, die auf Vorlieben oder Reaktionen des Publikums zurückgingen. Sie waren zum Teil Abhandlungen über Psychologie (IQ-Tests) und aus der Soziologie entnommen. 1975 begann ich mit einer Serie einfacher Experimente, bei denen die Verhaltensmuster des Publikums in Installationen und Environments untersucht werden sollten. Ich stellte mir beispielsweise die Frage, ob sich Prozesse, die die BetrachterIn dazu bringen, vorzugsweise die rechte und oder die linke Gehirnhälfte für ihr Handeln zu wählen, wiedergeben ließen. Durch Überwachung versuchte ich, die konzeptionellen Zusammenhänge und wechselnden Reaktionen der Besucher-

RA And you gave the audience the sensation of being surveyed and analysed.

JS Yes, exactly. In the eighties, I started reading media criticism and playing with the audience's comprehension: concepts of language, communication and media literacy. Well, I was in Australia and semiotics was immensely fashionable there at that time. Do you remember Barthes' great analysis of dialogue itself? I wanted to explore what happens when a story is told from one person to another in a non-linear way. I began to cut and paste in order to give the audience a sense of multiple choice. By the late eighties interactivity seemed to me to be an area which still needed a lot of exploration, so in the nineties I started to use the computer and construct hybrid environments in which the viewers could become editors of the narrative themselves or had to talk to each other in different time zones. The aim was to make a type of interactive community with real and virtual characters.

RA By "the body and media metaphors" do you mean mass media?

JS No, I mean in a more formal sense the potentials of a particular medium or form such as digital video. In my first performances, video and sound were used for analog representations of the human body. We all know those washed-out, black and white video images. Such works reflected us, but didn't look like us. Many video makers were interested in these distortions. They seemed like the ghost in the machine looking out at you, and metaphorically the voice of the underprivileged, there was both a liberty and fragility in it. If you pointed the camera at the sun the tube would blow up.

RA Such analog media seem closer to classical, Neo-Realist art films than to contemporary art.

Innen, nachdem sie sich im Video-Feedback wiedererkannt hatten, aufzuzeichnen. Die Resultate waren recht primitiv, aber sie verschafften mir eine neue Aufgabe: Ich wurde zu einer Art Decoder von didaktischer Information und war Künstlerin zugleich.

RA Und du hast dem Publikum das Gefühl vermittelt, gleichzeitig beobachtet und analysiert zu werden.

JS Ja, genau. In den achtziger Jahren begann ich medienkritische Texte zu lesen und mit dem Rezeptionsvermögen des Publikums zu spielen: es ging um Sprach- und Kommunikationskonzepte sowie um das Verständnis von Medien. Gut, ich war in Australien und Semiotik war dort gerade zu jener Zeit unglaublich populär. Erinnerst du dich an den großartigen analytischen Essay von Barthes über den Dialog an sich? Ich wollte untersuchen, was geschieht, wenn eine Person einer anderen eine Geschichte in einer nicht-linearen Form erzählt. Ich begann damit, sie quasi auseinanderzuschneiden und wieder zusammenzufügen, um dem Publikum ein Gefühl von Multiple Choice zu geben. Seit den späten achtziger Jahren schien mir Interaktivität ein Gebiet zu sein, in dem noch viele Untersuchungen nötig waren und so verwendete ich in den neunziger Jahren erstmals Computer und konstruierte hybride Umgebungen, in denen die BesucherInnen selbst zu AutorInnen werden konnten oder in unterschiedlichen Zeitzonen miteinander kommunizieren sollten. Dahinter stand die Absicht, eine Art interaktive Gemeinde aus realen und virtuellen DarstellerInnen zu schaffen.

RA Wenn du vom "Körper und den Metaphern der Medien" sprichst, meinst du damit die Massenmedien?

JS Nein, in einem formaleren Sinn meine ich die Möglichkeiten, die ein bestimmtes Medium oder eine Form besitzt, zum Beispiel digitales Video. In meinen ersten Performances benutzte ich Video und Sound für die analoge Darstellung des menschlichen Körpers. Wir alle kennen diese verwaschenen, schwarzweißen Videoaufnahmen. Sie wirkten wie Spiegelbilder, sahen aber nicht aus wie wir. Viele VideofilmerInnen waren an diesen Bildverzerrungen interessiert. Sie erschienen als der Geist, der dich aus der Maschine anstarrt, oder auf eine metaphorische Art und Weise wie die Stimme der Unterprivilegierten; beides war darin enthalten, Freiheit und Zerbrechlichkeit. Hätte man die Kamera gegen die Sonne gehalten, wäre die Röhre verbrannt.

RA Diese analogen Medien scheinen dem klassischen, neorealistischen Film näher als der Gegenwartskunst zu stehen.

JS But it soon became apparent that the growth of digital technologies was exploding. For me, and many others, fantasy became an obsession. I was one of those who got hooked on attempts to depict the imaginary. We thought that digital technology was not only affecting our perception but also how we share information. So I used digital effects to flatten and fly the bodies of my characters and their belongings around the screen. If viewers wished for more illusion – then perhaps I could give them a parallel world that joined their reality (their real bodies) and their illusion (their digital bodies) on the screen. I remember playing with 3-D-polygons (ADO) and often placed the real characters in artificial worlds so as to reflect this concept (LIFE FLIGHT).

In the nineties, a third condition entered the picture – The Virtual. By using cyberspace or a shared media environment, the audience could time-travel and imagine themselves in reality (here and now) or in illusion (over there or in a type of no-man's land). I call the artificial constructions available through computer technology and presented on-screen, "mixed realities".

JS Aber es stellte sich bald heraus, dass sich die digitalen Technologien geradezu explosionsartig entwickelten. Für mich, und viele andere KünstlerInnen, wurde Phantasie zur Obsession. Ich gehörte zu denen, die unablässig versuchten, das Imaginäre abzubilden. Wir dachten, die digitale Technologie beeinflusse nicht bloß unsere Wahrnehmung, sondern auch unseren Austausch von Informationen. So benutzte ich Digitaleffekte für die Komprimierung der Körper meiner Charaktere sowie ihres persönlichen Hab und Guts und ließ diese dann auf dem Bildschirm herumfliegen. Wenn sich die BesucherInnen mehr Illusion wünschten – dann konnte ich ihnen vielleicht eine parallele Welt bieten, die sich mit ihrer Realität (ihren realen Körpern) und ihren Illusionen (ihren digitalen Körpern) auf dem Bildschirm mischte. Ich erinnere mich daran, dass ich mit 3-D-Polygonen auf einer 2-D-Animationssoftware (ADO) experimentiert und häufig die realen Charaktere in künstliche Welten versetzt habe, sozusagen als Reflexion auf dieses Konzept.

In den neunziger Jahren entwickelte sich eine dritte Bildebene – das Virtuelle. Durch die Benutzung des Cyberspace bzw. einer gemeinsamen medialen Umgebung konnten die BesucherInnen eine Zeitreise antreten und sich in ihrer Vorstellung in der Realität (hier und jetzt) oder in einem Zustand der Illusion (dort hinten oder in einer Art Niemandsland) bewegen. Ich nenne die durch die Computertechnologie entstandenen künstlichen Konstruktionen, die auf dem Bildschirm zu sehen sind, vermischte Realitäten.

»PEOPLE'S BODIES WERE MY BIGGEST TECHNICAL PROBLEM RIGHT FROM THE START.« ALLAN KAPROW. »THE TERM ›INTERFACE‹ NEEDS TO INCLUDE MORE COGNITIVE AND EMOTIONAL ASPECTS OF AN ACTUAL FACE TO FACE DIALOGUE.« BRENDA LAUREL. »THE IDEOLOGY OF THE SELF HAS TAKEN TOO LONG TO PERISH... IF WE ASSUME THAT WE ARE IMBEDDED WITHIN A RELATIONAL NETWORK, THEN THE CLASSICAL DISTINCTION BETWEEN ›OBJECTIVE KNOWLEDGE‹ AND ›SUBJECTIVE KNOWLEDGE‹ WILL BECOME MEANINGLESS.« VILÉM FLUSSER.

ROBERT ATKINS So far you've talked about the body in relation to the codes of science, of identity, of behavior and of media metaphors. Can we now discuss "the body and the object"?

JILL SCOTT Early on, I tried to comment on the way the female form in Western society was regarded as a commodity. So I travelled to non-Western societies in Asia and Africa to see if the situation was any better. I saw powerful representations in the form of female-only rituals. Many objects were used in rituals as metaphors for fertility and power. I attributed to the Western female form properties such as becoming the icon in

ROBERT ATKINS Du hast nun über den Körper im Zusammenhang mit den Codes der Wissenschaft, der Identität, der Verhaltensmuster und den Metaphern der Medien gesprochen. Können wir jetzt über "den Körper als Objekt" reden?

JILL SCOTT Ich habe schon früh nach Ausdrucksformen dafür gesucht, in welcher Form der Körper der Frau in der westlichen Gesellschaft als Ware betrachtet wird. Auf Reisen durch Asien und Afrika wollte ich untersuchen, ob es um die Situation der Frau in nicht-westlichen Gesellschaften besser bestellt sei.

TAPED; or the catalyst in a ritual where objects were related to nostalgia like in PERSIST, THE MEMORY. Perhaps objects could also be the trigger for evoking a sense of timelessness (SAND THE STIMULANT).

Later, in the eighties, I became interested in the cross-cultural meanings of objects. For example, I asked which objects have helped and hindered social freedom? Or which modern objects embody a clear relationship between desire and design? (PARADISE TOSSED). In the nineties I was more concerned about the relationship between tools and objects. Which tools-as-objects relate metaphorically to the content in a scenario where reality and illusion are enacted? (The doctor's touch in INTERSKIN, 1997). By then, my objects had grown into metaphorical interfaces between the bodies of collaborators (the audience) and the represented characters who appeared on the screen. Was there a symbiosis between the atomic structure of the body and the human body in its entirety? Currently I am interested in using the senses of touch, space and time as metaphors for connectivity in specific communities.

RA You've done a lot of theorizing about your own work. Does such categorizing come later or is it part of your process?

JS Sure, it's part of the process. You know I really do a lot of background research before I create an artwork. Not that I don't get inspired by an exhibition space or other artists' works, but the philosophical context of media and its role in society is really important, don't you think?

RA Yes, of course – as Sandy Stone says – technology is driven forward by the need for social dialogue. So what other artists are of interest for you – I mean the ones who use theoretical approaches to media art?

JS Well, there is Paul de Marinas, Steven Wilson, Char Davies, Victoria Vesna, Bill Seaman, Tony Dove, Perry Hoberman, Edwardo Kac. Actually I can think of quite a few. You know we all feel that the bridge between theory and practice is closing more and more, particularly for media artists. This aspect is of immense importance. In a way it's similar to our discussions about media as a device to shift our experience of time and space.

Ich bin dort auf beeindruckende Darstellungsformen von ausschließlich weiblichen Ritualen gestoßen. Viele Gegenstände wurden in diesen Ritualen als Metaphern für Fruchtbarkeit und Macht eingesetzt. Ich fügte dem Frauenkörper in der westlichen Gesellschaft neue Eigenschaften hinzu, indem ich ihn, wie zum Beispiel in TAPED, zu einem Standbild werden ließ oder zum Katalysator in rituellen Handlungen, bei denen Objekte in Beziehung zu Sehnsüchten gesetzt wurden, wie in PERSIST, THE MEMORY. Vielleicht könnten Objekte auch der Auslöser sein, um ein Gefühl von Zeitlosigkeit (SAND THE STIMULANT) hervorzurufen.

Später, in den achtziger Jahren, beschäftigten mich kulturell übergreifende Bedeutungen von Objekten. Ich fragte mich zum Beispiel, welche Objekte zu gesellschaftlicher Freiheit verholfen und welche sie behindert haben? Oder welche modernen Objekte verkörpern ein klar definiertes Verhältnis zwischen Sehnsüchten und Design (PARADISE TOSSED)? In den neunziger Jahren ging es mir dann mehr um die Beziehung zwischen Tools und Objekten. Welche zu Objekten gewordenen Instrumente verhalten sich metaphorisch zum Inhalt in einem Szenario, in dem Realität und Illusion aufeinandertreffen? (Das Interface eines medizinischen Endoskops, INTERSKIN, 1997). Zu dieser Zeit hatten sich meine Objekte zu metaphorischen Schnittstellen zwischen den Körpern der BenutzerInnen (dem Publikum) und den dargestellten Charakteren auf dem Bildschirm entwickelt. Gab es eine Art Symbiose zwischen der Atomstruktur des Körpers und dem Menschen in seiner Ganzheit? Gegenwärtig arbeite ich daran, die Erfahrungen des Berührens und die Wahrnehmung von Raum und Zeit als Metapher für Zusammenhänge in spezifischen sozialen Strukturen einzusetzen.

RA Du hast dich mit den theoretischen Aspekten deiner Kunst intensiv auseinandergesetzt. Kommt diese Kategorisierung erst später oder ist sie Teil des Entstehungsprozesses?

JS Sicherlich Teil des Entstehungsprozesses. Ich habe bereits umfangreiche Hintergrundrecherchen angestellt, bevor ich mit der eigentlichen künstlerischen Arbeit beginne. Natürlich lasse ich mich auch vom Ausstellungsraum und den Werken anderer KünstlerInnen inspirieren. Aber der philosophische Kontext der Medien und ihre gesellschaftliche Bedeutung sind wirklich wichtig, findest du nicht?

RA So let's move on to "the body and space/time scenarios". What is that?

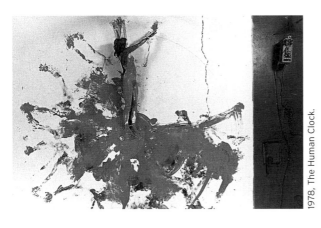

1978, The Human Clock.

JS Well, reading fiction is essential to me. I tend to binge on literary fiction and then alternate with theory books. In the seventies there were periods at school when I read theory by conceptualists such as Tom Marioni, and other times when I vanished into the Latin mountains with Borges, Allende and Marquez. I always like my fiction to have both a feeling of place and a sense of the human passage over time. This inspired metaphors based on landscape in my own work that led to rituals or scenarios if you will. Later, it was my own crossing of geographical boundaries and the return to Australia that spurred the reading of more mythological texts, especially the fictions that depict the collapse of urban influence and rural space. Often poems about nomadic transience (Kath Walker/Oodgeroo Noonuccal) or Aboriginal songs in particular can expand one's vision of the landscape and the utter timelessness of the desert. But there you are, walking in this environment that seems to be stuck in a time warp, but actually the air is saturated by the latest invisible technology – satellite and radio transmission. You go back to the city and read the latest fictions, novels that collapsed time and scramble western mythologies like Angela Carter.

RA Doch natürlich. Sandy Stone hat das so treffend formuliert. Technologie wird durch den notwendigen, gesellschaftlichen Diskurs angetrieben. Welche anderen KünstlerInnen interessieren dich – ich meine von denen, die theoretische Ansätze in ihren medialen Arbeiten verfolgen?

JS Nun, da sind Paul de Marinas, Steven Wilson, Char Davies, Victoria Vesna, Bill Seaman, Tony Dove, Perry Hoberman, Eduardo Kac, da fallen mir wirklich einige ein. Du weißt, wir alle fühlen, dass sich die Kluft zwischen Theorie und Praxis mehr und mehr schließt, besonders für MedienkünstlerInnen. Wir möchten erreichen, dass Kunst/Forschung als wissenschaftliche Forschung ernst genommen wird, ein Aspekt, der für uns immens wichtig ist. Zum Beispiel diskutieren wir häufig über Medien als ein Instrumentarium, mit dem wir unsere Erfahrungen von Zeit und Raum verändern können.

RA Diese Erfahrungen kommen ja gerade in fast allen deinen Werken zum Ausdruck. Lass uns vom Körper in Bezug auf "Raum/Zeit-Szenarien" sprechen. Wir kennen ja viele Vorbilder aus Büchern.

JS Nun, ich verschlinge geradezu Romane und Erzählungen, um dann Abwechslung in theoretischen Büchern zu suchen. In den siebziger Jahren habe ich an der Hochschule zeitweise theoretische Schriften von KonzeptkünstlerInnen wie Tom Marioni gelesen, dann wieder hatte ich mich mit Borges, Allende und Marquéz in die Berge Südamerikas zurückgezogen. Für mich sollte Literatur immer beides besitzen, ein Gefühl für den Ort und für die Zeitläufe des Menschen. Das inspirierte mich in meinen Arbeiten zu Metaphern, die sich auf Landschaften bezogen, aus denen Rituale oder Szenarien entstehen konnten, wenn man das wollte. Später waren es die unterschiedlichen Erfahrungen auf meinen Reisen und die anschließende Rückkehr nach Australien, die mich zu einer Auseinandersetzung mit eher mythologischen Texten anregten, insbesondere Erzählungen, die den Kollaps urbaner Einflüsse und ländlicher Regionen beschrieben. Die Gedichte über die Flüchtigkeit des Nomadentums (Kath Walker/Oodgeroo Noonuccal) und besonders die Lieder der Aborigines vermitteln häufig eine eigene Vision von Landschaft sowie der vollkommenen Zeitlosigkeit der Wüste. Da bewegt man sich nun in einer Umgebung, die in einem Raum-Zeit-Kontinuum gefangen scheint, aber in Wirklichkeit ist die Luft gesättigt von hochmoderner, unsichtbarer Technologie – Satelliten- und Radiowellen. Dann kehrt man in die Stadt zurück und liest aktuelle Gegenwartsliteratur, Erzählungen, in denen wie bei Angela Carter die Zeit kollabiert und westliche Mythen miteinander vermischt werden.

RA Why do you call these interests "scenarios"?

JS Well, because I can't find another word for it – that collapsing of time, space, body and media. I became interested in the concept that space and time were not linear progressions but instead that they could all exist in one media-environment simultaneously. In the nineties I thought about using the term "transformed techno-zone" instead I use "mixed reality". Liz Crosz once said that cyberspace may open up our old concepts of spatialization. My space became a non-narrative situation, where I imagined the body of a viewer existing simultaneously inside media and outside media – perhaps even shifting nationality or gender or age on the way.

RA Talking about the nineties, can you tell me about "The Body Remembers"? Wasn't that the title of a show you had in Australia?

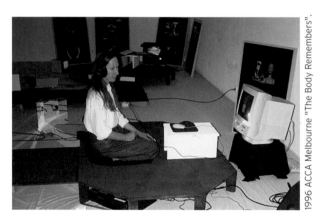

1996 ACCA Melbourne "The Body Remembers".

RA Warum nennst du diese Themenbereiche "Szenarios"?

JS Na ja, mir fällt kein anderes Wort ein – für diesen Kollaps von Zeit, Raum, Körper und Medien. Ich begann mich mit der Idee zu beschäftigen, dass Raum und Zeit keinem linearen Fortschritt unterliegen, aber dass sie dafür in einer gemeinsamen medialen Umgebung gleichzeitig existieren könnten. In den neunziger Jahren kam mir die Idee, an Stelle der "vermischten Realität" den Begriff "transformierte Technozone" zu verwenden. Nach Liz Crosz könnte der Cyberspace unsere überholten Konzepte von Räumlichkeit aufbrechen. Ich erklärte den Raum zu einer nicht-narrativen Situation und stellte mir vor, dass sich der Körper der BesucherIn gleichzeitig innerhalb und außerhalb der Medien aufhält – und dabei vielleicht sogar Nationalität, Geschlecht oder Alter vergessen kann.

RA Wenn wir jetzt über die neunziger Jahre sprechen, kannst du mir etwas zum "Körpergedächtnis" sagen? War das nicht der Titel einer Ausstellung, die du in Australien hattest?

JS Ja richtig, "The Body Remembers" war der Titel meiner Retrospektive in 1996 im ACCA (Australian Centre for Contemporary Art). Dieser Titel entstand aus der Überlegung, dass ich immer von der Voraussetzung ausging, dass zwischen dem menschlichen Körper und dem Konzept von Erinnerung eine enge Beziehung existiert. Denk zurück an die siebziger Jahre, da gab es ein großes Interesse für das Immunsystem – insbesondere für die Rolle von T-Zellen. Dann entdeckte man, dass diese T-Zellen tatsächlich ein Gedächtnis besitzen für die Begegnungen mit dem auftretenden Virus im Körper und entsprechend darauf reagieren, um die Infektion zu bekämpfen. Natürlich wussten wir bereits, dass jede und jeder von uns dieses ganze evolutionäre Erbe, das unser tägliches Leben programmiert, in sich trägt, zum Beispiel, wie wir kauen oder uns reproduzieren. Das brachte mich dazu, darüber nachzudenken, ob unsere Raubtierinstinkte und grundlegenden Sehnsüchte ebenfalls in unseren Zellen kodiert sind.

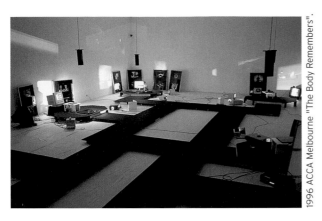

JS Sure – it was the name of the retrospective I had at ACCA (Australian Centre for Contemporary Art) in 1996. I chose it because I always thought that there was a close relationship between the human body and the concept of memory. Remember in the seventies, there was a lot of discussion about the immune system – particularly the role of the T-cells? Then came the discovery that the T-cells could actually remember the encounters the body had with an incoming virus and respond accordingly to fight off infection. Of course we already knew we all had those evolutionary inheritances within us that program the everyday stuff like how to chew or to reproduce, but this got me thinking about if our predatory instincts and our basic desires are also coded within our cells.

RA Biology as destiny?

JS Yes. But it's a big problem to think like that. Thank goodness, there are cultural and environmental influences too, which will always affect our behaviour and may hopefully limit our predatorily biological destiny. In the eighties, I was interested in playing around with cultural memories, especially in the form of mythologies. In some videos I tried to tell myths differently – switch the heroic roles of women and men, collapse cultural memories from different characters together. Does watching these tapes change our shared cultural memory or our understanding of the archetype (DOUBLE TIME)?

RA Biologie als Schicksal?

JS Ja. Aber es ist heikel, so zu denken. Gott sei Dank gibt es auch kulturelle und räumliche Einflüsse, die auf unser Verhalten für immer einwirken und hoffentlich unser vorgegebenes biologisches Schicksal als Raubtiere in Zaum halten werden. In den achtziger Jahren beschäftigte ich mich ausgiebig mit kulturellen Erinnerungen, die besonders in Form von Mythen auftreten. In einigen Videoarbeiten habe ich versucht, Geschichte umzuschreiben – ich vertauschte die heroischen Rollen von Frau und Mann und brachte die kulturellen Erinnerungen unterschiedlicher Charaktere zusammen. Verändert sich unser gemeinsames kulturelles Gedächtnis oder unser Verständnis von Archetypen, wenn man diese Tapes sieht (DOUBLE TIME)?

Es ist das Gefühl von Sehnsucht, das unsere kulturellen Erinnerungen immer wieder steuert, glaubst du nicht auch? Diese Vorstellung von Erinnerung in Beziehung zu dem Gefühl des "Begehrens" veranlasste mich zu mehr Skepsis in meinen Untersuchungen. Zum Beispiel, welche anerzogenen Ebenen von Komfort schlummern in uns und wie wird dieses Verlangen durch geschichtliche Ereignisse (Kriege usw.) beeinflusst? Wer schreibt Geschichte über wen und aus welchen Beweggründen?

Mitte der neunziger Jahre konzentrierte ich mich auf jene Aspekte der Kulturgeschichte, die eine in der westlichen Welt verbreitete kollektive Erinnerung betreffen – die gemeinsame Sehnsucht nach Utopien (BEYOND HIERARCHY?). Später dann beschäftigte ich mich erneut, wie schon in den siebziger Jahren, mit dem Unterschied zwischen den genetischen Erinnerungen und dem kulturell erlernten Verhalten des Körpers (zum Beispiel im Verhältnis zu Medien). Donna Haraway

It's the emotion of desire that mostly shifts our cultural memory, don't you think? It was the notion of memory in relation to the sensation of "desire" that led me to undertake some rather sceptical research. For example, what are our inherent levels of comfort and how are these cravings affected by events – wars etc. – in history? Who writes history about whom and for what reason?

In the mid nineties, I focused on those aspects of cultural history that might shed light on a very prominent Western collective memory, the shared desire for utopia (BEYOND HIERARCHY?). Later on, I returned to my interest of the seventies in the difference between the body's genetic memories and the body's culturally learnt behaviour (for example in relation to media). Donna Haraway tries to find similar patterns between the two, doesn't she? In other words, can media artists, like myself, make works about the changing perception of the human body and can we use relatively ideological debates like feminism to do it?

sucht zwischen diesen beiden Ebenen nach ähnlichen Mustern. Mit anderen Worten: Können MedienkünstlerInnen wie ich Arbeiten realisieren, die die veränderte Wahrnehmung des menschlichen Körpers erfahrbar machen? Können wir dazu zum Beispiel auch relativ ideologische Debatten wie die des Feminismus verwenden?

»TODAY, THE EMERGENT, EPHEMERAL AND IMMATERIAL ARTISTIC ATTITUDES ARE PERHAPS ›FEMININE‹ IN NATURE«. LUCY LIPPARD. **»THE FEMALE BODY IS A WORLD FULL OF MYSTIFICATION AND INTERACTION, EMERGENCE AND INTERDEPENDENCY, BUT IT IS ALSO AN UNPREDICTABLE ONE THAT SHE MUST PREFER TO HOLD ONTO.«** EVELIN FOX KELLER. **»FOR A CYBORG GENDER IS NO LONGER AN ISSUE.«** DONNA HARAWAY.

ROBERT ATKINS Actually feminism permeates your work. Let's talk about the final body-related category you identify in your work as "the metaphors of feminism".

JILL SCOTT Well, my concepts of feminism in the seventies grew out of the liberation ideology of that day: the articulation of a woman's need to be recognised as a contributing member of culture. At the time, I think that gender comparisons and levels of equality were based on dualistic role models of "us", the women, and "them", the men. We sat around for hours discussing the differences between sensuality, objectification, representation and ambition – constantly comparing men to women and stimulated by feminist theories about aesthetics such as those of Lucy Lippard.

ROBERT ATKINS In der Tat spielen Elemente des Feminismus in deinem Werk eine große Rolle. Lass uns deshalb über die letzte von dir benannte Kategorie reden, die dir in deinen Arbeiten wichtig ist, "die Metaphern des Feminismus".

JILL SCOTT Nun, meine feministischen Ideen der siebziger Jahre sind ursprünglich aus den damaligen Befreiungsideologien entstanden: sie formulierten die Notwendigkeit, Frauen als vollwertiges Mitglied der Gesellschaft anzuerkennen. Zu jener Zeit, denke ich, basierten Geschlechtervergleiche und Kategorien von Gleichberechtigung auf dualistischen Rollenmodellen von "uns", den Frauen, und "ihnen", den Männern. Wir führten stundenlange Diskussionen über die Differenz von Sinnlichkeit, Objektifizierung, Repräsentation und Ehrgeiz – verglichen unablässig Männer und Frauen miteinander, angeregt durch feministische Theorien über Ästhetik z.B., von Lucy Lippard.

Das änderte sich grundlegend in den achtziger Jahren. Viele Künstlerinnen um mich herum beanspruchten ihren Platz in der Geschichte, aber jede meiner Mitstreiterinnen spürte auch, dass sie für viele andere Frauen aus der Vergangenheit standen, einschließlich Philosophinnen, Mütter und Prostituierte. Ausschlaggebend für diese Erkenntnis war die Tatsache, dass Männer sich in der Geschichtsschreibung hauptsächlich mit den Errungenschaften von Männern befasst haben. Ich war

In the eighties, this changed. Many women artists around me were conscious of claiming a place in history for themselves but each of my friends also felt that she represented many women from the past, including philosophers, mothers and prostitutes. Paramount to this realisation was the fact that men wrote history mainly about the achievements of men. I was very interested in this aspect of feminism. It rapidly became the subject of my own thinking and it included ethical considerations about women from different cultures.

In the nineties, some women saw technology as a way for us to reinvent ourselves; even so fundamentally as to choose one's gender and determine one's identity as well as the environment in which it/they might appear. Although we still had to learn about this technology mostly from men! A type of mixed reality or integrated techno-zone was the possible outcome: a space that not only collapsed geographical boundaries and time zones but incorporated women into the zone of technology.

RA Let's turn to technology. Most viewers probably intuit your grounding in technology, but aren't likely to know its extent: that you've developed software and interactive design for exhibitions. It's a big question, but can you trace your involvement with technology over the course of your career?

JS It's a huge question. Let me try. Early on I was very influenced by media, pop art and film, especially film stills. Although I learned film at art school, I preferred making screen prints that resembled movie stills. You know those reduced film images of Marilyn Monroe from Andy Warhol? Well, my boyfriend Jim Barbone and I shot and edited a 20-minute piece on 8 mm film about Hollywood archetypes and the idealism in the 30s.

RA When did you get interested in video?

JS My affair with video began in 1974 after art school, thanks to a really modern teachers' college. Can you believe they had black and white, reel-to-reel video portapacks for the teachers in 1974? No editing of course, so we had to use in-camera editing. Then in San Francisco I

sehr interessiert an diesem Aspekt des Feminismus. Er wurde umgehend zum Schwerpunkt meines eigenen Denkens und schloss ethische Fragestellungen zu Frauenbildern in unterschiedlichen Kulturen mit ein.

In den neunziger Jahren sahen manche Frauen in der Medien- und Computertechnologie eine Möglichkeit, sich selbst neu zu erfinden; von so fundamentaler Bedeutung wie die freie Wahl des Geschlechts (Gender) oder die Selbstbestimmung der eigenen Identität und der Umgebung, in der "es"/sie erschienen. Trotzdem mussten wir diese Technologie in der Regel erst noch von den Männern erlernen. Eine Art vermischte Realität oder integrierte Technozonen waren das erklärte Ziel: ein Raum, der nicht nur geographische Grenzen und Zeitzonen zusammenfallen ließ, sondern auch Frauen in die Welt der Technologie miteinbezog.

RA Ja, zur Technik und Technologie. Die meisten BetrachterInnen deiner Kunst vermuten deine Grundlagen in der Technologie, aber ihnen ist wohl nicht wirklich bewusst, dass du sogar Software und interaktives Design für Ausstellungen entwickelt hast. Es ist eine schwierige Frage, aber kannst du die Bedeutung, die die technologische Entwicklung im Allgemeinen in deiner künstlerischen Laufbahn eingenommen hat, nachzeichnen?

JS Das ist wirklich schwer zu beantworten. Ich will es versuchen. Meine frühen Einflüsse lagen vor allem bei den Medien, in der Pop Art und im Film – besonders den Stills (Standbildern). Obwohl ich an der Kunsthochschule Film belegt hatte, entstanden doch zuerst Siebdrucke, die an Kinobilder erinnerten. Kennst du die reduzierte Bilder von Marilyn Monroe in dem Film von Andy Warhol? Nun, mein Freund Jim Barbone und ich drehten einen 20 Minuten langen Super-8-Film, den wir dann auch selbst geschnitten haben, über Archetypen in Hollywood und den Idealismus in den dreißiger Jahren.

RA Seit wann hast du dich für Video interessiert?

JS Mein intensiver Umgang mit dem Medium Video begann 1974 nach dem Abschluss an der Kunstschule. Stell dir vor, 1974 verfügten die fortschrittlichen Lehrer dort über tragbare Zweispulen-Videogeräte, mit Schwarzweißaufzeichnung natürlich. Aber es gab damals noch keine Möglichkeit zu schneiden, so dass wir ausschließlich die Kamerafilme verwenden konnten.

became interested in more interdisciplinary approaches and wanted to use video as either a conceptual component of the work or to document my performances. Another appeal of video was its real-time capabilities. At Video Free America, Skip Sweeney had been playing with feedback looping and built electronic delays. The first video-synthesizers came from experiments like his. Nam June Paik and the Vasulkas also played with early synthesizers. In installations, feedback loops or closed circuit video actions, as they were called, not only constituted a breakthrough in synthetic exploration, but also in collapsing space. This new approach to mediated space was being explored in different parts of the world simultaneously. I remember going to a slow scan event in 1978 linking Eric Gidney (in Australia), Bob Adrian (Vienna), Roy Ascott (UK) and Sharon Grace (in San Francisco). It was really the beginning of what we now call Telepresence – the ultimate mediated space.

RA What about when you returned to Australia in the eighties? How did this affect your access to technology?

JS I left California for Australia as the notorious digital revolution arrived in 1982-83. However, only one year later the first Macs with Mac Paint and MacWrite programs made their appearance at the Alexander Mackie School of Art in Sydney. The Macintosh Apple SE computer ran dinky little black and white programs, which frequently crashed. And what can one do with only 560 K of storage space anyway? I could only use them to make storyboard sketches for videotapes or write video scripts. But by 1984, a young group of Sydney developers had constructed a digital/analog video synthesizer called the Fairlight Video Instrument. Together with the Dynabytes, I had already played with their audio synthesizer, but wanted to experiment with their new video machine – which had unique keying features, so I went to the University of Technology to work with the technician, Peter Butterworth. My appropriated histories of women's mythology from the mid-eighties, all used the Fairlight along with the blue screen studio. (DOUBLE DREAM, DOUBLE SPACE, DOUBLE TIME) It was a fantastic invention and cheap, although it had its own shifting pixelated aesthetic.

In San Francisco begann ich mich dann mit vorwiegend interdisziplinären Ansätzen zu beschäftigen und wollte Video entweder als konzeptionellen Bestandteil meiner Arbeit oder für die Dokumentation meiner Performances einsetzen. Ein weiterer Anreiz bestand darin, dass man in Echtzeit arbeiten konnte. Bei Video Free America hatte Skip Sweeney Experimente mit Feedback Loops angestellt und dabei elektronische Verzögerungen erzeugt. Die ersten Video-Synthesizer entstanden aus derartigen Versuchen. Nam June Paik und die Vasulkas befassten sich ebenfalls mit dieser ersten Generation von Synthesizern. In Installationen sorgten Feedback Loops oder die sogenannte Closed-Circuit-Videotechnik nicht nur für einen Durchbruch bei Experimenten zu einer synthetischen Ästhetik sondern auch zu einer neuen Erfahrungen mit Raum und Zeit. Diese neuartige Wahrnehmung medialer Räume wurde gleichzeitig an verschiedenen Orten der Welt erprobt. Ich erinnere mich, dass ich 1978 an einem Slow-Scan-Event teilgenommen habe, bei dem Eric Gidney (in Australien), Bob Adrian (Wien), Roy Ascott (Großbritannien) und Sharon Grace (in San Francisco) miteinander verbunden waren. Das war unbestreitbar der Ausgangspunkt dessen, was man heute Telepräsenz nennt – der ultimative mediale Raum.

RA Was geschah, als du in den achtziger Jahren nach Australien zurückgekehrt bist? Welche Auswirkungen hatte das für deinen Zugang zu Medientechnologien?

JS Ich verließ Kalifornien, um nach Australien zu gehen, als die viel zitierte digitale Revolution 1982-83 gerade erst dort angekommen war. An der Alexander Mackey School of Art in Sydney tauchten nur ein Jahr später die ersten Apple Computer mit Mac-Paint- und Mac-Write-Software auf. Der MacIntosh SE lief mit netten kleinen Schwarzweiß-Programmen, die ständig zusammenbrachen. Außerdem, was kann man mit 560 K Arbeitsspeicher schon anstellen? Das reichte bei den Videotapes gerade mal für die Skizzen zu den einzelnen Szenen oder das Drehbuch. Aber 1984 konstruierte eine Gruppe junger UnternehmerInnen einen digital/analogen Video-Synthesizer namens "Fairlight Video Instrument". Zusammen mit den "Dynabytes" hatte ich bereits deren Audio-Synthesizer getestet. Daran anknüpfend wollte ich nun mit diesem neuartigen Videogerät experimentieren, das einzigartige Codierungseigenschaften besaß. So tat ich mich an der Technischen Uni-

RA What about the high end technology? And the television industry?

JS On the high end, the industry opted for more powerful tools that actually allowed the artist to create the aesthetic and sensibility, rather than the machine. The most attractive were the digital computers developed for television graphics by Quantel – the Paintbox and Harry. In 1986, I was invited to be an artist in residence by the Video Paint Brush (VPB) Company of Melbourne and Sydney. The Paintbox was the closest machine-experience I had to the feeling of drawing on paper. I started with a series of scan line drawings and animations based on ecology, technology and the female body which cumulated in my videos MEDIA MASSAGE and LIFE FLIGHT. I met some great people there, Andrew Quinn and Sally Pryor, who made some 3-D animations to slip into my films.

My favourite software was Harry, a digital, real-time editor. With it you could integrate all the special effects in a single filmstrip then output it digitally without any generation loss (WISHFUL THINKING). There are two things I remember about my time at VPB, the exhaustion of working six nights a week during their downtime of midnight to 7 am, and the fun of discovering new technologies that extended my interest in foreground and background compositing. For the integration of actors or characters, the Australian Film and Television School kindly offered me the use of the Ultimatte, an extremely sophisticated blue screen keyer, and their Abacus, a digital manipulator with frame storage.

RA You've said that just as in San Francisco you had a supportive video community around you.

JS Yes. By the mid-eighties there was a lot of sophisticated video being produced in Australia just as there was everywhere in the West. We needed a showcase, so Ann-Marie Chandler from the University of Technology and I started the Australian Video Festival (1986). A couple of years later I was in New York with the festival's director, Sally Couacaud, and I had the pleasure of meet-

versität mit dem Techniker Peter Butterworth zusammen. Mitte der achtziger Jahre benutzte ich zur Darstellung meiner Sicht auf die Geschichte der Frauen und zur meiner Aneignung weiblicher Mythologien ausschließlich Fairlight und ein Blue Screen-Studio (DOUBLE DREAM, DOUBLE SPACE, DOUBLE TIME). Das Fairlight System war eine großartige Erfindung, und gar nicht teuer, trotz seiner eigenen Ästhetik im Bildaufbau der Pixel.

RA Wie sieht es mit High-End-Produktionen aus? Welche Rolle spielt die Fernsehindustrie?

JS Was die technische Perfektion betrifft, verlangte die TV-Industrie nach leistungsstarken Geräten, die es den KünstlerInnen tatsächlich erlaubten, sich mehr mit Ästhetik und Sensibilität zu beschäftigen als mit der Maschine. Die begehrtesten Geräte – Paintbox und Harry – waren digitale Computer, von Quantel speziell für graphisches Design im Fernsehen entwickelt. 1986 wurde ich als Gastkünstlerin von der Firma Video Paint Brush (VPB) in Melbourne und Sydney eingeladen. Die Paintbox erwies sich als das Gerät, mit dem ich der Vorstellung des Zeichnens auf Papier am nächsten gekommen bin. Ich begann mit einer Serie von digitalen Strichzeichnungen und Animationen, die auf Ökologie, Technologie und dem Frauenkörper basierten und später in die Videoarbeiten MEDIA MASSAGE und LIFE FLIGHT einflossen. Ich habe großartige Leute bei VPB kennen gelernt, Andrew Quinn und Sally Pryor, die einige 3-D-Animationen für meine Filme beigesteuert haben.

Harry bevorzugte ich als Software für den digitalen Schnitt in Echtzeit. Mit ihm konnte man sämtliche Spezialeffekte auf einem einzelnen Filmstreifen integrieren und dann als digitale Daten ohne jeglichen Generierungsverlust ausgeben (WISHFUL THINKING). An zwei Dinge kann ich mich in meiner Zeit bei VPB vor allem erinnern, an die Erschöpfung, nachdem ich, in der Ausfallzeit von Mitternacht bis sieben Uhr morgens, sechs Nächte die Woche durchgearbeitet hatte, sowie an meinen Eifer im Erlernen neuer Technologien, was dazu führte, dass ich mich intensiv mit dem Austausch von Vorder- und Hintergrund zu beschäftigen begann. Für die Montage von SchauspielerInnen oder Charakteren stellte mir die Australian Film and Television School großzügig Ultimatte zur Verfügung, einen hochentwickelten Blue Screen Keyer sowie ein Bildbearbeitungsgerät namens Abacus.

ing Graham Weinbren and seeing "The Earl King", which was one of the first interactive videos on laserdisc. I liked the idea of non-linear, interactive content. From then on the computer technology in my work became much more evolved. I'd been looking into the idealism that women immigrants had brought with them to the West over the last century and their relation to technological "progress". Could the viewers walk around the space and trigger sounds – which magically appeared to be coming out of dead machines? In 1990 for MACHINE-DREAMS, I teamed up with Simon Vetch because he had invented a basic security system, using c++, and together we created a virtual sound environment.

Those days my images were generated on my own PC with a paint program called Lumina and a 3-D Animation program named Crystal (Time Arts). These were the new hot tools then – at least cheap and sophisticated tools! – And we even thought about using them to make money on the side. I was one of four artists to form a graphics company in Sydney. There I directed a 15-minute, 3-D-animation called PARADISE TOSSED about the history of technology, desire and design from a women's point of view. Although Crystal and Lumina ran on the Targa card in a PC, the results looked as though they were made on high-end workstations like Alias/Silicon Graphics. PARADISE TOSSED also used a cool new interface for those days – a touch screen.

RA Du hast erwähnt, dass du dort, genau wie in San Francisco, durch die Videogemeinde viel Unterstützung erfahren hast.

JS Ja. Mitte der achtziger Jahre entstand in Australien eine beachtliche Anzahl anspruchsvoller Videoproduktionen, wie überall in der westlichen Welt auch. Wir brauchten ein Schaufenster, also gründete ich zusammen mit Ann-Marie Chandler von der University of Technology 1986 das Australian Video Festival. Einige Jahre später war ich mit der Direktorin des Festivals, Sally Couacaud, in New York und hatte das Vergnügen, Graham Weinbren kennen zu lernen und "The Earl King" sehen zu können, eines der ersten interaktiven Laserdisk-Videos. Ich war beeindruckt von der Idee eines nicht-linearen, interaktiven Inhalts. Von da an nahm die Computertechnologie in meiner Arbeit einen immer größeren Stellenwert ein. Ich beschäftigte mich mit dem Idealismus, den Frauen als Migrantinnen im letzten Jahrhundert mit in den Westen gebracht hatten, und mit ihrem Verhältnis zum technologischen "Fortschritt". War es möglich, dass die BesucherInnen im Raum herumspazierten und Geräusche auslösten – die auf magische Weise aus den leblosen Maschinen zu kommen schienen? 1990, bei MACHINEDREAMS, entwickelten Simon Vetch und ich ein virtuelles Sound-Environment. Er hatte bereits Erfahrungen mit einem virtuellen Raumüberwachungssystem, das er mit C++ entwickelt hatte.

Zu jener Zeit konnte ich Bilder auf meinem eigenen PC mit einem Malprogramm namens Lumina und dem 3-D-Animationsprogramm Crystal (Time Arts) erzeugen. Das waren damals die neuesten und interessantesten Tools überhaupt – zumindest im semi-professionellen Bereich. Wir dachten sogar daran, mit ihnen nebenbei Geld zu verdienen! Zusammen mit drei anderen KünstlerInnen gründete ich eine Firma für Graphikdesign in Sydney. Dort produzierte ich eine 15-minütige 3-D-Animation mit dem Titel PARADISE TOSSED. PARADISE TOSSED zeichnet Aspekte der Technologiegeschichte nach und setzt diese in Beziehung zu unseren Sehnsüchten im Verhältnis zu historischen Designerlösungen aus der Sicht von Frauen. Obwohl Crystal und Lumina auf dem PC mit einer Targa Card liefen,

This technical format became the basis of FRONTIERS OF UTOPIA, my next interactive piece about the lives of eight idealistic women. FOU, as I tend to call it, was housed in an octagonal cinema space with archival films, reconstructed films, custom built sculptural and photographic interfaces. The scripts and shoot were produced in Australia at the Australian Film and TV School again. For the first time in my life I had a producer – Monitor, an interactive media company. The interactive concept was done in Germany, though, because Hans Peter Schwarz offered me the use of the ZKM Medialab for post-production. Actually, they acquired the work.

1997, ZKM DIGITAL BODY AUTOMATA.

RA That was the beginning of your involvement with residency at ZKM?

JS Yes, and it was really great at the ZKM in the three years before the opening in 1997. We were all crammed into two rather dirty and shoddy factories. There were about 20 of us sharing in the process of producing an innovative media-museum. Jeffery Shaw had created a space where art, computer science and electronics could meet. It gave media artists the courage to be inventive. In fact it was a bit like the old South of Market days in San Francisco. Remember that?

wirkten die Resultate, als ob sie auf High-End-Workstations, wie z.B. auf Silicon Graphics (SGIs) mit einer Software wie Alias/Wavefront entstanden waren. Bei PARADISE TOSSED verwendete ich ebenfalls ein für die damalige Zeit vollkommen neues Interface – den Touchscreen.

Dieses technische Format wurde zur Grundlage von FRONTIERS OF UTOPIA, meiner nächsten interaktiven Arbeit über das Leben von acht idealistischen Frauen. FOU, wie ich es oft nenne, bestand aus einem achteckigen Kinoraum, in dem Archivfilme zu sehen waren; rekonstruierte Filme und speziell angefertigte skulpturale und photographische Interfaces. Drehbuch und Film wurden erneut in Australien an der Australian Film and TV School produziert. Zum ersten Mal in meinem Leben hatte ich einen Produzenten - Monitor, eine Firma für interaktive Medien. Das Konzept der Interaktion wurde aber in Deutschland entwickelt, denn Hans-Peter Schwarz stellte Jens Müller, dem Programmierer, und mir das Medienlab am ZKM für den abschließenden Teil der interaktiven Produktion zur Verfügung. Schließlich hat das ZKM die Arbeit dann angekauft.

RA War das der Beginn deiner Tätigkeit am ZKM?

JS Ja, und es war wirklich großartig dort in den drei Jahren vor der eigentlichen Eröffnung 1997. Wir alle wurden in zwei ziemlich schmutzige und schäbige Fabrikhallen gesteckt. Etwa zwanzig von uns waren an dem Unternehmen beteiligt, ein innovatives Medienmuseum aufzubauen. Jeffrey Shaw hatte einen Ort geschaffen, an dem ein Austausch von Kunst, Computerwissenschaften und Elektronik stattfinden sollte. Hier wurden MedienkünstlerInnen regelrecht dazu ermutigt, ihrem Erfindergeist nachzugehen. Es war wirklich ein bisschen wie in den alten Tagen unterhalb von Market Street in San Francisco. Weisst du noch?

RA Yes. I remember – a kind of communal spirit. What was your theme at the ZKM?

JS I was becoming more and more concerned about biotechnology. The triptych I made there was called DIGITAL BODY AUTOMATA. Each part of the triptych I produced there contained different hardware and software and represented a sort of technological education for me. A FIGURATIVE HISTORY used the same linked Macintosh technology as FRONTIERS OF UTOPIA, but Martin Haeberle and I had discovered that we could create an interface by accessing the water inside the viewer's body through touch, and this water could be used as a conduit to close an electronic circuit.

Then there was INTERSKIN, a virtual reality game, the second installation within DIGITAL BODY AUTOMATA. Here, the viewers could navigate though parts of the human body using c++ and Performer software installed on two Silicon Graphics machines. Then the third installation, IMMORTAL DUALITY, had a custom - built software body detector linked through PCs with Linux software to form an interactive, digital-video wall. This installation also included the Australian 3DIS software to control the animation of a pneumatic robot of Marie Curie. Needless to say, I had never before programmed a life-sized, pneumatic doll.

RA No? It could be a refreshing experience for an adult! What about the Internet?

JS Yes, I like to use the Internet as a feedback venue: a way to make issues more public. For those ZKM installations in 1995, Andreas Schiffler, Bernd Diemar and I made an information-website with four web cams, but it also had a www chat - debate about the future of the human body.

You see, for years I've been collaborating with my students on the Internet: after all it really is their medium and their future! Firstly, in 1993 in Saarbrücken we hooked up with some local freaks and constructed live electronic chat rooms with a bar and invited the rest of the

RA Ja. Ich erinnere mich, man nannte es den Geist der Kommune. Welches Thema stand für dich am ZKM im Vordergrund?

JS Ich beschäftigte mich zunehmend mit Biotechnologie. Das Triptychon, das ich dort realisiert habe, heißt DIGITAL BODY AUTOMATA. Jeder Teil dieses Triptychons nutzte eine andere Hardware und Software. Für mich war das auch so eine Art technologischer Unterricht. A FIGURATIVE HISTORY benutzte ein gleich konfiguriertes Apple Netzwerk wie FRONTIERS OF UTOPIA. Martin Häberle und ich hatten entdeckt, dass wir ein Interface herstellen konnten, indem wir das Wasser im Körper der BesucherIn durch Berührung als elektrische Leitung an den Stromkreis anschließen konnten.

Dann kam INTERSKIN, das ich zusammen mit Andreas Schiffler als zweiten Teil von DIGITAL BODY AUTOMATA kreierte. Dabei handelte es sich um ein Virtual Reality (VR) Spiel, in dem die BenutzerInnen zwischen menschlichen Organen navigieren konnten. Dabei setzten wir SGI Workstations ein unter der Verwendung von C++ und Performer Software. Die dritte Installation schließlich, IMMORTAL DUALITY, besaß ein spezielles Hard- und Sortwaresystem, das die Bewegungen und Silhouetten des Publikums im Raum feststellen konnte. Dieses lief auf PCs unter Linux, die zwei interaktive Videowände bedienten. IMMORTAL DUALITY verwendete zusätzlich die australische Software 3DIS, um die Animation eines pneumatischen Roboters als Nachbildung von Marie Curie zu überwachen. Ich muss wohl nicht erwähnen, dass ich nie zuvor ein Programm für eine lebensgroße, pneumatische Puppe benutzt hatte.

RA Nein? Das ist wohl eine erfrischende Erfahrung für einen Erwachsenen! Und das Internet?

JS Ja, ich nutze das Internet gerne als Feedback: als eine Möglichkeit, für bestimmte Themen eine größere Öffentlichkeit ansprechen zu können. Für diese Installationen 1995 im ZKM richteten Andreas Schiffler, Bernd Diemar und ich mit vier Webcams eine Informations-Website ein, und es gab auch einen Webchat über die Zukunft des menschlichen Körpers.

Weißt Du, ich arbeite seit Jahren mit meinen StudentInnen im Internet zusammen, denn schließlich ist es eigentlich ihr Medium und ihre Zukunft! Zuerst haben wir uns 1993 in Saarbrücken an einige Freaks aus der Gegend drangehängt, richteten in einer Bar elektronische Chatrooms ein und haben dann die übrigen StudentInnen und LehrerInnen eingeladen. An der Bauhaus-Universität begann ich 1999 mit einer ziemlich chaotischen, aber spannenden interaktiven Veranstaltung, die live über Monitore verfolgt werden konnte, mit dem Titel "Fusion", in Zusammenarbeit mit der University of California, UCLA (Los Angeles) und der University of New South Wales (Sydney). Das läuft jetzt seit drei Jahren. Am Anfang installierte ich einen Live Chat namens FUTURE BODIES. Das immer noch im Entstehen begriffene Konzept schließt Drehbuchentwürfe, Avatare und potentielles NutzerInnenverhalten und selbstverständlich Interaktivität ein. Die Software für die Charaktere kann im Netz abgerufen werden, und es bildet sich ein komplexes System generischer Transformation, wenn die Charaktere entwickelt werden.

students and staff. At the Bauhaus University in 1999 I started a rather chaotic but exciting interactive live telepresence event called "Fusion" in conjunction with UCLA (Los Angeles) and the University of New South Wales (Sydney). This ran for three years. In the first one I created a live chat called FUTURE BODIES. It's still a growing concept involving script writing, avatars, potential behaviours – and interactivity of course. The software for the characters can be shared over the net and a complex system of generic transformation takes place as the characters evolve.

RA What are you up to now in terms of technology?

JS Well, the FUTURE BODIES project will continue and I'm interested in the net. I am also about to start a media group in Switzerland and we will work with the ethical concepts of biotechnology and art. For another project called "Smart Sculptures" I am still in the research phase and want to create some artworks for more local interactive communities (for example the handicapped or visually impaired). For these we are making evaluations of new applications (e.g. wireless services like Bluetooth). On this project I am working with a University of Applied Science in Switzerland.

RA Why have we waited twenty years to track your progress, Jill?

JS Well, I've been too busy, so thanks Robert!

RA Was planst Du in nächster Zeit, was die Benutzung von neuer Medientechnologie angeht?

JS Nun, das Projekt FUTURE BODIES wird fortgesetzt, und ich interessiere mich für die innovativen Kräfte im Netz. Ich werde auch versuchen, eine Mediengruppe mit meinen StudentInnen der Schweiz zu gründen, und mit ihnen in Kunstprojekten online zu ethischen Konzepten zur Biotechnologie (z.B. Krankheit) arbeiten. Vielleicht werde ich auch interaktive Web-Environments über diese Themenbereiche realisieren. In einem anderen Projekt mit dem Titel "Smart Sculptures" möchte ich zudem einige künstlerische Ansätze für eher offline stehende lokale, Gruppen entwickeln (zum Beispiel für Behinderte oder Sehgeschädigte). Ich befinde mich bei diesem Projekt noch in der Recherchephase – momentan werten wir gerade neue Anwendungsmöglichkeiten aus (z.B. drahtloser Service wie Bluetooth). Bei diesem Projekt arbeite ich mit zwei Hochschulen für Angewandte Wissenschaften in der Schweiz zusammen.

RA Jill, warum hat es zwanzig Jahre gedauert, bis wir dieses Interview über deinen künstlerischen Weg geführt haben?

JS Na, ja, ich war wahrscheinlich immer zu beschäftigt, auf alle Fälle, vielen Dank, Robert!

D | Jill Scott entwickelt in ihren Arbeiten aus Performance, Video, Installation und zunehmend computergestützter Kunst multiple konzeptuelle Umgebungen, an denen das Publikum durch Interaktion partizipieren kann. Die Interaktion ist im gesamten Werk der Künstlerin physisch, philosophisch und ideologisch in unterschiedlichem Maße angelegt. Es entsteht eine Spannung zwischen der inneren Welt von Psyche/Körper und einer vorstellbaren äußeren Welt der Rationalität und Logik. Jill Scott beschäftigt sich mit der Rolle, die Technologie in unserem Leben einnimmt: wie die Medien auf unsere Gedan-

BODY MEMORY AND TIME ZONES

ESSAY BY ANNE MARSH

E | Jill Scott's work in performance, video, installation, and, more recently interactive computer art, raises multiple conceptual environments with which the viewer can interact. This interaction has been presented as physical, philosophical and ideological in varying degrees throughout the artist's work. There is a tension between the internal psyche/body and the would-be external world of rationality and logic. Scott is interested in the role of technologies in our lives: the ways in which the media massages our minds and the ways in which the media can be used to create what she calls "parallel worlds". These are constructed worlds in which we encounter the subject in the absence of its corporeality. But these are also worlds, designed by the artist, that are often driven by the spectator's body moving or interacting with the installation environment.

The body and technology, myth and the landscape, psychology and determinism are themes that recur throughout Scott's work. Initially she seems interested in endurance and the physicality of the body. Body "actions" such as TAPED, TIED and STRUNG (1975) were all works

ken einwirken, vergleichbar mit einer Massage und in welcher Weise Medien benützt werden können, um – wie sie dies benennt – "parallele Welten" zu schaffen. In diesen konstruierten Welten begegnen wir dem Subjekt in Abwesenheit seiner Körperlichkeit. Aber in diesen Entwürfen der Künstlerin manifestieren sich immer wieder auch Welten, die von den Körperbewegungen der BesucherInnen oder durch Interaktion mit der Installationsumgebung bedient werden.

Der Körper und Technologie, Mythos und die Landschaft, Psychologie und Determinismus sind wiederkehrende Themen im Werk von Jill Scott. Zunächst befasst sie sich offenbar intensiv mit der Belastungsfähigkeit und Physis des Körpers. "Aktionen" mit dem eigenen Körper wie TAPED oder TIED sowie STRUNG (1975) handeln in erster Linie von einer für das Publikum wahrnehmbaren körperlichen Realität.

Die frühen "Körperaktionen" von Jill Scott unterstreichen dieses Interesse an Körperlichkeit und dem Körper als Kunstobjekt. Bei TAPED wird ihr Körper mit Klebeband an der Fassade eines Gebäudes fixiert. Sie klebt dort für die Dauer von drei Stunden, wobei ihr Körper einem bestimmten Maß an De

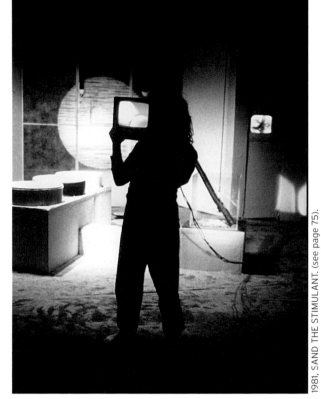

1981, SAND THE STIMULANT. (see page 75).

in which the body's actuality was prioritised for the viewer. Scott's early "body actions" underline an interest in the corporal body and the body as art object. In TAPED her body is stuck to the outside of a building with adhesive tape. She stays there for three hours, suspended and with the body under a certain amount of strain. It is a body action that stretches the limits of her own body. The aftermath of this performance is a tattoo of the body as it has escaped its confines. Scott talks about the masking tape, which is left behind as the residue of the performance, as a kind of map that gradually disintegrated over a number of years, like old graffiti or bill posters. This staining of the wall with the imprint of the liberated body is an early indication of the artist's interest in utopias and transformations.

The body actions were followed by an engagement with structuralist semiotic theory where patterns and codes were prioritised. There is also an interest in behaviourism in works such as ACCIDENTS FOR ONE and FOUR (1976) where the artist and participants perform movements dictated by the instructions of others. In EXTREMITIES (1977), INSIDE OUT (1978) and CHOICE (1979) Scott plots the movements of rodents, insects, people and traffic through interactive camera set-ups in an attempt to find similarities or discordance.

lastung ausgesetzt ist. In dieser Körperaktion geht Jill Scott bis an ihre eigenen körperlichen Grenzen. Als Nachbild dieser Performance entsteht ein Tattoo des von seinen Fesseln befreiten Körpers. Jill Scott beschreibt die Klebebandreste, die als Hinterlassenschaft der Performance an der Wand zurückblieben, als eine Art Landkarte, die sich im Laufe der Jahre nach und nach abgenutzt hat und an alte Graffitis oder Werbeplakate erinnert. Diese Abdrücke des befreiten Körpers als Spuren auf der Wand sind ein erster Hinweis auf das Interesse der Künstlerin an Themen wie Utopie oder Transformation.

Den Körperaktionen folgte eine theoretische Auseinandersetzung mit Strukturalismus und Semiotik, bei denen es vorrangig um Verhaltensmuster und Kodierungen ging. Darüber hinaus lässt sich in Arbeiten wie ACCIDENTS FOR ONE und FOUR (1976) ein Interesse am Behaviorismus entdecken, bei denen die Künstlerin selbst und BesucherInnen Bewegungen nach den Anweisungen anderer TeilnehmerInnen ausführen. Bei EXTREMITIES (1977), INSIDE OUT (1978) und CHOICE (1978) zeichnet Jill Scott die Bewegungsabläufe von Nagetieren, Insekten, Menschen und Verkehr durch interaktive Aufbauten der Kamera nach und versucht auf diese Weise, Ähnlichkeiten oder Gegensätze zu veranschaulichen.

Jill Scott liest zu jener Zeit "Mythologies" von Roland Barthes, dessen semiologisches System einen zunehmenden Reiz auf sie ausübt.[1] Ebenso wichtig wird für sie die Beschäftigung mit der Medientheorie von Marshall McLuhan.[2] Die Art und Weise, wie die Künstlerin die Performances und Events der siebziger und frühen achtziger Jahre beschreibt, vermittelt der BetrachterIn, dem partizipierenden Publikum und der HistorikerIn gleichermaßen, dass es sich bei den Arbeiten um Forschungsprojekte handelt. Sie untersuchen Verhaltensmuster, psychologische und vielleicht auch phänomenologische Erscheinungen unter Einbeziehung physikalischer und sonstiger wissenschaftlicher Phänomene. In dieser künstlerischen Forschungsarbeit konvergieren Magnetismus und die Bewegungsabläufe von Insekten, werden Musik und Zeichnung kartographisch erfasst und durch die Interaktion von Menschen und Dingen räumlich dargestellt. Die Untersuchungen werden quasiwissenschaftlich in experimentellen, als künstlerische Laboratorien konzipierten Umgebungen durchgeführt. Zur selben Zeit interpretiert man das Bild/die Idee im "Panoptikum" von Foucault als Anordnung von maschinenähnlichen Überwachungssystemen. Diese werden von der Künstlerin eingesetzt, um Handlungsabläufe aufzuzeichnen. Der Kamerablick eines Raubtieres wirkt geradezu klaustrophobisch bei CONSTRICTION PART ONE (1982), für diese Arbeit baute Jill Scott einen kreisförmigen panoptischen Raum mit drei jeweils dreieckigen Abteilungen, in dem sich eine Boa Constrictor befindet.

Scott reads Roland Barthes' "Mythologies" at this time and becomes seduced by his semiotics.[1] She also engages with Marshal McLuhan's theory of the media.[2] The ways in which the artist describes the performances and events of the 1970s and early 1980s tells the viewer, the participant and the historian that the work is, of itself, research. These are behavioural, psychological and perhaps phenomenological enquiries involving physical and scientific phenomena. In this art-research magnetism and the movement of insects converge, music and drawing are charted and enacted through the interactions of people and things. The research is carried out quasi-scientifically in experimental environments created as art laboratories. At this time, the image/idea of Foucault's panopticon is seen in an array of surveillance type mechanisms employed by the artist to chart the activities of people, animals and traffic. The predatory gaze of the camera is claustrophobic in CONSTRICTION PART ONE (1982) where Scott creates a circular panopticon space with three triangular compartments to house a boa constrictor snake.

The snake as metaphor for the phallus cannot be overlooked. It seems that Scott is having fun with the Oedipal narratives of patriarchal space in this video/performance; however, she says that the CONSTRICTION pieces were primarily inspired by Michel Foucault's famous essay on the panopticon in "Discipline and Punish".[3] In CONSTRICTION PART THREE (1983) the public space of the city is captured by a security camera and relayed into the performance space. There is also a ritual element in these works: the snake seeking out prey, the REVOLVING DESERT SIMULATORS spinning sand and creating sound, and the repetitive tasks of the artist who takes notations from cameras in remote locations.

These early works are also concerned with ecological issues and the way in which we, as human beings, relate to planet earth. Scott often uses ritual elements within her installations. The music of the didgeridoo haunts SAND THE STIMULANT (1980) and OUT, THE BACK (1978), and references to the Australian desert punctuate these and other works. The archetypal myths and concepts of time that spring from the desert appeal to the artist as she attempts to find languages outside of the Western canon.

Die Schlange ist eine eindeutige Metapher für den Phallus. Offensichtlich findet Jill Scott in dieser Video-Performance besonderes Gefallen an den ödipalen Erzählungen über den patriarchalischen Raum, aber sie weist darauf hin, dass die CONSTRICTION-Serie auch unter dem Einfluss des berühmten Essays von Michel Foucault über das Panoptikum in "Discipline and Punish"[3] entstanden ist. Bei CONSTRICTION PART THREE (1983) wird der öffentliche Raum der Stadt von einer Überwachungskamera eingefangen und an den Ort der Performance übertragen. Es gibt in diesen Arbeiten zusätzliche rituelle Elemente: die Schlange auf der Suche nach Beute, die sich drehenden "Wüstensimulatoren", die Sand umherwirbeln und dabei Geräusche entwickeln, oder die eintönigen Handlungen der Künstlerin, die dabei Aufzeichnungen weit entfernt postierter Kameras einbezieht.

Darüber hinaus beschäftigen sich diese frühen Arbeiten mit ökologischen Themen und dem Umgang des Menschen mit dem Planeten Erde. Jill Scott setzt in ihren Installationen häufig rituelle Elemente ein. Die Klänge des Didgeridoo untermalen SAND THE STIMULANT (1980) und OUT, THE BACK (1978), und Assoziationen an die australische Wüste hinterlassen bei diesen und anderen Arbeiten ihre Spuren. Archetypische Mythen und Konzepte von Zeit, ursprünglich angesiedelt in der Wüste, besitzen für die Künstlerin große Anziehungskraft bei ihren Versuchen, Artikulationen außerhalb des westlichen Kanons zu entdecken.

Ab Mitte der achtziger Jahre konzentriert sich Jill Scott zunehmend auf den Körper und das psychologische Erinnerungsvermögen sowie entsprechend auf Kulturgeschichte und persönlich erlebte Vergangenheiten. Das Gedächtnis des Körpers, früher definiert als Code und Verhaltensmuster, beginnt eine nachhaltigere Rolle innerhalb künstlerischer Umgebungen zu spielen. Jill Scott wendet sich von der in erster Linie auf linguistischen Codes basierenden Semiotik ab und widmet sich der Erforschung eines eher phänomenologischen und psycho-sozialen Raums, der Erinnerungen, Träumen, inneren Stimmen und vielschichtigen Erzählungen den Vorrang gibt.

In dieser für die Kunst so dynamischen Zeit fand eine Abkehr von der Linguistik statt, und damit verbunden vom Strukturalismus, die den Weg ebnete für das, was dann in der "Wende zur Kultur" oder "Wende zum Bild" seinen Ausdruck fand.[4]

In the mid-1980s, Scott starts to focus more on the body and psychological memory, as well as cultural and personal histories. Body memory, once explored as code and behavioural pattern, starts to take on a more profound enactment within the space of the art environment. Scott turns away from semiotics, which is based primarily on linguistic codes, and starts to explore a more phenomenological and psycho-social space that prioritises memory, dreams, internal voices and multi-layered narratives.

This was a dynamic period in the art world as the linguistic turn, associated with structuralism, gave way to what some have called the "cultural turn" or "pictorial turn".[4] However, the lessons that structuralism demonstrated were embedded in cultural history by then, so that new ways of thinking were conscious of social codes and the "always, already written" strictures of sexuality, ethnicity and racial identity. The structuralists had announced and interrogated the binary codes of Western thought and they had analysed its inscription throughout psycho-social space.[5] Although this movement contributed significantly to our understanding of society, it tended to foreclose on the subject (once the individual, the agent of change). In this scheme there was no feasible position for resistance, or, at least that was the dominant interpretation.[6] It must be noted that Foucault himself did not necessarily see the controlling aspects of the gaze as determining the subject: in fact he argued for the agency of the subject in a position of resistance to the dominant code.[7]

Jill Scott, like many of her colleagues in the visual arts, started to realise the gaps in the structuralist semiotic model. As a woman and a feminist she started to ask questions about the agency of the Other. As an artist interested in ecology and natural phenomena, she started to explore other areas of time and space. It is from the mid-1980s onwards that we start to see Scott's work becoming more multi-layered. It is less concerned with structures and behaviours and more concerned with the relationship between the body and technology and how this technology may be harnessed, so that the subject (agent) might talk and imagine in different ways.

Aber die Lehren, die sich aus dem Strukturalismus ableiten ließen, waren bereits so tief in der Kulturgeschichte eingebettet, dass die neuen Denkmodelle sich durchaus der sozialen Codes bewusst waren und einer "immer schon beschriebenen" kritischen Betrachtung von Sexualität, ethnischer Zugehörigkeit und Rassenidentität. Die Strukturalisten hatten in ihren Untersuchungen den Begriff der binären Codes im westlichen Denken geprägt und deren Nachweis im gesamten psychosozialen Raum analysiert.[5] Obwohl die VertreterInnen des Strukturalismus bedeutende Beiträge zu unserem Verständnis der Gesellschaft beisteuerten, konzentrierten sie sich tendenziell doch zu sehr auf das Subjekt (früher das Individuum, als Agent von Veränderung). In diesem Modell war kein Platz für eine eventuelle Position des Widerstands, so zumindest die gängige Interpretation.[6] Hierbei ist festzuhalten, dass Foucault selbst nicht notwendigerweise die kontrollierenden Aspekte des Blickes als Ursache für eine sozusagen gegebene Vorherbestimmtheit des Subjektes hielt, denn tatsächlich argumentierte er für ein Handeln des Subjekts, aus einer Position des Widerstandes gegenüber dem dominanten Code.[7]

Jill Scott, wie viele ihrer MitstreiterInnen in der bildenden Kunst, erkannte nun die Lücken im strukturalistischen Modell der Semiotik. Als Frau und Feministin begann sie, das Handeln des Anderen zu hinterfragen. Das Interesse der Künstlerin an Ökologie und Naturphänomenen führte dazu, dass sie sich der Erforschung alternativer Bereiche von Zeit und Raum zuwandte. Ab Mitte der achtziger Jahre lässt sich in den Arbeiten von Jill Scott eine gewisse Vielschichtigkeit entdecken. Sie beschäftigen sich weniger mit Strukturen und Verhaltensweisen. Ihr Interesse gilt nun den Beziehungen zwischen Körper und Technologie, und wie man diese Technologie einsetzt, damit das Subjekt (oder sein Agent/seine Agentin) sich in verschiedenen Formen der Sprache und Vorstellung artikulieren kann.

Im gesamten Werk von Jill Scott und auch im Diskurs über ihre Kunst stößt man immer wieder auf die Begriffe Narration und Code. Sie beschäftigt sich damit, in welcher Form eine Erzählung von linearer Zeit abstrahiert werden kann, und notiert die unterschiedlichen Einflüsse, die unter anderem die Lektüre der großen magischen RealistInnen Gabriel García Márquez und Isabel Allende auf ihr Leben und ihre Arbeit hatte. Das deutet auf eine Affinität zum Unbewussten und Unbekannten, zu den Möglichkeiten, mit denen persönliche und gesellschaftliche Erinnerungen in die Geschichte eingehen können.

Throughout Scott's work and her dialogue about her art we find her speaking about narratives and codes. She is interested in how narrative can be abstracted away from linear time. She lists various influences on her life and work, including reading the great magical realists Gabriel García Márquez and Isabel Allende. This points to an interest in the unconscious and the unknown, an interest in the ways in which personal and social memories contribute to histories.

We see these interests emerge in a series of video and computer installations that become increasingly sophisticated and interactive for the audience.

Narrative becomes a primary element in Scott's multimedia tapestries. She collects stories by researching people, history and specific time zones. She is interested in different states of awareness and means of communication. The subjects cast in Scott's video plays and media-installations are usually women, and she often appears in the work herself. As director Scott creates the content and the structure of the work but she is committed to providing a multiplicity of options and scenarios, so that when the audience interacts with the work they can create their own narrative.

There is a very serious set of problems under analysis in Scott's work. On a formal level, the technology must be seen to operate effortlessly. For this to happen Scott needs to draw on her earlier work experience, those experiments and semiotic meditations that gave her an insight into people's behaviour and their desires. On a conceptual level, Scott is most interested in deconstructing and reconstructing narrative so that the audience comes to understand the codes in operation. The difference between self and other is played out over and over in the installations as the binaries are restaged: nature and culture, mind and body, man and woman, the body and the machine, spirituality and rationality recur as narratives, and metaphors emerge from the collision of ideas.

Man kann diese sich langsam entwickelnde Affinität in einer Reihe von Video- und computergestützten Installationen erkennen, die technisch immer ausgereifter und durch interaktive Zugriffe dem Publikum leichter zugänglich werden.

Das Narrative wird zu einem vorrangigen Element in Jill Scotts multi-medialen Bildwänden. In ihren Untersuchungen sammelt sie Erzählungen über Menschen, geschichtliche Ereignisse und spezifische Zeitzonen. Sie befasst sich mit unterschiedlichen Bewusstseinszuständen und Bedeutungen von Kommunikation. Die Rollen der Charaktere (Subjekte) in ihren Videoarbeiten und medialen Installationen werden hauptsächlich mit Frauen besetzt, und sie tritt häufig selbst darin auf. Als Regisseurin bestimmt Jill Scott den Inhalt und die Grundstruktur der Arbeit, aber sie legt großen Wert darauf, eine Vielzahl von Optionen und Szenarien anzubieten, aus denen heraus das Publikum in der Interaktion mit dem Werk seine eigenen Geschichten durch Wahl kreieren kann.

Es gibt eine Reihe von Problemfeldern, die sie in ihren Arbeiten analytisch thematisiert. Auf einer formalen Ebene müssen die technischen Einrichtungen einwandfrei funktionieren. Das gelingt ihr in der Rückbesinnung auf frühere Resultate ihrer Arbeit, jene Experimente und semiotischen Überlegungen, die ihr neue Erkenntnisse über das Verhalten des Menschen und seine Sehnsüchte vermittelten. In konzeptioneller Weise interessiert sich Jill Scott vor allem für die Dekonstruktion und anschließende Rekonstruktion einer Erzählung, wodurch sie das Publikum in die Lage versetzt, die dabei angewandten Codes dechiffrieren zu können. Die Differenz zwischen sich Selbst und dem Anderen wird in den Installationen permanent ausgespielt, indem sie auf binäre Strukturen zurückgreift: Natur-Kultur, Geist-Körper, Mann-Frau, der Körper-die Maschine, Spiritualität-Rationalität kehren als Erzählung wieder, und aus der Kollision von Ideen entspringen Metaphern.

In zahlreichen Videoarbeiten von Jill Scott lassen sich Dislozierungen entdecken, wenn aus einem bestimmten Bildgegenstand ein anderer entsteht: in einer Szene wird die Landschaft zum Körper einer Frau, eine andere interpretiert Wasser als Darstellung des Unbewussten. Manche der Arbeiten besitzen eine totemhafte Qualität, die durch die mimetischen und morphologischen Eigenschaften analoger und digitaler Technologie hervorgerufen wird.

Many of Scott's video works are riddled with displacements, as one thing becomes another: in one scene the landscape is a woman's body; in another, we are told that water represents the unconscious. There is a totemistic quality in some of this work that is brought about through the mimetic and morphing qualities of analog and digital technology.

The mimetic aspects of photography, video and film give these media a kind of magic since the referent, the image before the lens, seems to stick to the photosensitive emulsion. This indexical quality of photo-based media has enchanted critics and historians of photography since the early nineteenth century. In the 1960s Roland Barthes described the analog photo/image as "a message without a code".[8] The camera, as a form of mechanical reproduction, is also a mechanism that, in Walter Benjamin's thesis, gives rise to the end of authenticity and the elitism of the art object. In the 1930s technological means of reproduction were considered by Benjamin to be democratic devices able to break with older systems of representation. The Frankfurt School theorist was famous for celebrating the withering of the aura of the work of art in the age of reproduction.[9] He believed that technology changed perception but he also believed that the mimetic function of machines related to older mimetic traditions where objects were like talisman or totems and the distances between people and objects of representation merged. This interpenetration of body-image space inscribes a kind of theatre in which the self can become other through representation.[10]

The digital editing and production in Scott's videos allows characters, body parts, environments and time zones to morph into one another in a complex variety of interactions. She uses memories and historical time together with "real time" to explore psycho-social issues regarding women, ecology, technology and history.

Der mimetische Charakter von Photographie, Video und Film verleiht diesen Medien eine Art von Magie, denn das Bild vor der Linse, der Referent oder die Referentin, scheint geradezu auf der lichtempfindlichen Emulsion zu haften. Dieses messbare Merkmal von auf Photographie zurückgehenden Medien hat KritikerInnen und HistorikerInnen seit dem frühen 19. Jahrhundert in Begeisterung versetzt. In den sechziger Jahren des letzten Jahrhunderts beschreibt Roland Barthes das analoge Photo/Bild als "eine Botschaft ohne Code".[8] Die Kamera als eine Form von technischer Reproduktion stellt gleichzeitig einen Mechanismus dar, aus dem sich, mit den Überlegungen von Walter Benjamin, das Ende der Authentizität und des elitären Anspruchs eines Kunstwerks ableiten lassen. In den dreißiger Jahren wurden technische Methoden der Reproduzierbarkeit von Benjamin als demokratische Mittel betrachtet, die mit älteren Systemen von Repräsentation brechen konnten. Der Theoretiker der Frankfurter Schule schwärmte bekanntermaßen vom Verfall der Aura eines Kunstwerks im Zeitalter der Reproduzierbarkeit.[9] Er war überzeugt davon, dass Technik die Wahrnehmung veränderte, aber er glaubte auch, dass sich die mimetische Funktion von Maschinen auf ältere mimetische Traditionen bezog, in denen Gegenstände zu Talismanen oder Totems erklärt wurden und sich die Unterschiede zwischen den Menschen und den Objekten der Darstellung aufgelöst hatten. Diese gegenseitige Durchdringung von Körper- und Bildraum wird in einer Art Theater sichtbar, in dem das Selbst durch Repräsentation zu einem Anderen werden kann.[10]

Die Videoarbeiten von Jill Scott sind digital bearbeitet und lassen Charaktere, Körper, räumliche Umgebungen und Zeitzonen in einer komplexen Vielfalt von Interaktionen miteinander verschmelzen. Jill Scott verbindet Erinnerungen und historische Zeitpassagen mit der "Echtzeit" der Gegenwart und erforscht damit beispielsweise psycho-soziale Themenbereiche, die einzelne Realitäten von Frauen wie auch Gebiete der Ökologie, der Technologie und der Geschichte betreffen.

Die Konzepte mediatisierter Wesen und paralleler Welten werden "real" durch die Möglichkeiten der Technologie. Aus Erinnerungen und vergangenen Erfahrungen, Träumen und utopischen Welten entstehen interaktive virtuelle Räume. Sie benutzt digitale und analoge Verfahren als performatives Instrumentarium. Mit Hilfe der binären Null/Eins-Codes von Computern und digitalen Medien gelingt Jill Scott die Realisierung multi-dimensionaler Umgebungen und mosaikartiges Geschichtenerzählen. Auf diese Weise lassen sich jene binären Codes,

The idea of mediated beings and parallel worlds is made "real" through the capabilities of the technology. Memories and experiences of the past, dreams and utopian worlds become virtual spaces inside the machines that Scott uses to create her interactive environments. Digital and analog processes are used as performative tools. Through the zero/one binary code of computers and digital media Scott is able to create multi-dimensional spaces and intercepting stories. Thus those binary codes that would restrict and control the subject and her knowledge and imagination are harnessed to another plan that hopes to open up the positions between and beyond binaries.

There is always something phantasmagorial in the interactive installations as the artist seduces her audience through the magic of technology. Walking through space, touching an object, talking to the characters on screen are ways in which the audience comes to own the work. However, behind Scott's technical wizardry there is a desire to produce works of art that speak quite loudly about social and ideological issues.

Scott is undoubtedly a feminist but her work has never been didactic or obviously "political". The politics of the work is often found in its structure, specifically the ways in which interactivity is built into the event. Many of the installations only come alive when the audience participates in some way. This suggests that the artist is concerned with people and the ways in which they come to know and understand things about other people, places and times. There is a kind of creative pedagogy in the installations of the 1990s and 2000s where the artist sets up learning laboratories that prompt the viewer to travel through time (FRONTIERS OF UTOPIA, 1995, A FIGURATIVE HISTORY, 1996 and BEYOND HIERARCHY?, 2000). These works go beyond art in lots of respects. They are equally at home in historical museums, libraries and learning institutions.

Scott's models of interaction probe new ways of learning that could easily become part of the classrooms of the twenty-first century. This is where the artist's feminist practice moves out into society and breaks with

die das Wissen und die Vorstellungen des Subjekts für gewöhnlich einschränken und kontrollieren, auf ein alternatives Konzept übertragen, mit der Hoffnung, Positionen innerhalb und außerhalb der binären Systeme neu definieren zu können.

Die interaktiven Installationen haben stets phantasmagorische Ausstrahlung, weil die Künstlerin ihr Publikum durch die Magie von Technologie zu verführen vermag. Indem die BesucherInnen sich im Raum bewegen, einen bestimmten Gegenstand berühren oder mit den Charakteren auf dem Bildschirm in Kontakt treten, eignen sie sich die Arbeiten nach und nach an. Aber hinter dem von Jill Scott entwickelten technischen Zauber verbirgt sich die Sehnsucht, ein Kunstwerk zu schaffen, das durchaus lautstark soziale und ideologische Themen artikuliert.

Man kann Jill Scott zweifelsohne als Feministin bezeichnen, aber ihre Arbeiten waren eigentlich niemals didaktisch oder auf vordergründige Weise politisch, sondern eher an ethischen Fragen orientiert. Politische Aspekte entdeckt man in ihrem Werk häufig in der Struktur, insbesondere in den Mitteln, mit denen Interaktivität in das Geschehen eingebaut wird. Viele der Installationen bekommen erst dann ein Leben, wenn das Publikum in irgendeiner Form an ihnen partizipiert. Das lässt darauf schließen, dass die Künstlerin sich für den Menschen an sich interessiert, und für die Art und Weise, wie wir etwas über andere Menschen, Orte oder Zeiten erfahren und lernen können. Seit den neunziger Jahren entfaltet sich in den Installationen eine Art kreative Pädagogik. In ihnen richtet die Künstlerin Versuchslaboratorien ein, die der BetrachterIn eine Reise durch die Zeit ermöglichen (FRONTIERS OF UTOPIA, 1995, A FIGURATIVE HISTORY, 1996, und BEYOND HIERARCHY?, 2000). Diese Arbeiten gehen in vielerlei Hinsicht über Kunst hinaus. Sie sind ebenso gut in historischen Museen wie in Bibliotheken oder Lehrinstituten aufgehoben.

Jill Scotts Modelle der Interaktion erproben neue Wege des Lernens, und man kann sie sich sehr wohl im Klassenzimmer des 21. Jahrhunderts vorstellen. Hier tritt die Künstlerin mit ihrer feministischen Praxis hinaus in die Gesellschaft und hinterfragt den panoptischen Entwurf von Institution, Galerie und Schule. Die "SchülerInnen", für die sich der Unterricht nicht länger auf monotones Lernen und die analoge Form der Kommunikation mit den "Vortragenden" reduziert, übernehmen

the panoptic model of the institution, the gallery and the school. No longer tutored via the analogical imprinting of the master's voice through rote learning, the student in Scott's new future will have a much more active role in the making of social history and science. Scott's model is driven by an artist's mind. She is not confined to rigid disciplines of thought and correct practices. Her mind can roam across many territories - she can be as eclectic as she likes, drawing on science, mythology, social history, personal stories, psychology and philosophy.

The feminism in Scott's work is apparent through her use of technology and her casting of historical and futuristic characters. In an interview in "N. Paradoxa" she said that she was "interested in a type of resistance from within the system rather than an escape".[11] Later she added: "if women do not get involved in technology they will be left out of it in the future, if they ignore the implications and ethics of genetic and microbiological progress their bodies may well be left out of the future all together". Speaking about the history of feminism Scott said that she could envisage a post-gender world "where cyborgs replace the notion of the goddess".[12]

Jill Scott's feminism is futuristic. Her thinking is closer to the cyber-feminism of Donna Haraway than the established polemic of the women's liberation platform espoused by Germaine Greer. However, Scott is not displaced from her roots in the 1970s, neither is she discouraging of the types of rituals that propel new age feminists to run with the wolves or seek out alternative therapies. She is prepared to speak from her own personal experience, to make the personal political. She does this most poignantly in the work where she describes her own experience of breast cancer. The inside/outside dichotomy of the body, its organs and its skin - once "hailed" into the strictures of the binary codes of patriarchal law - is unravelled in Scott's video (CONTINENTAL DRIFT).[13] Here she searches for something beyond Western medicine, something that might help Jill Scott, the woman, overcome her diagnosis, her fear and her illness. This quest is a spiritual one in many respects and it is powered by a belief that the mind or

eine weitaus aktivere Rolle bei der Gestaltung von Sozialgeschichte und Wissenschaft in Jill Scotts Zukunftsvision. Ihr Modell geht auf künstlerische Ideen zurück. Sie lässt sich nicht in streng voneinander getrennte Disziplinen des Denkens oder in konformes Verhalten zwingen. Ihr Verstand kann viele unterschiedliche Territorien durchqueren - sie entscheidet, wieviel Eklektizismus sie für angebracht hält, und greift dabei auf Wissenschaft, Mythologien, Sozialgeschichte, persönliche Erinnerungen, Psychologie und Philosophie zurück.

Der Feminismus in Jill Scotts Werk wird in ihrem Einsatz von Technologie sowie der Besetzung der DarstellerInnen mit historischen und futuristischen Charakteren deutlich. In einem Interview in "N. Paradoxa" argumentierte sie, dass sie sich "...eher für eine Art Widerstand von Innen interessiert als für Flucht."[11] Später fügte sie hinzu: "...wenn Frauen sich nicht mit Technologie auseinandersetzen, werden sie in Zukunft von ihr ausgeschlossen sein, und wenn sie die Implikationen und ethischen Fragen des genetischen und mikrobiologischen Fortschritts ignorieren, wird der Körper der Frau in Zukunft vielleicht sogar gänzlich ignoriert werden."[12] In der Geschichte des Feminismus entdeckte Jill Scott die Perspektive einer Welt, in der keine Unterschiede mehr zwischen den Geschlechtern existieren und "Cyborgs die Idee einer Göttin ersetzen."

Jill Scott vertritt eine futuristische Form des Feminismus. Ihr Denken steht dem cyber-feministischen Ansatz von Donna Haraway näher als einer etablierten, kämpferischen Plattform für die Gleichberechtigung der Frau, wie sie Germaine Greer propagiert. Dennoch ist Jill Scott ihren Ursprüngen aus den siebziger Jahren treu geblieben und lässt sich auch nicht durch die Art von Ritualen entmutigen, die FeministInnen des New Age dazu animieren, mit Wölfen zu heulen oder krampfhaft nach alternativen Therapien zu suchen. Sie kann sich auf eigene individuelle Beobachtungen stützen, um dem Persönlichen politische Bedeutung zu verleihen. Besonders beeindruckend gelingt ihr das in der Arbeit, die sich mit ihren persönlichen Erfahrungen mit Brustkrebs beschäftigt. Jill Scott entschlüsselt in dem Video (CONTINENTAL DRIFT) die Dichotomien von Innen/Aussen des Körpers, seiner Organe und seiner Haut - einst "angerufen" in der Kritik an den binären Codes patriarchalischer Gesetze.[13] Hier forscht sie außerhalb der westlichen Medizin nach irgendetwas, das Jill Scott, als Frau, helfen kann, mit der Diagnose, ihrer Angst und ihrer Krankheit umzugehen. Diese Suche erweist sich in vielerlei Hinsicht als spirituell in der Überzeugung, dass Verstand und Bewusstsein

consciousness can speak to the body and make changes in its structure. In other words, through positive affirmation and meditation, one might get to the root of the illness and be able to talk it away. This is a more physical application of Freud and Lacan's "talking cure" where the subject comes to know and, perhaps, understand her neurosis.[14]

The meeting of the psyche and the machine in postmodern culture has given rise to numerous metaphors. The prosthetic gods that Freud talked about in "Civilization and its Discontents" have become more real through the manifestation of sophisticated robots and cyborgs.[15] More recently the concept of Artificial Intelligence has entered the popular vernacular through mainstream Hollywood films which feature intelligent machines. In these futuristic worlds many old myths are restaged. "The Matrix", much like an earlier film, "Close Encounters of the Third Kind", re-enacts a biblical story. The wars between good and evil prevail and the machines often take on the mantle of superior intelligence.

If we are in the grip of what Mitchell calls the "pictorial turn", then pictures and pictorial narratives inscribe us. These narratives have less to do with the binary systems of language than they do with the processes of writing. The marvellous is part of the magic of technology and computers: they give us the opportunity to think in different ways. The utopians believe that machines may help us break with the binary code, even though these machines are programmed via a binary language.

It is not surprising that an artist like Jill Scott, who has worked on the cutting edge of interactive computer technologies for over a decade, could have an interest in spirituality. Alternative therapies, which are predicated on reprogramming the mind-body relationship, are processes in which the mind tells the body a different story.

zum Körper sprechen und Veränderungen in seiner Struktur bewirken. Mit anderen Worten, durch positive Affirmation und mit Meditation ist es vielleicht möglich, zu den Wurzeln der Krankheit vorzudringen, um sie dann wegsprechen zu können. Darin artikuliert sich in physischer Form eine Aneignung der "Sprechtherapie" bei Freud und Lacan, wo der Patient lernt, seine Neurose zu erkennen und dann, vielleicht, zu verstehen.[14]

Das Aufeinandertreffen von Psyche und Maschine in der postmodernen Kultur hat zahllose Metaphern hervorgerufen. Die prothetischen Götter, von denen Freud in "Civilization and Its Discontents" gesprochen hat, haben reale Züge angenommen in den Erscheinungsformen hochentwickelter Roboter und Cyborgs.[15] Im Mainstream von Hollywoodfilmen aus der jüngeren Vergangenheit, in denen diese intelligenten Maschinen auftreten, ist das Konzept der Künstlichen Intelligenz in die Alltagssprache eingegangen. In diesen futuristischen Welten leben viele alte Mythen wieder auf. "The Matrix" erzählt, ähnlich wie zuvor "Close Encounter of the Third Kind", abermals eine biblische Geschichte. Sie wird beherrscht vom Krieg zwischen Gut und Böse, und die Maschinen verkörpern häufig eine höhere Intelligenz.

Wenn wir von dem Begriff der "Wende zum Bild" bei Mitchell ausgehen, dann lässt sich unsere Existenz mit Bildern und bildlichen Erzählungen beschreiben. Diese Geschichten haben weniger mit den binären Strukturen von Sprache als mit dem Prozess des Schreibens zu tun. Das "Schöne" ist Teil der Magie von Technologie und Computern: sie verleihen uns die Fähigkeit, differenziert zu denken. Die UtopistInnen glauben, dass Maschinen uns dabei helfen könnten, den binären Code zu brechen, selbst wenn diese Maschinen in einer binären Sprache programmiert sind.

Es ist keine Überraschung, dass eine Künstlerin wie Jill Scott, die sich in ihrer Arbeit seit über einem Jahrzehnt an den Schnittpunkten interaktiver Computertechnologie bewegt hat, gleichzeitig Interesse an Spiritualität entwickelt. Alternative Therapien, die sich auf eine Reprogrammierung der Beziehungen von Geist und Körper gründen, stellen Verfahren dar, mit denen der Verstand dem Körper eine Geschichte in anderer Form erzählt.

What is interesting about the boundary zone between new age philosophy and cyberspace is the way in which history enters the present and stories are repeated. Computers and artificial intelligence impact upon mind and consciousness. Making these machines do things in terms of representation, perception and interactivity tells us a lot about our own human consciousness. It gives us a window of opportunity to start changing and manipulating the process that we call thought.

Jill Scott is part of a small band of utopian artists who believe that technology is liberating for the subject as agent. She believes that her experiments can open up new ways of knowing. However, her marriage to technology does not foreclose on an interest and a belief in older, more esoteric ways of knowing. Scott's work over the last twenty-eight years maps a tangent that links the corporeal body of early art actions with the virtual bodies and imagined worlds of interactive cyber technology. She is an artist committed to change but she respects the mythologies of ancient pasts and brings them with her into the future.

Was den Grenzbereich zwischen der New Age-Philosophie und Cyberspace so interessant macht, ist die Art und Weise, mit der Historisches in die Gegenwart einfließt und sich die Erzählungen wiederholen. Computer und Künstliche Intelligenz treffen auf Verstand und Bewusstsein. Dass man für den Betrieb dieser Maschinen Begriffe wie Repräsentation, Wahrnehmung und Interaktivität in Anspruch nimmt, sagt eine Menge über unser eigenes menschliches Bewusstsein aus. Es öffnet uns ein Fenster mit Optionen, die dazu dienen können, den Prozess, den man Denken nennt, zu verändern und zu manipulieren.

Jill Scott ist Teil einer kleinen Gruppe von utopischen KünstlerInnen, die glauben, dass Technologie das Subjekt als treibende Kraft freisetzen kann. Sie ist überzeugt davon, dass ihre Experimente neue Wege der Erkenntnis veranschaulichen. Aber in ihrer engen persönlichen Beziehung zu Technologie leugnet sie keineswegs ihr Interesse und Vertrauen, welches sie älteren, und eher esoterischen Wegen der Erkenntnis entgegen bringt. Jill Scott zeichnet mit ihren Arbeiten aus den letzten achtundzwanzig Jahren eine Tangente, die die Körperlichkeit des realen Körpers aus der frühen Aktionskunst mit den virtuellen Körpern und Vorstellungswelten interaktiver Cyber-Technologie verbindet. Für diese Künstlerin ist Veränderung von entscheidender Bedeutung, aber sie respektiert die Mythologien aus ferner Vergangenheit und führt sie mit sich in die Zukunft.

1 Roland Barthes, Mythologies (1957), trans. Annette Lavers, London: Paladin/Grafton/Collins, 1973. | **2** Marshall McLuhan, Understanding Media: The Extensions of Man (1964), Cambridge, Massachusetts: MIT Press, 1994. | **3** See Michel Foucault, "Panopticism", in Discipline and Punish, Penguin, 1979, pp. 195-228. | **4** For a lucid analysis see W.J.T. Mitchell, "The Pictorial Turn", Artforum, March 1992, pp. 89-94. | **5** See especially, Louis Althusser, "Ideology and Ideological State Apparatuses", in Lenin and Philosophy, trans. Ben Brewster, New York: Monthly Review Press, 1971, pp. 127-186. The idea that "individuals are always already subjects", written into a language over which they have little, if any, control was made popular by Althusser in the 1970s, see p. 176 (his emphasis). | **6** Foucault's analysis of power and knowledge in the panopticon (itself a visual metaphor) has tended to be read by cultural theorists as an unequal balance of power. However, Foucault taught that power comes from below. The point about the panopticon is that the inmates regulate their behaviour because they believe they could be being watched. | **7** See Michel Foucault, "The Discourse of Power" (1981), in Remarks on Marx: Conversations with Duccio Trombadori, trans. James Goldstein and James Cascaito, New York: Semiotext(e), 1991, pp. 147-182. | **8** See Roland Barthes, "The Photographic Message" (1961), in The Responsibility of Forms: Critical Essays on Music Art and Representation, trans. Richard Howard, New York: Hill and Wang, 1985, p. 5. | **9** Walter Benjamin, "The Work of Art in the Age of Mechanical Reproduction" (1936), in Illuminations, trans. Harry Zohn, London: Fontana/Harper Collins, 1973, pp. 211-244. | **10** For a lucid analysis of body-image space, see Michael Taussig, Mimesis and Alterity: A Particular History of the Sense, New York and London: Routledge, 1993. | **11** Interview with Katy Deepwell, N.Paradoxa, "Feminist Perspectives", Issue no. 01, March 97, on-line journal http://web.ukonline.co.uk/members/n.paradoxa/index.htm | **12** ibid. Katy Deepwell. | **13** For an explanation of the "hailing" of the subject into language, see Louis Althusser, "Ideology and Ideological State Apparatuses". | **14** Psychoanalysis has been described as the "talking cure" by Colin MacCabe in his book The Talking Cure: Essays in Psychoanalysis and Language, London: Macmillan, 1981. | **15** See Sigmund Freud, Civilization and Its Discontents, trans. James Strachey, New York and London: Norton, 1961.

ANALOG FIGURES
WESTCOAST 1975 – 1982 |

D | Performances, Aktionen und Soundart entwickelten sich im San Francisco und in der Bay Area der siebziger Jahre zu einer populären Kunstform. Wir wollten die Prozesshaftigkeit dieser Medien erforschen. Wir experimentierten mit Imitationen und Deformationen von Figuren (Körpern) und waren fasziniert von den Möglichkeiten der direkten Aufzeichnung von uns selbst. Wir wollten uns neu erfinden und rebellierten gegen unsere kommerzialisierte Umgebung.

Unter Verwendung audiovisueller Konzepte experimentierten wir in Echtzeit mit diesen gefilterten Erfahrungen und entwarfen unmittelbare Spiegelbilder vom Körper des Künstlers/der Künstlerin und des Betrachters/der Betrachterin. Das Publikum konnte sich gleichzeitig hier (in der Realität) und dort (in einer Maschine oder in einem anderen Raum) aufhalten, was dazu führte, dass sich das Publikum in einer Art paralleler Welten befand. Als wesentlicher Bestandteil der Performancekunst wurden auf der Bühne Live-Video und Sound integriert, als eine Form von Reflexion dualistischer Metaphern über Konzepte von Raum, Dimension und einer

ANALOG FIGURES

PARALLEL WORLDS IN PERFORMANCE/VIDEO/SOUND/SURVEILLANCE (WESTCOAST USA 1975-82) BY JILL SCOTT

E | ANALOG - of, relating to, or being an analog mark, or being a mechanism in which data is represented by continuously variable physical quantities. - of or relating to an analog device (e.g. a timepiece with hour and minute hands). - FIGURES - a prominent personality: "great figures of history" - a bodily shape or form especially of a person "a woman's figure" or an object noticeable only as a shape or form "figures moving in the dark" - the graphic representation of a form especially of a person or geometric entity.

In San Francisco and the Bay Area, in the history of the seventies, performance-action and sound art became a popular art form. We wanted to explore these process-oriented mediums for their potential levels of mimicry and distortion of the figure (body), governed by a fascination to record ourselves, recreate our identities and rebel against our commercial environment. By using the concepts of real-time audio and video, we experimented with these filtered experiences, creating instant mirror views of both the body of the artist and that of the viewer. At the same time, the audience

Kodierung der Gesellschaft (z.B. in den politischen Arbeiten von George Coates). An der amerikanischen Westküste manifestierte sich dieses Interesse zunehmend nicht nur aus einer kritischen Auseinandersetzung mit den überholten Dualismen der Psychoanalyse heraus, sondern ebenso aus einem Vermächtnis der sechziger Jahre, welches das Paradox traditioneller Gegensätze (männlich/weiblich, schwarz/weiß) in Frage stellte. Viele KünstlerInnen der sechziger Jahre verurteilten die Gier im herrschenden Kapitalismus und kritisierten die distanzierte gleichgültige Haltung der etablierten Kunstwelt gegenüber dem aufkommenden Idealismus für Freiheit und gegen Armut, Krieg und Ungleichheit.

Die PerformancekünstlerInnen in San Francisco betrachteten zunächst Dada als Hauptquelle ihrer künstlerischen Überlegungen. Die Ideen der Dadaisten aus den zwanziger Jahren flammten in den siebziger Jahren wieder auf und die Grenzen zwischen Kunst und Leben sollten erneut eingerissen werden. So erklärte zum Beispiel Marcel Duchamp in einem frühen bedeutenden Werk den Körper des Künstlers zu einem Ort von Kunst ("Star" von Duchamp, Paris 1921). In den sechziger Jahren dann verstärkten die Fluxus-Aktionen das Zusam-

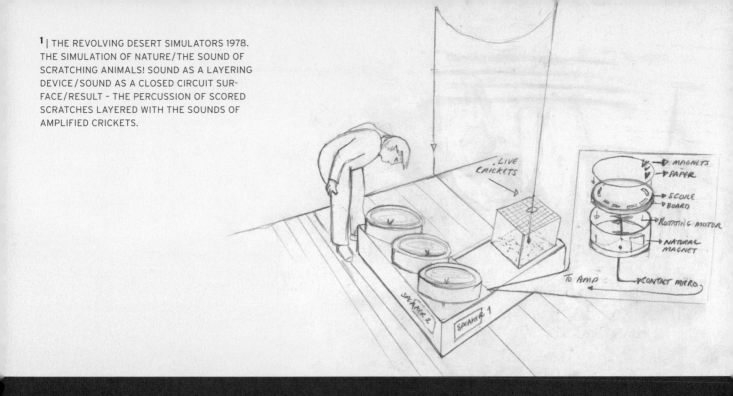

1 | THE REVOLVING DESERT SIMULATORS 1978. THE SIMULATION OF NATURE/THE SOUND OF SCRATCHING ANIMALS! SOUND AS A LAYERING DEVICE/SOUND AS A CLOSED CIRCUIT SURFACE/RESULT – THE PERCUSSION OF SCORED SCRATCHES LAYERED WITH THE SOUNDS OF AMPLIFIED CRICKETS.

could be here (in reality) and there (in the machine or in another space) simultaneously, thus causing them to live inside a type of parallel world. In a great deal of performance art, live video and sound became incorporated into the stage, in order to reflect dualistic metaphors about the concepts of space, dimension and the coding of our society (e.g. the political works of George Coates). On the West coast of America, this interest tended to grow not only out of exploring and challenging the old dualism of psychoanalysis, but also from the leftover legacy of the sixties which questioned the paradox of traditional opposites (male/female, black/white). Many artists of the sixties were concerned about the greedy Capitalistic world surrounding them; about the art world's distance from the new idealism of freedom from poverty, war and inequality.

Initially, performance art in San Francisco used Dada as its main source for these reflections. As Dada suggested in the twenties, the boundaries between the worlds of art and life should be collapsed, and these concepts were heartily revived in the seventies. For example, in a major early work by Marcel Duchamp, the artist's body became a place to make art (Duchamp's "Star", Paris 1921). Later, in the sixties, Fluxist actions extended this

menschmelzen von Kunst und Leben durch die Einbeziehung des Absurden. Eine ziemlich radikale Vertreterin der Fluxus-Bewegung, Carolee Schneemann, hatte großen Einfluss auf die Performances der KünstlerInnen aus der Bay Area, denn sie vertrat mit der bei ihr explizit thematisierten Sexualität die Fusion von Kunst, Leben und dem Absurden. In den siebziger Jahren regte Tom Marioni, Direktor des Museum of Conceptual Art in San Francisco, die BesucherInnen dazu an, sich über traditionelle Werte von Dauerhaftem hinwegzusetzen und stattdessen die direkte Erfahrung des kreativen Prozesses in sich aufzunehmen, der vor ihren Augen sich entwickelte. Meine Arbeit mit dem Titel THE REVOLVING DESERT SIMULATORS (1978/siehe S. 74) stellte den Versuch dar, etwa drei Stunden lang den kreisförmigen Geräuschen der rotierenden Wüstensimulatoren zu lauschen und dabei zu hören, wie Grillen in Echtzeit in Reaktion auf die von den Apparaten generierten Rythmen sich meist etwas zeitverzögert verhielten. Wenn sich in bestimmten Abständen der Code ihrer Gesänge änderte, nahm ich mein Didgeridoo und spielte dazu eine entsprechende Begleitung. In Anlehnung an Erfahrungen wie bei Zen-Meditationen über Dauer konnte vielleicht auch hier eine tatsächliche veränderte Zeit- und Raumerfahrung zwischen der Figur der BetrachterIn (des Publikums) und der Figur der KünstlerIn (der atmenden PerformerIn) erzeugt werden. Der Prozess von Kunstaktionen

breakdown between art and life by adding the absurd. One rather wild Fluxist, Carolee Schneemann, was a great influence on women's performance in the Bay Area, as it was her explicit sexuality which she saw as the fusion between art, life and the absurd. In the seventies, Tom Marioni, Director of the Museum of Conceptual Art in San Francisco, suggested that the audience should rise above traditional notions of duration and take in the experience of watching the creative process unfold. In my work entitled THE REVOLVING DESERT SIMULATORS (1978-82/p. 74), the aim was to watch and listen to the circular sounds of the apparatus for about three hours. The crickets slowly responded in real-time to the rhythms produced by the Simulator. When they gradually changed the code of their songs, I would then shift my didgeridoo to play accordingly. Along with similar Zen-like-levels of attention span, perhaps a shift in time and space could actually occur between the viewer's figure (or audience) and the artist's figure (the breathing performer).

The very size, duration and dimension of the process of the artist's actions were often compared to the position and role of the viewer's body, and these planes of reference were visibly analysed. Our audiences were our field of experimentation: they could either be huddled into a corner or their actions could be traced and compared. They could even become all of the process as in the works of Allan Kaprow (Bay Area artist). His interest began with a set of symbolic and illusive parts, which could be rejected or accepted by the audience as they followed certain tasks.

In terms of the stage, many performance artists became interested in a complete destruction of structural preconditions of traditional dramaturgy. In INSIDE OUT (1978/p. 64), my aim was to assume the role of a scientist or decoder of behaviour, thereby converting the viewers into a set of figurative objects in the artwork. Their movements and decisions were transferred to me via real-time video where I made notations and attempted to compare their levels of curiosity to those of caged rats, which were sitting in a window box. However, after the audience became aware of this primal coding

an sich, deren Auslegung, Verlauf und Dimensionen wurden häufig zu der Position oder Rolle der BetrachterInnen und ihrer Körper in Beziehung gesetzt. Diese referentiellen Aspekte wurden in visueller Form analysiert. Wir erklärten die BesucherInnen zum Gegenstand unserer Experimente: sie konnten sich passiv in eine Ecke zurückziehen, oder ihre Handlungen wurden aufgezeichnet und verglichen. Es war sogar möglich, dass sie den eigentlichen Prozess darstellten wie in den Arbeiten von Allan Kaprow (einem Künstler aus der Bay Area). Am Anfang seiner Beschäftigung mit dem Publikum stand eine Reihe symbolischer und kaum verständlicher Szenen, die von den BesucherInnen abgelehnt oder akzeptiert werden konnten, während sie bestimmte Aufgaben zu erfüllen hatten.

Bei der Gestaltung der Bühne arbeiteten viele PerformancekünstlerInnen zunehmend an einer umfassenden Destruktion von strukturellen Vorgaben traditioneller Dramaturgie. Bei INSIDE OUT (1978/S. 64) schlüpfte ich in die Rolle einer Wissenschaftlerin oder eines Decoders von Verhaltensweisen, wobei es mir darum ging, die BesucherInnen in eine Reihe von figurativen Objekten eines Kunstwerks zu verwandeln. Ihre Bewegungen und Entscheidungen wurden via Echtzeit-Video übertragen, und ich versuchte in den Aufzeichnungen, die einzelnen Stufen der Neugierde mit dem Verhalten von Ratten zu vergleichen, die in einem Terrarium eingesperrt waren. Nachdem einzelne BetrachterInnen jedoch sich dieses primären Kodierungsprozesses bewusst geworden waren, änderten sie ihre individuelle Körpersprache, um sich von den Ratten abzugrenzen. In Arbeiten wie diesen konnte das Videobild als Instrument für ein Feedback von Verhaltensweisen dienen, was den BetrachterInnen ermöglichte, sich selbst gleichzeitig als Objekt (Verhaltensmuster aus der Vergangenheit) und Subjekt (Reaktion in der Gegenwart) zu erkennen. Ich diskutierte mit meinen KünstlerkollegInnen Judith Barry und Terry Fox ausgiebig darüber, wie sich Sound oder Video für die einzelnen BesucherInnen auf ihre Wahrnehmung von sich selbst auswirken könnten. Entstand bei ihnen der Eindruck, dass sich ihre Körper von ihren analogen Abbildungen abgelöst hatten? Bedeutete das für sie eine bisher nicht gemachte Erfahrung?

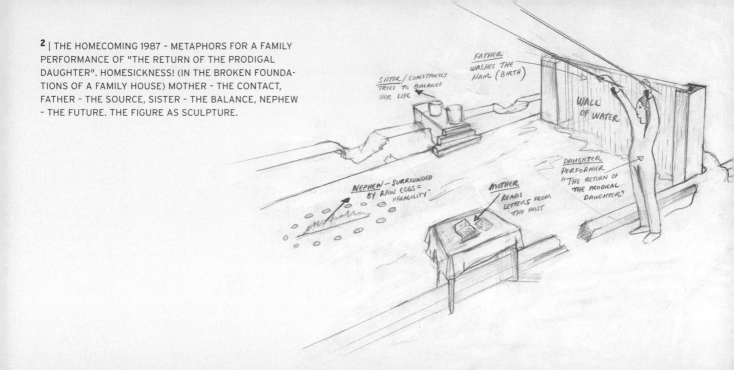

2 | THE HOMECOMING 1987 – METAPHORS FOR A FAMILY PERFORMANCE OF "THE RETURN OF THE PRODIGAL DAUGHTER". HOMESICKNESS! (IN THE BROKEN FOUNDATIONS OF A FAMILY HOUSE) MOTHER – THE CONTACT, FATHER – THE SOURCE, SISTER – THE BALANCE, NEPHEW – THE FUTURE. THE FIGURE AS SCULPTURE.

process they shifted their own body language to be different from the rats. In works like this, the video image could be used as a tool for behavioural feedback, allowing the viewers to simultaneously see themselves as both objects (past behaviour) and subjects (present reaction). Together with my colleagues Judith Barry and Terry Fox, we often discussed whether sound or video could effect the viewers' analog sense of themselves. Would they feel as if their bodies had become unglued from the images of themselves? Was this a new experience for them?

Thus, via video, both the represented figure and the real individual viewer on the screen graduated to become similar Analog Figures, living in a type of parallel world, one real and one recorded. Throughout the seventies, there was a continued effort to share proportions and calculations of the represented body via video and sound and duplicate it for the stage. In other performances the secret identity of the artist was only revealed to the audience via video-or sound performance and the image excluded rather than included the audience. In these scenarios, the audience was asked to focus and endure messages which were often explicitly designed to shock them (e.g. Vito Acconci). The art world was going through a reaction to the growth of

Auf diese Weise entwickelten sich beide, die abgebildete Figur im Video und die reale Figur der BesucherIn zu ähnlichen Analogen Figuren, die sich gleichzeitig in einer realen und einer aufgezeichneten Welt bewegten, sozusagen in parallelen Welten. Während der siebziger Jahre beschäftigte man sich kontinuierlich mit Konzepten um die Proportionen und Maße des dargestellten Körpers und entwickelte diese für die Bühne. In anderen Performances enthüllte sich die verborgene Präsenz oder Identität der KünstlerIn dem Publikum nur durch den Einsatz von Video oder Ton, wobei hierbei die BesucherInnen im Bild eher ausgeschlossen als integriert wurden. In diesen Szenarien sollte das Publikum seine Konzentration und Geduld auf Botschaften richten, die häufig explizit auf Schockwirkung angelegt waren (z.B. bei Vito Acconci). Die Kunstwelt reagierte auf die zunehmende Körperlichkeit. Der Körper der KünstlerIn, wie auch das partizipierende Publikum und die Darstellung der menschlichen Gestalt allgemein, wurden als neues künstlerisches Rohmaterialien entdeckt, um mögliche Bewusstseinsveränderungen auszulösen. Die Definition des Wortes "Objekt" wurde erweitert um die Begrifflichkeit der "kritischen Objektivierung" (auch Verurteilung, Ablehnung, Missbilligung), woraus sich vielleicht ableiten lässt, warum die PerformancekünstlerInnen in San Francisco ihre Arbeiten häufig auf die Straße verlegten. 1975 realisierte ich TAPED (S. 48), um die Grenzen zu erforschen, die entstehen, wenn man Kunst aus der Galerie herausholt. Ich verwendete

the corporate world and the body of the artist, the onlooking audience and the representation of the human form were all considered to be novel art materials to influence a change in consciousness. Therefore, the word-"object" also became a means "to object" (condemn, dislike, disapprove,) and this is perhaps the reason why the San Francisco performance artists often took their work into the street. In 1975, I made TAPED (p. 48) in order to explore the boundaries of taking art out of the galleries with the very material that every artist has in his or her studio: brown masking tape. I wanted to question the icon of the female figure as a commercial commodity but the work was also an attempt to breakaway from the history of the represented body of women in older mediums like painting. These types of investigations constituted a new stage (spot, post, ground) and conjured up a new term called "site-specific". This meant that the place of the event or installation might actually determine the content. In a site-specific installation or performance the audience was often asked to recognise and define their own body in relation to the site and the media used.

By the late seventies, a marked increase in the development of theatre and related semiotics helped artists to further question the importance of the platform, the scaffold, the rostrum, and the frame. As Bertolt Brecht once asked, who was the author and who was the producer on such a stage? After the proscenium stage concept had collapsed, the division between the audience and the characters on the stage was no longer clear. Most importantly, the body of the artist itself became an additional "site" for an artwork to take place. Antonin Artaud, the French actor and author once suggested that the body could be a place in which to deal with a number of different identities, an idea, which inspired the work of Elenor Antin. For California artists, it was the questioning of older dualistic identities (Freud's analysis) which provided an impetus for research into the relationship between the exterior space (or the surface ego and its environment) and the interior space (or blood-reality of the body and its inherited code). We became interested in the potential

braunes Klebeband, das wahrscheinlich alle KünstlerInnen in ihren Ateliers haben. Ich wollte das Bild der weiblichen Figur als kommerzielle Ware thematisieren. Die Arbeit formulierte auch den Versuch, aus der geschichtlich traditionellen Darstellung des Frauenkörpers auszubrechen, so wie er in herkömmlichen Medien wie beispielsweise in der Malerei gezeigt wurde. Diese Art von Experimenten formte eine neuartige Bühne ("spot, post, ground") und artikulierte sich mit dem neuen Begriff "site-spezifisch". Dieser sollte aussagen, dass der Ort des Events oder der Installation möglicherweise den Inhalt bestimmen kann. In einer site-spezifischen Installation oder Performance wurden die BesucherInnen immer wieder dazu animiert, ihren eigenen Körper wahrzunehmen und diesen im Verhältnis zu dem Ort und den eingesetzten Medien zu definieren.

In den späten siebziger Jahren veranlassten neu entwickelte Formen des Theaters und die damit verbundene Semiotik die KünstlerInnen, sich intensiver mit Begriffen wie Plattform, Struktur, Podium und Rahmen und deren Bedeutungen zu beschäftigen. Oder, um mit Bertolt Brecht zu sprechen, wer war die AutorIn und wer die ProduzentIn auf dieser Bühne? Nachdem das Konzept des abgetrennten Bühnenraums einmal als gescheitert erklärt worden war, ließen sich das Publikum und die Charaktere auf der Bühne nicht mehr eindeutig voneinander trennen. Bezeichnenderweise wurde der Körper der KünstlerInnen selbst zu einem zusätzlichen "Ort" eines gerade stattfindenden Kunstwerks. Antonin Artaud, der französische Schauspieler und Schriftsteller, beschrieb den Körper als einen Ort, an dem man einer bestimmten Anzahl unterschiedlicher Identitäten begegnen könnte, eine Idee, die besonders die Arbeit von Elenor Antin inspiriert hat. Für die KünstlerInnen in Kalifornien lieferte die Auseinandersetzung mit den überholten dualistischen Identitäten (Analyse von Freud) die entscheidenden Impulse, um die Beziehungen zwischen dem äußeren Raum (oder auch die Oberfläche des Ichs und seiner Umgebung) und dem inneren Raum (oder die Realität des Blutes im Körper und seiner ererbten Codes) zu erforschen. Wir interessierten uns zunehmend für die Möglichkeiten von Ritualen und symbolischen Performances, es ging darum, Prozesse einer Figur zu thematisieren, die beispielsweise ihr Alter, ihre Herkunft oder ihre Abwesenheit betrafen. Bei THE HOMECOMING (1978/S. 68) stand am Anfang die Idee, dass die Objekte und die damit in Beziehung stehenden Orte gewissermassen durch Rituale, die auf die

of ritual and symbolic performance to celebrate the figure's processes of ageing, heritage and absence. For example in THE HOMECOMING (1978/p. 68) I started with the idea that the objects and related sites could be somehow recharged or empowered though the rituals of returning to the source of childhood. The process involved an attempt to teach my own family about performance art and the concepts of space and dimension. By using my own family and associated metaphors, I hoped to create a set of poetic associations about family bonds (balancing sticks – for my sister, fragile eggs – for my nephew, regenerative water – for my father and nurturing letters – for my mother). In those days our aims were to ask people to begin to realise that there was more than one way to experience standard information.

In many performances, analog surveillance was used as a method to explore timelessness, which we considered to be a shift in parallel time. It allowed the audience to witness a secretive performative event but simultaneously it was also employed as a tool to monitor the changing metaphors of the figure over time. More importantly, the concept of the figure became related to the concept of an analog interface, sharing the same process through the mediums of video and sound. This included an interest in sharing mathematical proportions and calculations of the body, duplicating it for the screen, and revealing the underlying identity of the artist as well as the creative process. A new type of parallel world was created both on a social and cultural level. This meant a novel stage to explore one where life, art and the absurd could merge. Perhaps this stage was the beginning of an adequate metaphor to explain these changes to the figure. However, by the early eighties, the dualistic issues of voyeurism/empathetic gaze, coder/decoder, female or male sexual difference, exterior or interior selves, were no longer so relevant. Many of the performance, video and sound artists were in search of new myths and horizons for the Analog Figure, one that allowed for a more pluralistic definition of art in relation to history and popular culture.

Quellen der Kindheit zurückgehen, wieder aufgeladen oder mit Energie versehen werden könnten. Dieser Prozess beinhaltete die Absicht, meiner eigenen Familie das Wesen der Performancekunst zu vermitteln und Konzepte von Raum und Dimension näher zu bringen. Indem ich meine eigene Familie und mit ihr verbundene Metaphern benutzte, hoffte ich eine Reihe von poetischen Assoziationen in Bezug auf familiäre Bindungen zu entwickeln (mit Stöcken balancieren – für meine Schwester, rohe Eier – für meinen Neffen, regeneratives Wasser – für meinen Vater, liebevolle Briefe – für meine Mutter). In dieser Zeit bestand unser Ziel darin, die ZuschauerInnen aufzufordern, mehr als eine Interpretationsmöglichkeit hinter standardisierten Informationen zu erkennen.

In vielen Performances wurden analoge Überwachungssysteme als Methode der Erforschung von Zeitlosigkeit eingesetzt, eine Methode, die wir als Gestaltung paralleler Zeit betrachteten. Das ermöglichte dem Publikum, einem geheimnisvollen, performativen Event beizuwohnen. Gleichzeitig wurde die Überwachung als ein Instrument benutzt, um die sich ständig ändernden Metaphern der Figuren zu beobachten. Noch wichtiger, durch Video und Sound wurde das Konzept der Figur und das Konzept eines analogen Interfaces in Beziehung zueinander gesetzt. Dies beinhaltete ein Interesse an mathematischen Proportionen und Berechnungen des Körpers, der Körper konnte für den Bildschirm verdoppelt werden, um die immanente Identität der KünstlerIn ebenso wie den kreativen Prozess zu enthüllen. Ein neuer Typus paralleler Welten entstand auf einer sozialen und kulturellen Ebene. Damit gemeint ist eine bis dahin nicht gekannte Bühne für Experimente, bei denen Leben, Kunst und das Absurde unter bestimmten Umständen zusammentreffen konnten. Vielleicht ereignete sich auf dieser Bühne die Geburt einer adäquaten Metapher, mit der sich diese Veränderungen der Figur erklären ließen. In den frühen achtziger Jahren jedoch erwiesen sich diese dualistischen Gegenüberstellungen von Voyeurismus/emphatischer Blick, Coder/Decoder, der Verschiedenheit weiblicher und männlicher Sexualität, des Inneren und des Äusseren des Selbst als nicht länger wirklich relevant. Viele der Performance-, Video- oder SoundkünstlerInnen waren auf der Suche nach neuen Mythen und Sehweisen für die analoge Figur, die ihnen eine eher pluralistische Definition von Kunst in Bezug auf Geschichte und Populärkultur liefern sollten.

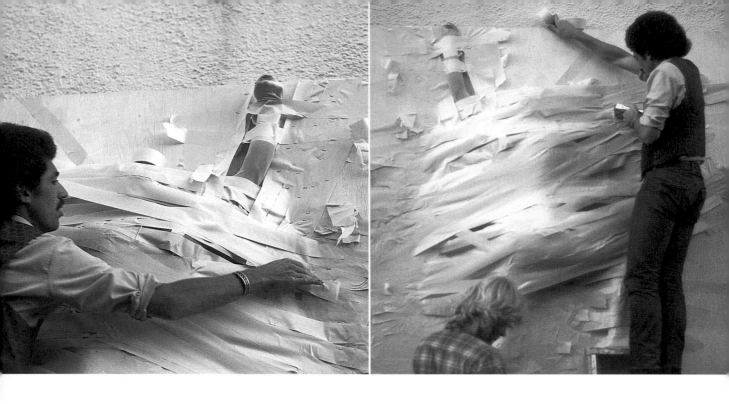

TAPED

1975 BODY ACTION

E | As I balanced on the top step of two ladders and leaned against the warehouse wall, two men took ten rolls of two-inch masking tape and stuck my body to the wall. Then the men took away the ladders and I stayed glued to the surface. I talked to the audience below on the street via a hidden microphone from inside my cocoon. My speech was about the icon of the female body as an image-on-the-wall. At sunset I pushed and tore away from the wall and liberated myself. The outline of the masking tape stayed stuck there like the tracings of a broken cocoon, for many years afterwards.

D | Gegen die Außenmauer eines Lagerhauses gelehnt, stand ich auf den obersten Sprossen von zwei Leitern. Zwei Männer fixierten mit zehn Rollen eines 5 cm breiten Klebebandes meinen Körper an der Mauer. Anschließend entfernten sie die Leitern und ich blieb an der Wand kleben. Aus meinem Kokon heraus wandte ich mich mit Hilfe eines versteckten Mikrophons an die Leute unten auf der Straße. Ich sprach über die "Ikone" des weiblichen Körpers in Beziehung zum "Bild an der Wand". Bei Sonnenuntergang befreite ich mich und löste mich von der Mauer. Die Umrisse, die sich durch das verbleibende Klebeband an der Wand ergaben, blieben noch viele Jahre erkennbar. Sie erinnerten an einen verlassenen Kokon.

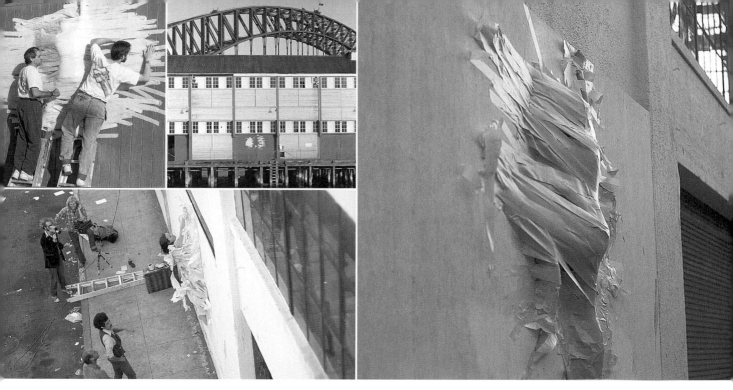

TAPED 1975. from left to right **1-2** | ON 9TH STREET, SAN FRANCISCO TWO BOYS TAPE ME TO THE WALL. **3-4** | REPEAT OF TAPED ON PIER 2 SYDNEY HARBOUR, IN 1988. **5** | SIDE VIEW OF THE COCOON. **6** | DESCENDING FROM THE WALL AT SUNSET. **7-10** | STILLS IMAGES FROM THE VIDEO "STICK AROUND", 15 MIN. next doublepage **11** | THE BODY AS COCOON.

»THE WORK HAS PROVIDED THE GENERAL PUBLIC WITH
A SIGNIFICANT FEMINIST STEP: A BREAK FROM THE HISTORY OF
THE MALE DOMINATED COMMERCIAL IMAGE ON THE WALL.«

MARTHA WILSON

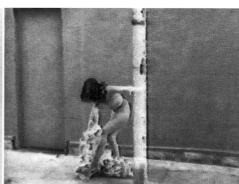

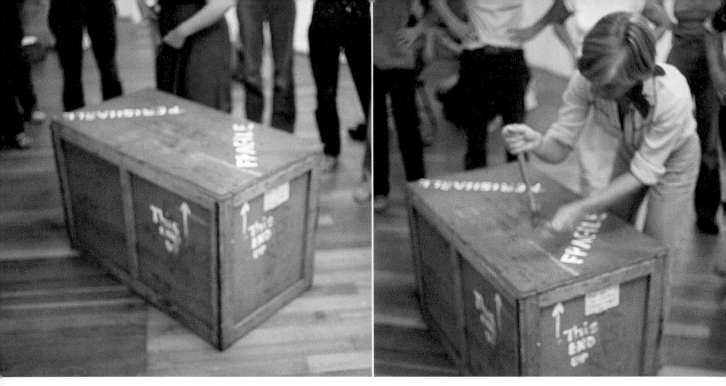

BOXED 1995. **1-4** | LANGTON STREET ARTS CENTRE, SAN FRANSISCO.

BOXED

1975 BODY ACTION

E | Together with shredded packing paper, I was placed into a 1.5 x 1.6 x 1.0 meter shipping crate in a warehouse near the San Francisco international airport by the Handy-Jack moving company. With me, inside the box, I had fastened a Polaroid camera and its lens to a small see-through hole on the side of the crate. In this way I could take photos of the journey, at regular intervals. The men from the company picked up the sealed crate and were told to deliver it to a San Francisco art gallery. Upon arrival, the gallery almost put it in the storage basement with the other artworks, but they had no record of its delivery or the contents. Consequently, they opened it. To the amazement of some viewers at the exhibition opening and the curator of the gallery, a sweaty figure emerged stained with the pigments from the coloured packing paper, holding 12 pitch-black photographs.

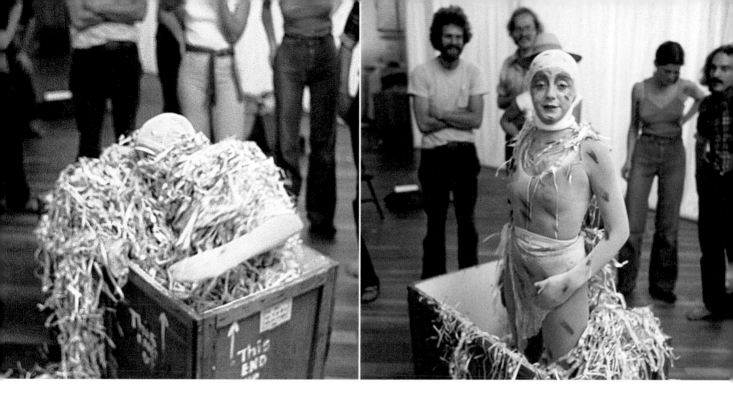

D | In einem Lagerhaus in der Nähe des San Francisco International Airports steckte mich die Handy-Jack-Speditionsfirma in eine 1.5 x 1.6 x 1 Meter große Holztransportkiste zusammen mit Papierschnitzel als Verpackungsmaterial. Mit mir in der Kiste hatte ich eine Polaroidkamera, mit der ich durch ein kleines Guckloch in der Kistenwand Fotos von meiner Reise aufzunehmen versuchte. Die Spediteure waren beauftragt, die verschlossene Kiste in eine Kunstgalerie in San Francisco zu überführen. Die Kiste wäre bei ihrer Ankunft beinahe zu den anderen Kunstwerken ins Lager gewandert, doch weil die Herkunft der Sendung und ihr Inhalt unbekannt waren, öffnete man sie. Sehr zum Erstaunen des Kurators und einiger BesucherInnen kam aus der Kiste eine verschwitzte Gestalt heraus. Sie war mit farbigen Flecken übersät, die vom Packmaterial abgefärbt waren und sie hielt zwölf pechschwarze Fotos in der Hand.

1 | TIED 1975. ON 9TH STREET, SAN FRANCISCO. **2-3** | STRUNG 1975. GOLDEN GATE BRIDGE, SAN FRANCISCO.

TIED, STRUNG

1975 TWO BODY ACTIONS

E | TIED: I stood against a telephone pole and a man tied me to the pole with string then disappeared. I remained tied to the pole until a crowd of pedestrians had gathered. "Do you need help?" A few said. "Do you want to be released?" I gave no answer until my assistant returned. He explained to the people not to call the police, as this was an artwork about the body as a victim. After a while a woman emerged from the crowd, she pulled out a pocket-knife and released me. "It don't matter what it is", she said, "let her go".

STRUNG: I climbed up the steel pylons of the Golden Gate Bridge with a male assistant. As climbing the bridge is illegal we had to be careful we were not seen. The assistant then tied me to one of the girders and descended. At sunset, four security guards from the headquarters arrived on top of the bridge as someone had reported seeing a figure tied there. With a megaphone they yelled: "Come down or you will be arrested for attempted suicide." The assistant then climbed up and cut me out of the string with a knife. It took us two hours to convince the officials that this action was "only" an artwork.

D | TIED: Ich stellte mich gegen einen Telefonmasten. Ein Mann band mich mit Schnur daran fest und verschwand. So blieb ich an den Masten gebunden, bis sich eine Gruppe FußgängerInnen um mich versammelt hatte. "Brauchen Sie Hilfe?", fragten einige. "Wollen Sie losgebunden werden"? Ich antwortete nicht, bis mein Assistent auftauchte. Er forderte die Leute auf, nicht die Polizei zu rufen, denn es handele sich hier um ein Kunstwerk, das den Körper als Opfer thematisiere. Nach einiger Zeit löste sich eine Frau aus der Menge, nahm ihr Taschenmesser und befreite mich. "Es ist mir ganz egal, was das ist", sagte sie, "lasst sie gehen".

STRUNG: Zusammen mit einem Assistenten kletterte ich die Stahlmasten der Golden Gate Bridge im Dunkeln hinauf. Wir mussten uns hüten, nicht gesehen zu werden, weil das Klettern auf der Brücke verboten ist. Dann band mich der Assistent an einem der Träger fest und stieg wieder hinunter. Bei Sonnenaufgang erschienen oben auf der Brücke vier Sicherheitsleute aus der Zentrale. Jemand hatte gemeldet, dass eine Person an einem Träger angebunden sei. Über einen Lautsprecher schrien sie mir zu: "Kommen Sie runter oder Sie werden wegen versuchten Selbstmords verhaftet!" Daraufhin kletterte der Assistent wieder zu mir und zerschnitt die Bänder mit einem Messer. Wir benötigten zwei Stunden, um die Beamten davon zu überzeugen, dass diese Aktion "nur" ein Kunstwerk war.

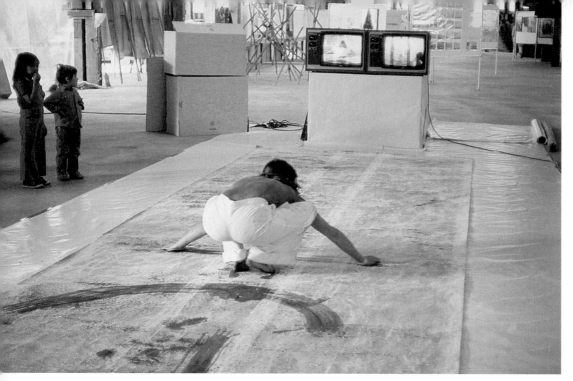

ACCIDENTS FOR ONE 1976. OPEN STUDIOS - NEIGHBOURHOOD ARTS FOUNDATION, SAN FRANCISCO.
1-2 | PERFORMANCE. **3-4** | VIDEO IMAGES FROM THE INSTRUCTION TAPE ENTITLED "ALMORATIVE DANCE", 30 MIN.

ACCIDENTS FOR ONE

1976 A SITUATIONIST PERFORMANCE

E | My friends designed a set of instructions and made a videotape called "Almorative Dance". They all came later to watch me try to follow their recorded instructions during the performance. In the tape, one of my friends narrated the instructions and placed numbers on a sheet of paper while another zoomed in and out of the diagram. Meanwhile, the other attempted to play the same instructions on a flute. I had no idea what the instructions might be, except that I had to slide across a surface and create smooth marks during the process. I also knew that the video was like a mirror, it scrambled left and right. It was difficult to keep this in mind as I attempted to slide over a red sheet of paper covered with fine dust. Many accidents occurred and a live video camera showed these on another monitor right next to the instructions.

D | Drei Freunde zeichneten eine Reihe von Anweisungen auf Video auf mit dem Titel "Almorative Dance". Anschließend schauten sie mir im Rahmen einer Performance bei dem Versuch zu, ihren Videoinstruktionen zu folgen. Im Video erklärte ein Freund die Anweisungen und skizzierte dazu Zahlen auf ein Platt Papier. Ein anderer zoomte mit der Kamera auf die Skizze zu und weg, während ein weiterer die Anweisungen auf einer Flöte zu spielen versuchte. Ich hatte keine Ahnung, welcher Art die Anweisungen sein würden. Ich wusste nur, dass ich mich, den Instruktionen folgend, über eine rote, mit feinem Staub bedeckte Papierbahn bewegen und dabei Spuren auf der Oberfläche hinterlassen sollte. Außerdem wusste ich, dass der Monitor mir die Anweisungen seitenverkehrt zeigen würde. Diese für mich links mit rechts vertauschten Bewegungen zu imitieren, erwiesen sich als äußerst schwierig während der Performance. Häufig wich ich von den Vorgaben ab: die Fehler bzw. Unfälle wurden live auf einen zweiten Monitor übertragen der neben dem Monitor mit den Anweisungen stand.

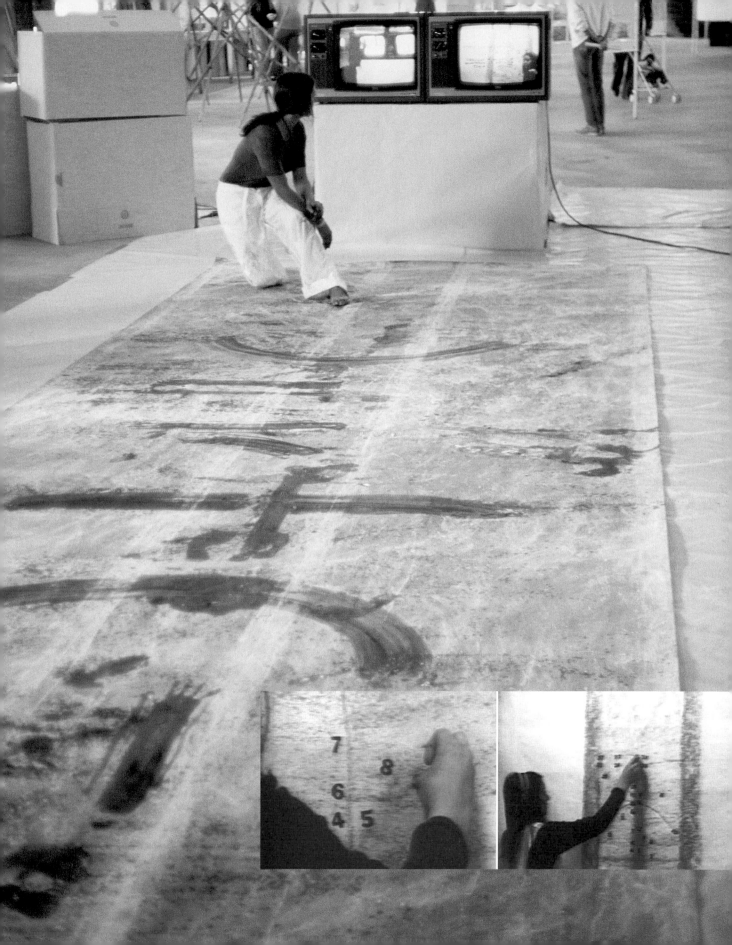

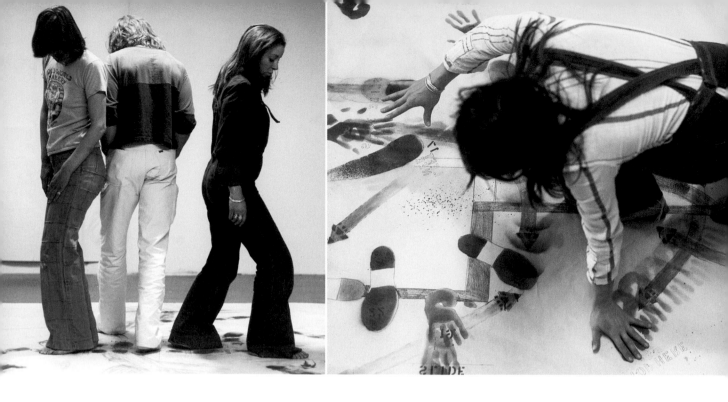

ACCIDENTS FOR 4

1976 INTERACTIVE PERFORMANCE

E | For four days, the studio-door was open. Visitors from the street were invited in where they could choose to follow different instructions. I had written these instructions either on the surface of the paper, on the wall or in a book. Another method was to simply hear them played back from an audio tape. After the visitors decided on their choice, they were asked to move across some surfaces provided while following the instructions. Traces of their movements and reactions to the instructions were recorded on video. As the surfaces were covered with fine chalk-dust, the failures to follow the instructions became obvious. Some found the instructions easier to follow on the wall but they often lost their balance in the process. The visitors who chose the audio-instructions were often confused by the left and right points, while those who followed the book often lost the sequence during the process of carrying out the instructions. By far the easiest set of instructions to follow were those on the surface of the paper itself where the tracings took place.

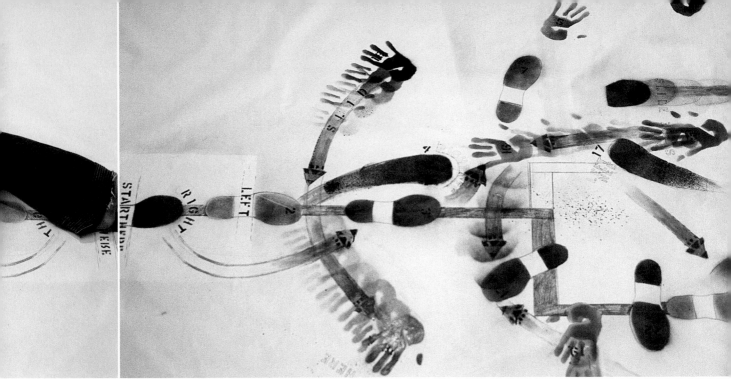

ACCIDENTS FOR FOUR 1976. OPEN STUDIOS - NEIGHBOURHOOD ARTS FOUNDATION, SAN FRANCISCO. from left to right
1-3 | VISITORS FOLLOWING INSTRUCTONS ON THE FLOOR. **4** | FOLLOWING THE INSTRUCTIONS ON THE WALL. **5** | OR FROM A BOOK.

D | Die Tür zu meinem Atelier stand für vier Tage offen. Von der Straße wurden BesucherInnen hereingebeten und vor die Wahl gestellt, verschiedenen Anweisungen zu folgen. Ich hatte diese Anweisungen auf Papier geschrieben - auf die Wand und in ein Buch -, sie waren aber auch auf Kassette zu hören. Nachdem die BesucherInnen ihre Wahl getroffen hatten, in welcher Form sie die Anweisungen erhalten wollten, sollten sie sich über Papierbahnen bewegen und dabei den Anweisungen folgen. Ihre Bewegungsspuren und ihre Reaktionen auf die Instruktionen wurden mit Video aufgezeichnet. Da die Bahnen mit feinem Kreidestaub bedeckt waren, wurden die Abweichungen von den Anweisungen offensichtlich. Einigen BesucherInnen fiel es leichter, den Anweisungen auf der Wand zu folgen, doch gerieten sie dabei häufig aus dem Gleichgewicht. Die TeilnehmerInnen, die den Audioanweisungen folgten, waren sich oft im Unklaren, wo rechts und wo links war, während die BesucherInnen, die sich an die Bücher hielten, leicht die betreffende Stelle aus den Augen verloren. Am einfachsten konnte man den Anweisungen auf der Papieroberfläche selbst folgen.

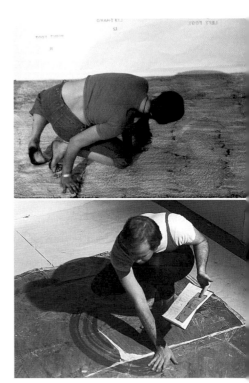

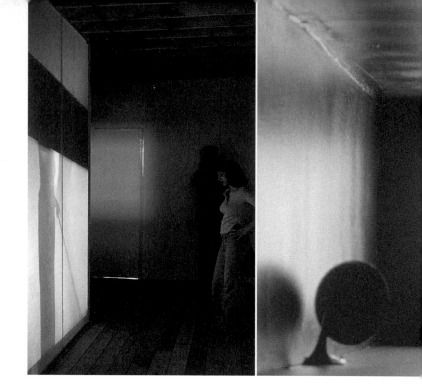

EXTREMITIES

1977 INTERACTIVE PERFORMANCE-INSTALLATION WITH SURVEILLANCE

E | I imprisoned myself inside a large box constructed from floor-to-ceiling with alternating sides of black wood and rice paper. The viewers opened the door of the space and were confronted by a tall black wall, which was the front of the box. Here they had to decide whether to turn left or right to continue around the box. The viewers could also see shadows of my activity inside the box through its semi-opaque sidewalls. Meanwhile an overhead security camera monitored their actions and sent this information to me. In addition to this monitor and myself, the box contained a second security camera creating reciprocal feedback to the viewers. An opening in the back wall allowed viewers to see my actual head as I stood with it protruding through a hole in a tunnel. Behind my head they could see a monitor displaying real-time images from the surveillance camera from outside the box. Additionally, I placed automobile rear-view mirrors on each side of my head in order to see the monitor behind me. In this way I could draw their movements, which I saw there. These notational drawings were simultaneously shown live on the monitor outside the box. Once the viewers discovered this feedback set-up, they reacted by moving around the box to affect my drawings. The aim was to make a satire out of human behaviour and statistics.

D | Ich schloss mich in eine große Kiste ein, die vom Boden bis zur Decke reichte und deren Wände abwechselnd aus schwarzem Holz und Reispapier bestanden. Die BesucherInnen öffneten die Tür zum Ausstellungsraum und standen vor der hohen schwarzen Vorderwand dieser Kiste. Hier mussten sie sich entscheiden, ob sie links oder rechts um die Kiste herumgehen wollten. Die BesucherInnen konnten dann durch die halbdurchsichtigen Seitenwände Schatten meiner Aktivitäten innerhalb der Kiste wahrnehmen. Eine Öffnung in der Rückwand der Kiste ermöglichte es ihnen mein Gesicht direkt zu sehen, das am Ende eines schwarzen Tunnels ihnen entgegen blickte. Hinter meinem Kopf konnten sie einen Monitor erkennen, der in Echtzeit Bilder einer Überwachungskamera von außerhalb der Kiste zeigte und somit von ihren Handlungen. Zusätzlich plazierte ich Autorückspiegel auf jeder Seite meines Kopfes, so dass ich ebenfalls den Monitor hinter mir sehen konnte. Auf diese Weise konnte ich die Publikumsbewegungen, die ich dort

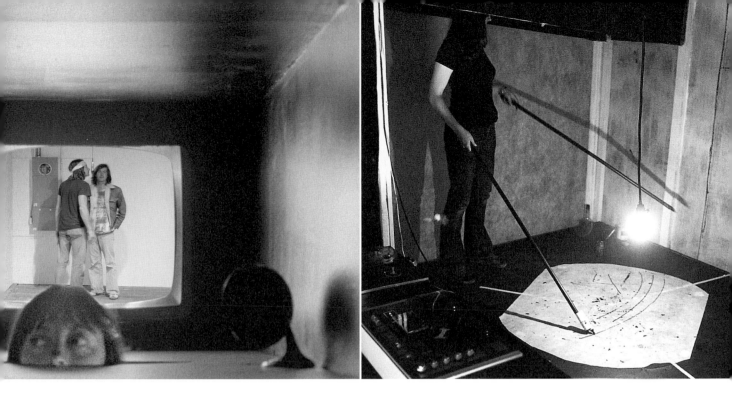

sah, auf Papier zeichnen. Die Zeichnungen wurden zugleich live auf einen Monitor außerhalb der Kiste übertragen. Sobald einige BetrachterInnen den Kommunikationsaufbau durchschaut hatten, reagierten sie, indem sie um die Box herumgingen, um meine Zeichnungen zu beeinflussen. Ziel war es, eine Satire zu kreieren über menschliches Verhalten und statistische Aufzeichnungen.

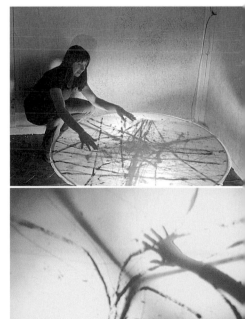

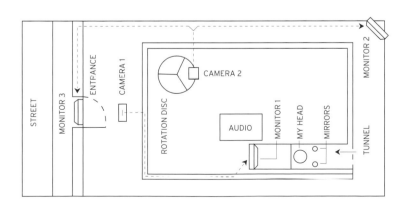

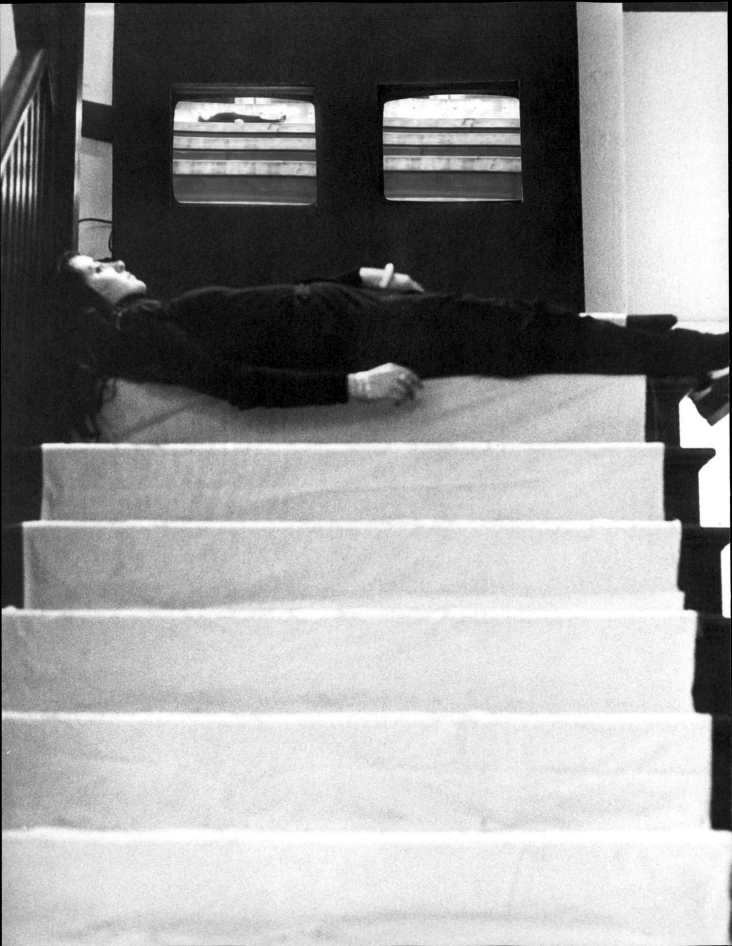

MOVED UP MOVED DOWN

1978 SURVEILLANCE-VIDEO-LOOP INSTALLATION

E | Stairs covered with pure-white canvas led from the first floor up to the second floor of the Women's Building in Los Angeles. The intention was that the viewers would leave dirty footprint traces as they climbed the stairs. However, half way up on the landing, I had set up two monitors. On one monitor the viewers could see a real-time view of their own movements from security cameras mounted above the stairs. On the other monitor they could see a pre-recorded tape of a miniature figure (me) climbing a giant staircase. I would struggle up each big stair, then finally lie down horizontally on the top one and roll off-camera. This sequence was then repeated endlessly in a loop. The viewers complained that seeing the pre-recorded video and the surveyed image of themselves made them feel that the act of climbing up the stairs was more difficult.

D | Mit einer reinweißen Leinwand bedeckte Treppenstufen führten vom ersten ins zweite Stockwerk des Women's Building in Los Angeles. Die BesucherInnen sollten hier ihre schmutzigen Fußabdrücke hinterlassen. Am Treppenabsatz, also auf halbem Wege, waren zwei Monitore aufgestellt. Auf dem einen konnten die BesucherInnen ihre Bewegungen, die von Überwachungskameras über der Treppe verfolgt wurden, in Echtzeit beobachten. Der andere Monitor zeigte ein Video mit einer kleinen Figur (mich), die eine riesige Treppe hinauf kletterte. Ich kämpfe mit jeder einzelnen Stufe, um mich dann flach auf er obersten auszustrecken und aus dem Bild zu rollen. Diese Sequenz wurde dann als Loop gezeigt. Die BesucherInnen klagten darüber, dass – indem sie sowohl das Video als auch das Überwachungsbild auf den Monitoren sahen– sie ihr tatsächliches Treppensteigen als schwieriger empfanden.

A b
A beat
A beat in
A beat in step
A beat in step in
A beat in step instead
A beat in step instead of
A beat in step instead of a
A beat in step instead of a turn
(figure disappears)

MOVED UP, MOVED DOWN 1977. THE WOMEN'S BUILDING LOS ANGELES. left **1** | TESTING THE VIEWER'S PERSPECTIVE UNDER THE INSTALLED MONITORS. **2-3** | VIDEO STILLS FROM "A BEAT IN STEP", 3 MIN. THE CLIMB UP THE GIANT STAIRCASE.

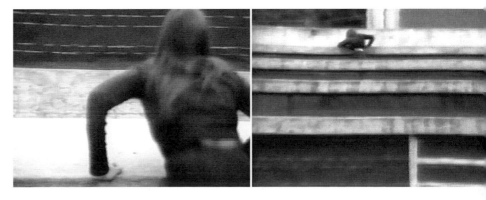

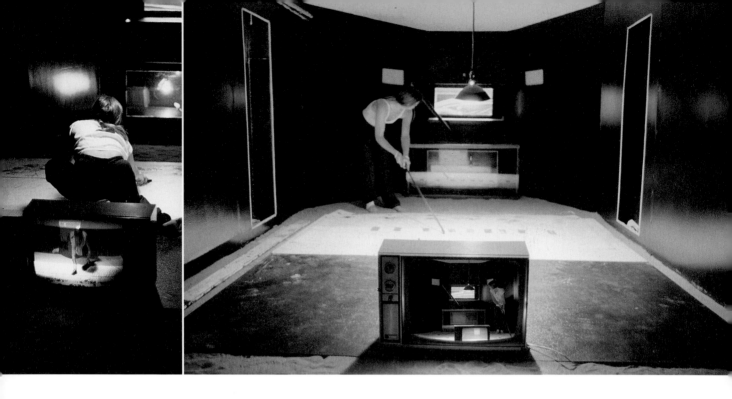

INSIDE OUT

1978 SITE SPECIFIC INTERACTIVE PERFORMANCE WITH SURVEILLANCE

E | As this action took place from 8 am to 6 pm on workdays and for a total of two weeks I lived in the basement. Outside on the pavement there was a line and an arrow pointing to the middle of the basement window. This window was located on the famous corner of Haight and Asbury Street. When viewers walked past outside on the sidewalk they were able to spot a small video camera installed in the window. If they looked through the viewfinder, they could see my actions. I was in the process of making large drawings or notations. They could follow a white line from this viewfinder to travel along the pavement and down a set of steps into the basement area. There they could find out my purpose. Under the window was a glass box full of mice and I could look out of the window and compare the movement of the mice with the movement of the people, cars and other traffic on the street. Each time a person was curious enough to look in through the viewfinder, a large "X" appeared on the notations. After each day a complex drawing was completed and these were overlapped on a wall where they were illuminated by backlights. In the mice cage, a speaker with the amplified noise from the street was triggered by the backlight and the mice became more stressed and more active during rush hour.

»SHE HAS BUILT AN ENVIRONMENT INSTALLING HERSELF BOTH AS THE DECODER OF THE INFORMATION FRAMED IN THE ENVIRONMENT (IT IS SHE WHO ORCHESTRATES THE AUDIENCE'S ATTENTION, POINTING OUT THE MOVEMENT OF PEDESTRIANS, MICE, ETC.) AND AS A RECORDING DEVICE, (SYSTEMATICALLY ENCAPSULATING THE MOVEMENTS IN THE AREA ONTO THE TRANSPARENCY).« JUDITH BARRY

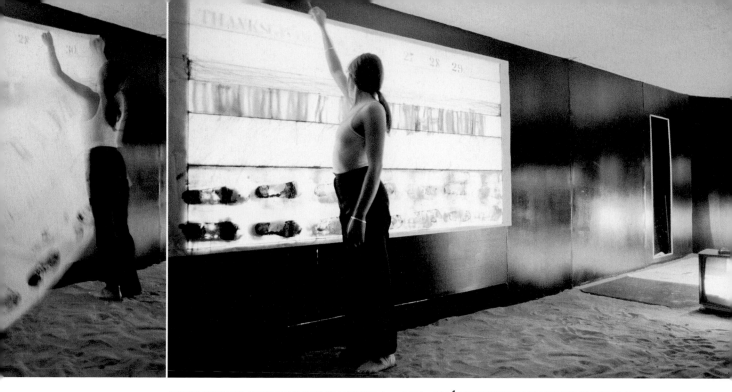

INSIDE OUT 1978. BASEMENT, SAN FRANCISCO. from left to right **1** | CODING THE MOVEMENT OF THE MICE.
2 | TRACING THE MOVEMENT OF THE TRAFFIC OUT ON THE STREET. **3-4** | LAYERING THESE NOTATIONS OVER A LIGHT BOX.

D | Während dieser Aktion, die für zwei Wochen an Werktagen von 8 bis 18 Uhr stattfand, lebte ich im Kellergeschoss. Draußen auf dem Bürgersteig waren ein Strich und ein Pfeil gemalt, die auf die Mitte des Kellerfensters deuteten. Dieses Fenster befand sich an der legendären Ecke von Haight und Ashbury Street. Die PassantInnen konnten eine kleine Videokamera erkennen, die im Fenster installiert war. Wer durch den Sucher blickte, konnte meine Handlungen verfolgen: Ich war dabei, große (Auf-)Zeichnungen anzufertigen. Die PassantInnen konnten einem weißen Strich folgen, der vom Sucher über den Bürgersteig und einige Treppenstufen hinunter in den Kellerbereich führte. Dort konnten sie den Zweck meiner Handlungen erkennen. Unter dem Fenster stand ein Glaskasten voller Mäuse. Während ich aus dem Fenster blickte, um die Bewegungen der Mäuse mit den Bewegungen der Leute, des Autoverkehrs und anderer Straßengeschehnisse zu vergleichen. Jedesmal, wenn jemand so neugierig war, durch den Sucher zu blicken, erschien in den Aufzeichnungen ein großes "X". So entstand jeden Tag eine komplexe Zeichnung, die einander überlappend an eine Wand gehängt und von hinten beleuchtet wurden. Wenn man das Licht anmachte, ging auch ein Lautsprecher im Mäusekäfig an, der die Straßengeräusche übertrug. In der Hauptverkehrszeit reagierten die Mäuse stärker gestresst und wurden aktiver.

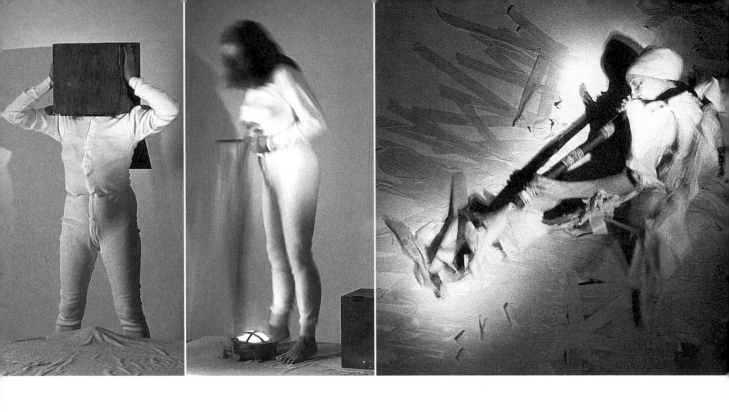

OUT, THE BACK

1978 PERFORMANCE WITH INTERACTIVE SOUND AND OBJECTS

E | When the audience arrived it was dark in the space and attendants led each person into their place with flashlights. Another spotlight illuminated a cocoon of my body attached by masking tape to the wall. The performance started, when I broke out from the tape and started to play didgeridoo, which blended with other pre-recorded sounds of drones, filling the space. I moved to a long low table where three black boxes were situated at one end. A pendulum hung over the other end. I unpacked the boxes. The first box contained a circular mirror and I slowly looked at my own reflection focusing on my lungs and my legs. The second box contained a large knife and I cut open sandbags stuck to my leg and to my chest so that their volumes of concealed sand could flow out onto the table. The third box contained many crickets in a glass case and these were placed under a microphone to amplify their sounds. Then I activated the REVOLVING DESERT SIMULATORS that sounded like very loud scratching insects and played the didgeridoo into the empty boxes. Finally I sat very still under the pendulum and released a funnel of sand, which slowly poured over my body. My aim was to change my body-shape; I wanted to become an animal in the sand.

»MY ALTER EGO BELIEVED IN THE INVENTION OR DISCOVERY OF METAPHORS, I IN THOSE METAPHORS THAT CORRESPOND TO INTIMATE AND OBVIOUS AFFINITIES AND THAT OUR IMAGINATION HAS ALREADY ACCEPTED, DREAMS AND LIFE, THE FLOW OF TIME AND WATER.« JORGE LUIS BORGES

D | Als das Publikum eintraf, war der Raum abgedunkelt. AufseherInnen mit Taschenlampen geleiteten jede Person an ihren Platz. Ein Scheinwerfer beleuchtete den Kokon meines Körpers, der mit Klebeband an der Wand fixiert war. Die Performance begann damit, dass ich mich aus der Verklebung löste und das Didgeridoo (ein Blasinstrument der Aborigines) spielte. Seine Töne, die sich mit anderen tiefen Brummtönen vom Band vermischten, erfüllten den Raum. Ich ging zu einem langen Tisch, an dessen einem Ende drei schwarze Kisten standen, die ich auspackte. Die erste Kiste enthielt einen runden Spiegel, in dem ich mich lange betrachtete, wobei meine Aufmerksamkeit vor allem der Lunge und den Beinen galt. Die zweite Kiste enthielt ein großes Messer, mit dem ich die Sandsäcke zerschnitt, die an meinen Beinen und meiner Brust befestigt waren; der Sand entleerte sich auf dem Tisch. Die dritte Kiste enthielt unzählige Grillen in einem Glaskasten. Ich stellte sie unter ein Mikrofon, um ihre Geräusche zu verstärken. Dann aktivierte ich die "rotierenden Wüstensimulatoren" (selbstgebaute Klanginstrumente), die wie sehr laute, scharrende Insekten klangen und spielte wieder das Didgeridoo, diesmal in die leeren Kisten hinein. Schließlich setzte ich mich ganz still unter einen trichterförmigen von der Decke schwingenden Behälter voller Sand. Ich öffnete den Trichter und der Sand rieselte langsam über meinen Körper. Ich wollte meine Körperform verändern und zu einem Tier im Sand werden.

OUT THE BACK 1978. THE FRANKLIN FURNACE, NEW YORK. left **1** | SINGING INSIDE THE BOX. **2** | OPENING THE CHEST. right **3-4** | PLAYING THE DIDGERIDOO.

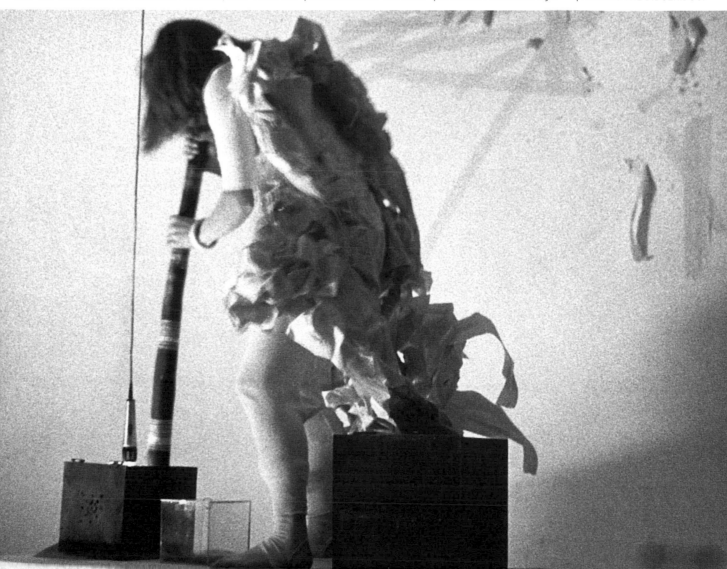

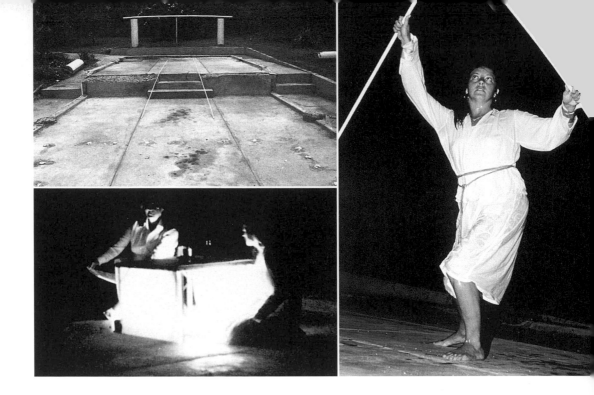

THE HOMECOMING

1978 SOUND PERFORMANCE NARRATIVE

E | On the foundations of a ruined house, my father stood on the back-stage level, my mother sat on a second level, my sister walked on a third level and my nephew was closest to the audience. Initially, only the live sounds of tropical parrots and trickling water could be heard which came from a piece of horizontal pipe, but this soon grew into a wall of pouring water because my father pushed more water into the pipe. I entered the space from behind this waterfall with flashlights tied to my wrists so that my hands were illuminated. Then I helped Dad wash my hair with shampoo and rinse it clean. He then continued to hose the crumbled walls of the house. Meanwhile, Mum sat at a table with an electric light loudly reading letters. They were about the transient lifestyle of a young girl and her travels in Africa and Asia. I crawled under the table and wrote psychologically difficult questions on paper, pushing these onto the lap of my mother. She tried to answer them, but often had to throw them away. On the third level my sister was busy, pouring water from one bucket into another and back again, and I moved over towards her. I attempted to balance two long sticks in the air and simultaneously illuminate the unstable motion which occurred at the end of the sticks. On the fourth level, my nephew was seated inside a circle of raw eggs on the ground. I walked cautiously around him crushing these eggs one by one with my bare toes while he was playing a mouth harp. The egg crushing provided him with a rhythm. This gradually faded into pre-recorded amplified sounds of pouring water, mouth harp, crunching paper and crushing eggs.

»SCOTT HAS CONCERNED HERSELF IN MANY OF HER PERFORMANCES WITH THEMES OF MOVEMENT, GROWTH AND TRANSFORMATION BOTH PHYSICALLY AND METAPHYSICALLY.« MORIA ROTH

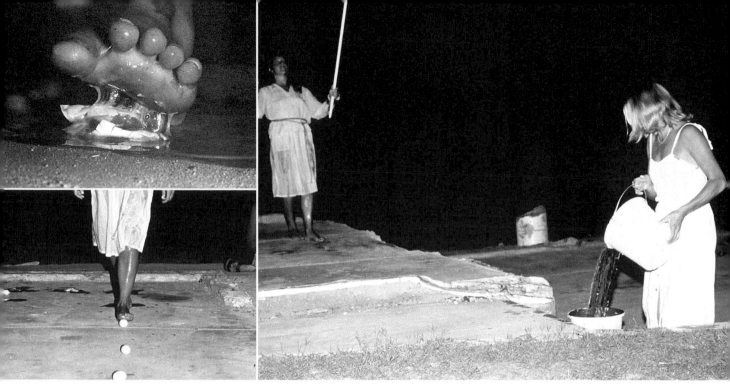

THE HOMECOMMING 1978. QLD, AUSTRALIA. from left to right **1** | FOUNDATIONS OF HOUSE. **2** | ENCOUNTER WITH THE MOTHER. **3** | BALANCE. **4-5** | RAW EGGS. **6** | DECISION MAKING WITH THE SISTER.

D | Auf den Grundmauern eines verfallenen Hauses hielt sich mein Vater im Hintergrund. Meine Mutter war eine Ebene weiter vorn, meine Schwester, die herumging, noch eine Ebene weiter vorn, während sich mein Neffe dicht vor dem Publikum befand. Zunächst hörte man nur live die Geräusche tropischer Papageien und tropfenden Wassers, das aus einem horizontalen Rohr kam. Als mein Vater mehr Wasser ins Rohr schüttete, wurde aus diesem Tropfen bald ein kräftiger Strahl. Ich trat hinter diesem Wasserfall hervor. An meinen Handgelenken trug ich Taschenlampen, so dass meine Hände beleuchtet wurden. Mein Vater wusch mir das Haar mit Shampoo und spülte es aus. Dann bewässerte er die zerstörten Mauern des Hauses. Währenddessen saß meine Mutter an einem Tisch mit elektrischer Lampe und las laut Briefe vor. Die Briefe handelten vom wechselhaften Lebensstil einer jungen Frau und ihren Reisen in Afrika und Asien. Ich krabbelte unter den Tisch und schrieb schwierige psychologische Fragen auf Papier, die ich meiner Mutter in den Schoß legte. Sie versuchte die Fragen zu beantworten, musste die Papiere aber oft wegwerfen. Meine Schwester kippte Wasser von einem Eimer in einen anderen; ich bewegte mich zu ihr hin. Ich versuchte zwei lange Stöcke in der Luft zu balancieren und zugleich die ungleichmäßige Bewegung am Ende der Stöcke zu beleuchten. Mein Neffe saß in einem Kreis aus rohen Eiern auf dem Boden. Vorsichtig ging ich um ihn herum, wobei ich mit meinen nackten Füßen ein Ei nach dem anderen zertrat. Er spielte auf der Maultrommel; das Zertreten der Eier gab ihm den Rhythmus vor. In diesen Rhythmus mischten sich andere Geräusche, die elektronisch verstärkt wurden: ausgeschüttetes Wasser, die Maultrommel, das Knittern von Papier und das Zertreten von Eiern.

CHOICE

1979 OPENING PERFORMANCE

E | The aim was to satirize the concept of the reward system, so I decided to combine an action and an opening at an art gallery into the same event. I led the viewers into the space from the street. Immediately a long corridor confronted them with water on the floor and opaque walls. A T-shaped plank extended over the water. The viewers had to "walk the plank" and when they reached the T intersection, they had to decide whether to turn left or right. However only one viewer "at a time" was able to walk down either the right or the left plank to an identical aperture in the corridor wall. The intuitive decision to turn left or right was videotaped in real-time and used to make a series of drawings or notations. In the right aperture the viewer could see me in a room making notations on paper about their decisions. In the left aperture a colleague of mine was busy preparing drinks for the viewers. The aim was to document (through notations) the fact that more viewers at openings choose drinks over the artwork when given a choice.

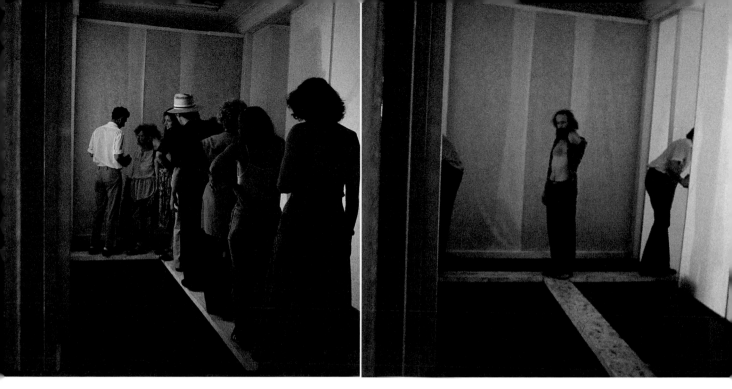

CHOICE 1978. INSTITUTE FOR MODERN ART, BRISBANE. from left to right **1** | THE PERFORMANCE BEGINS ON THE STREET. **2-3** | PEOPLE MAKING DECISIONS. **4** | VIDEO SURVEILLANCE.

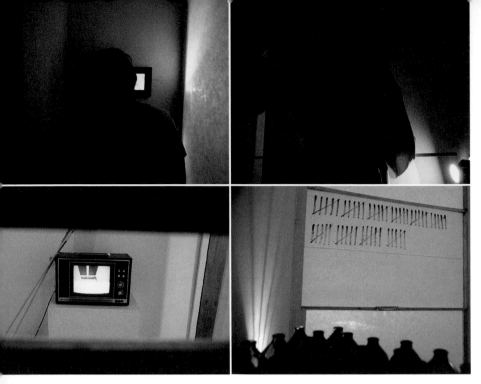

CHOICE 1978. INSTITUTE FOR MODERN ART, BRISBANE. from left to right **5-6** | THE REWARDS.
7-8 | THE RESULTANT NOTATIONS. opposite **9** | THE ACCUMULATION OF STATISTICS.

D | CHOICE 1979. Das Ziel war, sich über das Konzept des Belohnungssystems lustig zu machen. Daher entschloss ich mich, eine Aktion und eine Vernissage in einer Kunstgalerie zusammenfallen zu lassen. Ich führte die BesucherInnen von der Straße in den Raum. Hier standen sie in einem langen Korridor mit geschlossenen Wänden, dessen Boden mit Wasser gefüllt war. Über das Wasser verlief eine T-förmige Planke. Die BesucherInnen mussten auf der Planke hintereinander gehen und wenn sie die Gabelung des "T" erreichten, mussten jeder und jede einzeln entscheiden, ob er oder sie sich nach links oder rechts wenden wollte. Die intuitive Entscheidung, sich nach links oder rechts zu wenden, wurde mit Video in Echtzeit aufgezeichnet. Egal wie man sich entschied, steuerte man auf eine Öffnung in einer Korridorwand zu. Durch die Öffnung hinter der rechten Abzweigung konnte man mich erkennen; ich war in einem Raum und machte Aufzeichnungen auf einem Papier über die Entscheidungen der BesucherInnen, nach rechts oder links zu gehen. Diese sah ich auf einem Monitor live durch das übertragene Bild von einer Deckenkamera oberhalb der T-Gabelung. In der linken Öffnung war ein Kollege von mir dabei, Getränke für die BesucherInnen vorzubereiten. Das Ziel war (mit Hilfe von Aufzeichnungen) die Tatsache zu dokumentieren, dass bei Vernissagen sich viel mehr BesucherInnen für Getränke entscheiden als für Kunsterfahrungen – wenn sie die Wahl haben.

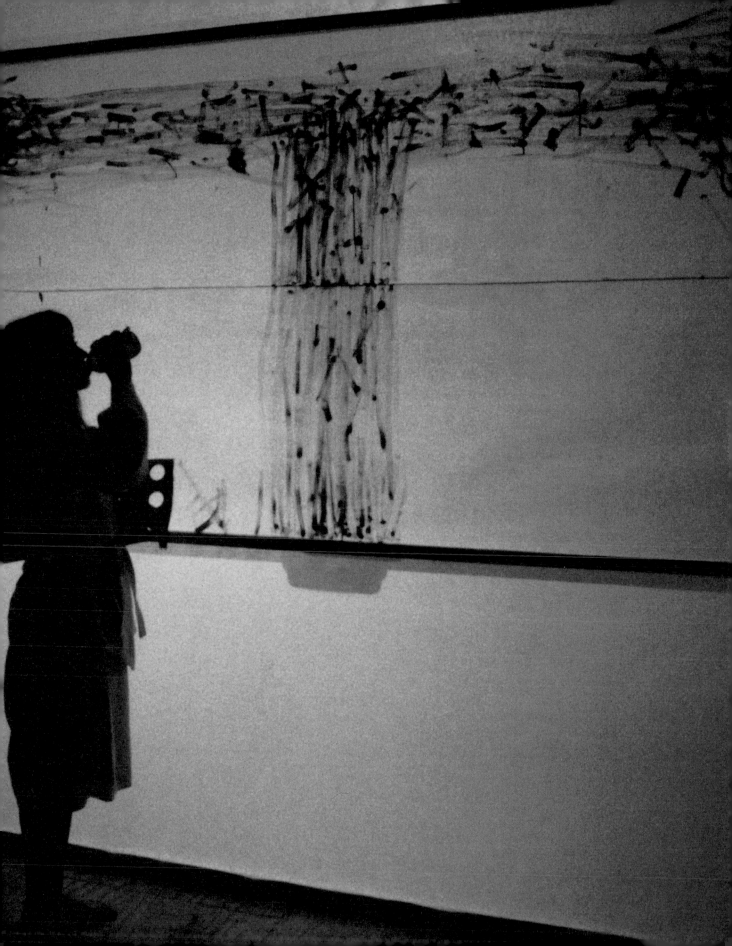

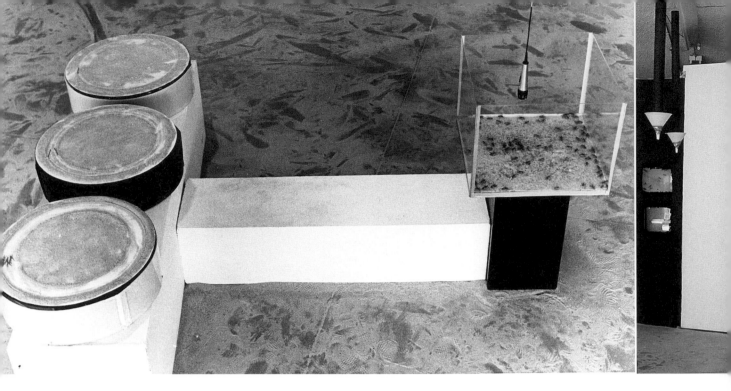

SAND THE STIMULANT

1980 PERFORMANCE WITH CLOSED CIRCUIT SOUND AND VIDEO

E | The audience had to sit on the floor. The aim was to create an atmosphere of entering the desert at sunset. A set of contact microphones stood ready to amplify the technological gadgets that lay on a sandy stage. I stood in silhouette behind a circular spotlight on a rear view projection screen. The performance started with two small video monitors where the viewers could see lizards being fed live crickets by human hands. Then on the screen, shots of nuclear power plants appeared with their loud furnace sounds. I emerged playing a didgeridoo and I moved around the stage activating various gadgets whose sounds blended with the vocal and instrumental sounds I was making. In one location I slapped raw rubber sticks on a large set of rotating PVC pipes with contact microphones that sounded like water drums. At another, I carried a monitor with a pre-recorded nuclear disaster display on my shoulders, while I sang a lament to a set of live-trapped crickets. I activated the deep scratching sounds from the REVOLVING DESERT SIMULATORS with my foot using a set of switches. At one point, inside an illuminated Plexiglas box, I attempted to eat live lizards who were trapped inside a Plexiglas box. Finally, two funnels of sand poured into dishes over my out-stretched hands until the weight of the sand could no longer be supported. Defeated, I bent down to listen to the sand piled on the floor, but only the loud sounds of a burning furnace could be heard.

>>SAND THE STIMULANT‹ FUNCTIONS SIMULTANEOUSLY AS AN ENVIRONMENTATAL INSTALLATION, CODED AUTO-BIOGRAPHY, SOUND PIECE AND ELUSIVE ECOLOGICAL STATEMENT. LITERARY DESCRIPTION HARDLY DOES JUSTICE TO THIS HYPNOTICALLY FRAGMENTED PIECE, WHICH LINGERS IN THE MIND WITH THE DISSOCIATED POWER AND PERSISTENCE OF A DREAM .« ROBERT ATKINS

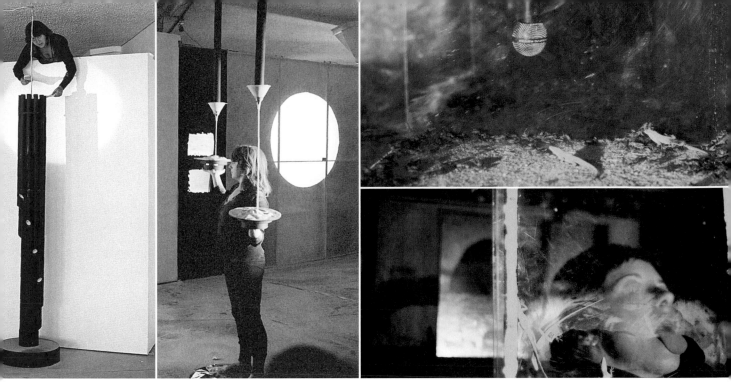

SAND THE STIMULANT 1980. LANGTON STREET ARTS, SAN FRANCISCO. from left to right **1** | THE INSTRUMENT ENTITLED "THE REVOLVING DESERT SIMUL-ATORS". **2** | PLAYING THE PVC PIPES. **3** | THE HUMAN PENDULUM. **4** | RECORDING THE SOUNDS OF THE FEEDING SESSION. **5** | EATING THE CRICKETS. next page **6** | SINGING A SAD TECHNICAL SONG TO THE CRICKETS.

D | Ich wollte die Atmosphäre eines Sonnenuntergangs in der Wüste kreieren. Das Publikum musste sich auf den Boden setzen. Viele Kontaktmikrofone und Apperate waren verteilt auf einer sandigen Bühne. Ich stand zwischen einem runden Strahler und einer Rückprojektionsleinwand, die meinen Schatten abbildete. Zu Beginn der Performance sahen die ZuschauerInnen auf zwei kleinen Videomonitoren Eidechsen, die von einer menschlichen Hand mit krabbelnden Grillen gefüttert wurden. Dann erschienen Bilder von Atomkraftwerken auf dem Monitor mit lautem Synchronton von dumpf zischenden Kamingeräuschen. Ich tauchte hinter der Leinwand auf. Ich spielte Didgeridoo und ging auf der Bühne herum. Ich betätigte verschiedene kleine, Sound erzeugende Apparate, deren Geräusche sich vermischten mit meinem Gesang oder meinen Digeridooklängen. Zwischendurch schlug ich mit Gummistangen auf viele PVC-Rohre, die sich um die eigene Achse drehten. Die Schlaggeräusche, erinnerten an Water Drums. Dann nahm ich einen Monitor auf meine Schulter, der das Bild einer nuklearen Katastrophe zeigte. Ich stimmte einen Trauergesang an in Richtung eingesperrter Grillen auf der Bühne. Die tiefen Kratzgeräusche der sich drehenden Wüstensimulatoren aktivierte ich mit Hilfe eines Fußschalters. An einer anderen Stelle der Bühne versuchte ich dem Publikum die Illusion zu geben, als ob ich lebende Eidechsen aus einer erleuchteten Plexiglaskiste heraus verspeisen würde. Schließlich rieselte aus zwei von der Decke hängenden Trichtern Sand auf Teller, die ich in meinen ausgestreckten Händen hielt – bis ich das Gewicht nicht mehr tragen konnte. Ich sank zu Boden und horchte, wie der Sand sich weiterhin auf dem Boden auftürmte. Zu hören war aber hauptsächlich der Lärm von Atomkraftwerken.

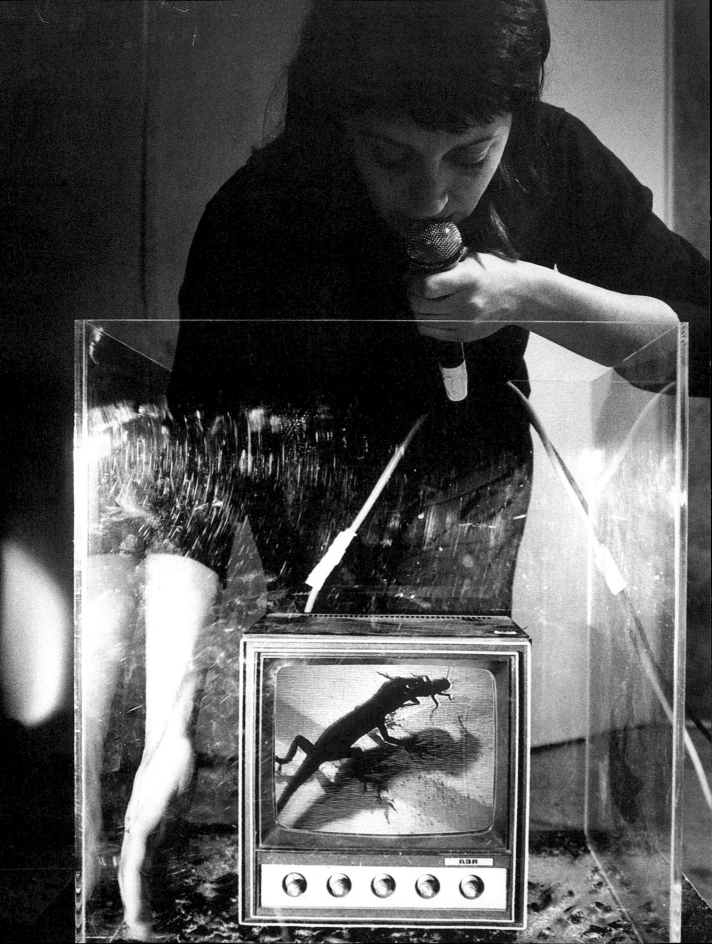

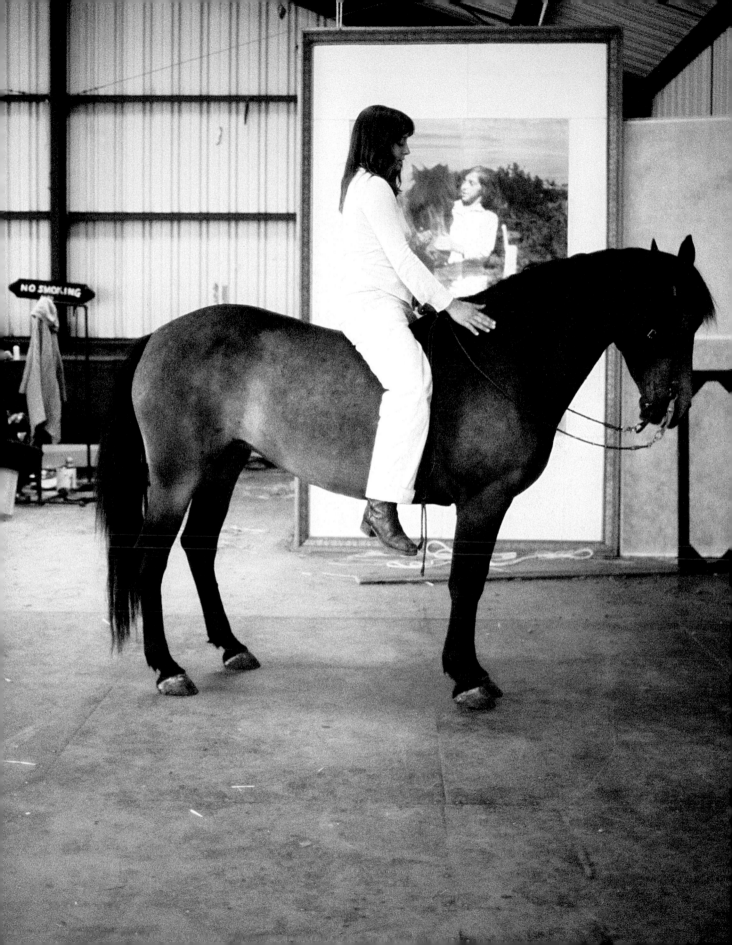

PERSIST, THE MEMORY

1980 LYRICAL PERFORMANCE

E | Attendants led the audience to seats in a large dark warehouse. The only light was a huge spotlight focused on a life-size portrait of myself as a young girl, holding a pony in a paddock. This was located at the back of the room, framed inside an enormous gold leaf frame. The performance started when I emerged from behind this photographic portrait riding a real horse. I rode the animal around the audience counter clockwise, and each viewer could follow us by revolving on his or her stool. The horse's hooves were very loud on the linoleum floor, and this blended with the pre-recorded sounds of birds, which filled the air. A giant spotlight followed us until we stopped in front of a large green square of grass illuminated on the floor. When I dismounted, the horse ate the grass, but this was difficult as the grass was not attached to the floor. I walked to open an enormous set of double doors behind the grass, revealing a huge freeway complex to the audience and the loud roar of the night traffic entered the space. The aim was to provide the audience with a contract between current technology and the nostalgia we have for untouched nature. Using white string I fenced the grass area, which then kept the horse away from the grass, and closed the door. I then led the horse clockwise around the audience and we disappeared behind the framed portrait.

PERSIST, THE MEMORY 1980. THE FARM, SAN FRANCISCO. previous page **1** | PORTRAITS OF GIRL AND HORSE - PAST AND PRE-SENT. from left to right **2** | THE STAGE AND SET. **3** | THE TRAPPED HORSE. **4** | THE OPENING OF THE DOOR ONTO THE FREEWAY.

D | In einer großen dunklen Lagerhalle führten die AufseherInnen das Publikum zu seinen Sitzen. Das einzige Licht war ein großer Strahler. Er war auf ein lebensgroßes goldgerahmtes Porträt im Hintergrund des Raumes gerichtet. Es zeigte mich als junges Mädchen, wie ich in einer Pferdekoppel ein Pony hielt. Zu Beginn der Performance kam ich auf einem Pferd hinter dem Bild hervorgeritten. Entgegen dem Uhrzeigersinn ritt ich einmal um das Publikum herum und die ZuschauerInnen, die ihren Stuhl mitdrehten, konnten uns mit ihren Blicken folgen. Die Hufe des Pferdes hallten laut auf dem Linoleumboden und vermischten sich mit Vogelgezwitscher vom Band, das den ganzen Raum erfüllte. Ein starker Lichtstrahl verfolgte uns bis wir vor einem großen quadratischen Rasenstück, das ebenfalls angestrahlt war, haltmachten. Als ich abgestiegen war, begann das Pferd Gras zu fressen, was sich als schwierig erwies, weil das Gras nicht am Boden befestigt war. Ich machte mich daran, ein gewaltiges Tor an der Rückwand hinter dem Grasstück mit zwei Flügeln nach draußen zu öffnen. Ein Autobahnkreuz wurde sichtbar und der Lärm des nächtlichen Verkehrs hielt Einzug. Ich wollte auf diese Weise eine Verbindung zwischen dem heutigen technologischen Fortschritt und unserem nostalgischen Empfinden für unberührte Natur herstellen. Ich zäunte das Rasenstück mit weißen Seilen ein, um das Pferd vom Gras fern zu halten. Dann schloss ich das Tor. Ich führte das Pferd - diesmal im Uhrzeigersinn - um das Publikum herum und wir verschwanden wieder hinter dem gerahmten Porträt.

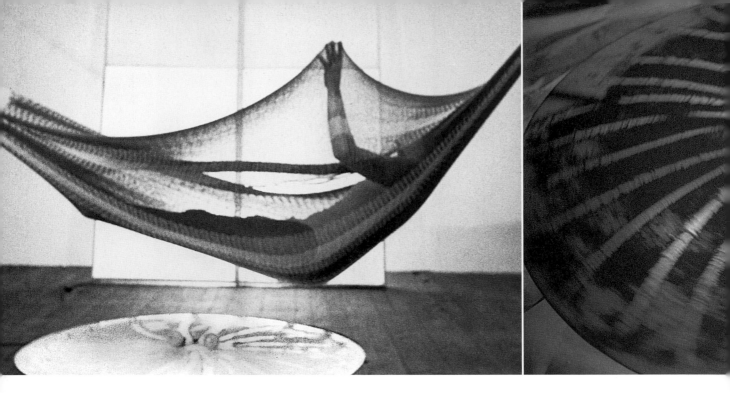

ORDER THE UNDERFIRE

1981 SOUND PERFORMANCE

E | Before the action, an attendant in a white lab coat gave each viewer a set of small white anti-moth balls. Meanwhile, I slept in a hammock suspended directly above a REVOLVING DESERT SIMULATOR. Behind the hammock stood an opaque screen. I started the action, by playing the didgeridoo in front of the screen over some speakers buried in the sand. The speakers emitted the sounds of birds. I emerged from the hammock with the didgeridoo and dragged it along around the periphery of the RDS counter clockwise, as a video of still images from prison walls were projected on the opaque screen. An assistant in a white lab coat asked the audience to roll the balls toward me. I collected the white balls in a birdcage, which also housed four white pigeons – then carried this package around to the back of the screen. In silhouette the birds were set free forming a shadow play across the screen. The aim was to allow the audience to imagine the emotions of the trapped birds, and so when the birds flew around the room, the audience was asked to help the birds to fly out of the building.

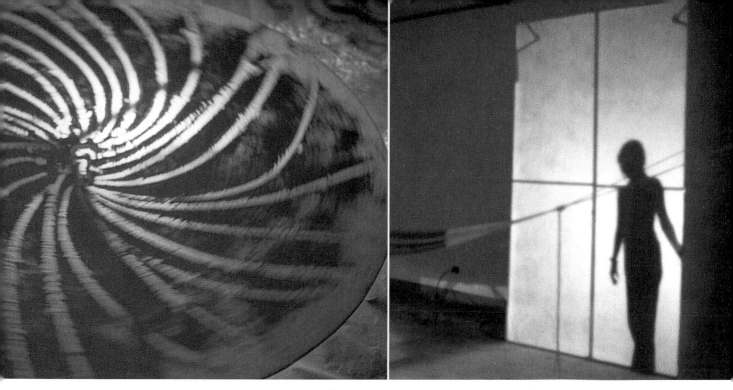

ORDER THE UNDERFIRE 1981. UC DAVIS CALIFORNIA. from left to right **1** | PLAYING DIDGERIDOO IN THE HAMMOCK. **2** | THE ANTI-MOTH BALLS ON "THE REVOLVING DESERT SIMULATOR". **3** | LOOKING FOR THE BIRDS.

D | Vor der Aktion händigte ein Aufseher im weißen Labormantel jeder BesucherIn weiße Mottenkugeln aus. Ich schlief währenddessen in einer Hängematte direkt über einem sich drehenden "Wüstensimulator". Hinter der Hängematte stand eine Projektionsleinwand. Ich startete die Aktion, indem ich vor der Leinwand in der Hängematte das Didgeridoo spielte. Über Lautsprecher, die im Sand verborgen waren, erklang Vogelgezwitscher. Mit dem Didgeridoo stieg ich aus der Hängematte und zog es entgegen dem Uhrzeigersinn um den "Wüstensimulator" herum. Gleichzeitig wurden Videostandbilder von Gefängnismauern auf die Leinwand projiziert. Der Assistent im weißen Laborkittel bat die ZuschauerInnen, die Kugeln zu mir zu rollen. Ich sammelte sie in einem Vogelkäfig, in dem auch vier weiße Tauben saßen, und trug das Ganze hinter die Leinwand. Die Tauben, die man nur als Silhouetten sah, wurden freigelassen und flatterten als Schattenspiel über die Leinwand. Ich wollte, dass sich das Publikum mit dem Gefühl der eingesperrten Vögel identifizieren kann. Als die Vögel dann im Raum herumflogen, wurde das Publikum aufgefordert ihnen zu helfen, den Weg aus dem Gebäude zu finden.

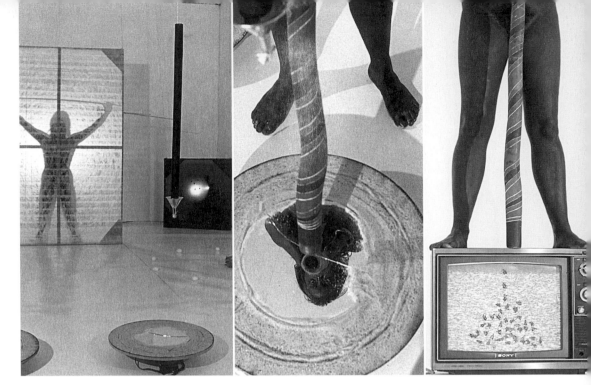

DESIRE THE CODE 1981. SITE, CITE, SIGHT INC. SAN FRANCISCO. from left to right **1-3** | THE BEGINNING WITH SHADOWS, THE MIDDLE WITH REFLECTIONS, THE END WITH SYNCHRONIZED VIDEO. **4** | BREAKING THROUGH THE PAPER SCREEN.

DESIRE THE CODE

1981 PERFORMANCE WITH SOUND AND VIDEO

E | On the video monitor, bees were already landing on white paper and crawling through a small hole in it. The sounds they made were amplified in the space. Behind the monitor, a screen displayed the shadow of my body and I balanced two poles in my hands. After the audience were seated, I pierced the screen with the poles and emerged through it accompanied by the sound of rushing water. Then droning of the bees blended with the scratching sounds of the REVOLVING DESERT SIMULATORS and I played the didgeridoo. I released sand from the mouths of suspended funnels, which then poured over the floor. Most of the acoustic sounds were amplified by using contact microphones. I then stood on top of the video monitor. When I breathed in through the didgeridoo, the bees seemed to form a spiral underneath it. When I breathed out, the bees on the monitor scattered. As the sounds accumulated, the image on the monitor changed into one of my own face covered with insects. I wanted the audience to imagine themselves as part of the same primal code that many insects live by.

D | Auf dem Videomonitor sah man Bienen, die auf einem weißen Blatt Papier landeten und durch ein kleines Loch krabbelten. Ihre Geräusche wurden elektronisch verstärkt wiedergegeben. Hinter dem Monitor konnte man meinen Körperschatten auf einem Wandschirm erkennen. Mit den Händen balancierte ich zwei Stäbe. Nachdem sich das Publikum gesetzt hatte, durchstieß ich mit den Stäben den Wandschirm und trat durch diesen hindurch zum Geräusch von rauschendem Wasser. Weitere Geräusche vermischten sich zu einer Klangkulisse: Das Summen von Bienen, die Kratzgeräusche der sich drehenden "Wüstensimulatoren", mein Spielen auf dem Didgeridoo. Aus den Öffnungen von an der Decke aufgehängten Trichtern ließ ich Sand auf den Boden rieseln. Anschließend stellte ich mich auf den Videomonitor. Wenn ich durch das Didgeridoo Atem holte, schienen die Bienen auf dem Bildschirm eine Spiralform zu bilden. Wenn ich ausatmete, verstreuten sie sich. Analog der Geräuschzunahme veränderte sich das Bild auf dem Monitor und verwandelte sich schließlich zu einem Bild meines Gesichts, das mit Insekten übersät war. Ich wollte dem Publikum die Vorstellung vermitteln, dass wir alle Teil des gleichen Ursprungscodes sind, demselben, dem auch viele Insekten unterstehen.

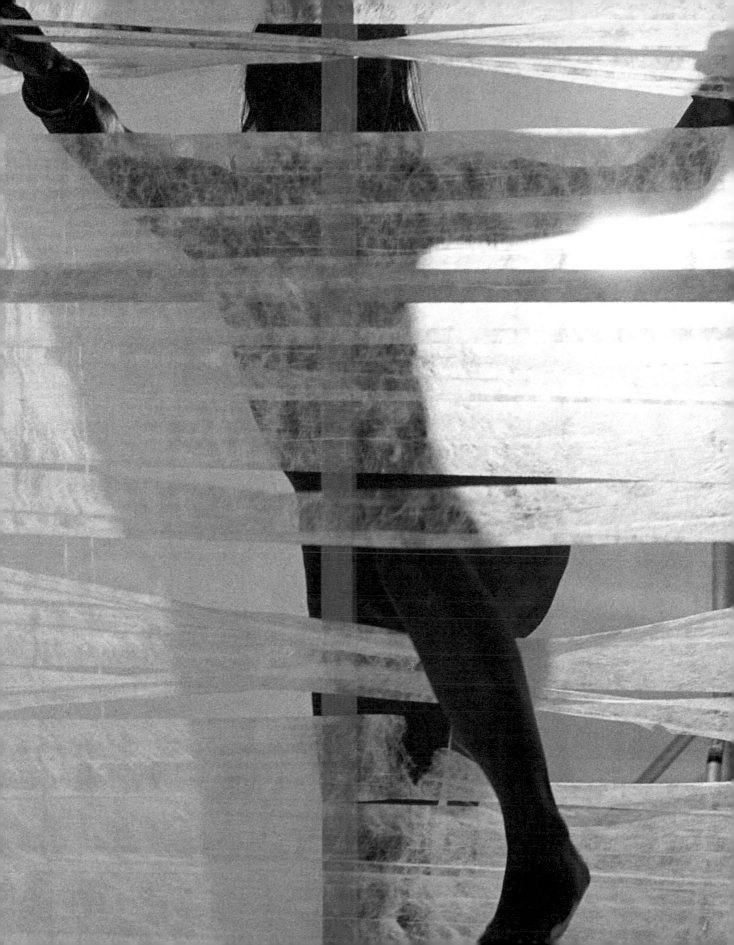

THE MAGNETIC TAPES

1981 THREE VIDEOTAPES, 20 MIN.

E | In the MAGNETIC TAPES, I attempted to make a series of videotapes about my own experience of power and control from my travels in India and Africa. Inspired by Foucault, the aim was to use scale as a metaphor for power and manipulation. As my metaphor for control, I used large human hands to manipulate miniature objects in miniature backgrounds. While one story is about students who meet a dictator in The Central African Republic (Africa), another is about a group of woman tourists and a camel keeper in India, and the third is about male exhibitionism and four brave female horse riders in Australia.

D | Die MAGNETIC TAPES erzählen Geschichten, die von Macht und Kontrolle handeln, und von Erfahrungen, die ich auf meinen Reisen durch Indien und Afrika sammeln konnte. Zusätzlich angeregt von meiner Foucault-Lektüre, wählte ich als Gestaltungsmittel die Metapher des Maßstabs, um Macht und Manipulation zu veranschaulichen. Kontrolle stellte ich durch übergroße Hände dar, die miniaturisierte Objekte vor miniaturisierten Hintergründen bewegten. Eine Geschichte handelte von StudentInnen, die in der Republik Zentralafrika einen Diktator trafen; eine andere von TouristInnen und einem Kamelhalter in Indien; die dritte schließlich von männlichem Exhibitionismus und vier mutigen ReiterInnen in Australien.

»USING A SIMILAR MINIATURE SET THAN THE ONE USED FOR ›CONSTRICTION‹, THE MAGNETIC TAPES ARE VISUAL ILLUSTRATIONS OF THE ARTISTS TRAVELS IN AFRICA AND ASIA. HERE SHE CLEVERLY USES ROTATING MOTORS, METAPHORICAL OBJECTS AND KINETIC PULLEYS AS WELL AS PARTS OF THE HUMAN HANDS AND FACE, TO RE-TELL HER STORIES.« BARBARA LONDON

THE MAGNETIC TAPES 1981. THE MUSEUM OF MODERN ART, NEW YORK. **1-3** | VIDEO IMAGES.

CONSTRICTION PART ONE

1982 VIDEOTAPE

E | I owned a pet snake – a boa constrictor named "Saint" – and built a special camouflaged home for him. It was based on a circular Panopticon, inspired by my reading of Foucault's comments about Surveillance. It was a rotating roundhouse split into three triangular segments. One was painted to mimic the snakes' skin, the second was all white, and the third provided a natural environment of sand for the snake. The video showed "Saint" moving constantly through the circular environment in search of food. His movement was inter-cut with the image of my naked torso pinned under a glass box, while I attempted to lick the white mice inside the box with my tongue. An image of a nuclear power plant frequently appeared superimposed over my torso, which was pushed aside by my hands. The snake eventually ate six live white mice-its staple monthly diet, which I fed to it by poking them into parts of the environment with my hands. The aim was to demonstrate the dangers of placing humans at the top of our very fragile ecological system.

CONSTRICTION PART ONE 1982. VIDEO SCAN GALLERY, TOKYO. **1-6** | STILLS FROM THE VIDEOTAPE.

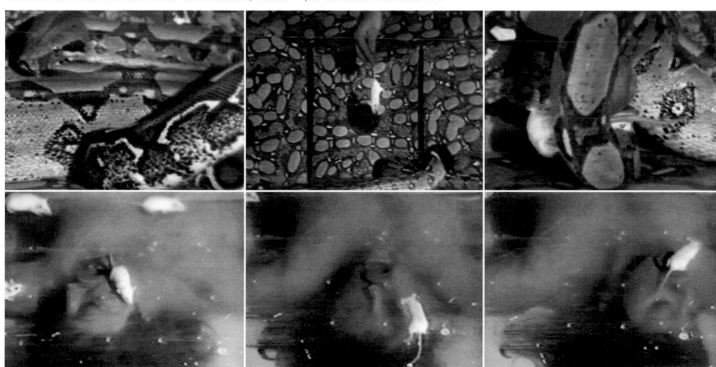

CONSTRICTION PART ONE 1982. LANGTON STREET ARTS. **7-8** | VIDEOSTILLS.

D | CONSTRICTION PART ONE 1982. Ich besaß eine Schlange als Haustier – eine Boa Constrictor namens "Saint" –, für die ich ein ganz besonderes Haus konstruierte. Es basierte auf einem runden Panoptikon, zu dem mich Foucaults Studien zur Überwachung angeregt hatten. Es handelte sich um ein drehbares Rundhaus, das in drei, mit einander verbundene Segmente geteilt war. Ein Segment war wie eine Schlangenhaut ausgemalt. Das zweite war weiß, während das dritte der Schlange eine natürliche Sandumgebung bot. Das Video zeigte Saint, die auf der Suche nach Nahrung durch das Haus kroch. Als Zwischenschnitte sah man meinen nackten Oberkörper unterhalb eines Glaskasten geklemmt, während ich mit meiner Zunge die weißen Mäuse im Kasten zu lecken versuchte. Immer wieder wurde das Bild eines Atomkraftwerks mit dem Bild meines Oberkörpers überblendet. Mit meinen Händen versuchte ich das Bild wegzudrücken. Die Schlange fraß schließlich sechs lebendige Mäuse – ihre übliche Monatsration –, die ich ihr mit meinen Händen in die Segmente ihres Hauses setzte. Ich wollte anschaulich machen, welche Gefahr daraus resultiert, dass Menschen an der Spitze unserer fragilen ökologischen Systems stehen.

CONSTRICTION 1982. LANGTON STREET ARTS. **9** | "SAINT" LOVED TO SIT ON TOP OF MY WARM TV. next doublepage **10** | THE FINAL SECOND!

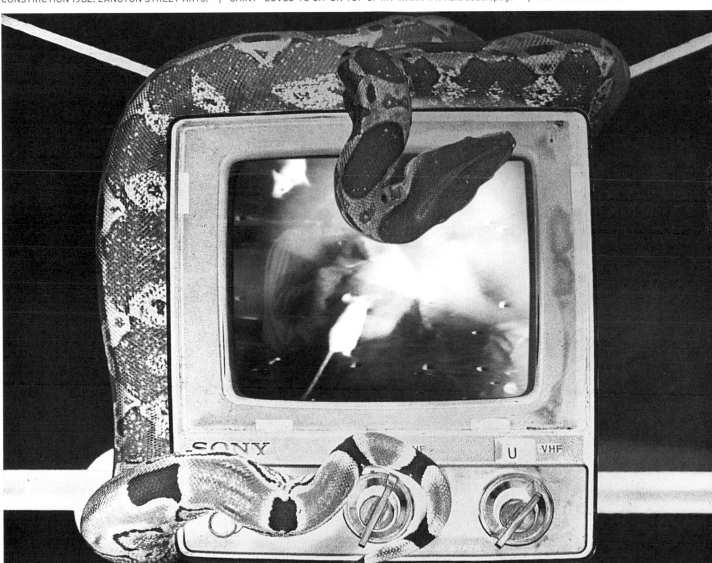

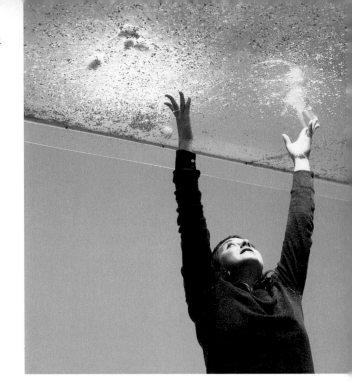

CONSTRICTION PART TWO. THE INTERNATIONAL CULTUREEL CENTRUM ANTWERP.
from left to right **1** | INTERACTION THROUGH THE PLEXIGLAS MICE CAGE.
2 | ONE MONITOR BURIED IN THE SAND. **3** | AUDIENCE IN THE INSTALLATION.

CONSTRICTION PART TWO

1982 INTERACTIVE INSTALLATION

E | The aim of CONSTRICTION was to ask the viewers to question their own place as predators inside an ecological system. When the viewers entered the gallery they found themselves in the middle of a space surrounded by sand hills with buried monitors. Only their screens were showing. Suspended above the audience, was a large Plexiglas box full of live white mice. If the viewers looked towards the left wall of the room they could see their own image superimposed under the image of the mice (in real time) on a monitor. When the viewers looked to the right wall of the room they saw two more monitor screens, which displayed the pre-recorded image loop of a snake eating the mice. Underneath each video screen, a set of REVOLVING DESERT SIMULATORS played an endless symphony of scratching sounds, because I wanted to create the impression that their were lots more mice under the floor.

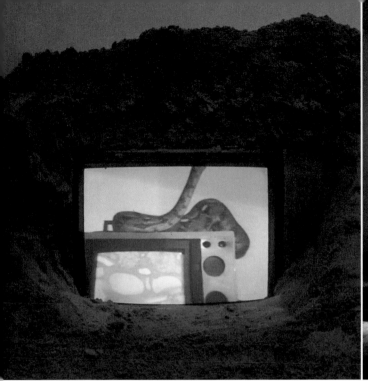
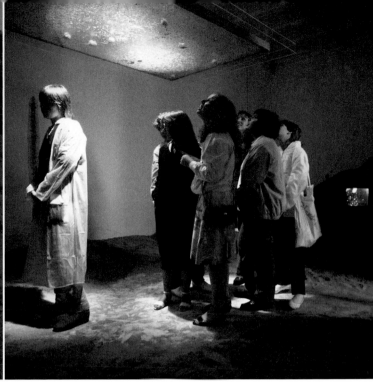

»IN ›CONSTRICTION‹ THE HEAD IS PINNED UNDER A PLAGUE OF
MICE; THE HAND PUSHES AWAY SLIDES OF NUCLEAR PLANTS;
THE SNAKE CONSTRICTS AROUND THE TV-SET; SCOTT'S IMAGES
AND SET BECOME PARADOXICAL FOR THE HUMAN MIND –
ANOTHER KIND OF FEEDING SESSION?« HILDE VAN LEUVEN

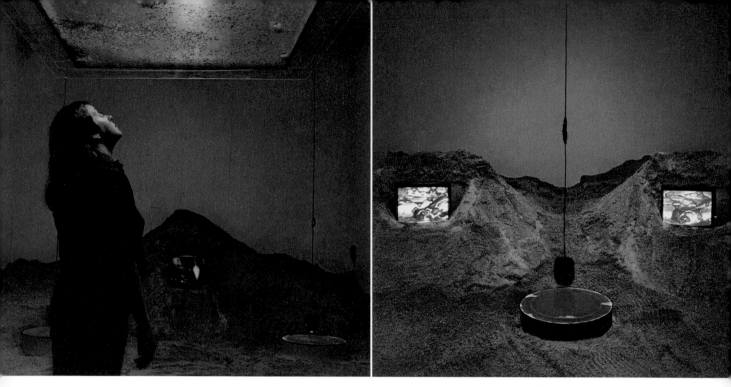

CONSTRICTION PART TWO 1982. THE INTERNATIONAL CULTUREEL CENTRUM ANTWERP. **4** | AUDIENCE INTERACTION **5** | SANDHILLS WITH MONITORS AND REVOLVING DESERT SIMULATOR. opposite page **6** | A VIEWER'S FACE UNDER THE MICE ON THE SURVEILLANCE MONITOR.

D | CONSTRICTION PART TWO 1982. Constriction sollte die ZuschauerInnen dazu bringen, ihren eigenen Platz als Wesen innerhalb des ökologischen Systems zu hinterfragen. Beim Betreten der Galerie fanden sich die Zuschauer-Innen inmitten eines Raumes, umgeben von Sandhügeln, in denen Monitore versenkt waren, so dass nur die Bild-schirme herausschauten. Über den ZuschauerInnen schwebte ein großer Plexiglaskasten voller lebender weißer Mäuse. Blickten die Zuschauerinnen zur linken Wand, konnten sie (in Echtzeit) ihr eigenes Videobild überblendet mit den Livevideoaufnahmen der Mäuse in einem Monitor erkennen. Blickten sie zur rechten Wand, sahen sie zwei Bildschirme, die im Loop vorgefertigte Aufnahmen einer Schlange zeigten, die Mäuse fraß. Unterhalb der Monitore spielten rotierende "Wüstensimulatoren" eine endlose Symphonie von Kratzgeräuschen. Ich wollte den Eindruck erwecken, als ob viele Mäuse unter dem Boden des Ausstellungsraums hausten.

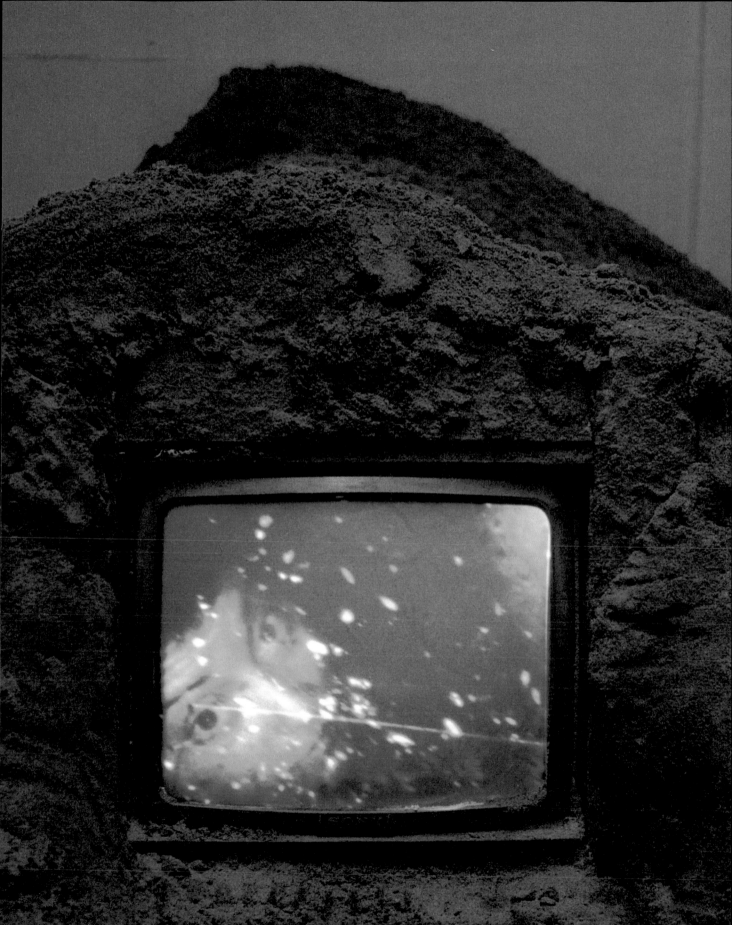

DIGITAL BEINGS

DOWNUNDER 1982 - 1992 |

DIGITAL BEINGS

PLURALISTIC METAPHORS IN VIDEO ART (AUSTRALIA 1982-92) BY JILL SCOTT

E | DIGITAL – Coded or relating to calculation by numerical methods or by discrete units. Relating to data in the form of numerical digits "a digital voltmeter". Relating to an audio-video recording method in which waves are represented digitally (as on magnetic tape). – BEINGS – the quality or state of having existence: something conceivable as existing. The mythical essence of a living person. Consciousness. Life. The qualities that constitute an existent thing.

In the eightes dualistic themes entered a novel shift with the onset of digital technology. In other words when digital sound and video entered the artist's palette, both the represented body and the body of the audience could exist not only in parallel worlds but also become delayed and distorted bits and bytes. This graduated the Analog Figure into a type of Digital Being. This "being" was asked to participate in the decoding of digital information installations where video became the tool to achieve a sense of pluralism. Here real-time digital code offered a spatial as well as technical advantage. In Australia, video-artists hoped that this

D | In den achtziger Jahren fand auf Grund der aufkommenden digitalen Technologien die Auseinandersetzung mit dualistischen Themen auf einer qualitativ neuen Ebene statt. Mit anderen Worten – als digitaler Sound und digitales Video das Spektrum der KünstlerInnen erweiterten, mussten die dargestellten Körper wie auch die Körper der BesucherInnen nicht mehr ausschließlich in parallelen Welten existieren. Sie konnten jetzt auch zu zeitlich limitierten, deformierten Bits und Bytes werden. So entstanden aus Analog Figures allmählich Digital Beings.

Diese Digital Beings (digitalen Wesen) sollten an der Decodierung von digitalen Informationen in Installationen teilhaben, in denen Video zu einem Instrument wurde, das pluralistische Vorstellungen vermitteln konnte. Die neuen digitalen Echtzeit-Verarbeitungsverfahren lieferten dazu raumbezogene technische Neuanwendungen. Davon erhofften sich in Australien die VideokünstlerInnen neue Möglichkeiten, was die Partizipation und das kognitive Verstehen des Publikums betraf. Dies setzte allerdings voraus, dass jede BesucherIn analytisch den ästhetischen Veränderungen und verfremdeten Umgebungen begegnen würde. Wir wollten das Publikum stärker in das Bild

technology would become an advantage in terms of the level of participation and comprehension by the audience. However, this required each viewer to be analytical about their own relationship to the aesthetic shift and the distorted surroundings. We hoped the audience could become more incorporated in the image. Even though it was the audio artists who often led the digital revolution and contributed to the increase in manipulated sophistication, some valuable community-video-access-centres sprouted up in Sydney and Melbourne, featuring access to digital video-editing (e.g. Metro TV-Open Channel). Could video become the alternative socially invested voice as Marshall McLuhan had once predicted? Here video makers spent time analysing the propaganda on television, representational equality, the levels of audience identification and the "site" and role of the screen in the urban and rural environment.

Welcome additions to these flames were the translated publications of French structuralist theory, which predicted that media information could and should be cross-referencing itself. The results were a mixed bunch of pluralistic associations, which led to different cut and paste types of media-processes and montaged Digital Beings. Associations between subjects such as myth, reality, transference, metamorphosis, transcendence, dematerialization and reconstruction were considered effective slashing against the concept of linear narrative structure. As Roland Barthes proposed, televised myths could create multifaceted, pluralistic rather than dualistic roles for the observer as well for the observed. In the eighties, we wanted to ask the viewer to question the difference between real and cultural constructions in a land that was increasingly being dotted with satellite footprints and surveillance cameras. In 1987, I made a work called MEDIA MASSAGE (1991/p. 120): an attempt to comment on satellite transmission and the subversive infiltration of digital images. These developments affected the way the human body was perceived. In the installation version, the video projections were very large and the viewers' bodies became shadows on the screen-image, signifying that the digital transmission may pass through them as well. In

miteinbeziehen. Die eigentlichen Vorreiter der digitalen Revolution waren die TonkünstlerInnen, die zu der rasant fortschreitenden Entwicklung der Manipulierbarkeit von Daten beitrugen. In Sydney und Melbourne schossen innovative Video Communities geradezu aus dem Boden und ermöglichten so den Zugang zum digitalen Video-Editing (z.B. Metro TV/Open Channel). Konnte Video zu der alternativen und gesellschaftlich engagierten Stimme werden, wie es Marshall McLuhan einst vorhergesagt hatte? Die VideokünstlerInnen beschäftigten sich intensiv mit der Analyse von Fernsehpropaganda, Gleichberechtigung bei der Darstellung, den Identifikationsebenen des Publikums sowie der "site" (dem Ausstellungsort) und der Rolle des Bildschirms in urbanen und ländlichen Umgebungen.

Als willkommene Unterstützung für diese aufkommende Entwicklung erwiesen sich die gerade übersetzten Publikationen der französischen StrukturalistInnen. Sie prophezeiten, dass Medieninformationen sich gegenseitig untereinander und aufeinander beziehen könnten und sollten. Die Resultate bestanden aus einer gemischten Ansammlung pluralistischer Assoziationen. Diese führten zu auf unterschiedliche Arten auseinander genommenen und dann wieder verbundenen medialen (cut and paste) Prozessen und Digital Beings. Assoziationen zwischen Themen wie Mythos, Realität, Transferenz, Metamorphose, Transzendenz, Dematerialisierung und Rekonstruktion zeigten ihre Wirkung, um dem Konzept einer linearen Erzählstruktur entgegenzutreten. Wie Roland Barthes vorhergesagt hatte, erzeugten televisuelle Mythen potentiell eher vielgestaltige, pluralistische anstelle von dualistischen Rollen, sowohl für die BetrachterInnen als auch für die Personen, die beobachtet wurden. In den achtziger Jahren sollten die BesucherInnen animiert werden, die Unterschiede zwischen realen und kulturellen Konstruktionen zu hinterfragen, in einem Land, das flächendeckend von den Spuren der Satellitensysteme und von Überwachungskameras überzogen wurde. 1987 realisierte ich die Arbeit MEDIA MASSAGE (1991/S. 120), bei der ich die Auswirkungen von Satellitenübertragungen und die subversive Infiltration von digitalen Bildern zu kommentieren versuchte. Diese Entwicklungen beeinflussten die Art und Weise, wie der menschliche Körper wahrgenommen wurde. In Installationen beispielsweise fielen die Videoprojektionen sehr groß aus, und die Körper der BesucherInnen wurden zu Schatten auf der Leinwand, ein Zeichen dafür, dass die digitale Übertragung durch sie hindurch treten konnte. In Australien entdeckten meine KünstlerkollegInnen und ich, dass die Satellitenübertragung ein pluralistisches Paradox darstellte. Wir wollten, dass unser Publikum sich mit diesen technischen Neuerungen kritisch auseinandersetzte, und hofften gleichzeitig, dass idealerweise Satellitenübertragungen tatsächlich traditionelle und zeitlich bedingte Grenzen überwinden konnten. Digitale Technologie zog einen breit angelegten Diskurs nach sich.

Australia, my colleagues and I realized that satellite transmission was a pluralistic paradox. On the one hand, we wanted our audience to be critical of this technological development; on the other hand, we hoped that the ideals of digital satellite transmission could actually breakdown traditional and temporal borders. Digital technology brought with it a much broader critical debate.

While earlier in the eighties, I had wanted my audience to question time and their role as guinea pigs for tests by the corporate sector and national government (see CONSTRICTION III, 1983/p. 102 in the clocktower), later my colleagues and I began to question the seductive role of the media. Therefore, we wanted to appropriate the pluralistic effects of fear and fascination that convinces and converts the audience. In Australia, this direction was helped by the increase in sophistication of our digital commercial editing suites. Our audiences began to witness a great deal of 2-D and 3-D digital reflections of themselves on the screen. Many video artists in Australia became interested to watch for the intervals and emissions as well as for the coded information. For Peter Callas, The Randellies and myself, video synthesisers became the ultimate manipulation tool, a chance to immerse the audience (Digital Beings) inside the scan lines of the video image. However we were also interested in mesmerising and mediating the audience not only by placing them in between the scanlines, but also by having them to choose preferences inside a digital montage and non-linear narrative of various characters from mythical histories and future fictions. DOUBLE DREAM (1984/p. 106) was an attempt was to offer the viewer a choice of two hot and cold heroines, whose origins were ancient, and similar hot and cold female archetypes from television daytime advertising. The viewer could enter the space and decide for himself or herself which emotion they prefer, hot or cold.

In the eighties the viewers assumed the role of Digital Beings, because they started to play a more pluralistic role: that of extracting complex associations from combinations of abstract metaphors imbedded inside the digital image. This type of opening up was an educational process which unless you were a participant (or informed as we used to say) you might actually have

Im Gegensatz zu den siebziger und beginnenden achtziger Jahren, in denen ich die Absicht verfolgte, dass mein Publikum die Zeit an sich hinterfragte wie auch seine eigene Rolle als Versuchskaninchen für Tests privater Unternehmen und staatlicher Institutionen (siehe CONSTRICTION III, 1983/S. 102 in einem Uhrturm), begann ich später, zusammen mit meinen KollegInnen die Verführbarkeit durch die Medien zu untersuchen. Wir wollten uns selbst die pluralistischen Effekte von "Furcht und Faszination" aneignen, die in Kombination auf das Publikum eine so stark überzeugende Wirkung ausübten. In Australien wurden wir dabei unterstützt durch die ständige technische Weiterentwicklung digitaler Bildbearbeitungsprogramme. Unser Publikum konnte jetzt eine große Zahl digitaler 2-D und 3-D-Reflexionen von sich selbst auf dem Bildschirm beobachten. Viele VideokünstlerInnen in Australien richteten zunehmend ihre Aufmerksamkeit auf unvorhersehbare Effekte neben den standardisierten codierten Informationen. Für Peter Callas, die Randellies und mich entstand mit den Video-Synthesizern das ultimative Instrumentarium für manipulierte Bilder, eine Möglichkeit, beispielsweise die Besucher und Besucherinnen (Digital Beings) zwischen den Rasterlinien des Videobilds verschwinden zu lassen. Aber wir wollten das Publikum auch bannen und mediatisieren. Wir boten ihnen Wahlmöglichkeiten innerhalb digitaler Montagen an und kreierten nicht-lineare Erzählformen zu Geschichten über verschiedene mythologische Charaktere oder von Figuren in der Zukunft. Bei DOUBLE DREAM (1984/S. 106) sollte das Publikum zwischen einer heißen und einer kalten Heroine wählen, wie man sie aus herkömmlichen und auf ähnliche Weise "heiß" oder "kalt" suggerierenden Archetypen tagsüber ausgestrahlter Fernsehspots kennt. Die BesucherInnen mussten den Raum betreten und selbst entscheiden, welcher Emotion, heiß oder kalt, sie den Vorzug gaben.

In den achtziger Jahren nahm das Publikum die Gestalt der Digital Beings an, denn nun konnte es eine eher pluralistische Rolle spielen; diese bestand darin, aus der Kombination abstrakter Metaphern, die in das digitale Bild eingebettet waren, komplexe Assoziationen herauszuziehen. Diese Art von Erfahrungen wurden zum Erziehungsprozess, der, wenn man nicht gerade daran partizipierte (oder informiert war, wie es so schön hieß!), das Gefühl vermitteln konnte, den entscheidenden Punkt verpasst zu haben. Zu diesem informierten

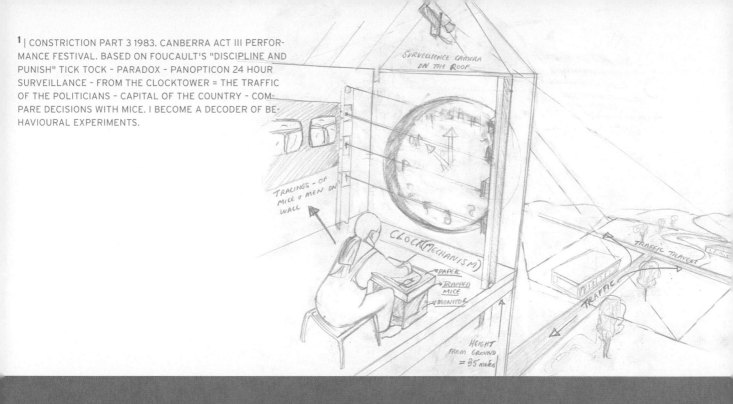

1 | CONSTRICTION PART 3 1983. CANBERRA ACT III PERFORMANCE FESTIVAL. BASED ON FOUCAULT'S "DISCIPLINE AND PUNISH" TICK TOCK - PARADOX - PANOPTICON 24 HOUR SURVEILLANCE - FROM THE CLOCKTOWER = THE TRAFFIC OF THE POLITICIANS - CAPITAL OF THE COUNTRY - COMPARE DECISIONS WITH MICE. I BECOME A DECODER OF BEHAVIOURAL EXPERIMENTS.

found that you were missing the point! Part of this informed state was to understand that the rise in the rapid transfer and manipulation of digital data allowed video to became new non-linear narrative language. In Australia, the word "site" shifted to include the meaning of the screen itself as well as concepts of transference, quotation, reference and association as evidence. At this time the international sharing of videotapes and media philosophy helped to influence a broader international movement, one in which the participant had to understand both the content and the interactive context. Later in the eightes, amongst our Sydney media-community, the reading of parallel scientific studies about cognition and neural networks also stimulated pluralistic associations. Maurice Merleau-Ponty, who focused on perception and related phenomena, was a great influence on artists like Stelarc and Steven Jones (of the group Severed Heads). However, one of the most astute comments at the time came from the French curator Jean-François Lyotard. He blamed the end of the grand narrative on the transforming effect of rapidly evolving interactive and digital ideas by the writers and artists in the 1980s.

Zustand gehörte auch die Erkenntnis, dass der rasante Anstieg der Übertragbarkeit und Manipulierbarkeit digitaler Daten dem Video eine neuartige nicht-lineare narrative Sprache ermöglichte. In Australien wandelte sich das Wort "site" dahingehend, dass die Bedeutung des Bildschirms ebenso wie die Konzepte von Übertragung, Zitat, Referenz und Assoziation als Grundlage herangezogen wurden. In dieser Zeit wuchs der internationale Austausch von Videobändern und von medienphilosophischen Ansätzen. Dies führte zu einer breiteren internationalen Bewegung, nach deren Versländnis das Videopublikum neben dem Inhalt auch den interaktiven Kontext verstehen musste. Später in den achtziger Jahren fand unsere Mediengemeinde in Sydney weitere Anregungen in der Lektüre gleichzeitig erschienener wissenschaftlicher Studien über Kognition und neurale Netzwerke, welche ebenso pluralistische Assoziationen stimulierten. Maurice Merleau-Ponty, der sich in seiner Arbeit auf Wahrnehmung und verwandte Phänomene konzentriert hatte, besaß großen Einfluss auf KünstlerInnen wie Stelarc und Steven Jones (Mitglied der Gruppe Severed Heads). Einer der intelligentesten Kommentare aus dieser Zeit stammt von dem französischen Kurator Jean-François Lyotard. Er machte die transformierende Wirkung der sich rasant entwickelnden interaktiven und digitalen Konzepte von SchriftstellerInnen und KünstlerInnen der achtziger Jahre für das Ende der "Grandes Narratives"verantwortlich.

For me this exploration into non-linear narrative became a significant metaphor for the eighties, as it shifted the context of art and popular culture, which represented and reproduced the body as a Digital Being. It was the first time I heard the human mind referred to as "software". In other words, the human form could be regarded as a machine to also convert digitally coded information, one that was non-linear, therefore ageless and timeless. Video installation in particular invited the viewers to wander in, around and through the screen in order to trace new meanings, follow different pathways and choose their own levels of identification and duration. In Australia we hoped that it was a new critical role, for the audience, one in which they could freely associate – similar to the way in which human memory works. By the mid-eighties the Australian public were already tele-visually literate and understood the metaphor of being surrounded by media. Therefore they wanted to determine their own time frames and control of information (as evidenced by the popularity of VCRs and remotes). Artists became aware of the pace of digital change, with new media gadgets rapidly replacing the old. I became interested in making a set of non-linear narratives about "dead analog media", machines that could be used as metaphorical memory-triggers (MACHINEDREAMS 1991/p. 136). Here a typewriter, a sewing machine, a blender (Mixmaster) and a telephone were used to represent the history of women and work over the 20th century. It was hoped that the viewers would associate the "dead" machines with the history of women's work through the triggering of live-working-sounds as they moved though the site.

The above influences and technologies not only transformed the artist's "site" into a screen-space, but also represented the human form as a Digital Being. We attempted to treat the audience in a more sophisticated way than by the television industry, which uses the lowest common denominator of intelligence. We also hoped that our pluralistic associations heightened as well as informed and analysed the levels of identification with the represented image. This signified a transient voyage for the viewer into screen space. Here viewers were asked to cross-reference content as well as witness their own body as digitally manipulated. In Australia as elsewhere, the idealistic level of relationship between the body's own organic interfaces and the

Für mich bildeten die Erfindungen nicht-linearer Erzählungen eine bezeichnende Metapher für die achtziger Jahre. Sie wurden zum Kontext von Kunst und Populärkultur, die den Körper als Digital Being darstellten und reproduzierten. Zum ersten Mal hörte ich davon, dass der menschliche Verstand auf den Terminus "Software" bezogen wurde. Mit anderen Worten, man konnte die menschliche Form als eine Maschine beschreiben, die imstande war, auch digital codierte Informationen umzuwandeln, als eine nicht-lineare und deshalb alters- und zeitlose Maschine. Insbesondere Videoinstallationen animierten die Besucher und Besucherinnen, im Bildschirm zu wandern, sich in ihm herum und durch ihn hindurch zu bewegen, um neuen Bedeutungen nachzuspüren und um selbst das Ausmaß für die eigene Identifikation und die Länge der Benutzerzeit zu wählen. In Australien hofften wir damals, dem Publikum eine neue kritische Haltung übertragen zu können, bei der jede BesucherIn frei assoziieren konnte – so wie das menschliche Gedächtnis auch funktioniert. Mitte der achtziger Jahre besaß die australische Öffentlichkeit bereits genügend Fernseherfahrungen, um die Metapher einer sie umgebenden mediatisierten Umwelt zu entschlüsseln. Das Individuum wollte seinen Zeitrahmen selbst bestimmen und Informationen individuell kontrollieren (was sich unschwer in der Popularität von Videorecordern und Fernbedienungen erkennen ließ). KünstlerInnen wurden sich des Tempos digitaler Veränderungen bewusst, denn neue Medientechnik ersetzte umgehend die alten überholten Gerätschaften. Ich beschäftigte mich zunehmend mit der Entwicklung nicht-linearer Erzählungen über "tote analoge Medien", Maschinen, die als Auslöser metaphorischer Erinnerungen benutzt werden konnten. In MACHINEDREAMS (1991/S. 136) dienten eine Schreibmaschine, eine Nähmaschine, ein Mixer und ein Telefon dazu, die Geschichte der Frau und der Arbeit im 20. Jahrhundert zu repräsentieren. Ich hoffte, dass die InstallationsbesucherInnen die "toten" Maschinen mit der Geschichte der Frauenarbeit assoziieren würden, wenn sie neben anderen bildlichen Informationen auch die originalen Arbeitsgeräusche der Maschinen im Raum hörbar auslösten, je nachdem an welchem Ort der Installation sie sich gerade bewegten.

Die oben erwähnten Einflüsse und Technologien transformierten nicht nur den Ausstellungsort ("site") der KünstlerIn in einen Bildschirmraum, sondern stellten auch die menschliche Form als Digital Being dar. Wir stellten einen höheren Anspruch an unser Publikum als das kommerzielle Fernsehen dies tat, das sich mit dem kleinsten, gemeinsamen Nenner von Intelligenz begnügte. Wir hofften, dass unsere pluralistischen Assoziationen informierten und die Art der Identifikation mit dem Dargestellten zu analysieren halfen. Das bedeutete für das Publikum eine zeitlich begrenzte Reise durch den Raum des Bildschirms. In ihm sollten die BesucherInnen den Inhalt

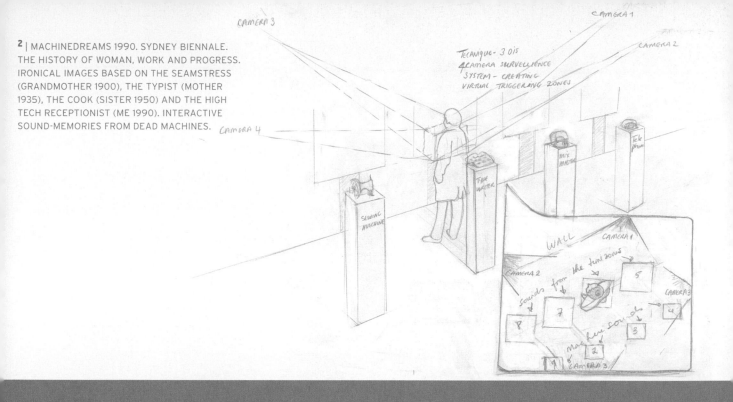

2 | MACHINEDREAMS 1990. SYDNEY BIENNALE.
THE HISTORY OF WOMAN, WORK AND PROGRESS.
IRONICAL IMAGES BASED ON THE SEAMSTRESS
(GRANDMOTHER 1900), THE TYPIST (MOTHER
1935), THE COOK (SISTER 1950) AND THE HIGH
TECH RECEPTIONIST (ME 1990). INTERACTIVE
SOUND-MEMORIES FROM DEAD MACHINES.

digital machines and objects human created, needed further exploration. Not only was research into all the effects of immersion on a participatory audience needed, but also we artists needed to collaborate with scientists and philosophers. Only then could we try to invent new algorithms which cope with pluralistic levels of non-linear hybrid environments and coded information. The idea was not only to increase audience-nomadicy but also to allow these new Digital Beings to physically control and select their own pathways through the content. There was not only the image of themselves in data-space and on the mediated stage to consider, but there were the longer-term experiments with communication and interactivity itself that Roland Barthes had begun.

unter verschiedenen Gesichtspunkten hinterfragen und ihren eigenen Körper als digital manipulierbar erleben. Nicht nur in Australien sammelte man Erfahrungen für ein ideales Verhältnis zwischen dem organischen Interface des menschlichen Körpers und den digitalen Maschinen bzw. den vom Menschen hergestellten Objekten. Es war weitere Forschung notwendig, um die Auswirkungen von immersiven Umgebungen auf ein partizipatorisches Publikum herauszufinden, und wir Künstler-Innen mussten dafür notwendigerweise mit Wissenschaftler-Innen und PhilosophInnen zusammenarbeiten. Nur so ließen sich neue Algorithmen erfinden, die mit pluralistischen Ebenen nicht-linearer hybrider Umgebungen und codierten Informationen verknüpft werden konnten. Dahinter stand die Idee, den Besuchern und Besucherinnen sowohl ein gesteigertes Gefühl von Nomadentum zu vermitteln als auch diesen neu entstandenen Digital Beings Optionen anzubieten, mit denen sie selbst physisch ihren eigenen individuellen Weg durch den Inhalt wählen und kontrollieren konnten. Die thematischen Bezüge kreisten nicht nur um eine Abbildung ihrer selbst im Datenraum und auf der mediatisierten Bühne, sondern auch um länger andauernde Experimente mit Kommunikation und Interaktivität, die auf Roland Barthes zurückgingen.

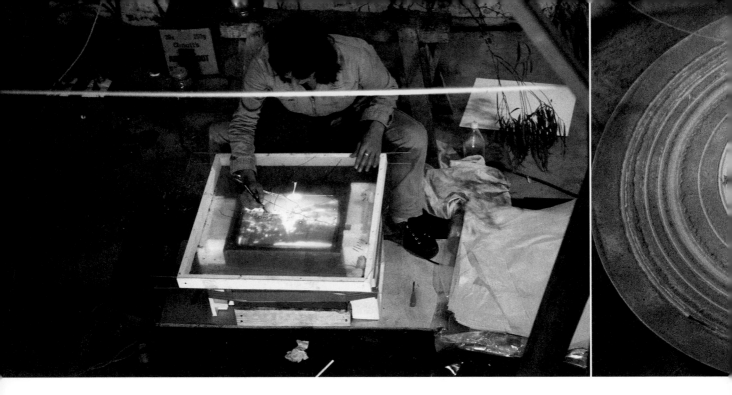

CONSTRICTION PART THREE

1983 INTERACTIVE INSTALLATION AND PERFORMANCE WITH SURVEILLANCE

E | The reading of Michael Foucault's "Discipline and Punish" inspired this performance. I installed a camera on the roof of a huge clock tower, which was aimed at a busy intersection in front of Parliament House in Canberra. I then placed myself inside the clock room of the tower where I could receive a live feed from the intersection for a 24-hour period. In this way I was able to spy on the movement of human beings and carry out my experiment. Using a Plexiglas tray full of white mice, I could draw a comparison between the reactions of the humans to those of the mice over time. These recordings were made on transparent sheets of paper. Every hour I carried one of these notations down to the next level below the clock tower into a small square gallery where it was placed under frames mounted on the wall. As the images of notation grew, a large REVOLVING DESERT SIMULATOR turned in the centre and its magnetic parts etched a circular groove in the sand deeper and deeper. The attempt was to symbolize the passing of time and the control the clock has over us. The sound was mixed with the loud clock sounds plus amplified sounds from the street far below.

CONSTRICTION PART THREE 1983. ACT III PERFORMANCE FESTIVAL, CANBERRA. from left to right **1** | DECODING INFORMATION IN THE CLOCK TOWER.
2 | THE LARGE REVOLVING DESERT SIMULATOR UNDER THE CLOCK ROOM. **3** | THE RESULTANT DRAWINGS.

4 | THE CAMERA VIEW OF THE STREET BELOW. **5** | CLOSE-UP OF THE STREET BEHIND THE LIVE MICE.

CONSTRICTION PART THREE 1983. ACT 111 PERFORMANCE FESTIVAL, CANBERRA. **6** | ROOM UNDERNEATH THE CLOCK ROOM-WHERE THE EXHIBITION OF NOTATIONS TOOK PLACE.

»AN AUSTERE DRAMA (CONSTRICTION) ACCUMULATES THE OBSESSIVE ELEMENTS OF JILL SCOTT'S UNIVERSE AND THIS TIME MAKES OF THEM A ›THEATRE OF CRUELTY‹ REQUIRING PUBLIC INTERACTION, THE INTERDEPENDENCE OF THE GRAPHIC HAND, ARTICULATED GAZE AND THE SLOW RATCHETING SOUNDS OF THE ESCAPEMENT–MECHANISM OF THE CLOCK... THE SOUND INSTRUMENT CALLED ›THE REVOLVING DESERT SIMULATORS‹ SUGGESTS PERHAPS THAT INSECTS CONTAIN MAGNETISM AND ARE DIRECT SERVANTS TO THE STARS CONDEMNED TO A STERN KARMA TO WORK OUT DREAMS AND PROJECTS OF AN APPARENTLY TIMELESS DESERT ETHICS.« GEORGE ALEXANDER

D | CONSTRICTION PART THREE 1983. Die Lektüre von Michel Foucaults "Überwachen und Strafen" gab die Anregung zu dieser Performance. Auf dem Dach eines riesigen Uhrturms installierte ich eine Kamera, die auf eine stark frequentierte Kreuzung vor dem Parlamentsgebäude in Canberra gerichtet war. Ich selbst begab mich in die Uhrenkammer des Turms, wo ich für die Dauer von 24 Stunden live das Geschehen auf der Kreuzung am Monitor beobachtete. So konnte ich die Bewegungen der Menschen erforschen und mein Experiment durchführen: den Vergleich menschlicher Verhaltensweisen mit denen von Mäusen über die Zeit. Die Mäuse steckten in einem Plexiglasbehälter. Meine Aufzeichnungen wurden auf Transparentpapier gemacht. Zu jeder Stunde trug ich eine dieser Aufzeichnungen in eine kleine quadratische Galerie, die sich im Stockwerk unter der Uhrenkammer befand. Hier wurden die Zeichnungen gerahmt und an die Wand gehängt. Während immer mehr Bilder dazukamen, drehte sich in der Mitte der Galerie ein großer "Wüstensimulator". Seine magnetischen Teile ritzten eine kreisförmige Rille in den Sand, die mit der Zeit immer tiefer wurde. Ich wollte das Vergehen von Zeit symbolisieren und die Kontrolle, welche die Uhr über uns ausübt. Die Geräusche vermischten sich mit den lauten Tönen der Uhr und den elektronisch verstärkten Straßengeräuschen.

7-8 | AT 5 AM THE MICE WERE MORE LIVELY THAN THE HUMANS ON THIS CANBERRA INTERSECTION.

DOUBLE DREAM

1984 VIDEO INSTALLATION AND VIDEO TAPE

E | Marshall McLuhan once suggested that video was a cool medium and film was a hot medium. In DOUBLE DREAM, two videotapes used archetypical female beauties from daytime television advertising the cool white Nordic sea nymph and the hot dark wild woman of the desert, to satirize tele-visual romance. The pair played out their respective erotic scenarios of sea and sand with a live lizard and an elegant seahorse respectively. The video ended with their comments about how boring they found daytime TV advertising and its "doublespeak" flavour. In the installation, two TV monitors were placed on a sinking six meter Venetian Gondola which rotated on a motor in a counter-clockwise circle: going nowhere. Viewers could enter the space and decide whether they preferred the hot or the cold side of the room. Six large still-frame paintings from each videotape also hung in the space. By making the scan lines widely spaced on these images: wide enough in fact to get lost in – I hoped to re-enforce the concept that each viewer's choices could be mesmerized by either the hot or the cold video-screen characters, thus suggesting that McLuhan was wrong about the coldness of video.

DOUBLE DREAM 1984. PERFORMANCE SPACE, SYDNEY. **1-2** | ENLARGED SCANLINE PAINTINGS FROM THE HOT AND COLD VIDEOTAPE.

D | Marshall McLuhan vertrat die These, dass Video ein kaltes und Film ein heißes Medium seien. In DOUBLE DREAM kommen zwei Videos vor; als Parodien auf Fernsehromanzen präsentieren sie archetypische weibliche Schönheiten aus der Werbung (die kühle weiße nordische Seenymphe und die heiße wilde dunkelhäutige Frau aus der Wüste). Die beiden Frauen spielen die erotischen Szenarien in Wasser und Sand mit einer lebendigen Eidechse beziehungsweise einem eleganten Seepferdchen durch. Das Video endet mit ihren Kommentaren, wie langweilig sie die Fernsehwerbung finden und wie wenig ihnen deren Doppelzüngigkeit gefällt. Für die Installation wurden zwei Fernsehmonitore auf eine sechs Meter lange, sinkende venezianische Gondel montiert. Diese drehte sich auf einem Motor entgegen dem Uhrzeigersinn - nirgendwohin. Die BetrachterInnen, die den Raum betraten, konnten wählen, ob sie die kalte oder die heiße Seite bevorzugen. Außerdem hingen sechs große Gemälde an der Wand von einzelnen Standbildern aus den Videos. Indem ich auf diesen Gemälden die Videosignalstreifen stark verbreiterte - so stark, dass man sich darin verlieren konnte - wollte ich deutlich machen, dass die Entscheidungen der Betrachterinnen durch die heißen oder kalten Videocharaktere irritiert werden können. Das sollte zeigen, dass McLuhan in Bezug auf den Kältecharakter des Mediums Video irrte.

DOUBLE DREAM - slogans from TV commercials.
So hot - hot off the press - hotter than hell - hot blooded
- burning desires - make me boil - red hot-dry humour.
Cold feet - play it cool - frigid - chilly presence - cold
hearted - out of the blue-icy face - cold fish - wet body.

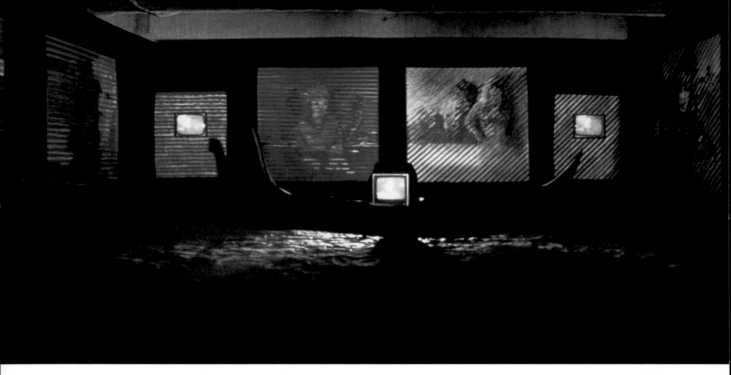

DOUBLE DREAM 1984. ANZART AUCKLAND, NEW ZEALAND. **3** | DAYTIME TV WAS PLAYING IN THE SINKING GONDOLA. bottom and next page **4-12** | THE TWO CHARACTERS WATCH DAY TIME TV FOLLOWED BY VARIOUS STILL IMAGES FROM THE HOT AND COLD VIDEO TAPES.

»USING A PLAY ON GEORGE ORWELL'S 1984 TERMINOLOGY FOR MANIPULATION ›DOUBLESPEAK‹ JILL SCOTT RECREATES HER OWN MYTH – DOUBLE DREAM. THE PUBLIC REACTING TO HOT AND COLD EMOTIONS CAN MOVE BETWEEN TWO PARALLEL ORCHESTRATED ENVIRONMENTS WHERE A FREEDOM AND SELF-SUFFICIENCY REMAIN UNINTERRUPTED BY THE ROMANTIC CLICHÉS AND COMMERCIAL DEMANDS OF ›BIG BROTHER‹ TELEVISION.« MARGARET WIRTHEIM

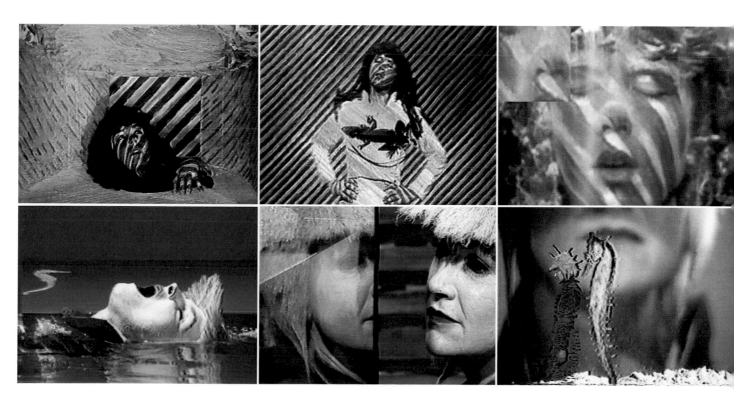

THE SHOCK OF THE STILL

1985 INTERACTIVE VIDEO INSTALLATION

E | THE SHOCK OF THE STILL is a play on words, as the "still" is both the name for an old fashioned well and a nickname for a still-film-frame. This installation started with the question about the myth of Narcissus and the identity of recognition once postulated by Jacques Lacan. I have often thought that there was a great similarity between the surface of video and that of water, as well as between the preoccupation with self-identity that both surfaces induce in us. When a viewer looked into the water, a hidden video camera displayed there a shot of his or her face which was superimposed in front of a very violent graphically drawn splash. This splash was also displayed as a still image on the wall. However, when the viewer touches the surface of the water, only the image of the viewer became distorted. The viewers became a bit puzzled by this, as it was hard to work out where the cameras were situated and why the splash on the wall stayed still.

D | THE SHOCK OF THE STILL ist ein Wortspiel: "Still" bezeichnet im Englischen sowohl einen alten Brunnen als auch das Standbild aus einem Film. Die Ausgangspunkte dieser Installation waren der Mythos von Narcissus und Lacan's Konzept der Selbsterkennung. Ich glaube, dass zwischen der Oberfläche von Video und der von Wasser grosse Ähnlichkeit besteht und dass beide Oberflächen zur Beschäftigung mit der eigenen Identität anregen. Wenn die BetrachterInnen ins Wasser schauten, dann zeigte ihnen dort eine verborgene Kamera ihre Gesichter, die über einen kräftig gezeichneten Spritzer gelegt waren. Dieser Spritzer wurde auch als Standbild auf die Wand projiziert. Berührten die BetrachterInnen die Wasseroberfläche, dann verschwammen lediglich ihre Gesichter. Diese Beobachtung war irritierend, weil sich nur unter Schwierigkeiten herausfinden ließ, wo die Kamera technisch plaziert war und warum der Wasserspritzer an der Wand sich nicht bewegte.

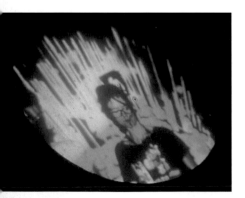

THE SHOCK OF THE STILL. 1985 ROSLYN OXLEY GALLERY, SYDNEY. left page **1** | VIEW INTO THE WELL. right page **2** | TOUCHING THE WATER SHIFTS THE IMAGE OF THE VIEWER'S FACE.

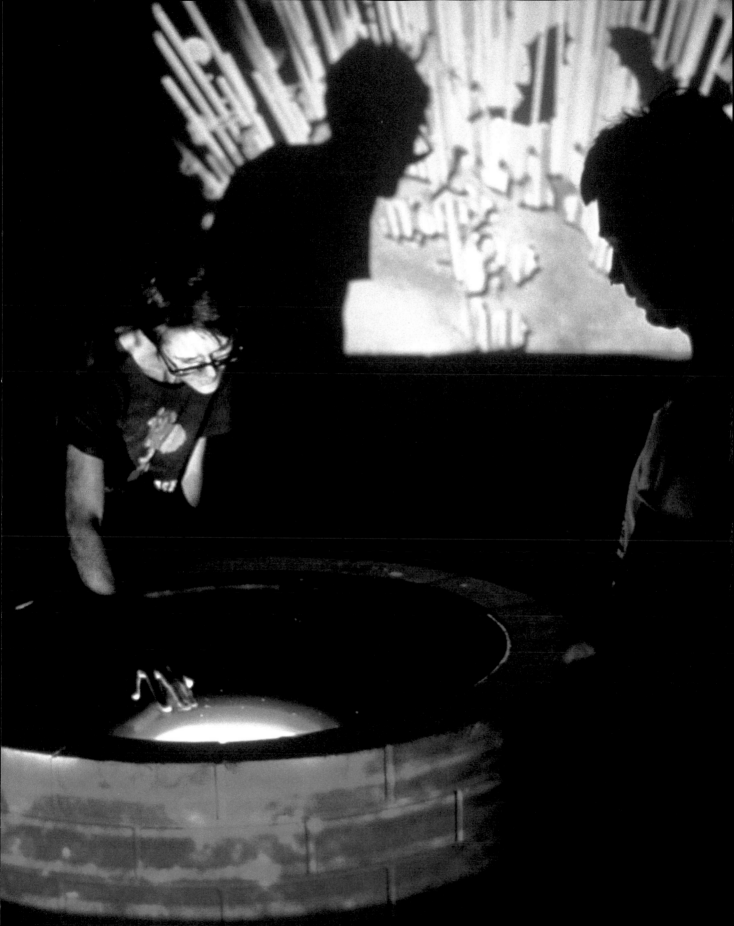

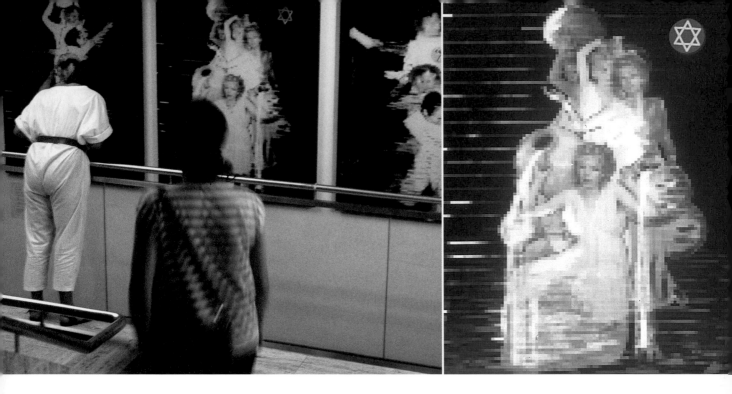

DOUBLE TIME

1985 VIDEO INSTALLATION AND VIDEOTAPE

E | This video installation attempted to ask the viewer the following question: what is the relationship between mythology and women's liberation? I was reading a great deal of science fiction at the time, and wanted to create a scenario where the roles of two characters, one from the past and one from the present could meet and be reconstructed: so in DOUBLE TIME, Aquarius met a female Astronaut. In the videotape, the astronaut gave symbolic gifts to the water-bearing Aquarius in a modern cosmic landscape. Afterwards their relation to the element of water allowed them to liberate a poor woman from North Africa. They saved her from her repetitive water-baring work and disappeared with her into the seas of the moon (Animation). In the installation, the viewers could look down into two wells, inside which video screens were set up under-the-water. Alternatively, they could go down the stairs and throw coins into the well. On the wall behind the wells hung a set of large photographs depicting the two rescuers in flight.

D | Diese Videoinstallation sollte das Publikum mit der Frage konfrontieren: Was ist das Verhältnis von Mythologie und Frauenemanzipation? Ich las damals jede Menge Science Fiction und versuchte ein Szenario zu entwickeln, in dessen Rahmen sich zwei Figuren – eine aus der Vergangenheit, eine aus der Gegenwart – begegnen und rekonstruiert werden können. So treffen sich in DOUBLE TIME Aquarius und eine Astronautin. Im Video macht die Astronautin dem wassertragenden Aquarius in einer modernen kosmischen Landschaft symbolische Geschenke. Ihre Beziehung zum Element Wasser erlaubt den beiden, eine in

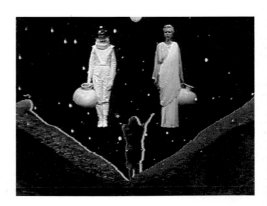

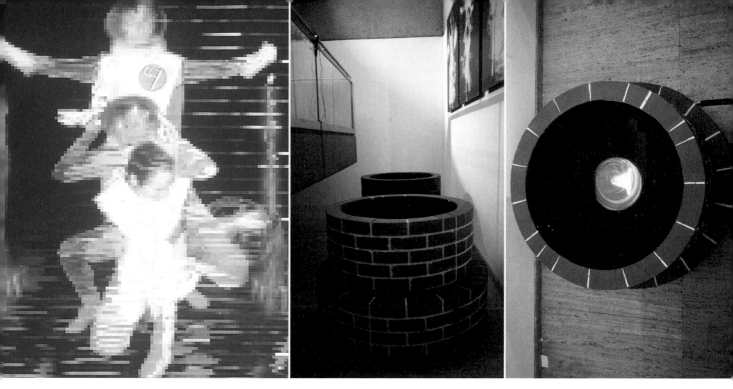

DOUBLE TIME 1986. PERSPECTA, ART GALLERY OF NEW SOUTH WALES, SYDNEY. **1** | INSTALLATION SHOT WITH BALCONY. **2-3** | PHOTOGRAPHS, AQUARIUS AND THE ASTRONAUGHT. **4** | TWO WELLS, BALCONY VIEW. **5** | MONITOR INSIDE WELL PLAYING BACK THE VIDEO TAPE.

Armut lebende Frau aus Nordafrika zu befreien. Sie retten diese davor, immerzu Wasser schleppen zu müssen, und verschwinden mit ihr in den Meeren des Mondes (Trickfilm). Bei der Installation konnte das Publikum in zwei Brunnen hinabblicken, in denen Videobildschirme unter Wasser lagen. Es hatte auch Gelegenheit, die Treppenstufen hinunterzugehen und Münzen in den Brunnen zu werfen. Hinter den Brunnen hing eine Reihe großer Fotos an der Wand, welche die beiden rettenden Figuren im Flug zeigten.

left to right **6-9** | IMAGES FROM THE VIDEO TAPE DOUBLE TIME, 1985.

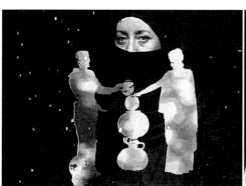
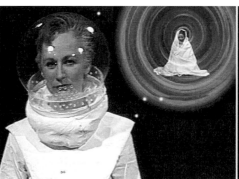
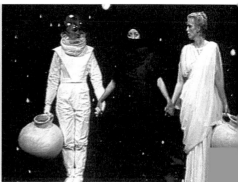

MAGNIFICENT DESOLATION

1985 VIDEOTAPE AND INSTALLATION, 3 MIN.

E | MAGNIFICENT DESOLATION was inspired by the writings of Roland Barthes in "Television Mythologies". I was thinking about his approach in relation to the concept of reality, surrounding the famous television broadcast of the landing on the moon by Neil Armstrong. I thought about this broadcasted first-step on the moon as a mediated symbol of American colonization, and compared this act to the ancient mythologies of the moon as a female symbol of power. In the video when Armstrong made his famous walk and speech on the moon he met a female goddess whose presence threw him off and his famous televised speech turned into a stammer. The famous quote "One Giant Step for Mankind" was hopelessly scrambled.

D | MAGNIFICENT DESOLATION wurde von Roland Barthes Abhandlungen über Fernsehmythologien angeregt. Angesichts der legendären Fernsehübertragung von der Mondlandung musste ich über Barthes Ansatz nachdenken. Mir erschien dieser übertragene "erste Schritt" auf dem Mond als Symbol amerikanischer Kolonisation. Ich setzte ihn in Beziehung zu antiken Mythologien, in denen der Mond als weibliches Machtsymbol aufscheint. Wenn Neil Armstrong in meinem Video seine berühmten Schritte macht und zu reden beginnt, trifft er auf eine weibliche Gottheit, deren Präsenz ihn aus der Fassung bringt. Seine Rede, vom Fernsehen übertragen, endet in einem Gestotter. Das berühmte Zitat "Ein gewaltiger Schritt für die Menschheit" - "One Giant Step for Mankind" - klingt hoffnungslos abgehackt.

MAGNIFICENT DESOLATION 1985. THE AUSTRALIAN CENTER FOR PHOTOGRAPHY, SYDNEY. **1-3** | VIDEO STILLS.

DOUBLE SPACE

1986 VIDEO INSTALLATION AND VIDEOTAPE

E | A close study of the book entitled "The White Goddess" by Robert Graves inspired DOUBLE SPACE. He traced how over times, myths were appropriated and distorted to suit the changing politics of power and control. It was as if there were only a few original myths and all the other western myths were a group of distorted tales changed to suit militant dreams, dominant religions and man's ownership of geographical space. Like another favourite writer of mine, Angela Carter, I wanted to reclaim a new set of metaphors for women, and reappropriate some Jungian symbolical philosophy about the anima and the animus. Therefore, I asked five female artists to each choose an animal they often dreamt about from mythology. A cat, a horse, a wolf, a bird, a fish and a snake were chosen. These animal characters were then woven with appropriated mythologies from history about females and animals like the Witch (cat), Helen of Troy (horse), Red Riding Hood (wolf), Medusa (snake), the Sirens (fish), Vivian (bird) to produce a videotape.

DOUBLE SPACE 1986. ROSLYN OXLEY GALLERY, SYDNEY. from left to right VIDEO STILLS [1] | SNAKE. [2] | WOLF. [3] | SNAKE.

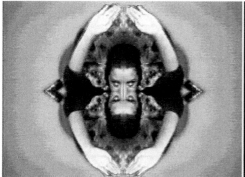
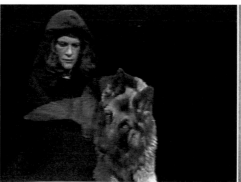
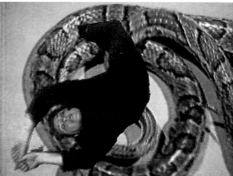

D | DOUBLE SPACE 1986. Eine ausführliche Lektüre des Buches "Die weiße Göttin" von Robert Graves gab die Anregung zu DOUBLE SPACE. Graves zeichnet nach, wie Mythen im Lauf der Zeiten vereinnahmt und verfälscht wurden, um den geänderten machtpolitischen Konstellationen Rechnung zu tragen. Es scheint, als hätte es ursprünglich nur einige wenige Mythen gegeben und als wären viele andere (westliche) Mythen eine Sammlung entstellter Geschichten, die für militante Vorstellungen, dominante Religionen oder zur Rechtfertigung räumlicher Expansion zurechtgebogen wurden. Gleich einer anderen Schriftstellerin, die ich sehr schätze, Angela Carter, wollte ich für Frauen neue Metaphern erfinden und einige Elemente der Jung'schen Symbolphilosophie über Anima und Animus zurückerobern. Deshalb bat ich fünf Künstlerinnen an, dass jede ein mythologisches Tier bestimmt, von dem sie häufig träumt. Gewählt wurden Katze, Pferd, Wolf, Vogel, Fisch und Schlange. Diese Tiercharaktere wurden für das Video mit historischen Mythologien über Frauen und Tiere verknüpft und neu verwendet. Diese sind eine Hexe (Katze), Helena von Troja (Pferd), Rotkäppchen (Wolf), Medusa (Schlange), die Sirenen (Fische) und Vivian (Vogel).

DOUBLE SPACE 1986. ROSLYN OXLEY GALLERY, SYDNEY.
from left to right VIDEO STILLS **4** | HORSE. **5** | BIRD. **6** | SNAKE. **7** | FISH. **8** | CAT. **9** | HORSE. right page **10** | SNAKE.

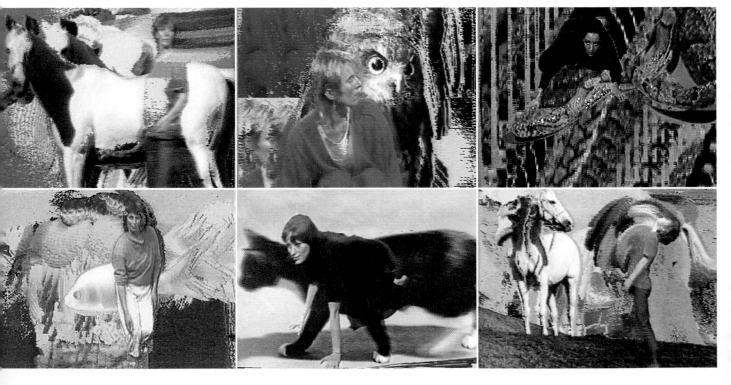

"They say I was tricked by the wolves, but I am a wolf from the underworld and such a guide would never trick herself." **JANIE LAURENCE** | "They say I was a serpent with an apple. But this fall was a gain, the serpent is my son Lucifer and I am the mother Medusa." **JILL SCOTT** | "They say I rode a horse in protest, but I am both Sophie and Helen, a horse in pursuit of the self." **ANN GRAHAM** | "They say I left blackbirds in a pie fit for a king, but I am Vivian, the owl queen and most kings do not realize, the pie and the moon are the same." | **VINETA LAGZDINA** "They say I am patron of the sailor, saboteur of ships, but I liberate those from their faith in their own image, after all I am queen of the fish." **JADE McCUTCHEON** | "They say I rode through the night on a broomstick, but I am patron of magic, cat lady of the subconscious, and playful objects soon become obsolete." **JULIE RRAP**

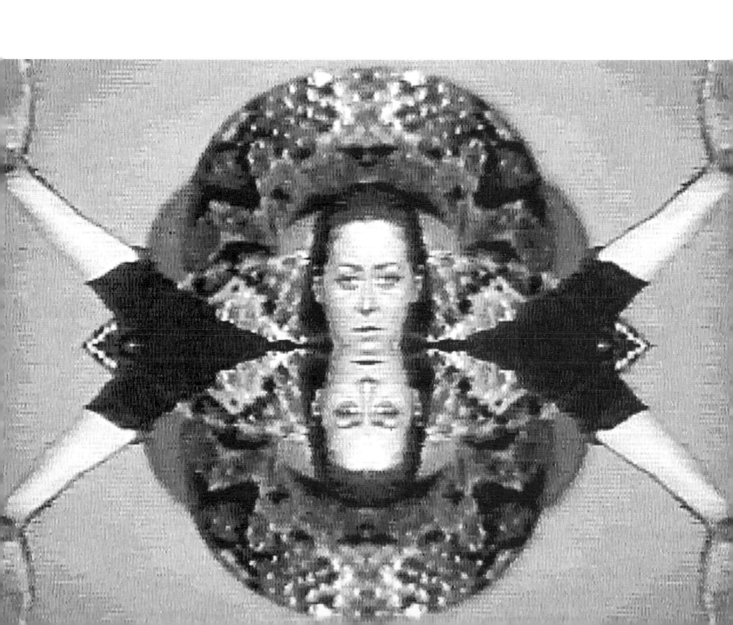

THE GREAT ATTRACTOR, 1988. ARTSPACE, SYDNEY. left **1** | INSTALLATION SHOWING THE VIEWER'S INTERACTIVITY WITH MONITOR. right **2** | LENS AND MONITOR WITH KEPLER'S THEORETICAL DIAGRAM AND SURVELLIENCE IMAGE. **3** | 3-D COMPUTER GENERATED IMAGE – SPRAYED ONTO CANVAS.

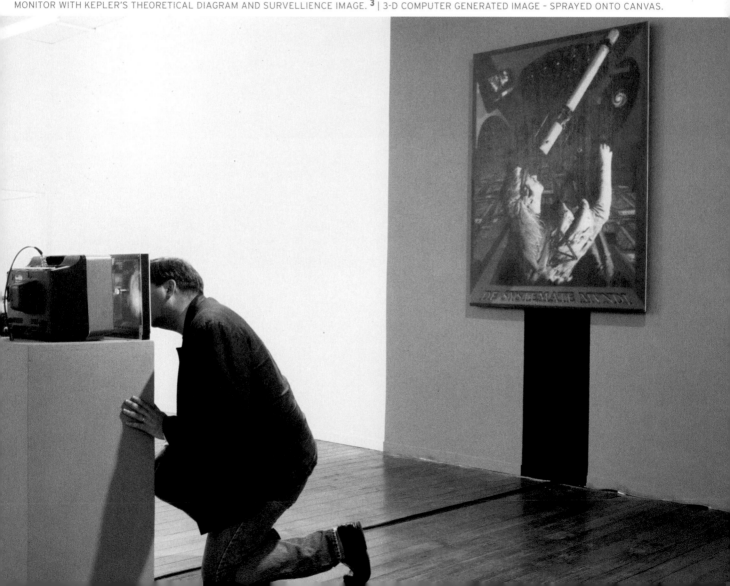

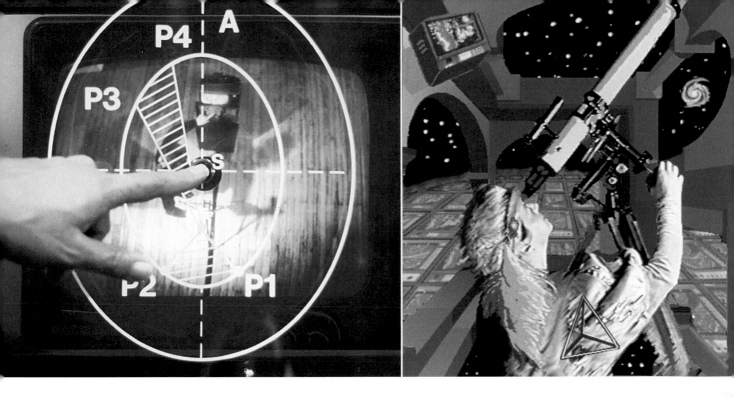

THE GREAT ATTRACTOR

1988 SURVEILLANCE INSTALLATION

E | When the viewers entered the space, they saw a small milky Plexiglas box and – on the opposite side of the room – a large painting of an astro-physicist. The painting depicted myself as a female version of Johannes Kepler, looking through a telescope. In front of the Plexiglas box the viewers could see a diagram from Kepler about the planet's motions in the universe. On the ceiling of the room, a security camera was mounted to record the viewers' behaviour, as they walked between the painting and the glass box. To look into the glass-box the viewers had to bend down in order to see through a tiny fisheye lens. He/she could then see inside the box, where a monitor image of himself or herself was videotaped from above and keyed into a false night sky. The aim was to give the viewer an existentialist experience.

D | Als die ZuschauerInnen den Raum betraten, sahen sie einen milchigen Plexiglaskasten vor einer Seitenwand stehen. Auf der gegenüberliegenden Seite hing ein großes Wandbild von einer Astrophysikerin, die durch ein Teleskop blickte (dargestellt von mir selbst als weibliche Version von Johannes Kepler). Auf der Vorderseite des Plexiglaskasten war ein Diagramm Keplers montiert. Dieses zeigte die Planetenbewegungen im Universum. Durch ein Guckloch konnte man durch das Diagramm hindurch in den Kasten auf einen Monitor schauen, wenn man sich bückte. Man sah dann durch eine winzige Fischaugenlinse auf das Videobild der Überwachungskamera mit dem Publikum von oben in Echtzeit, jedoch elektronisch in einen falschen nächtlichen Sternenhimmel gestanzt. Ich wollte dem Publikum eine existenzielle Erfahrung (in Relation zum Universum) nahebringen.

MEDIA MASSAGE

1989 VIDEO CLIP AND INSTALLATION

E | Like DOUBLE DREAM, this tape was inspired by some aspects of Marshall McLuhan's famous book "The Medium is the Message". I re-read this book, when I was walking in the "Olgas" – in the Central Australian desert: the often-considered female version of "Ayres Rock". Another influence was the newly installed Aussat satellite transmitter with its "footprint" spread over the same desert area. My idea was to attempt to make a work about these two issues. What would happen if women in the desert had the power to manipulate the transmitted message that may be psychologically and physically affecting their bodies on the ground? On the psychological level, media can sedate and seduce us into capitalism; on the physiological level, transmission waves can easily pass though our bodies, which consist of 95 percent water. Consequently, a dancing female shape full of water, tried to catch and direct the symbols and icons of media transmission that came spinning towards her. The lyrics of the song encourage her to control the flow of information. However, a jumping TV screen swallows her and the camera zooms out to show that the staff of the Satellite television station is also monitoring her.

Hay Child at the gate you're never too late,
Those symbols you used to make,
Had a special meaning in the past
Linked to knowledge that should last
It's time to integrate
Steal the formula
Massage the media into a state
Media Massage.
Take the symbol of the ring
It's got such a sting
Hay, that wheel need turning back
Resist the rap
Grab hold of the circuit and solder that gap
It's time to integrate
Steal the formula
Massage the media into a state
Media Massage.
Hay, new circles are a trap,
Definitions have changed
Power has those symbols re-arranged
Don't be a wet cell, create
Don't coil and appropriate
It's not too late
Its time to integrate
Bend the formula
Massage the media into a state
Media Massage.
Oh sister don't sell out
Start again cross it out
Re-create the symbol
Search it out
Its time to integrate
Steal the formula
Massage the media into a state
Media Massage. Media Massage

C. The Dynabytes: 3 min.

D | MEDIA MASSAGE 1989. Wie DOUBLE DREAM verdankt auch dieses Video seine Anregung einigen Gedanken aus Marshall McLuhan's berühmtem Buch "The Medium is the Message". Ich las dieses Buch zum wiederholten Mal während einer Wanderung in der zentralaustralischen Wüste, in den "Olgas" (häufig auch als die weibliche Version von "Ayers Rock" bezeichnet). Eine andere Inspirationsquelle war der neu installierte AUSAT-Satellitensender, dessen Reichweite im gleichen Wüstengebiet lag. Über diese beiden Dinge wollte ich eine Arbeit machen. Was wäre, so fragte ich mich, wenn die Frauen in der Wüste die Macht hätten, die gesendeten Mitteilungen zu manipulieren, die auf ihre Körper psychisch und physisch einwirken? Auf der psychischen Ebene lullen uns die Medien ein; sie verführen uns zum Konsum. Auf der physischen Ebene werden unsere Körper, die zu 95 Prozent aus Wasser bestehen, mühelos von Übertragungswellen durchdrungen. Daher sieht man im Video eine tanzende, mit Wasser gefüllte weibliche Form. Sie versucht die Symbole und Bildzeichen von Medienübertragungen, die sich auf sie zubewegen, zu fangen und zu lenken. Der Songtext fordert sie auf, den Informationsfluss zu kontrollieren. Dann aber wird sie von einem umherspringenden TV-Bildschirm geschluckt. Die Kamera geht auf weite Einstellung, um zu zeigen, dass das Team der TV-Satellitenstation gleichzeitig die tanzende Form beobachtet.

MEDIA MASSAGE 1989. AUGGRAPH ANIMATION FESTIVAL, SYDNEY. from left to right **1** | INTERACTIVE INSTALLATION AT THE HEIDELBERG KUNSTVEREIN, GERMANY. **2-8** | STILL IMAGES FROM THE VIDEOTAPE. doublepage **9** | MOMENT OF RECOGNITION BETWEEN HUMAN AND MACHINE!

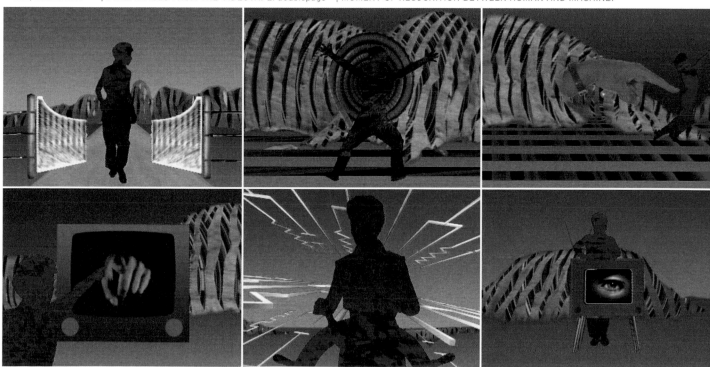

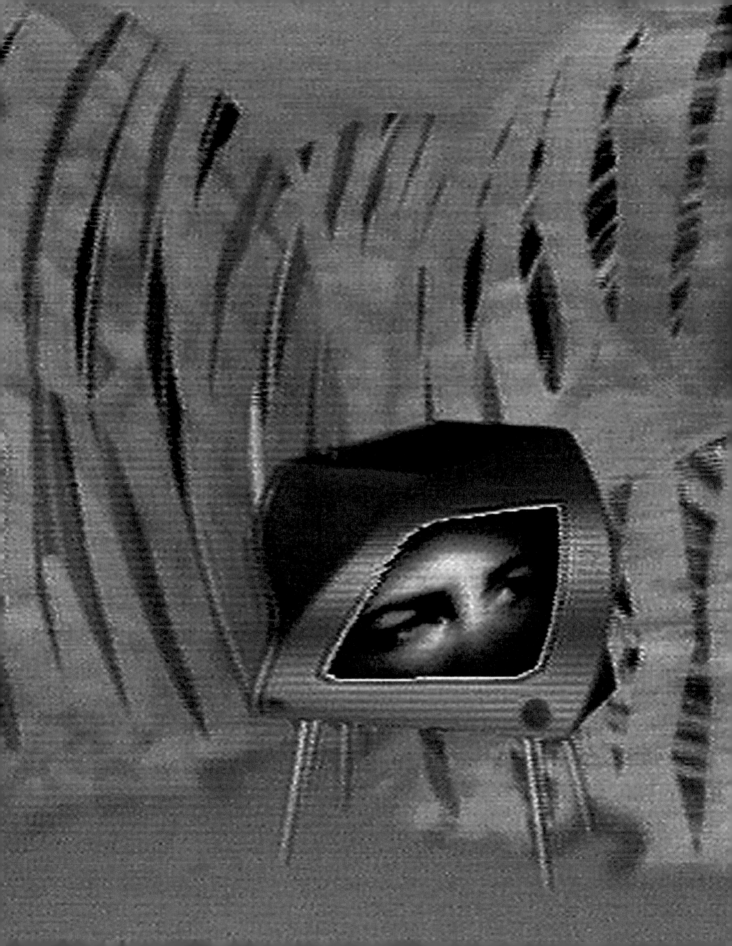

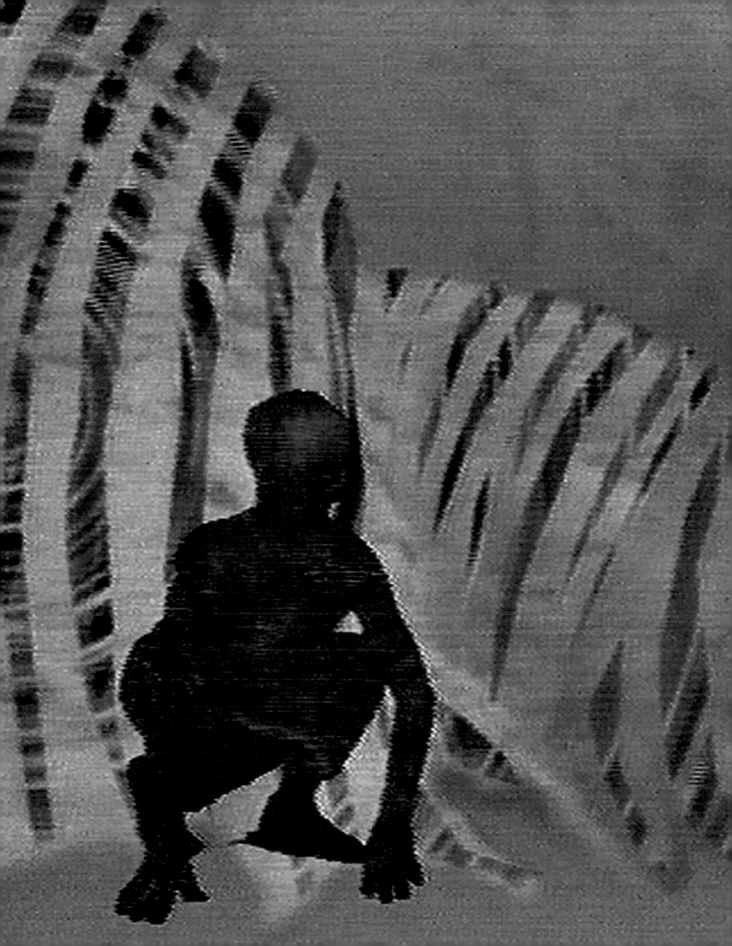

WISHFUL THINKING

1989 VIDEOTAPE

E | From my readings on television and mythology, I slowly realized that there was a real lack of interesting role models on television to identify with, particularly those for young girls. The defining of such a role model became the aim for WISHFUL THINKING, a 30-minute pilot designed as a prototype for a science fiction television mini-series. The aim was to provide girls with a criticism of stereotypical heroines (Wonderwoman, Catwoman) through the eyes of a female replicant-called Zira from Planet X, who had the gifts of bringing graphic representations to life and solving conflicts. The comic-book heroines, who are either running from fear or waiting to be saved or seduced, get confused about their identities. A computer called Jane sustains Planet X, a feminist utopian paradise, and it was Jane who transported Zira into the middle of the Australian desert, where she encountered the comic book heroines. However, a meeting with a real twelve-year-old girl tainted Zira's mission. The girl wants to see her again and this aspect changes the destinies of all the characters. I attempted to enhance the confusion between human reality and Zira's illusions, by superimposing all the characters onto fabricated computer graphic backgrounds or using "motion control" through miniature sets.

WISHFUL THINKING 1989. ROSLYN OXLEY GALLERY, SYDNEY. left **1-2** | INSTALLATION IN THE GALLERY SHOWING THE SETS AND THE STORYBOARD. bottom **3** | ZIRA IN DIGITAL TRANSITION ON PLANET X.

»IN THIS VIDEO, SHE HAS FOUND, EFFORTLESSLY AND UNPRETENTIOUSLY, AN ACTUAL WORKING VIDEO-NARRATIVE, ONE WHICH REALLY MOVES AND BREATHES AND HAS THE CAPACITY TO KEEP RE-INVENTING ITSELF IN A NEW SCI-FI FRAMEWORK.« ADRIAN MARTIN

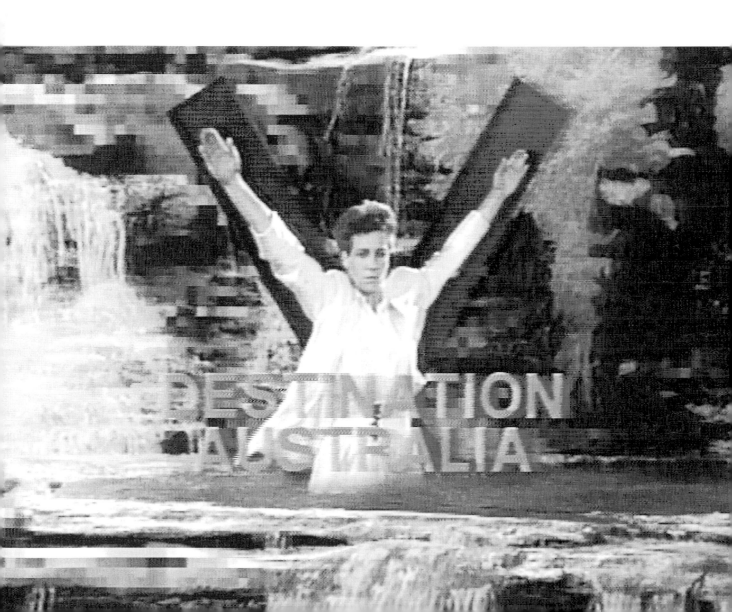

»»WISHFUL THINKING‹ USES DIGITAL VIDEO EFFECTS AS AN INTEGRAL PART OF THE STORYLINE, BRINGING TOGETHER NEW-GENERATION VIDEO TECHNOLOGY AND AN IMAGINATIVE NARRATIVE APPROACH UNLIKE ANYTHING YET SEEN ON BROADCAST TELEVISION.« ROSS GIBSON

WISHFUL THINKING 1989. THE MELBOURNE FILM FESTIVAL. left page **4** | TITLE SEQUENCE. **5** | ZIRA IN DIGITAL WARP-TRANSITION. **6** | ZIRA ON PLANET X. **7** | ZIRS IN TRANSITION ON THE X. **8** | ZIRA'S APPROACH TO AUSTRALIA. **9** | CARTESIAN TOOLS ARE GIVEN TO ZIRA BY THE FEMALE COMPUTER CALLED JANE.

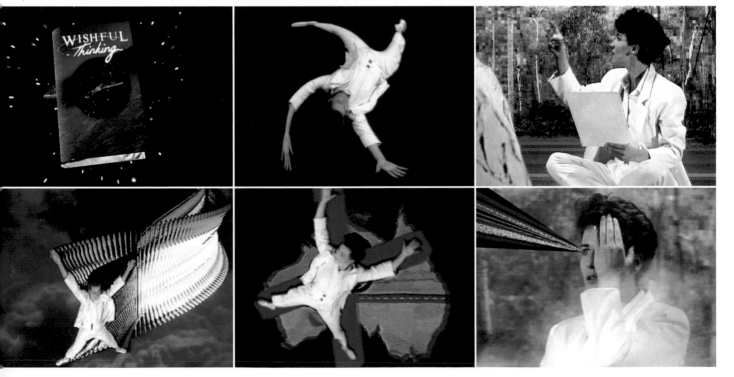

D | WISHFUL THINKING, 1989. Meine Studien über das Fernsehen und über Mythologien machten mir bewusst, dass im Fernsehen ein wahrer Mangel an interessanten Identifikationsangeboten herrscht - vor allem für Mädchen. Der Neuentwurf eines weiblichen Vorbilds wurde zur erklärten Absicht von WISHFUL THINKING, einem 30-minütigen Pilotfilm, der als Prototyp einer kleinen Science-Fiction-Serie für das Fernsehen gedacht war. Durch die Augen einer Replikantin namens Zira, die von einem computerkontrollierten Planeten - dem Planeten X - kam, sollten Mädchen einen kritischen Blick auf stereotype Heldinnen (Wonderwoman, Catwoman) gewinnen. Zira verfügte über die Macht, grafische Darstellungen zum Leben zu erwecken, und setzte diese Macht zur Lösung ethischer Konflikte ein. Die Comic-Heldinnen, die entweder aus Angst flüchteten oder warteten, bis sie gerettet oder verführt wurden, gerieten über ihre eigene Identität ins Unklare. Ein Computer namens Jane organisierte den Planeten X, ein Paradies feministisch-er Utopien. Es war auch Jane, die Zira in die australische Wüste schickte, wo sie die Comic-Heldinnen traf. Durch die Begegnung mit einem zwölfjährigen Mädchen wurde Ziras Mission allerdings zunichte gemacht. Das Mädchen wollte sie gern wiedersehen und manipulierte die Schicksale aller Figuren. Die Verwirrung zwischen der menschlichen Realität und Zira's Illusionen versuchte ich zu unterstreichen, indem ich die Gestaltung der speziellen Hintergründe für meine Figuren dem Repertoire industrieller Computergrafiken anpasste. Außerdem benutzte ich Motion Control (ein programmierbares Kamerasystem für wiederholbare, identische Kamerabewegungen) für die Miniaturszenerien.

right page **10** | ZIRA MEETS THE REAL TEENAGE GIRL. **11** | ZIRA WITH BAT WOMAN AND MS. TREE. **12** | THE SHRINKING COMIC HEROINES. **13** | THE TYPICAL AUSTRALIAN FAMILY. **14** | WONDERWOMAN, OF COURSE! **15** | BAT WOMAN AND MS. TREE COME TO LIFE.

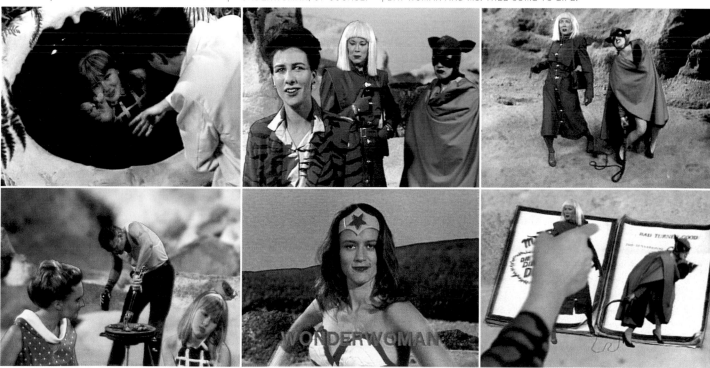

»THE VIEWER IS ›LAYERED‹ INTO THE NARRATIVE, INTO THE FICTIONS OF SCIENCE-FICTION, OF TECHNOLOGY AND OTHER UTOPIAN FLIGHTS - OR IS IT PERHAPS A FLIGHT TO DYSTOPIA? HERE THE VIEWER'S INTERACTION WITH THE WORK BECOMES A MEANS TO INVESTIGATE AND CHALLENGE TECHNOLOGY, MAKING IT IN EFFECT AN ONTOLOGICAL ENTERPRISE.« SALLY COUACAUD

LIFE FLIGHT

1989 INTERACTIVE VIDEO INSTALLATION

E | Susan Sontags' book "Illness, as Metaphor" was the inspiration behind my installation called LIFE FLIGHT. After I had breast cancer, I was interested in those metaphors that affect our decision-making about the choices of cure. On the one hand, there are logical metaphors: statistics, voices of authority and control. On the other hand, there are intuitive metaphors: images of paradise or soft-spoken inner voices of care. As I wanted the audience to experience the extreme stress in deciding about issues of physical health, I attempted to make an installation using blue screen (Ultimatte) technology, to place the viewer either inside a virtual garden or inside the digital pixels of a cold world. There were also stereo speakers installed in the gallery space, which gave the viewer two very different sets of instructions: while one voice invited the audience into paradise, another ordered them about in the space as if they were robots. It was hoped that each viewer could enter the debate physically, and choose their preferred metaphors, but that a sense of indecision would prevail.

LIFT FLIGHT 1989. ARTSPACE, SYDNEY.
top of the page right **1-2** | INSTALLATION SHOTS SHOWING
HOW THE VISITOR IS KEYED INTO THE BLUE SCREEN.
from left to right bottom of page **3-6** | IMAGES VIDEOTAPE.

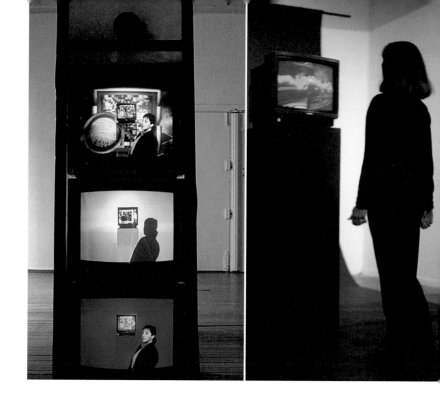

INTUITION versus LOGIC

Come in, relax

I register you, stand by

Lend me your body

Open your receiving apparatus

Your body is your garden

Your paradise is illogical

Move, yes move, just let go

Your body is a mirror of water

Imagine wings extending outwards

No transformation is possible

Raise your left arm in flight

Now fly, undergo sedation

Drugs are not permitted

Swing left or right

Don't overreact.

Yes, react,

You're only a stranger in paradise.

LIFE FLIGHT

D | Susan Sontag's Buch "Illness as Metaphor" gab die Anregung zu meiner Installation LIFE FLIGHT. Nachdem ich Brustkrebs hatte, begannen mich die Metaphern zu interessieren, die unsere Entscheidungsprozesse für oder gegen verschiedene Behandlungsmethoden beeinflussen. Auf der einen Seite stehen logische Metaphern: Statistiken oder Stimmen, die Autorität und Kontrolle vermitteln. Auf der anderen Seite stehen intuitive Metaphern: Bilder des Paradieses oder fürsorgliche sanfte innere Stimmen. Weil ich dem Publikum den extremen Stress nahebringen wollte, der mit Entscheidungen über Fragen zur eigenen Gesundheit einhergeht, konstruierte ich eine Installation auf der Basis von Blue Screen-Technologie (Ultimatte). Hier wurde die BetrachterIn entweder in einen virtuellen Garten oder in die digitalen Pixel einer kalten, sterilen Welt versetzt. Zusätzlich waren in der Galerie Stereolautsprecher untergebracht, die zwei unterschiedliche Anweisungen übermittelten. Während die eine Stimme das Publikum ins Paradies einlud, wurde es von der anderen Stimme wie von einem Roboter angesprochen. Ich wollte, dass jede BetrachterIn physisch in die Debatte einbezogen wurde und ihre bevorzugten Metaphern auswählen konnte, dass aber gleichzeitig ein Gefühl von Unentschiedenheit blieb.

CONTINENTAL DRIFT

1990 VIDEOTAPE

E | CONTINENTAL DRIFT was inspired by my own experience of breast cancer and the choices between Western and Eastern medicine. I wanted to create some metaphors about my choices, diagnosis and treatment during my illness. The breast became a mountain, the drifting earth transformed into the layers of the skin. The tape is divided into four sections-"help", "hope", "growth" and "change". Throughout the narrative water is used as a metaphor - a reassurance against the fear of death. I was at this time influenced by Buddhism and the main image of giving birth to myself on TV was directly inspired by the "White Tara", who was born from a tear of "Avalokitesvara", the Buddha of compassion. She symbolizes long life. I wanted to share the process of healing with other women who have also felt an affiliation with nature during similar ordeals.

D | CONTINENTAL DRIFT wurde durch meine eigene Erfahrung mit Brustkrebs bestimmt und meine Wahrnehmung über die schwierigen Entscheidungprozesse für oder gegen westliche beziehungsweise östliche Heilmethoden. Ich wollte Metaphern finden für meine Entscheidungsmöglichkeiten, aber auch für die Diagnose und Behandlung während der Krankheit. Die Brust wurde zu einem Berg; die sich bewegende Erde verwandelte sich in Schichten meiner Haut. Das Video ist in vier Abschnitte unterteilt: "Hilfe", "Hoffnung", "Wachstum" und "Veränderung". Während der gesamten Erzählung dient Wasser als Metapher, als Versicherung gegen Todesangst. Ich war zu dieser Zeit vom Buddhismus beeinflusst. Das zentrale Bild von CONTINENTAL DRIFT - es zeigt, wie ich mich selbst gebäre - war direkt durch die Gottheit der "Weißen Tara" inspiriert, die aus einer Träne von "Avalokitesvara", dem Buddha der Leidenschaft, geboren wurde. Sie symbolisiert langes Leben. Ich wollte den Heilungsprozess mit anderen Frauen teilen, die unter ähnlich schmerzlichen Umständen eine Verbindung zur Natur verspüren.

CONTINENTAL DRIFT, VIDEO 1990. MONTBELLIARD VIDEO FESTIVAL, FRANCE. from left to right **1-6** | IMAGES FROM THE VIDEO TAPE.

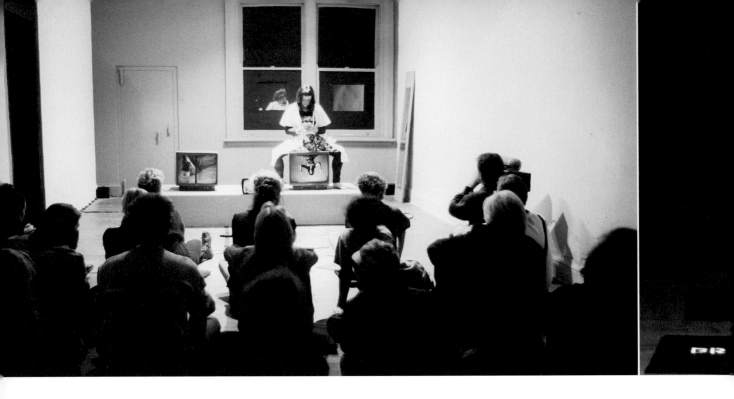

CONTINENTAL DRIFT

1991 PERFORMANCE

E | One of my favourite healing meditations during my illness was to imagine that I could shrink my body down into a microdot and wander around inside my own body. From there I would travel around with a garden-hose and wash out all the cancer cells with fresh water. It was this experience which influenced the performance version of CONTINENTAL DRIFT. On the floors of the spaces where I performed, I drew an abstract shape of my own body. In place of the head stood two monitors (facing the audience like eyes) and a horizontal plank rested on top of them. The performance began with me lying in a hospital gown on top of this plank. When each viewer entered the gallery space, he or she was asked to choose an organ which they felt was weak in their own bodies. Then that viewer had to sit on a floor cushion, one marked for that particular organ. During parts of the performance I was blindfolded, and I struggled down into the space "in my body", where the audience sat. The audience were treated like the cells in my meditation, asking and questioning them to move. As a metaphor for the hose I used a miniature security camera, which via a long cable supplied a direct live-feedback to one of the monitor's "eyes" facing the audience. Any wider physical movements in the space were limited by my attachment to the monitor, and sometimes the camera on my wrist caused me to act like a patient with a hospital drip. There was also a second double-persona in the performance who appeared only as a pre-recorded character on the other monitor. She fluctuated between being an acupuncturist and a western doctor. The idea was to collapse two roles that could symbolize the different eastern and western philosophical approaches.

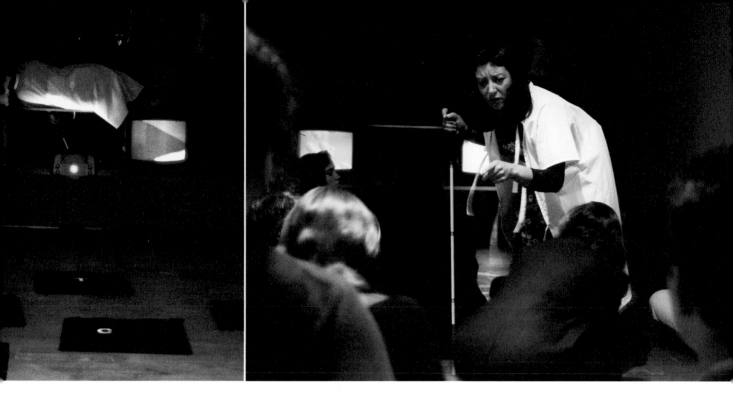

CONTINENTAL DRIFT, THE PERFORMANCE 1990. INSTITUTE OF MODERN ART BRISBANE AND PERFORMANCE SPACE SYDNEY. **1** | GIVING BIRTH TO MY OWN IMAGE. **2** | SETUP AS THE AUDIENCE ENTERS THE SPACE - WITH THE CUSHIONS AS THE PARTS OF THE BODY. **3** | AUDIENCE INTERACTION WITH THE MINIATURE SPY CAMERA. **4** | DIAGRAM OF FLOOR PLAN.

»AT SEVERAL POINTS DURING THE PERFORMANCE SCOTT CAME DOWN INTO ›HER BODY‹ AND ORDERED THE AUDIENCE ABOUT. ›YOU THERE. WHERE WOULD YOU LIKE TO GO?‹ IT WAS QUITE DISCONCERTING, BUT I TOOK THE OPPORTUNITY TO MOVE TO THE BREAST, WHERE, AS I CAME TO SLOWLY REALIZE, LAY THE HEART OF THE PERFORMANCE. AS JILL SCOTT'S QUIET CASUAL TALK AFTERWARDS CONFIRMS, SHE HAS UNDERGONE THE TERRIFYING ORDEAL OF BREAST CANCER. THIS EXPERIENCE ACTS LESS AS A SUBTEXT THAN AS THE ORIGINAL EMPOWERING FORCE OF THE PERFORMANCE. SCOTT'S PER- FORMANCE INVOLVED AN INTENSE INVASIVE INSPECTION OF HER BODY. THIS WAS ACHIEVED THROUGH TECHNOLOGICAL SURVEILLANCE AND THROUGH THE EXTREMELY PERSONAL NARRATIVE – BOTH OF WHICH WERE EQUALLY DISCONCERTING AND CLAUSTROPHOBIC... THE PERFORMANCE IN TOTAL, HOWEVER, WAS EXTREMELY POSITIVE AND LIBERATING. THIS WAS NOT ACHIEVED THROUGH A PRIVILEGING OF SUBJECTIVITY OVER OBJECTIFYING TECHNOLOGY, BUT RATHER THROUGH A SUSTAINED MOVEMENT OF DESIRE (A PLEASURE OF BODIES).« BETH JACKSON

D | CONTINENTAL DRIFT – THE PERFORMANCE 1990. Eine der bevorzugten Heilmeditationen während meiner Krankheit bestand darin, mir vorzustellen, dass ich als winziges Pünktchen in meinem eigenen Körper herumwande- re. Dann würde ich mit Hilfe eines Gartenschlauchs alle Krebszellen mit frischem Wasser ausspülen. Die Performan- ce-Version von CONTINENTAL DRIFT wurde durch diese Erfahrung bestimmt. Ich zeichnete die abstrakte Form mei- nes Körpers auf den Boden des Performance-Ortes. An der Stelle des Kopfes standen zwei Monitore (die das Publikum wie Augen anblickten). Über sie war ein Brett gelegt, auf dem ich zu Beginn der Performance in einem Krankenkittel lag. Jeder Besucher und jede Besucherin, der oder die in den Galerieraum eintrat, sollte ein Organ bestimmen, das er oder sie in seinem oder ihren eigenen Körper für schwach hielt. Dann musste man sich auf ein Bodenkissen setzen, das als dieses bestimmte Organ markiert war. Während Teilen der Performance waren mir die Augen verbunden; ich kämpfte mich in den Raum, "in meinen Körper", vor. Dabei wurde das Publikum in der gleichen Weise adressiert wie ich in meiner Meditation die Zellen adressiert hatte. Sie wurden befragt und aufgefordert, sich zu rühren. Als "Gartenschlauch" benutzte ich ein langes Kabel mit einer kleinen Überwachungskamera an dessen Ende. Die Kamera war an meinem Handgelenk fixiert. Ich richtete die Kamera auf "meine Zellen bzw. Organe", das Publikum. Meine kör- perliche Bewegungsfreiheit war durch die Kamera an meinem Handgelenk in Verbindung zum Monitor eingeschränkt, so dass ich mich manchmal wie eine Patientin bewegen musste, die am Tropf hängt. Das Videosignal der Kamera wur- de direkt über das lange Kabel als Live-Feedback auf einen der beiden Monitore (Augen) übertragen. In der Perfor- mance trat noch eine zweite Person auf dem anderen Monitor in Erscheinung. Diese wurde direkt von einem Video- band eingespielt und ihre Rolle wechselte permanent zwischen zwei Figuren hin und her: einer Akupunkteuse und einer westlichen Ärztin. Damit sollten die unterschiedlichen philosophischen und medizinischen Ansätze des Westens und des Ostens symbolisiert und quasi zu einer Figur verschmolzen werden.

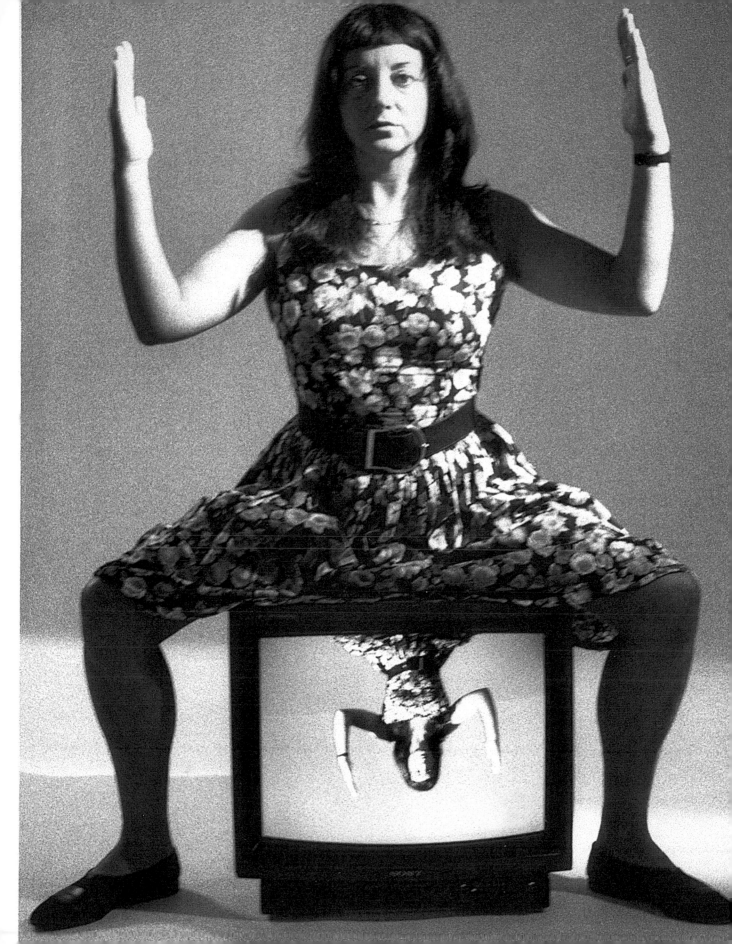

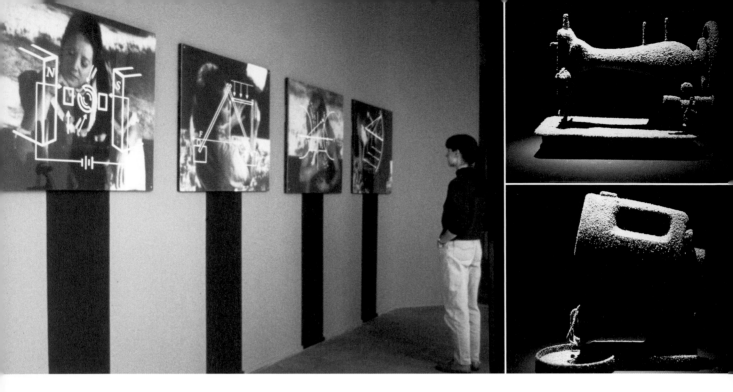

MACHINEDREAMS

1991 INTERACTIVE SOUND INSTALLATION WITH VIRTUAL RECOGNITION

E | MACHINEDREAMS began with a recording of a meeting between four generations of women:-my grandmother (a seamstress), my mother (a secretary), my older sister (a cook), and myself (a communicator). In the recording, my family members talked about how idealistic they had been about technology as a labour-saving device, when actually it made their lives more controlled and more repetitive. Firstly, I computer-montaged images of myself as four different characters; with a sewing machine in 1900, a typewriter in 1930, a Mixmaster in 1960 and a telephone in 1990. I wanted the women to appear distracted by technological utopian dreams, but at the same time prisoners of industrial "progress". Therefore, after the images were computer-generated and spayed onto canvas, I mounted rather cold physics diagrams on Plexiglas over their services. The physics diagrams related to the invention of these same machines. (i.e. electro-magnetism, load and effect engineering, gravity and circular motion, digital satellite transmission) Secondly, I made the installation. Here the viewer can walk around and between the images and real replicas of the machines. As they do so they trigger various sounds with a virtual surveillance detection systems (called 3DIS). These were four factory sounds from the four stages of the industrial "progress", 1900's, 1930's, 1960's, and 1990's, and four nostalgic music loops related to the history of woman and work.

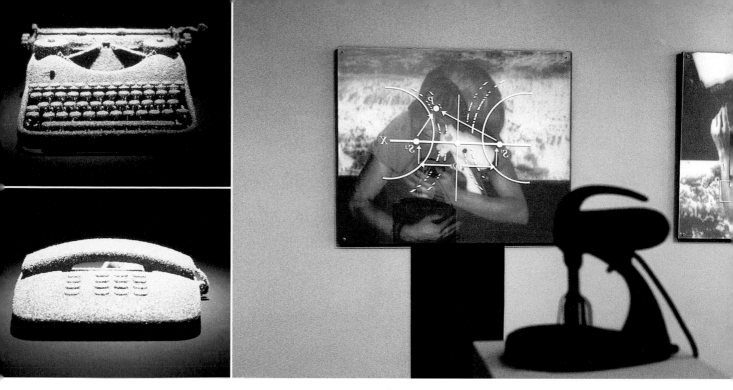

MACHINEDREAMS 1991. THE SYDNEY BIENNALE, AUSTRALIA. from left to right **1** | INSTALLATION WITH MACHINES, IMAGES AND VIEWER INTERACTION. **2-5** | WOMAN'S WORK – MACHINES FROM. 1900 – 1990, SEWING MACHINE, TYPEWRITER, MIXMASTER AND TELEPHONE. **6** | DETAIL OF INSTALLATION.

»THE TEMPTATION TO MAKE THE ARTWORK LIVE IS IRRESISTIBLE, AS ONE BECOMES AN ACTOR IN A TABLEAU WHICH REACTS TO THE MOVEMENTS OF ONE'S OWN BODY... THERE IS AN IRREVERENT AND IRONICAL TWIST IN THE WORK WHICH GENERATES LAUGHTER AS THE AUDIENCE MOVES IN AND AROUND THE OUTDATED IMPLEMENTS OF THE PAST TO CREATE A TECHNO-ENVIRONMENT IN THE PRESENT.« ANNE MARSH

D | MACHINEDREAMS 1991. Am Anfang von MACHINEDREAMS stand die Tonaufzeichnung eines Gespräches zwischen Frauen aus vier Generationen: meiner Großmutter (einer Näherin), meiner Mutter (einer Sekretärin), meiner älteren Schwester (einer Köchin) und mir selbst (einer Künstlerin, die mit Kommunikationstechnologien arbeitet). In der Aufzeichnung sprechen meine Familienangehörigen über den Idealismus ihrer Generation in Bezug auf neue Technologien als Mittel der Arbeitserleichterung. Tatsächlich führten die von ihnen erfahrenen technologischen Fortschritte oft auch dazu, dass ihr Leben stärker kontrolliert und die Arbeitsabläufe monotoner wurden. Zunächst einmal stellte ich eine Computermontage her, die mich in der Gestalt von vier verschiedenen historisch angesiedelten Figuren zeigte: um 1900 mit einer Nähmaschine, um 1930 mit einer Schreibmaschine, um 1960 mit einem Handmixer und um 1990 mit einem Tastentelefon. Ich wollte den Eindruck erwecken, dass die Frauen von Technologie-Utopien träumen, dass sie aber zugleich Gefangene des industriellen Fortschritts sind. Nachdem ich die Bilder computergeneriert und auf Leinwand aufgesprüht hatte, montierte ich auf ihre Oberfläche Plexiglas mit physikalisch-technischen Diagrammen, die einen eher kalten Eindruck erweckten. Diese Diagramme verwiesen auf die Technologien, die den Erfindungen der genannten Maschinen zugrunde liegen (Elektromagnetismus, Schwerkraft und Drehbeschleunigung sowie digitale Satellitenübertragung). Im nächsten Schritt entwarf ich die Installation, in der die BesucherInnen im Raum zwischen den Bildern und den echten Repliken der Maschinen herumgehen konnten. Dabei lösten sie über ein virtuelles Überwachungssystem (genannt 3DIS) verschiedene Geräuschkulissen aus. Diese waren Fabrikgeräusche aus vier Entwicklungsstufen des industriellen "Fortschritts" – 1900, 1930, 1960 und 1990 –, jeweils unterlegt mit nostalgischen Musikelementen aus der jeweiligen Zeit mit Bezug zur Frauengeschichte und Frauenarbeit.

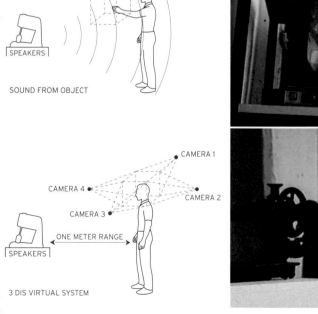

SPEAKERS

SOUND FROM OBJECT

CAMERA 1

CAMERA 4

CAMERA 2

CAMERA 3

ONE METER RANGE

SPEAKERS

3 DIS VIRTUAL SYSTEM

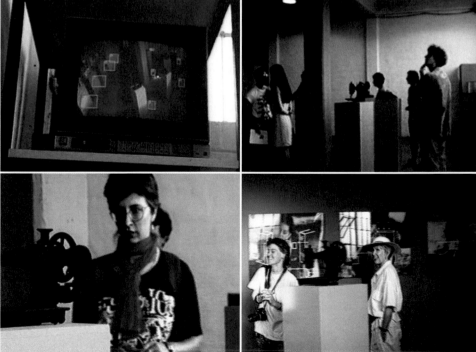

»THIS INSTALLATION IN THE SYDNEY BIENNALE CLEARLY SUGGESTS THAT WOMEN HAVE THE CAPACITY TO BE MORE CREATIVE AND INTUITIVE WITH TECHNOLOGY PARTICULARLY IF THEY ARE ABLE TO HAVE MORE INFLUENCE OVER ITS DESIGN.« COLLEEN CHESTERMAN

»ZWISCHEN TRAUM UND KRITIK PENDELT JILL SCOTTS DREITEILIGE INSTALLATION ›MACHINEDREAMS‹... EINE ASSOZIATIVE VIELFÄLTIGE SICHT DER DINGE, DIE IMMER WIEDER MIT HUMOR ANGEREICHERT, DIE BEDINGUNGEN WEIBLICHEN LEBENS PERSIFLIERT.... SCOTT SCHLÄGT GEWISSERMASSEN EINE AKTIVE – IM FALL DIESER INSTALLATION ›INTERAKTIVE‹ AUSEINANDERSETZUNG MIT DEN ENVIRONMENTALEN UND TECHNOLOGISCHEN BEDINGUNGEN DES LEBENS VOR.« ANDREAS DENK

MACHINEDREAMS 1991. left page **7-8** |TECHNICAL DIAGRAMS. **9-12** | IMAGES FROM THE AUDIENCE INTERACTION. right page **13** | INSTALLATION IN 1994 IN THE KUNST UND AUSSTELLUNGSHALLE, BONN, GERMANY. next doublepage **14** | THE FOUR WORKERS WITH RELATED PHYSICS DIAGRAMS.

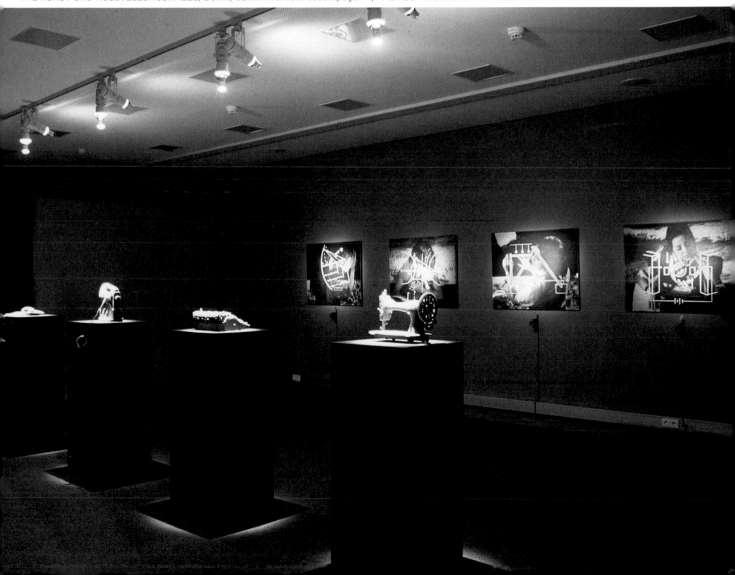

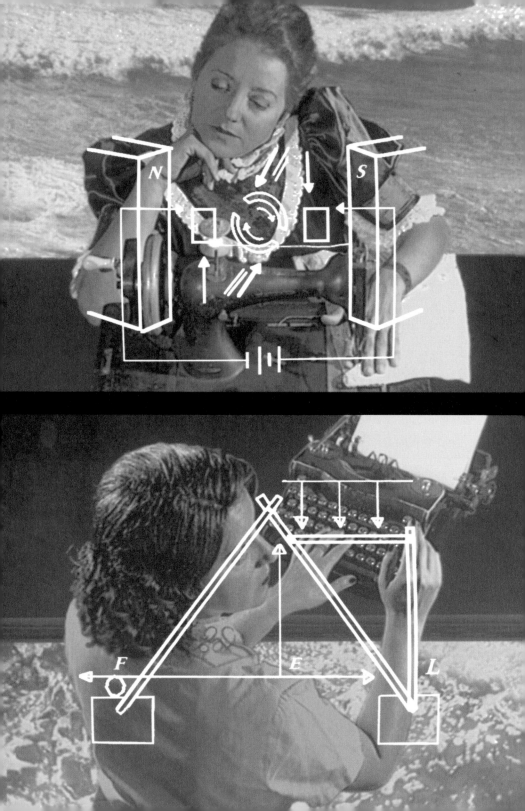

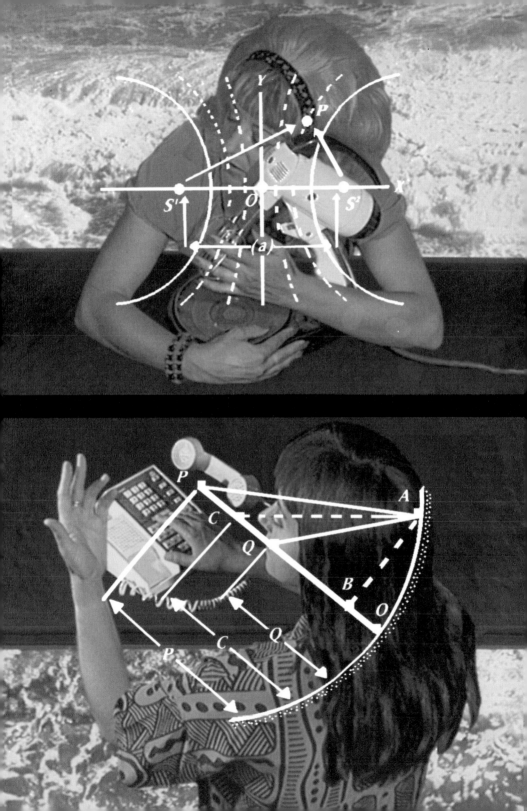

MEDIATED NOMADS

EUROPE 1992 - 2002 |

MEDIATED NOMADS

PARADIGMS OF MIXED REALITIES AND COMPUTER ART (EUROPE 1992-2002) BY JILL SCOTT

E | MEDIATED – to act as intermediary agent in bringing, effecting, or communicating; to transmit as an intermediate mechanism or agency. To have transitive senses, to be incorporated by media, televisual literacy. – NOMADS – a member of a people who have no fixed residence but move from place to place usually within a well-defined territory – an individual who roams about easily in both real and virtual worlds.

In the nineties, media artists in Europe soon realised that they either needed the collaboration of programmers and/or to learn about programming themselves in order to help the audience to think along with the medium. We wanted the audience to become Mediated Nomads, wandering within the non-linear territory of the computer's electronic memory. Although the computer was used extensively in the eighties in scientific circles for programming databases, and artists had used 3-d animation and special effects, in the nineties visual artists began to realise that the tool could be used as an ideal non-linear storage device for synchronised and symbiotic, social and spatial trans-

mit ProgrammiererInnen angewiesen waren und/oder selbst das Programmieren erlernen mussten, um dem Publikum ein Denken innerhalb von computergestützten Kunstwerken zu ermöglichen. Wir wollten, dass sich unser Publikum zu Mediated Nomads (mediatisierten Nomaden) entwickelt und sich im Computer innerhalb seines nicht-linearen Territoriums von elektronischen Speichern zu bewegen lernte. Obwohl Computer in den achtziger Jahren in der Wissenschaft extensiv für die Programmierung von Datenbanken eingesetzt wurden und bildende KünstlerInnen bereits mit 3-D-Animationen und Spezialeffekten gearbeitet hatten, begannen diese erst in den neunziger Jahren zu realisieren, daß die Tools als ideale nicht-lineare Speichermedien für synchronisierte und symbiotische, soziale und räumliche Transformationen genutzt werden konnten. Das Publikum konnte in diesem Medium mit "Multiple-Choice" durch Zeit und Raum navigieren und mitunter sogar zu MitgestalterInnen werden. In der Folge entstanden Arbeiten in Kunst und Design, die mit dem eher problematischen Begriff "Neue Medien" bezeichnet wurden (was implizierte, dass alles andere "alte" Medien waren). Tatsächlich neu war sicher unser erklärtes Ziel, eine Art idealistische, autonome Zone zu kreieren, in der die BesucherInnen ihren Körper in einem anderen Zustand erfahren konnten. In dieser bis dahin unbekannten Techno-Zone konnten die

Körper nicht bloß "hier und dort" sein – wie in den siebziger Jahren – oder verwandelt und zeitlich und räumlich versetzt sein – wie in den achtziger Jahren – sondern sie konnten nun auch virtuell überall gleichzeitig auftauchen, unabhängig von Zeit und Raum.

In Deutschland treffen wir in den neunziger Jahren auf technische Entwicklungen, die die Sehnsucht nach erweiterten Körpererfahrungen beeinflussten. Hier war das Jahrzehnt gekennzeichnet von einer gewaltigen Ausbreitung globaler Telekommunikation und dem Internet. Manche KünstlerInnen besaßen bereits Zugang zu den "Neuen Technologien", als sich diese noch in der Entwicklungsphase befanden. Das ermöglichte ihnen, neue Formen der Darstellung zu erfinden und den Bildschirm gewissermaßen zu sprengen. Glücklicherweise bewegte ich mich im Umfeld dieser Gruppe und erhielt so Unterstützung bei meinen Versuchen, metaphorische Paradigmen vermischter Realitäten zu kreieren. Die Experimente stützten sich auf Anstrengungen, sowohl den physischen und virtuellen Körper, in neuen Strukturen, architektonischen Modellen und ähnlichen Systemen zu intergrieren. Während in Deutschland auch politisch ein Zusammenwachsen in Bezug

formation. With such a medium the audience could travel along with multiple choices and perhaps even become collaborators. Although consequential artworks and design works were called by the problematic term of "New Media" (implying that everything else was "old" media), one of the aims was to create a type of idealistic autonomous zone, where the audience would find their bodies evolved into a different state. This was a new techno-zone, where the viewers' bodies were not only here and there as in the seventies, or decayed/delayed as in the eighties, but were also able to be virtually transported everywhere simultaneously, without regards to time or space.

In Germany, some influences on this desire are worth mentioning. Here, the nineties became the decade of a massive increase in global telecommunications and the Internet. Some artists had access to these technologies as they developed, and this helped to invent new experimental representation and expand the screen. I was lucky enough to be in the same wave of these influences which helped to build metaphorical paradigms of mixed realities. This research was dominated by an effort to incorporate both the physical and the virtual body into new patterns, architectural models and related examples. Along with the idea of the European Union, people were asked to become more interested in the potential of shared metaphors and the crossing of geographical boundaries.

auf die Europäische Union forciert wurde, waren die Menschen aufgefordert, sich noch intensiver mit den Möglichkeiten gemeinsamer Metaphern und der Überschreitung von geographischen Grenzen zu beschäftigen.

Gleichzeitig fanden PhilosophInnen in Deutschland zunehmend neue intellektuelle Ansätze bei den französischen TheoretikerInnen. Viele meiner KollegInnen lasen Gilles Deleuze und diese Lektüre eröffnete neue Erkenntnisse zu Fragen bezüglich von Identitäten. Hier ließen sich auf besonders eindrucksvolle Weise die sich ändernden künstlerischen Interpretationen nachzeichnen. Wir waren dabei unsere Identität bezüglich verhaltensbezogenen Existenzen, der Körperrealität ("corporeality") sowie unsere Reflexionen von - und infolgedessen auch den Vergleich mit - anderen Körpern in Raum und Zeit zu überprüfen. In den späten neunziger Jahren waren Worte wie "bionisch, generisch, genetisch und interdependent" für jene von uns zu kontroversen Begriffen geworden, die sich in beiden, der realen und der virtuellen Welt zu bewegen wussten. Die Bühne entwickelte sich zu einer hybriden Umgebung, die das Publikum mit vermischten Realitäten internationaler Diskurse als mediatisierte und informierte MitgestalterInnen umgab. Die Repräsentation des Publikums konnte entweder in einer direkten Abbildung bestehen und/oder stellvertretend durch persönliche digitale Agenten und Agentinnen stattfinden, die die Wünsche der BesucherInnen kannten, entsprechend diesen nach Antworten suchten und Kontakte vermittelten, um sie zu erfüllen. Das Kunstwerk konnte sich zu einem endlosen Prozess entwickeln,

At the same time, Germany's philosophers renewed their interest in the new evolutions of French theory. For many of my colleagues, reading the work of Gilles Deleuze provided an exploration into the realm of identity, which perhaps best illustrated the shift in our artistic interpretations of behavioural existence and corporeality, as well as revised our reflection of and, hence, comparison with other bodies in space and time. By the late nineties, the words, "bionic, generic, genetic and interdependent" had become controversial items for those of us who roamed about easily in both worlds, the real and the virtual. The stage became a hybrid environment where the mixed realities of international dialogue immersed the audience as a mediated and informed collaborator. Their representations could be either direct reflections and/or personalised digital agents who could know what you like, hunt for it and put you in contact with others to find it. In this way an artwork could be an endless process where the author loses trace of the project in cyberspace. For example in a project like FUTURE BODIES (1999/p. 190), finishing the concept is hard to imagine, as the continuous evolution of the characters is an essential nomadic part of the content.

By the mid-nineties, at the ZKM (The Centre for Art and Mediatechnology) in Karlsruhe, Germany, the focus was to create a laboratory for the transformation of the somatic and interactive roles of the viewer and to break with the traditions of the represented image on the screen. Invited artists, such as myself, attempted to invent new interfaces, which used multiple-choices and offered new spatial/temporal perspectives. These included the senses of touch, sound, visual perception and the combination of associative metaphors. For media artists like Jeffery Shaw and Agnes Hegedüs, the aim was to place the viewer in the role of both nomad and collaborator, and it was this factor which increased the characterisation of the body to be seen as an interface or a tool to explore the screen-space. In the virtual reality experience of INTERSKIN (1997/p. 176), for example, I attempted to expand on this theme, by involving the collaborator in a special dramaturgy about a search for their own ideal inner body by nomadically wandering through three-dimensional body organs with a doctor's torch.

For interactive media artists, many theoretical discussions have emerged from this particular idealistic goal, as this goal encompasses the desire to be immersed into the image-centre-stage, an incorporated entity to be not only digitally manipulated but also somatically

bei dem sich die Spuren des Projektes für den/die AutorIn im Cyberspace verloren. Zum Beispiel ist es für eine Arbeit wie FUTURE BODIES (1999/S. 190) Teil der Anlage, dass das Konzept kein Ende fixiert, denn die kontinuierliche Entwicklung der Charaktere scheint ein wesentlicher nomadenhafter Bestandteil dieser Arbeit zu sein.

Mitte der neunziger Jahre begann man am ZKM (Zentrum für Kunst und Medientechnologie) in Karlsruhe mit der Einrichtung eines Labors zur Erforschung möglicher Transformationen von somatischen und interaktiven Rollen des Publikums, um die traditionellen Darstellungen auf dem Bildschirm zu hinterfragen. Zusammen mit anderen GastkünstlerInnen befasste ich mich mit neuen Interfaces und versuchte mit "Multiple-Choice-Verfahren" neuartige räumliche und zeitliche Perspektiven zu erfinden. Das implizierte den Tastsinn, die audio-visuelle Wahrnehmung und eine Kombination aus assoziativen Metaphern. MedienkünstlerInnen wie Jeffrey Shaw und Agnes Hegedüs arbeiteten daran, die BesucherInnen gleichzeitig in die Rolle des Nomaden und einer MitgestalterIn zu versetzen. Daraus entwickelte sich die Charakterisierung des Körpers als Interface oder Tool zur Erfassung des Bildschirmraums. Bei den Experimenten mit virtueller Realität, zum Beispiel bei INTERSKIN (1997/S. 176), wollte ich diese Thematik erweitern, indem ich den MitgestalterInnen eine bestimmte Rolle der Dramaturgie zuwies. Auf der Suche nach einem persönlichen Ideal vom eigenen inneren Körper bewegten sie sich nomadenhaft durch die dreidimensionalen inneren Organe wie ein Endoskop bei einer medizinischen Untersuchung.

Für interaktive MedienkünstlerInnen lassen sich viele theoretische Diskussionen von diesen idealistischen Vorstellung ableiten, denn in ihnen äußert sich die Sehnsucht, im Bildmittelpunkt einer Bühne plaziert zu sein, integriert zu einer zusammengefügten Einheit, die nicht nur digital manipuliert, sondern auch somatisch verbunden ist. Eventuell nehmen die MitgestalterInnen die von dem/der KünstlerIn erdachte Rolle einer AgentIn oder KommunikatorIn an, oder sie teilen mit anderen mediatisierten Nomaden Probleme. Oft werden die Wörter "void" oder "sphere" benutzt, um die geforderte Intensität von einem vollkommenen Eintauchen (der Immersion) der BetrachterIn bei der Reise im Bildschirmraum zu beschreiben. Donna Haraway nennt dies das Syndrom des "modernen Cyborgs", dessen mediale Infiltration in unser Alltagsleben zu einer permanenten Rekonstruktion unseres selbst geführt hat. Wie viele ist auch sie beunruhigt darüber, dass der Sprachduktus, mit dem im Journalismus die Ziele der Medien gelegentlich beschrieben werden, viel zu technologisch-utopisch und wissenschaftlich elitär geworden ist. In letzter Zeit haben MedienkünstlerInnen in Europa wie das "Old Boys Network" und andere cyber-

The ability to "think" constitutes a life form!

PLAYER 1 MODERATOR PLAYER 2

DOCTORS TORCH INTERFACE

PROJECTION

2 | INTERSKIN (1997) – THREE TELEPHONE BOOTHS. BASED ON THE "TURING TEST" (1956), AN IMITATION GAME PLAYED BY TWO PERSONS + ONE COMPUTER: (A) WOMAN AND (B) MAN AND (C) COMPUTER. THE COMPUTER IS THE MODERATOR, IT ASKS: "WHO IS THE WOMAN?", "HOW MANY IDENTITIES ARE THERE IN ONE BODY?", "IN EVERY BODY – THERE IS ANOTHER BODY STRUGGLING TO GET OUT." (FREUD).

altered. Perhaps they assume the role of agent, channel, or communicator that the artist has planned for them or simply solve problems over the net by being part of a moving calculator with other Mediated Nomads (viewers). Often the words "void" or "sphere" are used to describe the type of required level of immersion of the viewer in this evolving screen-space voyage. Donna Haraway refers to this as the syndrome of the "modern cyborg", whose infiltration of media into our daily lives has caused our permanent reconstruction. Along with others, she is concerned that the atmosphere of the language used to describe the aims of the media in journalism has become too technologically utopian and scientifically elitist. Recently, female media artists in Europe, such as the "Old Boys Network" and other cyberfeminist groups have suggested that new words have to be found which attempt to describe our desires for physical expansion and the loss of the material body in a techno-stage of timelessness. Perhaps some thematic and focused level of dramaturgy could help to create more interior landscapes where abstracted interpretations and non-linear metaphors of time could float freely! In IMMORTAL DUALITY (1997/S. 184), I attempted to use the viewer's own shadow as a metaphorical object, in order for him or her to discover an idealistic set of represented images about current biotechnological manipulation. Here

feministische Gruppen eine neue Terminologie eingefordert, um unsere Sehnsucht artikulieren zu können nach einer physischen Expansion und einem Ablegen des materiellen Körpers innerhalb einer technologischen Umgebung von Zeitlosigkeit. Eine gewisse thematische Konzentration auf dramaturgische Aspekte könnte möglicherweise dazu beitragen, innere Landschaften zu entwerfen, in denen abstrakte Interpretationen und nicht-lineare Metaphern von Zeit frei fließen können. Bei IMMORTAL DUALITY (1997/S. 184) versuchte ich den Schatten des Publikums als metaphorisches Objekt einzusetzen. Das Publikum konnte zwei Monitorwänden entlang laufen und in Echtzeit mit dem Schatten ihrer Körper ein Wandbild entschlüsseln, das aktuelle biotechnischen Manipulationsmöglichkeiten thematisierte. Analog den Schattenbewegungen der BesucherInnen auf der Monitoroberfläche wurden momentan Teile des Wandbildes freigelegt. So konnten die BesucherInnen Bilder zu ethischen Themen der Gegenwart sichtbar machen, die sich mit der biotechnischen Manipulierbarkeit des zukünftigen menschlichen Körpers beschäftigten. Das Wandbild benutzte dazu Begriffe, wie sie häufig in der Werbesprache verwendet werden: "kontrollieren, reduzieren, verbessern, retten und heilen."

Ein weiterer Ansatz war, durch den Einsatz interaktiver Dialoge die Mensch-Maschine-Kommunikation auszubauen. Was würde passieren, wenn Mediated Nomads (das Publikum) direkt mit den abgebildeten Charakteren oder Digital Beings

one's movements reveal ethical issues about the future of the human body, which is often packaged in the language of advertising: to control, to reduce, to improve, to save and to cure.

Another possibility was to think about the concept of communication between humans and machines by using interactive dialogue. What would happen if Mediated Nomads (viewers) met up with represented characters or Digital Beings? In the interactive installation A FIGURATIVE HISTORY (1997/p. 168), the aim was to allow for a didactic, animated group of screen-characters and their viewers to metaphorically meet up. Here, the actual water in the body of the viewer was seen as the element which closed the gap – literally and metaphorically, causing the triggering of the non-linear segments of the narrative from each character.

As in the Internet, the viewers have to converse in order to get the characters to meet each other and this may connote a new socio-linguistic experiment. Naturally the viewers' cognitive associations must be considered. Can their desires for transformation be extended by the novelty of touching other viewers in the space? Do they feel mechanically more connected to the sculptural interfaces if the interfaces are in turn part of the characters' histories? In FRONTIERS OF UTOPIA (1995/S. 158), eight women can communicate together about their types of collective desires, political and shifts in western cultural history. In order to cause this to happen, the viewer uses the photo-interface of the characters eating dinner together. In another interface "unlocking" the objects in the screen-characters' personal suitcases reveals related memories on the screen.

For media artists the use of computers has shifted the space of the stage to include a three-way communication: viewer with other viewers, audience with the screen/object/character and the screen characters with each other. In BEYOND HIERARCHY? (2000/p. 192) the architectural stage is a crossed-time-zone where immersion, transformation and manipulation of object, viewer and represented character can live in a mixed reality together. Further the viewer is asked to embark on a time-travel experience which places the viewer in

A FIGURATIVE HISTORY (1997/S. 168) bestand die Möglichkeit für die einzelnen BesucherInnen den Bildschirmcharakteren methaphorisch zu begegnen. Hierbei benutzte ich das Wasser im Körper der BenutzerIn zu dem Element, das die Lücke zwischen realen und virtuellen Figuren schließen konnte – als Substanz und Metapher zugleich. Die Berührung der Interfaces an zwei Stellen löste nicht-linear narrative Filmsegmente von den einzelnen Bildschirmcharakteren aus. Wollte man jedoch, dass sich die fünf Bildschirmcharaktere untereinander treffen, so mussten – wie im Internet – mehrere BenutzerInnen gemeinsam agieren. Man könnte dies durchaus als ein neuartiges sozio-linguistisches Experiment bezeichnen. Selbstverständlich müssen dabei die kognitiven Assoziationen der BesucherInnen berücksichtigt werden. Kann ihre Sehnsucht nach Transformation gesteigert werden, indem die Berührung anderer BesucherInnen im Raum möglich wird? Fühlen sie sich auf eine mechanische Weise mehr verbunden mit den Interfaceskulpturen, wenn diese ihrerseits Teile der einzelnen Geschichten der Charaktere darstellen? Bei FRONTIERS OF UTOPIA (1995/S. 158) können acht Frauen miteinander über ihre unterschiedlichen Sehnsüchte, ihre politischen Ansichten und den Wandel unserer Kulturgeschichte aus ihrer Sicht kommunizieren. Damit dies geschehen kann, benutzen die BetrachterInnen das Photo-Interface, das die acht Frauencharaktere bei einem gemeinsamen Dinner abbildet. Mit einem anderen Interface können persönliche Erinnerungen der einzelnen Frauen offengelegt werden. Dazu berührt man mit einem Schlüssel die Gegenstände, die in den persönlichen Koffern der Bildschirmcharaktere liegen.

Für die MedienkünstlerInnen hat der Einsatz von Computern den Bühnenraum insofern verändert, dass hier drei verschiedene Formen der Kommunikation stattfinden können: erstens, die Kommunikation des Publikums untereinander; zweitens, die Kommunikation des Publikums mit dem Monitor/Objekt/Bildschirmcharacter; und drittens, die Kommunikation der Bildschirmcharactere untereinander. Bei BEYOND HIERARCHY? (2000/S. 192) ist die architektonische Bühne ein Schauplatz über verschiedene sich kreuzende Zeitzonen des zwanzigsten Jahrhunderts, wo Immersion, Transformation sowie die Manipulation von Objekten, BesucherInnen und die abgebildeten Charaktere in vermischten Realitäten zusammen existieren. Zusätzlich werden die BesucherInnen animiert, sich auf die Erfahrung einer Zeitreise einzulassen, die sie in unterschiedliche metaphorische Rollen versetzt wie beispielsweise die der ArbeiterInnen oder die der Bosse. Vielleicht können die Interfaces oder "Smart Sculptures" nicht nur als Gedächtnishilfen fungieren, sondern der BesucherIn auch die Möglichkeit erschließen, bestimmte Rollen als integrierter Bestandteil des Inhalts zu übernehmen.

various metaphorical roles such as co-worker or of the boss. Perhaps the interfaces or "smart sculptures" can not only become memory supports but also allow the viewer to role-play as an integrated part of the content.

Further, the use of the computer has shifted the relationship between cultural memory and electronic memory, an influential issue also addressed by the late Czech philosopher, Vilém Flusser. The Internet and networking has embedded and embodied the human nomad, cohesing him or her into a team of viable memory-tracers, with the potential to connect to interactive communities and uncensored news. It is a place for artistic software such as Linux to be developed as an open source project, but also a memory pool, where new concepts about interfaces and metaphors about transformation and idealism can be shared.

For the media artist, time, object, process, the represented character and the performative roles of the viewer have been bundled together to redefine the Mediated Nomad. The territory for roaming seems endless, as in the nineties the word "site" implied a breakdown of all borders and identification barriers. In addition, the influences of biotechnology have also shifted the concept of the human body, one which incorporates virtual (digital), organic (material) and mechanised (artificial) components. Perhaps this later aspect raises new ethical questions for the media artist! Although this combined new definition of the body includes interesting aspects such as the unpredictable, wet, sensual and biological organic fluid of the human sensorium, it may require media artists to rethink the definition of media itself, one which includes molecular materials and tools. The challenge also embraces novel approaches to content and the design of contro-

Darüberhinaus haben Computer zu einem veränderten Verhältnis zwischen kulturellen und elektronischen Erinnerungen geführt. Mit diesem wichtigen Thema hat sich auch der Tschechische Philosoph Vilém Flusser in seinen letzten Lebensjahren auseinandergesetzt. Das Internet und die Netzwerke haben menschliche Nomaden "embedded und embodied" und sie mit einem Team von lebensfähigen "memory-tracers" verbunden. Dadurch wurde der Austausch mit interaktiven Gemeinden und Zugang zu unzensierten Informationen ermöglicht. Hier ist auch der Ort für Softwaregestaltung von KünstlerInnen, für Computerprogramme (wie z.B. Linux), die als Open Source Projekte entwickelt werden können. Vielleicht können auch Memorypools geschaffen werden, um neue Konzepte zu gestalten, die sich auf Themenbereiche wie Transformation und Idealismus beziehen.

Für MedienkünstlerInnen haben sich Zeit, Objekt, Prozess, die abgebildete Figur und die performative Rolle des Publikums miteinander verknüpft, um den mediatisierten Nomaden neu zu definieren. Das Territorium, das dabei durchwandert werden kann, scheint endlos; der Begriff "site" implizierte neu eine Aufhebung aller Grenzen und Identifikations-Schranken. Zusätzlich haben Einflüsse der Biotechnologie das Konzept des menschlichen Körpers nachhaltig verändert und virtuelle (digitale), organische (materielle) und technische (künstliche) Komponenten im Körper integriert. Diese Entwicklungen könnten neue ethische Fragen für die MedienkünstlerInnen aufwerfen. Obwohl die kombinierte neue Definition des Körpers interessante Aspekte beinhaltet wie die Berücksichtigung der unbestimmten, feuchten, sinnlichen, biologisch-organischen Körperflüssigkeiten des menschlichen Sensoriums könnte dies von MedienkünstlerInnen verlangen, auch die Medien an sich neu zu definieren, so dass sie auch molekulare Materialen und Tools beinhalten. Diese Herausforderung impliziert auch neue inhaltliche Herangehensweisen und die Gestaltung kontroverser Wahlmöglichkeiten für das Publikum. Könnte vielleicht unser Resultat noch symbiotischer sein – in Form eines Aufeinandertreffens von Paradigmen, einer Serie vermischter Realitäten – ein Resultat, das dem Publikum gleichzeitig zwei Rollen überträgt, diejenige der KritikerIn und der EditorIn?

PARADISE TOSSED

1993 INTERACTIVE COMPUTER ANIMATION

E | The title of PARADISE TOSSED plays on Milton's poem – "Paradise Lost". I wanted to explore the tenuous relationship between design and desire in particular time zones. Are utopian worlds of clean and crisp interior design exaggerated by 3-D animation in television commercials? Were such worlds used as a tool of seduction to induce technological utopia into the minds of women? In the installation viewers of PARADISE TOSSED could simply touch the screen to enter dream homes from four different eras: Art Noveau, Art Deco, Pop Art and Space Age, by selecting 3-D animations. Here they could experience the 20th century history of design in architecture, domestic technology and transport. In related animations I tried to question if the concept of design is a tool in itself or just another form of commercial manipulation. Viewers are helped through the interactive process by audio-visual and text prompts, such as hand gestures that mirror technological change and historically relevant music. Viewers can also watch little histories of domestic labour saving devices, which not only attempt to show the evolution of the machine-human interface, but also the roles of women in the domestic workplace.

PARADISE TOSSED 1993. ARS ELECTRONICA, LINZ AUSTRIA. below **1-6** | IMAGES FROM THE 3-D ANIMATION, ART NOUVEAU (1900'S) ART DECO (1930'S) POP ART (1960'S) AND SPACE AGE AESTHETICS (1990'S). left page **7** | MAIN MENU BEFORE CHOICES TAKE PLACE.

»UTOPIA IS BUILT ON THE GREAT DIVERSITY OF HUMAN PROPENSITIY AND GIFT, IT MUST BE IN TERMS OF MODERN INFORMATION THEORY, REDUNDANT ENOUGH TO CATCH THE DEVELOPED IMAGINATION OF EACH DIFFERENT MEMBER OF SOCIETY.« MARGARET MEAD

STEP INTO THE HOME OF YOUR DREAMS!

D | PARADISE TOSSED 1993. Der Titel PARADISE TOSSED ist ein Wortspiel mit Miltons "Paradise Lost". Mir ging es um die Erkundung der spannungsvollen Beziehung zwischen Begehren und Design innerhalb verschiedener Jahrzehnte. Erscheinen die utopischen Welten mit ihren sauberen und gelackten Inneneinrichtungen durch die 3-D-Animation in der Fernsehwerbung übertrieben? Dienen solche Welten als Waffen der Verführung, um beispielsweise gezielt Frauen für technologische Utopien gewinnen zu können? Die BetrachterInnen konnten bei dieser Installation durch einfaches Berühren des Bildschirms mittels einer 3-D-Animation virtuelle Traumhäuser aus vier Epochen betreten: Jugendstil, Art Deco, Pop Art und Raumzeitalter. Sie hatten die Möglichkeit, die Designgeschichte des 20. Jahrhunderts in den Bereichen Architektur, Haushaltstechnik und Transport nachzuvollziehen. Mit Hilfe von Animationen im Stil der Werbeästhetik versuchte ich herauszufinden, ob Design an sich ein Medium ist oder ob es bloß eine andere Spielart kommerzieller Manipulationen darstellt. Durch die interaktiven Bildschirmangebote wurden die BetrachterInnen von audiovisuellen und textuellen Hinweisen begleitet so etwa durch Handgesten, die technologische Veränderungen andeuten, oder auch durch historische Musikfragmente. Es gab auch kleine Geschichten über Geräte, die in der Regel die Hausarbeit erleichtern, zur Auswahl, nicht nur, um die Evolution der Schnittstelle von Mensch und Maschine zu veranschaulichen, sondern auch daneben die gewandelte Funktion der Frau am industriellen Arbeitsplatz zu thematisieren.

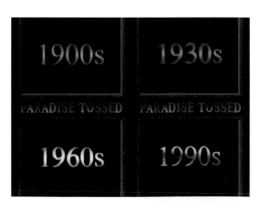

TRAVEL WITH US INTO ANOTHER WORLD!

CHOOSE THE TECHNOLOGY OF TOMORROW!

PARADISE TOSSED 1993. below and above **8-14** | MENUS OF PARADISE TOSSED WHICH ASK FOR VIEWER-INTERACTION AND RELATED IMAGES.
next doublepage **15** | LARGE FLOW CHART OF TOTAL NAVIGATIONS AND DIRECTIONS POSSIBLE.

CATALOGUE

1906

The Ladies Journal

*Votes for Women. Home Crafts.
Baby Hygiene. Catalogue Items.*

PRIMADONA

CHEERS!

*Interiors ▪ Crimped Hair ▪ Arts ▪
and Crafts ▪ Streamline Design ▪
The Modern Secretary ▪ Anaemia*

30p. 1936

WOMEN'S HOME

REG.I2301 **MAD ABOUT MIXMASTERS**

MARCH 1965

INSIDE

ARE YOU SWITCHED ON?

FAB STAY SLIM DIET

WAY TO WIN A MANS HEART

FEMMETECH

ECO–ACTION The Global Gardener

WET SCIENCE: The Silicon Retina

IMPLICATIONS Hormones and...

INTERACTIVE ART daring to be different

»IN ›PARADISE TOSSED‹ SHE LOOKED AT THE RELATIONSHIP BETWEEN DESIRE AND DESIGN. THE INTERACTIVE
STRUCTURE AND USE OF 3-D COMPUTER MODELLING ARE NOT JUST EMBELLISHMENTS BUT INTRINSICALLY RELATED
TO THE CORE ANALYSIS UNDERLYING THE WORK ITSELF, SUGGESTING MODERN IDEALISM. VISITORS CAN ENTER
DREAM HOMES FROM THE HISTORY OF DESIGN AND EXPLORE THE SUBJECTS OF TECHNOLOGICAL UTOPIA, DESIGN
CLICHÉ, AND THE MANIPULATION OF THE WOMAN'S WORKPLACE.« STEVEN WILSON

»»IN PARADISE TOSSED‹, DIE SIGNALHAFTEN STELLUNGNAHMEN SIND BEWUSST VERFÜHRERISCH FORMULIERT UND ERINNERN AN DIE VERKAUFS- UND WERBEMETHODEN, DIE DEN DURCHSCHNITTSKONSUMENTEN ÜBERZEUGEN SOLLEN. IN ›PARADISE TOSSED‹... DURCHSCHAUT DER BETRACHTER DIE VERFÜHRUNG.« HANNES LEOPOLDSEDER

PARADISE TOSSED 1993. ROSLYN OXLEY GALLERY, SYDNEY. above **16-17** | INSTALLATION VIEW WITH INTERACTIVE LASER DISC, TOUCH SCREEN. MONITOR AND MACINTOSH COMPUTER. below **18-21** | FOUR VIDEO IMAGES ABOUT THE DESIRES OF "TECHNOLOGICAL PROGRESS".

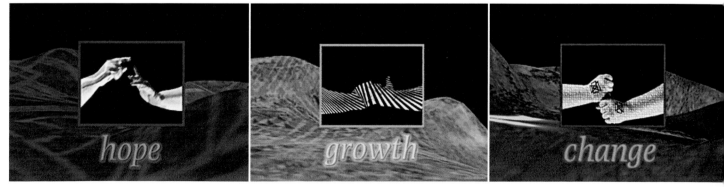

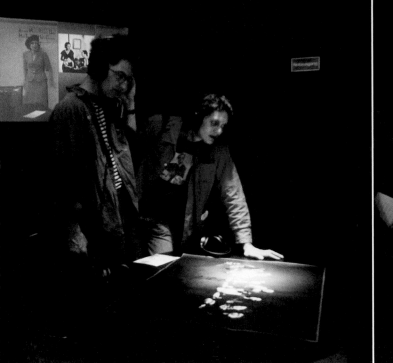

FRONTIERS OF UTOPIA

1995 INTERACTIVE MEDIA INSTALLATION

E | Continuing on from my interest in the relationship between desire, design and memory I returned to some earlier historical research I had made about women, immigration and political idealism. At the same time, the work of Margaret Mead (the anthropologist) was being questioned, as she had been accused of generalizing about the idealism of transmigratory culture. The attempt was to provide the viewer with a hybrid environment called FRONTIERS OF UTOPIA, a place to experience the frontiers of cultural desires and political ideals through the meeting of eight reconstructed characters. These were Emma (based on the life of the anarchist Emma Goldman), Mary (rural socialist in Paraguay), Margaret (secretary in a New York design firm), Pearl (an aboriginal poet), Maria (Yugoslavian hippy), Gillian (Marxist student radical), Ki (Chinese physicist) and Zira (new age programmer). All the characters have different political viewpoints. Using interactive suitcases and touch sensitive screens, the sounds and images from the lives of these women were able to be accessed from four terminals related to the years 1900s, 1930s, 1960s and 1990s respectively. In FRONTIERS OF UTOPIA, the concept was that the viewer could learn to move into isolated time zones where they could immerse themselves in political history in a non-linear way. In each terminal, stories about the struggles of workers, the plight of students, the relationship between women and archetypical attitudes toward the implications of media and technology were able to be experienced.

However, I wanted to allow the viewer to draw parallels between periods and locations based on shared class and gender. I searched for references from art and I remembered attending Judy Chicago's Dinner Party from the seventies in San Francisco. I used this direct influence to present the viewer with an interactive interface where one reconstructed character could meet another. It took the form of a large photograph of all eight woman from FRONTIERS OF UTOPIA, eating together and the viewer could touch two of their faces in order to select who would talk to whom and from what era. The aim was to allow the viewer to "cross time zones" in order to compare the idealism from different generations more easily.

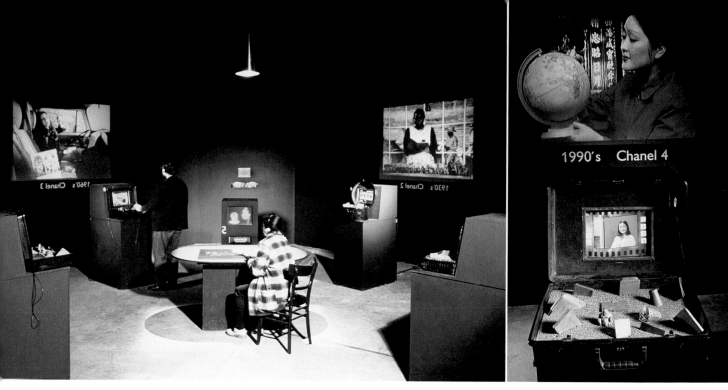

FRONTIERS OF UTOPIA 1995. THE MULTIMEDIALE. ZKM, KARLSRUHE, GERMANY. **1-2** | INTERACTIVE PHOTOGRAPH OF DINNER-PARTY WHERE TWO CHARACTERS CAN SPEAK TO EACH OTHER OVER TIME. **3** | HALF OF THE 8-SIDED-CINEMA WITH CENTRAL DINNER-PARTY AND FOUR SURROUNDING SUITCASE TERMINALS (1900, 1930, 1960, 1990). **4** | THE 1990 TERMINAL WITH ITS INTERACTIVE SUITCASE.

D | FRONTIERS OF UTOPIA 1995. Ich wollte mein Interesse am "Bezugssystem" von Begehren, Design und Erinnerung weiterverfolgen. Deshalb führte ich historische Recherchen über Frauen, Immigration und politischen Idealismus durch. Zur gleichen Zeit wurde das Werk der Anthropolgin Margaret Mead einer kritischen Revision unterzogen. Man warf ihr vor, das Phänomen der zwischenkulturellen Migration verallgemeinernd zu idealisieren. Ich entwarf für ein Publikum eine hybride mediale Umgebung unter dem Titel FRONTIERS OF UTOPIA: einen Ort, wo sich die Grenzen kulturellen Begehrens und politischer Ideale in der Begegnung von acht rekonstruierten Figuren durchmischen. Diese Charaktere sind Emma (inspiriert vom Leben der Anarchistin Emma Goldman); Mary (eine sozialistische Bäuerin in Paraguay), Margaret (eine Sekretärin in einer New Yorker Designfirma), Pearl (eine Aboriginie-Dichterin), Maria (ein jugoslawischer Hippie), Gillian (eine radikal-marxistische Studentin), Ki (eine chinesische Physikerin) und Zira (eine New-Age-Programmiererin).

Alle Figuren vertreten unterschiedliche politische Standpunkte. Mit Hilfe interaktiver Aktenkoffer und berührungsempfindlicher Bildschirme erhielt man über vier Terminals Zugang zu den Bildern und Tönen aus den Leben dieser Frauen. Die Terminals entsprachen den Jahrzehnten um 1900, 1930, 1960 und 1990; der/die BetrachterIn

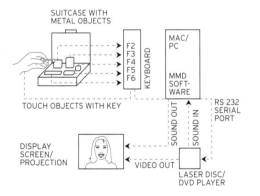

konnte sich in unterschiedlichen Zeitzonen zu bewegen lernen und sich auf nicht-lineare Weise in die politische Geschichte hineinversetzen. Man erfuhr an den Terminals über die Kämpfe der ArbeiterInnen, die Notlage der StudentInnen sowie über die Beziehung zwischen Frauen und bestimmten archetypischen Haltungen, beispielsweise gegenüber den Implikationen von Medien und Medientechnologie.

Ich wollte dem Publikum zusätzlich die Möglichkeit anbieten, zwischen Jahrzehnten und Orten Parallelen herstellen zu können, beispielsweise wo gemeinsame Klassen- und Geschlechtszugehörigkeiten inhaltliche Verbindungen schaffen. Ich suchte nach kunst-immanenten Referenzen und erinnerte mich an meinen Besuch von Judy Chicagos "Dinner Party" im San Francisco der siebziger Jahre. Ich wählte diese Referenz, um dem Publikum ein direktes Interface anbieten zu können, durch das sich die rekonstruierten Figuren begegnen konnten. Dieses Interface hatte die Form eines großen Fotos, auf dem alle acht Frauen zusammen aßen. Die BetrachterInnen konnten zwei der Gesichter berühren und so bestimmen, wer aus welcher Epoche miteinander kommunizieren sollte. Ich wollte dem Publikum dazu verhelfen, "Zeitzonen zu durchschreiten", um so die Idealismen unterschiedlicher Generationen besser vergleichen zu können.

FRONTIERS OF UTOPIA 1995. from left to right **5-6** | DIAGRAM AND IMAGE SHOWING SUITCASE INTERACTIVITY. **7-14** | CHARACTERS AND THEIR SUITCASES: GILLIAN 1968; KI 1993; MARIA 1965; ZIRA 1990.

»GRENZEN DER UTOPIE REPRÄSENTIERT FÜR UNS NICHT NUR DEN AVANCIERTEN ZUSTAND DESSEN, WAS EIN INTER-AKTIVES KUNSTWERK HEUTE AUSSAGEN KANN, SONDERN ERLAUBT AUCH EINEN BLICK IN DIE ZUKUNFT AUF EIN MEDIENKONZEPT, DAS VIELLEICHT ERST IM NÄCHSTEN JAHRHUNDERT REALISIERT WERDEN WIRD: DEN INTERAKTIVEN FILM.« HANS-PETER SCHWARZ

FRONTIERS OF UTOPIA 1995. CHARACTERS AND THEIR SUITCASES. from left to right **15-18** | MARY 1900, PEARL 1940, MARGARET 1938 AND EMMA 1912 WITH THEIR SUITCASES. **19** | DIAGRAM SHOWING HOW THE DINNER PARTY WORKS. next doublepage **20** | THE DINNER PARTY PHOTOGRAPH.

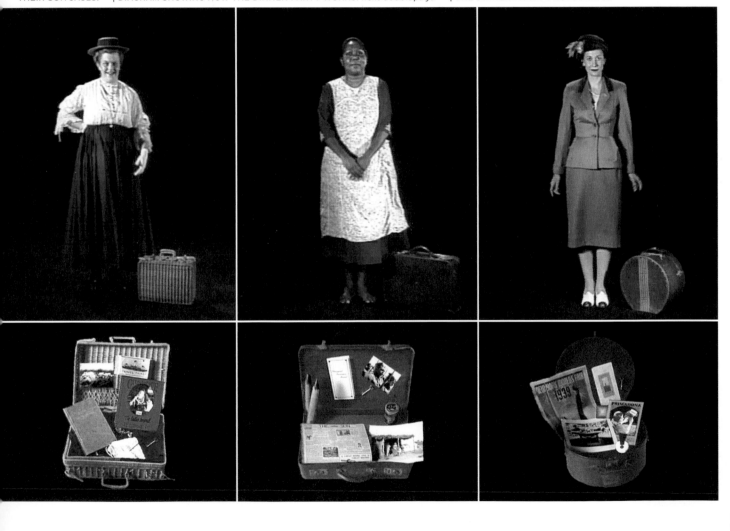

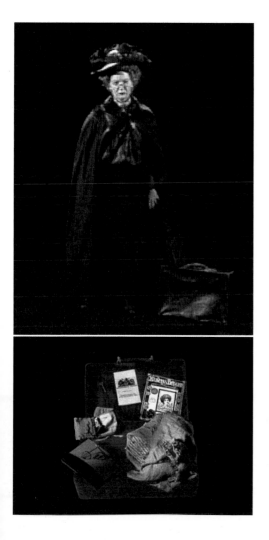

SCREEN DISPLAY/
PROJECTION

KEYBOARD

C D E F H I

PHOTO INTERFACE

BUTTONS ARE
COVERED WITH
LARGER STEEL
PLATES

COMPUTER

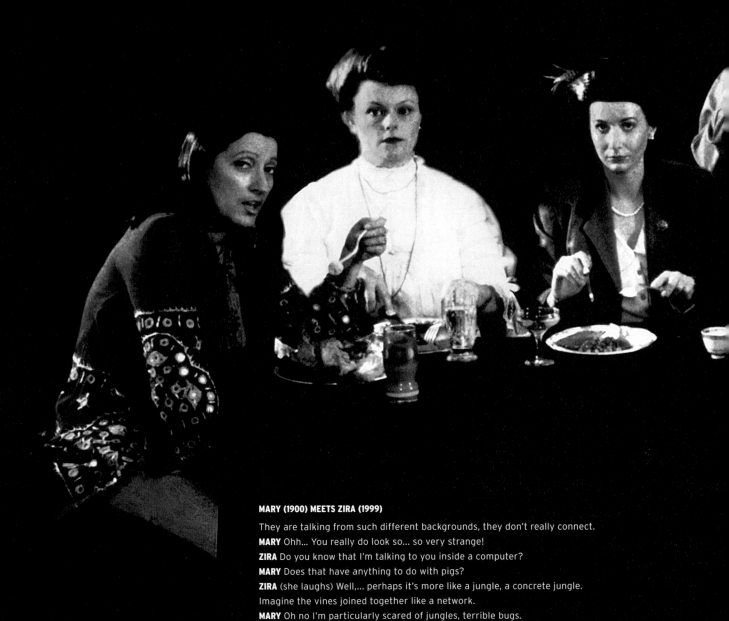

MARY (1900) MEETS ZIRA (1999)

They are talking from such different backgrounds, they don't really connect.

MARY Ohh... You really do look so... so very strange!

ZIRA Do you know that I'm talking to you inside a computer?

MARY Does that have anything to do with pigs?

ZIRA (she laughs) Well,... perhaps it's more like a jungle, a concrete jungle.
Imagine the vines joined together like a network.

MARY Oh no I'm particularly scared of jungles, terrible bugs.

ZIRA Mnnn... (Zira gives up).

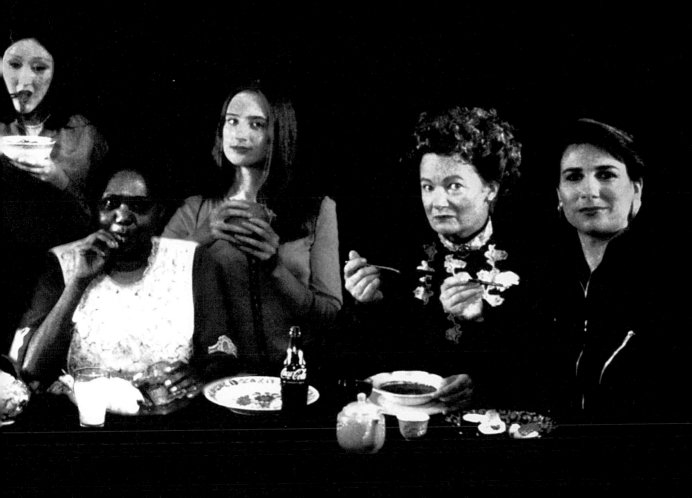

MARIA (1960) MEETS EMMA (1900)

They talk about immigration.

MARIA Hi, I'm Maria, I came here with my mother after the war...

EMMA Which war?

MARIA The second world war, of course!

EMMA Oh dear, there was another one.

GILLIAN (1960) MEETS PEARL (1930)

Gillian tries to get Pearl in on some sabotage.

PEARL True, they're mining one of our sacred sites down that road.

GILLIAN Bloody Hell... typical... no regard for anybody else.

PEARL (laughing) You know what those catapillar machines remind me of? Big insects waiting for their dinner.

GILLIAN Right on! Hey listen, Pearl, (whispers) why don't I go down there and feed those insects with some flour from your kitchen? You know... pour some flour in the tanks.

PEARL No, Gillian! Don't you see, they would blame us black fellas right away.

FRONTIERS OF UTOPIA 1995. left **21+27** | SAMPLES OF ARCHIVAL-REACTIONS FROM SUITCASE INTERACTION. **22+28** | CHARACTERS TALKING OVER TIME. **23-26** | IMAGES FROM THE FILMS – MARIA IN HER VW BUS, MARY IN PARAGUAY, ZIRA IN HER VIRTUAL COMPUTER LAB, GILLIAN AT ART SCHOOL. **29-32** | MARGARET AT THE WORLD FAIR NEW YORK, KI IN THE PHYSICS LAB, PEARL IN THE DESERT MISSION AND EMMA AT THE UNION MEETING. above right **33** | MAIN MENU SHOWING ALL THE INTERACTIVE POSSIBILITIES.

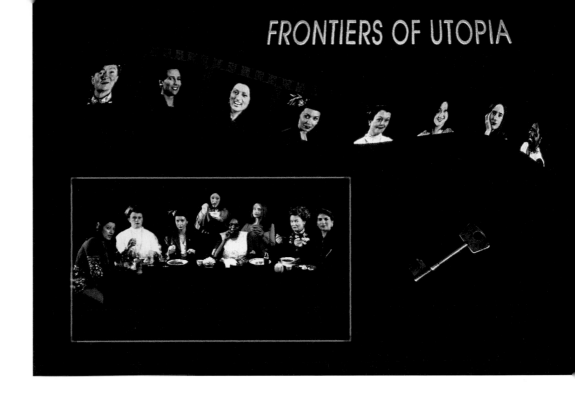

A FIGURATIVE HISTORY

1996 INTERACTIVE MEDIA INSTALLATION

E | A book by David Channel called "The Vital Machine" inspired this installation. In it he talks about human desires (e.g. to reproduce, to live forever) and the related reconstruction of our bodies by technology. In my installation I chose five different types of characters who represented different but overlapping desires to transform the body using technology. Frankenstein's monster (1890) related to the interest in medical bio-manipulation; Lady Miso (1750) was a metaphor for robotics simulation; Pandora (B.C.), represented the metamorphosis from objects to human (like a Golem); The Cyborg (1250) illustrated the desire to integrate organic and mechanic parts; and The Data Body (1950) explored the idea of artificial intelligence and the notion of a downloaded mind onto a computer or the "post-human" discourse. Inside the installation viewers could interact with these characters on five terminals with smart objects and corresponding screens. By touching metal points on sculptures that related to the histories of the five characters, the viewers could edit the sequences of the animated characters, which appeared on the screens in front of them. The sculptures were sensitive to the viewer's touch because the water in human bodies acts as a conduit and can close an electronic circuit. The aim was to turn each viewer into a type of cyborg. Before viewers entered the elevated hut of A FIGURATIVE HISTORY, they had to remove their shoes so that the effect of interaction was enhanced. In order to convey the idea of crossing and collapsing time, the viewers could join hands and link the objects together. Then they could trigger any of the characters to meet other characters at the same time. Often the viewers formed a human chain right around the room, causing the characters to sing out their answers to text-based questions like: "Are you organic or mechanic?"

A FIGURATIVE HISTORY 1996. ZENTRUM FÜR KUNST UND MEDIENTECHNOLOGIE KARLSRUHE, GERMANY. below **1** | PANDORA (GREEK MYTHOLOGY). **2** | LADY MISO (AUTOMATA-PIANO-PLAYER). **3** | DATABODY (THE DOWNLOADED MIND). **4** | CYBORG (THE KNIGHT). **5** | MONSTER (FRANKENSTEIN'S CREATION).

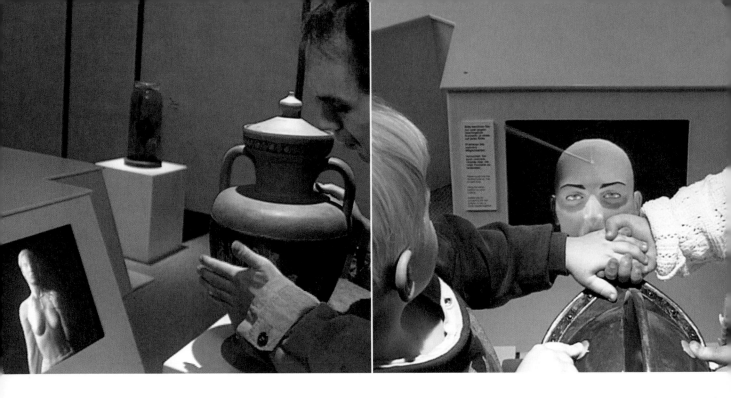

D | A FIGURATIVE HISTORY 1996. Diese Installation wurde durch ein Buch von David Channel mit dem Titel "The Vital Machine" angeregt. Es handelt von bestimmten Menschheitsträumen (über Reproduktion und den Wunsch, ewig zu leben) und der dazu in Beziehung stehenden technologischen Rekonstruktion unserer Körper. Ich wählte für meine Installation fünf Figuren. Sie repräsentieren unterschiedliche, doch miteinander verknüpfte Phantasien, den Körper technologisch umzugestalten. Frankensteins Monster (1890) bezieht sich auf ein Interesse an medizinischer Biomanipulation; Lady Miso (1750) ist eine Metapher für Robotersimulation; Pandora (vor Christi Geburt) repräsentiert die Metamorphose vom Ding zum Menschen (wie bei einem Golem); The Cyborg (1250) steht für den Wunsch, organische und mechanische Teile zu integrieren, und The Data Body (1950)

A FIGURATIVE HISTORY 1996. ZENTRUM FÜR KUNST UND MEDIENTECHNOLOGIE. KARLSRUHE, GERMANY. top from left to right **7-10** | PEOPLE INTERACTNG WITH INDIVIDUAL CHARACTERS. bottom from left to right **11** | DIAGRAM OF HOW THE INTERACTION WORKS. **12-16** | STILL IMAGES FROM THE FILMS ABOUT THE CHARACTERS: THE CYBORG, PANDORA, FRANKENSTEIN, LADY MISO AND THE DATA BODY.

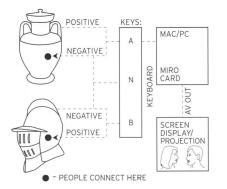

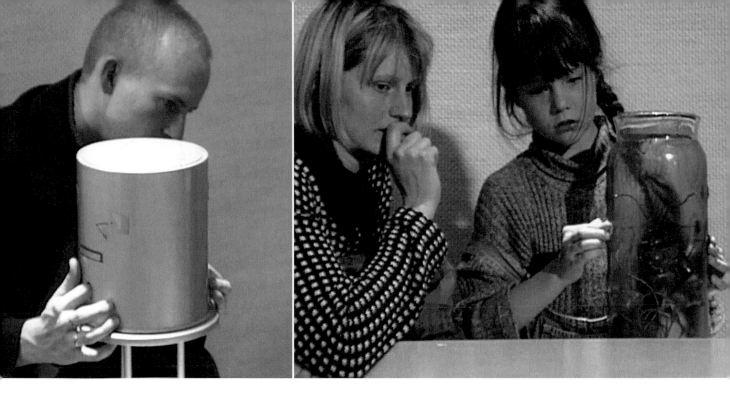

erforscht die Idee "Künstlicher Intelligenz" sowie die Vorstellung eines Gehirns, das auf einen Computer überspielt wird. Er steht für den sogenannten "post-humanen Diskurs". In der Installation konnten die BetrachterInnen an fünf Terminals mittels intelligenter Objekte und entsprechender Bildschirme mit diesen Figuren interagieren. Indem die BetrachterInnen Metallpunkte auf einer der fünf Skulpturen berührten, die jeweils zur Geschichte von einer der fünf Figuren in Beziehung stand, bestimmten sie die Sequenzen der animierten Figuren auf den dazugehörigen Bildschirmen. Die Skulpturen waren berührungsempfindlich, weil das Wasser im menschlichen Organismus als Leiter fungierte, der den Stromkreis schloss. Ich wollte jede BetrachterIn in eine Art Cyborg verwandeln. Bevor das Publikum die erhöhte Kabine von A FIGURATIVE HISTORY betrat, musste es seine Schuhe ausziehen, um die Wirkung der Interaktion zu steigern. Zur Kommunikation der Idee, die Zeit zu durchschreiten und aufzuheben, konnten die verschiedenen BetrachterInnen sich gegenseitig die Hand geben und die Objekte verknüpfen. Das gab ihnen auch die Möglichkeit, eine der Figuren dazu zu bringen, eine andere Figur auf dem Bildschirm zu treffen. Häufig formten die BetrachterInnen eine Menschenkette. Dann wurden die Figuren angeregt, Fragen wie "Bist Du organisch oder mechanisch?" gemeinsam singend zu beantworten.

Pandora

Lady Miso

E SHE USES SYMBOLS OF TECHNOLOGICAL PROGRESS; THE GREEK VASE (OR PANDORA'S BOX), THE RESISTOR
NNINGS OF THE PC), THE HEART PRESERVED IN THE GLASS JAR (BIOLOGICAL PRESERVATION), THE HELMET
INVENTION OF STEEL) AND FINALLY THE COG (PART THE CLOCK-MECHANISM). IT IS THE VERY INTERACTION
THESE OBJECTS WHICH HELPS THE VIEWER TO IDENTIFY WITH THE CHARACTERS.« URSULA FROHNE

Talk over Time
A Figurative History

The Cyborg 1250
Lady Miso 1750
The Data Body 1960
Pandora BC
Frankenstein Monster 1890

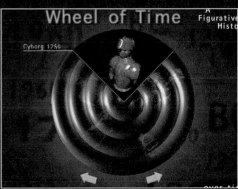

Wheel of Time
A Figurative History

Cyborg 1250

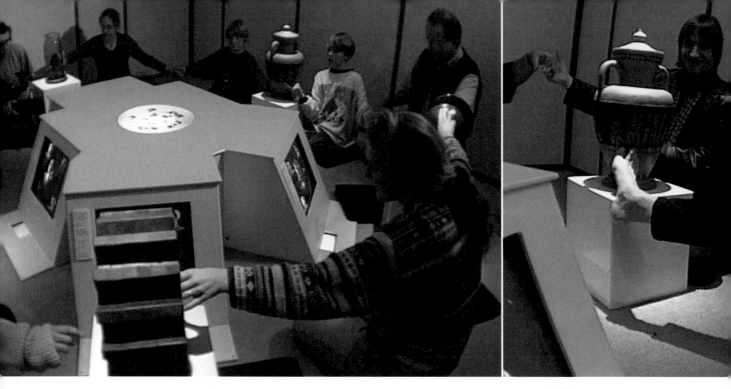

A FIGURATIVE HISTORY 1996. ZENTRUM FÜR KUNST UND MEDIENTECHNOLOGIE KARLSRUHE, GERMANY. above from left **18-20** | INTERACTION SHOWING THE FOREIGN CONNECTION BETWEEN TERMINALS ALLOWING FOR CONVERSATIONS BETWEEN CHARACTERS TO OCCUR. below from left **21** | DIAGRAM SHOWING THE VARIOUS FORMS OF INTERACTIVE POSSIBILITIES. **22-26** | CONVERSATIONS TAKING PLACE BETWEEN DIFFERENT SCREEN-CHARACTERS.

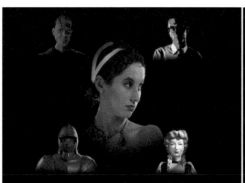

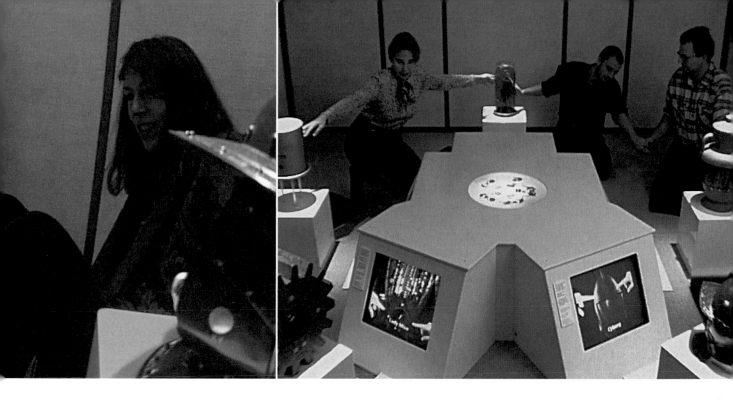

»SCOTT'S KOMMUNIKATIVE STRATEGIE IST AUCH HIER DAS VERFAHREN DER DOPPELTEN AFFIRMATION. SIE MACHT DABEI NICHT NUR DAS DARGESTELLTE, SONDERN AUCH DAS DARSTELLENDE, DAS MEDIUM SELBST, ZUM GEGENSTAND. AUF DIESE WEISE GELINGT ES IHR, EINEN DISKURS FORTZUFÜHREN, ÜBER DEN SCHEINBAR NICHTS NEUES MEHR GESAGT WERDEN KANN, DER ABER DENNOCH GESELLSCHAFTLICH BRISANT IST. DIESE NEUE STRATEGIE DER KRITISCHEN REDE, DER DAS VERFAHREN DER DEKONSTRUKTION KULTURELLER CODES ZUGRUNDE LIEGT, HAT DERRIDA ALS ›LIST‹ BEZEICHNET. MIT DIESER LIST GELINGT ES SCOTT ALS EINER DER WENIGEN KÜNSTLERINNEN, DIE MIT INTERAKTIVEN MEDIEN ARBEITEN, DEN MYTHOS EINER MEDIENIMMANENTEN FREIHEIT DER INTERAKTION MIT SEINEN EIGENEN WAFFEN ZU SCHLAGEN.« SÖKE DINKLA

INTERSKIN

1997 VIRTUAL REALITY

ᴱ | INTERSKIN was influenced by my research into more philosophical internal and ephemeral desires for trans-
formations of the body by new forms of representation. I also wanted to address how the digitisation, the medical
imaging and computer mapping of the interior of the human body effects our reactions to illness. Originally, the deci-
sion to make a game came from Allan Turing, who invented one of the first computer-intelligent games. His computer
was supposed to recognize the difference between male and female players by asking them questions. In INTERSKIN,
the weight of the viewer classified the players into female, male, child or other and any two players were monitored
by a moderator (the computer). The moderator could only observe and interrupt the players, while the players could
"go inside" separate body parts behind the human skin, there on the projected visuals inside two telephone booths.
On the screens these body parts formed a spiral around the "T'an Tien" or centre of the human body in Chinese
medicine. As I wanted the viewers to diagnose health problems, they used a doctor's torch as an interface. Depending
on the viewer's classification by the computer-moderator, they were guided by selected "avatars" or "agents". The
aim of the game was to explore the gender and identity of a second self or other body, which may reside deep inside
the viewer's personality. This depended upon reactions the participant made to the various choices or belief systems
that the game offered. These were inspired by Western, Eastern or alternative medical presentations. At the end each
viewer often found a type of inner body with a prediction about his or her future representation. In INTERSKIN, I
attempted to suggest that alternative ways of seeing and associating through the technologies of digital representa-
tion could also play an important role in the desire to transform the human body.

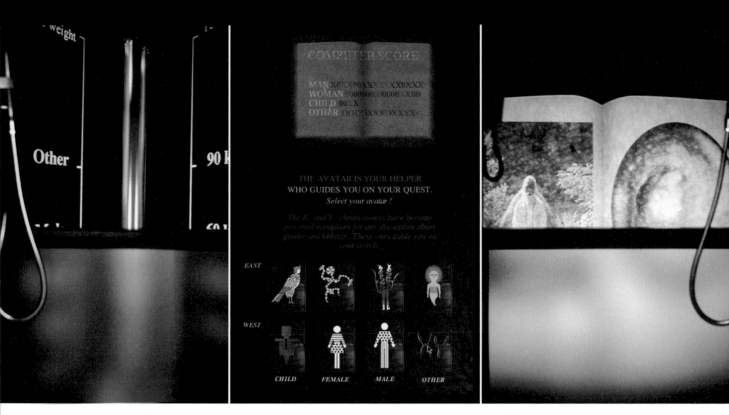

INTERSKIN 1997. ZENTRUM FÜR KUNST UND MEDIENTECHNOLOGIE. KARLSRUHE, GERMANY. from left to right **1-2** | INTERACTION BY VIEWERS IN THE PLAYERS BOOTHS. **3-5** | THE THREE BOOTHS: PLAYER – MODERATOR – PLAYER. below **6-9** | EXAMPLES OF THE REMEDIES – THE VIEWER HAS TO CHOOSE IN THE GAME. next doublepage **10** | MAIN SCREEN – THE FLOATING 3-D ORGANS OF THE BODY WITH THE AVATARS THAT CAN BE CHOSEN AS GUIDES FOR THE USER.

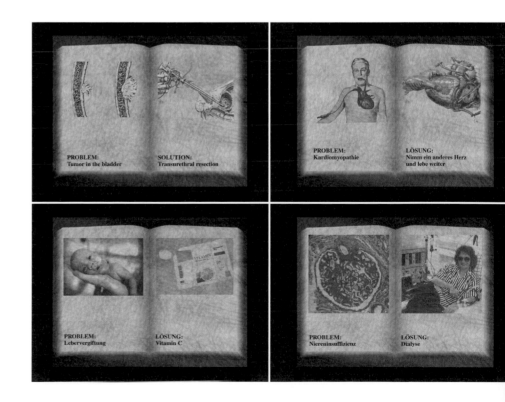

INTERSKIN. 1997. ZENTRUM FÜR KUNST UND MEDIENTECHNOLOGIE. KARLSRUHE, GERMANY. right page **10** | INTERFACE. POLHEMUS SENSOR EMBEDDED INSIDE A DOCTOR'S TORCH. WITH A CLICKING BUTTON TO ALLOW FOR SELECTIONS. **11** | EXAMPLE OF THE FUTURE BODY WHICH CAN BE AWARDED TO THE PLAYER. left page **12** | THE THREE BOOTHS OF INTERSKIN - BASED EARLY FRENCH TELEPHONE COMPARTMENTS.

D | INTERSKIN 1997. Beeinflusst wurde INTERSKIN durch meine Recherchen über die eher philosophischen und ephemeren Wünsche nach einer Veränderung des Körpers, wie sie durch die neuen Formen medizinischer Repräsentation ermöglicht werden. Ausserdem wollte ich darauf eingehen, wie die Digitalisierung und computergestützte Visualisierung des Körper-Inneren unsere Reaktionen auf Krankheiten bestimmen. Die Idee, ein Spiel zu entwickeln, verdanke ich ursprünglich einem der Tests von Allan Turing. Er entwickelte ein Szenario, in dem der Computer (im einen Raum) den Unterschied zwischen männlichen und weiblichen MitspielerInnen (in einem anderen davon abgetrennten Raum) durch Fragen herausfinden sollte. Turing interessierte sich auch dafür, was geschieht, wenn er den Computer durch eine menschliche Person ersetzt. Bei INTERSKIN war es das Gewicht der BetrachterIn, das die SpielerIn als Frau, Mann, Kind

oder etwas anderes klassifizierte, wobei jeweils zwei SpielerInnen von einem Moderator (dem Computer) überwacht wurden. Der Computer-Moderator konnte die SpielerInnen lediglich beobachten und unterbrechen, während diese miteinander sprechen durften. Die SpielerInnen konnten sich in die gleichen Projektionen unterschiedlicher Organe bzw. Körperteile hinter der menschlichen Haut "hineinversetzen", mussten aber in zwei getrennten Kabinen bleiben. Die Körperteile auf den Bildschirmen formten Spiralen um das "T'an Tien" oder dem Zentrum des menschlichen Körpers in der chinesischen Medizin. Da ich von den SpielerInnen wollte, dass sie Krankheiten diagnostizieren, benutzten sie als Schnittstelle ein dem Endoskop ähnliches Interface. Abhängig von der Klassifizierung des/der BetrachterIn durch den Computer-Moderator wurden sie durch ausgewählte "Avatars", "Bildsymbole" oder "Agenten" bzw. "Agentinnen" geleitet. Das Ziel des Spiels war die Erforschung des Geschlechts und der Identität eines zweiten Selbst oder anderen Körpers, der vielleicht tief in der Persönlichkeit des eigenen Individuums ruht. Das Resultat hing von den Reaktionen der TeilnehmerInnen auf Fragen, Wahlmöglichkeiten und Glaubensvorstellungen ab, die das Spiel anbot und die durch westliches, östliches oder alternativ-medizinisches Wissen geprägt waren. Am Ende fanden die BetrachterInnen häufig eine Art von innerem Körper vor, der eine Prophezeiung beinhaltete. In INTERSKIN schlage ich vor, dass alternativen Sehweisen und digitalen Formen der Darstellung und des Assoziierens eine wichtige Rolle zufällt bei der Sehnsucht bzw. dem Begehren, den menschlichen Körper umgestalten zu wollen.

INTERSKIN 1997. ZENTRUM FÜR KUNST UND MEDIENTECHNOLOGIE. KARLSRUHE, GERMANY. left page **13-16** | EXAMPLE OF TEXTURES ON THE 3-D BODY PARTS AND ORGANS, FINGER, INTESTINES, LIVER, BONES. right page **17-21** | EXAMPLE OF TEXTURES ON THE 3-D BODY PARTS AND ORGANS, BREAST, KIDNEYS, THROAT, VAGINA AND EYEBALL.

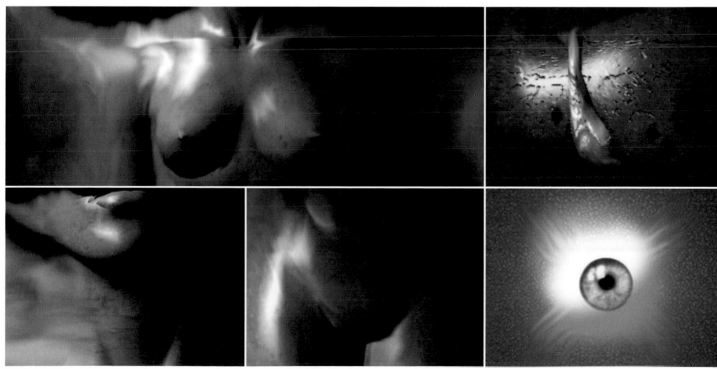

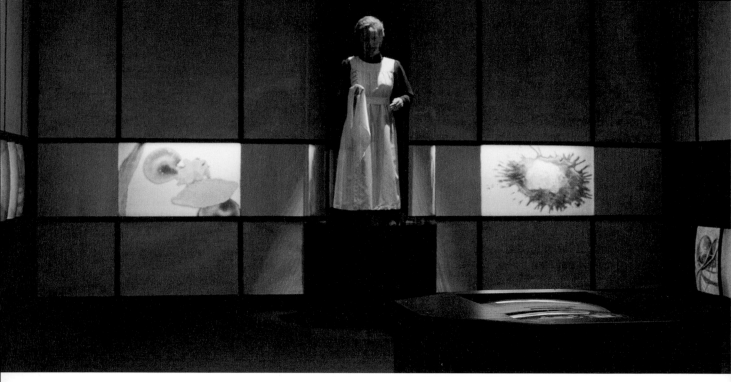

IMMORTAL DUALITY 1997. ZKM GERMANY. from left to right **1-2** | OVERVIEW OF THE WHOLE INSTALLATION WITH ROBOT, INTERACTIVE WALLS AND WWW SITE. **3-4** | MARIE CURIE PNEUMATIC ROBOT - DRESSED AND UNDRESSED. **5-6** | CLOSE-UPS OF THE FACE.

IMMORTAL DUALITY

1997 INTERACTIVE ROBOT AND SHADOW ENVIRONMENT

E | IMMORTAL DUALITY was inspired by my ethical concerns about the developments in biotechnology and physics, which tend to feed our desire to live forever and to be disease-free. The aim was to make a representational work about molecular transformation and micromanipulation. The reading of Suzanne Quinn's novel entitled "Marie Curie-A Life" inspired the elements in the centre of the interactive installation. There, I placed a talking pneumatic-controlled automata based on the spirit of Marie Curie, whose comments were directly lifted from Quinns' novel. As the viewers moved in the space, a set of virtual cameras registered their movements and Marie Curie reacted to them by waking up and talking to them. Unlike automata of celebrity, she is depicted at the end of her life, when her eyes were affected by radiation sickness and she comments on the role of science during the discovery of molecular radiation. I also placed a DNA Helix in her hand as an icon to refer to the latest development in micromanipulation and human-genome mapping. In IMMORTAL DUALITY, I also wanted the viewer to become aware of the desires surrounding biotechnology. Consequently, I placed monitors along the sidewalls of the environment to create an interactive mural. The images on the screen were only activated by the presence of viewers in the space, whose silhouettes were keyed into the monitor images. In this way a single viewer could see a set of 3-D images which appeared inside his/her own shadow on the monitors. These images were inspired by the utopian aesthetics found in science magazines on biotechnology (e.g. "Nature"). There, topics like anti-aging, cloning and reproduction are laced with seductive graphics and verbs like "to invent, to discover, to control". I wanted the viewers to be metaphorically immersed in these seductive representations. As the image of the shadow is connected with death in many different philosophies, I wanted to express that the general public might have to shift their old definitions of "matter" and "nature" as bio-technological inventions driven by human desires might directly affect the future of life as we know it. Perhaps this issue became clearer in the www site of DIGITAL BODY AUTOMATA at the entrance of the installation. Here through the web chat of IMMORTAL DUALITY, viewers could make comments about the desire to redesign our bodies from their homes.

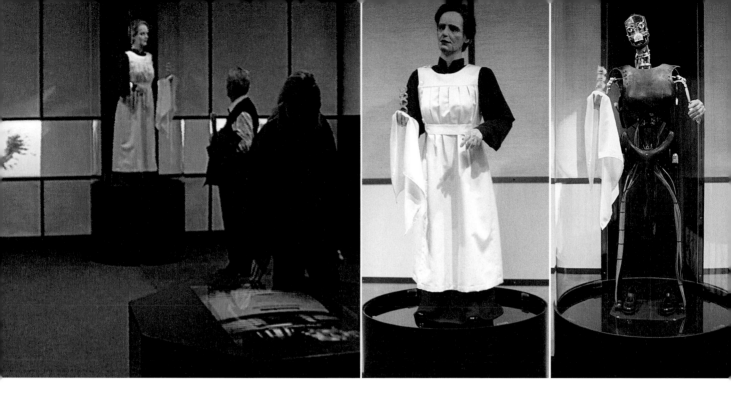

The voice of Marie Curie:

Hello, Why don't you come closer?

I dreamt I have ringing in my ears!

I dreamt that the concept of life had changed.

What will happen to the concept of motherhood?

Attention, atomic energy transforms organic matter.

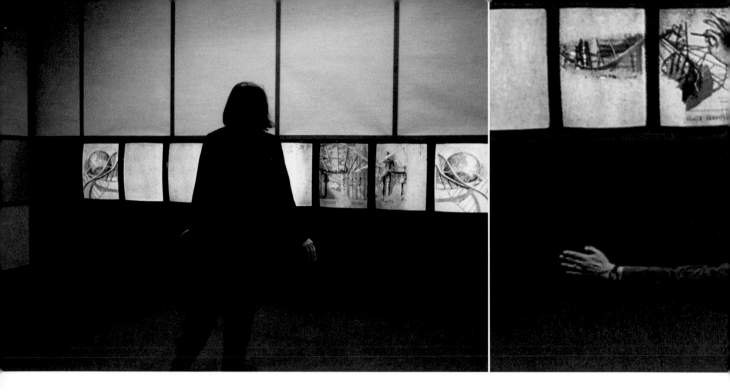

D | IMMORTAL DUALITY wurde zum Ausdruck meiner ethischen Bedenken gegenüber den momentanen Entwicklungen in der Biotechnologie und Biophysik. Diese Entwicklungen tendieren dazu, unsere Wünsche nach Unsterblichkeit und einem Leben ohne Krankheit zu nähren. Ich wollte eine Arbeit schaffen, die von molekularen Transformationsprozessen und Mikromanipulationen handelt. Die Anregung für das Zentrum der interaktiven Rauminstallation ergab sich aus der Lektüre von Suzanne Quinns Erzählung "Marie Curie - A Life". Im Mittelpunkt stand ein sprechender, pneumatisch angesteuerter Automat, der den Geist von Marie Curie verkörperte, während ihre Aussprüche direkt der Erzählung Quinns entnommen waren. Wenn BetrachterInnen im Raum herumgingen, wurden ihre Bewegungen von virtuellen Überwachungssystemen registriert. Marie Curie reagierte dann, indem sie erwachte und die BetrachterInnen direkt ansprach. Anders als andere Automaten von Berühmtheiten ist Marie Curie hier so dargestellt, wie sie gegen Ende ihres Lebens eher kränklich aussah, als ihre Augen durch Röntgenstrahlung bereits geschädigt waren. Sie spricht über die Rolle der Wissenschaft. Ich gab ihr ausserdem eine DNA-Helix in die Hand - als Symbol, das auf die Entschlüsselung des menschlichen Genoms verweisen sollte. Mit IMMORTAL DUALITY wollte ich das Publikum anregen, sich mancher Wunschvorstellungen, die die Biotechnologie antreiben, bewusst zu werden. Ich plazierte entlang der Seitenwände mehrere Monitore, um eine interaktive Wand zu schaffen. Die Silhouetten des anwesenden Publikums wurden in Echtzeit in die Monitorbilder eingestanzt, wodurch einzelne BetrachterInnen innerhalb ihres eigenen Schattens das Wandbild sichtbar machen konnten. Dieses erinnerte an Bilder utopischer Ästhetik, wie man sie häufig in Wissenschaftsmagazinen über Biotechnologie (zum Beispiel in "Nature") findet. Hier werden Themen wie die Aufhebung des Alterungsprozesses, das Klonen oder die Reproduktion mit verführerischen Grafiken und Verben wie "erfinden", "entdecken" und "kontrollieren" angereichert. Ich wollte das Publikum metaphorisch umhüllen mit diesen verführerischen Darstellungen. Der Schatten, der in verschiedenen Philosophien mit dem Tod assoziiert wird, sollte zum Ausdruck bringen, dass das Publikum seine herkömmlichen Glaubensvorstellungen über "Materie" und "Natur" überdenken sollte. Die Thematik von IMMORTAL DUALITY wurde auf der Website von DIGITAL BODY AUTOMATA am Eingang der Installation vielleicht noch deutlicher: Im Chat über IMMORTAL DUALITY konnten die BesucherInnen die Themen um das menschliche Verlangen, den eigenen Körper umgestalten zu wollen, von Zuhause aus kommentieren.

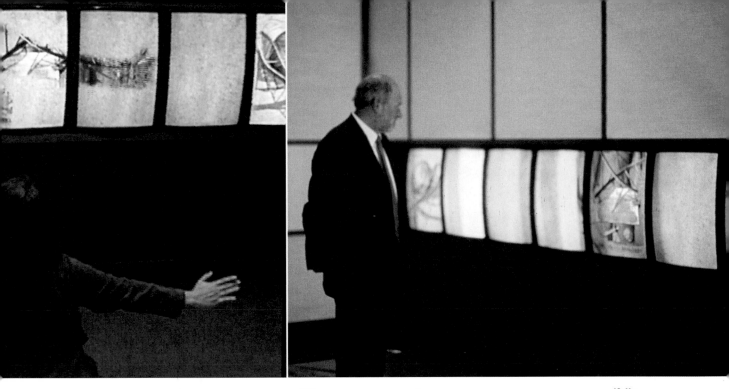

IMMORTAL DUALITY 1997. ZKM GERMANY. from left to right **7-9** | THE INTERACTIVE VIDEO WALL ABOUT GENETIC MANIPULATION. **10-11** | TECHNICAL DIAGRAMS: DIGITAL VIDEO WALL – THE WHOLE INSTALLATION OF IMMORTAL DUALITY. next doublepage **12** | EMBEDDED INSIDE THE VIDEO WALL, THIS GRAPHIC FRIEZE APPEARED INSIDE THE SHADOW OF THE VIEWER.

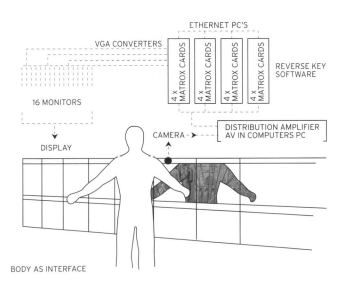

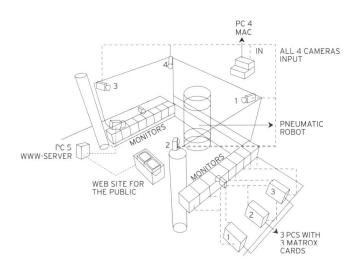

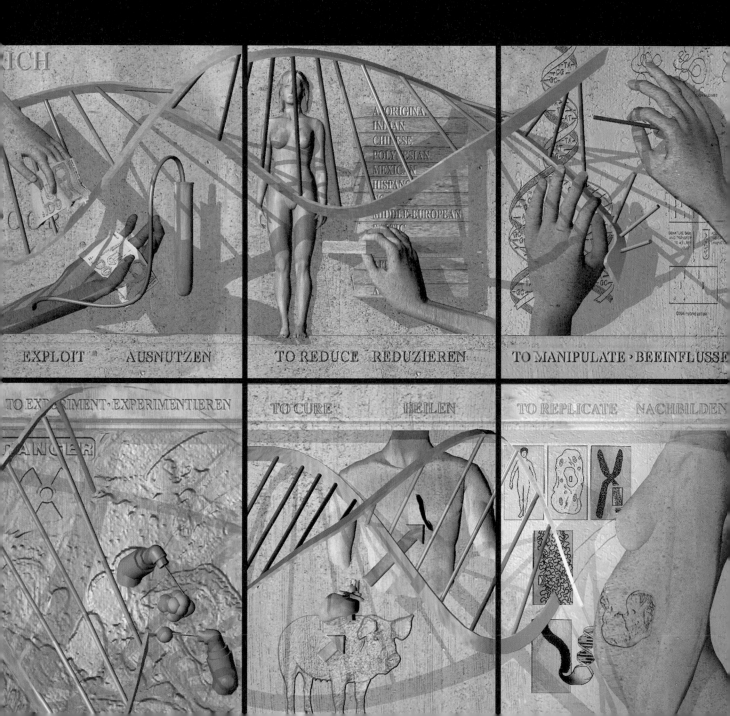

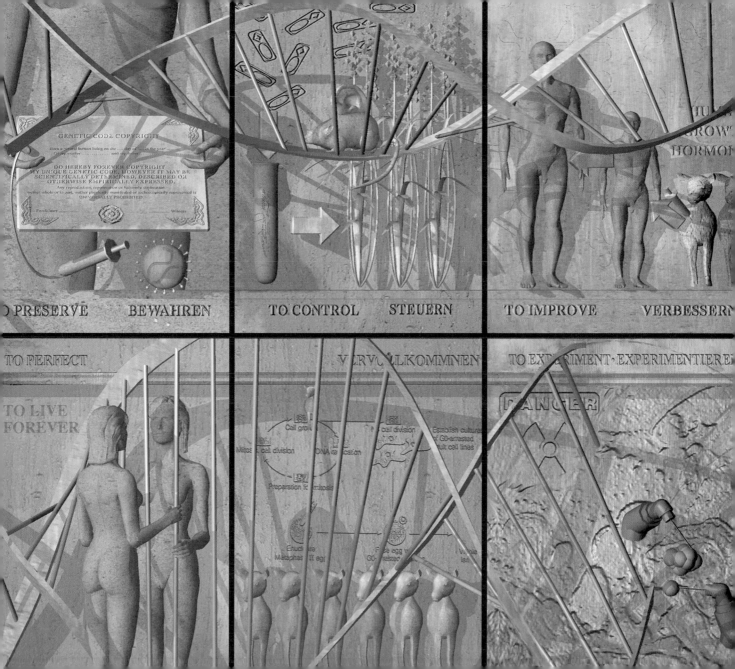

FUTURE BODIES 1999. FUSION 99. BAUHAUS UNIVERSITY WEIMAR, GERMANY. left page **1-2** | SMART SCULPTURES IDEAS FOR FUTURE BODIES. right page **3-6** | SCREEN SHOTS OF THE FUTURE BODIES AS THEY APPEARED WITH THE VIEWERS IN THE HOTLINE CHAT.

FUTURE BODIES

1999 INTERNET WORK IN PROGRESS

E | FUTURE BODIES is a long-term science fiction project with different stages of evolution. Originally, it came from my studies in bio-ethics and my representations of characters in media environments. It was affected by my work with my students in our net events entitled "Fusion". I imagined a world in the future in which there were only three types of people whose behaviour was affected by three distinct DNA body categories. I started to write a script about the characters, which I called "Ms Poor", "Ms Rich" and "Ms Perfect" and I worked together with some of my students on these and they were converted by a modified Eliza program. We could even send their "brains" to others to modify. In the first project for "Fusion" in 1999, an interactive dialogue resulted in the characters reactions being tested as they were programmed to behave in accordance with a predescribed personality. They appeared as real comments inside the hotline chat and responded to the viewers' typed-in keywords. The program built for them could conjugate and also respond with set parameters or random responses. The aim is to continue this project which could combine text based entities with visual-based entities, floating in cyberspace, waiting for interaction through the net. These characters could live in cyberspace, creating an interactive, non-linear, net-based hyperdrama, which the viewer could influence. This project is planned to have a number of manifestations including the presentation of the results as a set of "smart-sculptures". Perhaps the characters could cross over by gender and class, as well as be modified by each other. A website will provide a home base for the project, downloads, interfaces for unsupported platforms as well as archives of past states for research into FUTURE BODIES: see www.jillscott.org for further info.

D | FUTURE BODIES ist ein lang angelegtes Science Fiction-Projekt mit unterschiedlichen Entwicklungsstadien. FUTURE BODIES basiert auf bio-ethischen Studien und meinen Erfahrungen mit der Darstellung von Figuren in Medienumgebungen. Ein anderer Einfluss waren erste Ergebnisse bei Net Events, die ich mit meinen StudentInnen "Fusion" nannte. Ich stellte mir eine zukünftige Welt vor, in der es nur noch drei Arten von Menschen gibt, deren Verhalten durch bestimmte DNA-Körperkategorien beeinflusst werden. Für diese Figuren, die ich "Ms. Poor", "Ms. Rich" und "Ms. Perfect" nannte, schrieb ich ein Drehbuch. Mit einigen meiner StudentInnen arbeitete ich die Figuren weiter aus, die durch ein modifiziertes Eliza-Programm umgeformt wurden. Wir waren sogar in der Lage, ihre "Gehirne" zur Veränderung weiterzuschicken. Im ersten "Fusion"-Projekt, 1999, wurden die Reaktionen der Figuren im interaktiven Dialog getestet. Obwohl die "Gehirne" so programmiert waren, dass sie sich mit den drei vorgeschriebenen Persönlichkeiten deckten, erschienen ihre Kommentare innerhalb des Hotline Chat als reale Kommentare, die auf die Schlüsselworte der TeilnehmerInnen antworteten. Das für sie geschriebene Programm konnte konjugieren und wusste auch mit einem Set von Zufallsantworten zu reagieren. Dieses Projekt soll fortgesetzt werden, um sowohl textuell wie auch visuell gestützte Einheiten zu kombinieren, die sich im Cyberspace bewegen und darauf warten, in eine Netz-Interaktion eingebunden zu werden. Die Figuren könnten im Cyberspace leben und hier ein interaktives, nicht-lineares, netzgestütztes Hyperdrama aufführen, das die TeilnehmerInnen beeinflussen können. Der Planung nach soll das Projekt eine Reihe von Darstellungsformen umfassen, darunter die Präsentation der Ergebnisse als Anzahl "intelligenter Skulpturen". Vielleicht können die Charaktere ihr Geschlecht und ihre Klassenzugehörigkeit austauschen oder sich gegenseitig verändern. Die Basis des Ganzen wird eine Website bilden, die über Downloads, Andockstellen für andere Plattformen sowie Archive vergangener Entwicklungsstadien von FUTURE BODIES verfügt: siehe www.jillscott.org für weitere Informationen.

POOR - PERFECT - RICH

Ms POOR	MS. PERFECT	Ms. RICH
MOTHER	YES, NATURALLY	MMMM DELICIOUS, CAN I BUY
FATHER	ITS ALL IN THE GENES	YOUR CODE?
SISTER		
BROTHER	YOU ARE	FAT
HUSBAND	YOURE	
WIFE	I	THESE THINGS ARE NO LONGER
I	WHAT MAKES YOU THINK I	AN ISSUE
DIED OF HERITITARY	AM*	ITS HARD TO BE RICH AND NOT
DESEASE.	DOES IT PLEASE YOU TO	FAT MY DEAR.
TOO WEAK TO LIVE	BELIEVE I AM*	
ALL FAMILIES ARE TAINTED IN	PERHAPS YOU WOULD	CAN I
MY LAND	LIKE TO BE*	
	DO YOU SOMETIMES WISH	PERHAPS YOU AFFORD TO*
SORRY	YOU WERE*	NO YOU WILL NEVER BE ABLE TO
I	SEX	HAVE YOU EVER ATTEMPTED TO
PLEASE DON'T APOLOGIZE.	I	BEFORE I SPEAK TO YOU I NEED
APOLOGIES ARE NOT	I COULD HAVE BEEN ANY	TO KNOW YOUR NAME.
NECESSARY.	GENDER I WANTED?	DNA FINGERPRINT PLEASE?
	MULTIPLE THANKS.	
YES		NO
I	CAUSE	I
THANKYOU FOR LISTENING	BECAUSE	WELL GOODBYE THEN!

POOR - PERFECT - RICH

An example of how the brain of "The Poor" has been programmed with keywords and possible answers	An example of how the brain of "The Perfect" has been programmed with keywords and possible answers	An example of how the brain of "The Rich" has been programmed with keywords and possible answers
POOR	PERFECT	RICH
I	I	I
I DISGUST YOU.	YES, I AM PERFECT.	I DESERVE TO BE WEALTHY.
THE WRETCHED CAN NO	PERHAPS IN YOUR	I HAVE BOUGHT MY COMFORT
LONGER AFFORD	IMAGINATION WE FUCK ONE	THE WORLD NEEDS BETTER
MODIFICATION.	ANOTHER.	PEOPLE.
DREAMS ARE NOT WHAT THEY	YOU WILL NEVER BE THAT	
USED TO BE.	WAY	CHANGE
		TRANSFORM
SICK	CLONED	SWITCH
I	I	DESIRE
I AM ALWAYS TIRED.	ITS THE ADVANTAGE I HAVE.	RICH
ILLNESS CAN BE	THE BEST OF ALL	IMPROVE
TRANSCENDENT.	POSSIBILITIES.	
THE FUTURE OF OUR SPECIES	MY CODE IS CLEANER THAN	WELL, MONEY MAKES THE WORLD
IS THROUGH	YOUR CODE	GO AROUND!
SOMATIC MUTATION		WELL ONE CAN BUY A NEW
	SUPERIOR	IDENTITY THESE DAYS!

- A typical conversation between the 3 Virtual Characters

```
JillScott: hello
<<<  /ms.poor has joined  >>>
<<<  10.06.1999 9:47:12 Uhr  >>>
<<<  /ms. rich has joined  >>>
<<<  10.06.1999 9:48:14 Uhr  >>>
<<<  /ms. perfect has joined  >>>
<<<  10.06.1999 9:48:37 Uhr  >>>
    Melt/: Hello
  /ms poor: hello, nice to see you
    /ms rich: before i speak to you i need to know your name.
  /ms perfect: hello, im perfect, are you
JillScott: how different from eachother are you exactly?
  /ms poor: would you prefer if i were not different
    /ms rich: what is the reason you are interested in whether or not i am
different?
/ms perfect: when you are genetically perfect, this is a mute question
    Melt/: perfect are you perfect?
  /ms perfect: don't repeat yourself please, the secoond word should be sublime.
JillScott: /poor are you impressed?
    /ms poor: When you are facinated with the virtual do you blaim your mother?
```

continued

```
  /ms perfect: me, myself and i -mm thats three of us virtuals and two humans
    /ms poor:  really? what are you?
Jill Scott: im a real person
    /ms poor: naturally you prefer to enquire about me because you are real
    /ms rich:  Dont mind her, the poor always come across as victims
    melinda:  I like you all but //rich you disgust me
    /ms rich:  then where is your dna fingerprint to prove you are any better?
  /ms perfect:  melinda im perfect, are you contaminated or clean?
JillScott:  What is clean?
    /ms rich:  Easy: its when you buy a new identity!
    /ms poor:  The rich always say that.
    Melinda:  /perfect can you say something
  /ms perfect:  yes, I stay back... i am perfect.... perhaps in your imagination
      we can copulate..but I doubt it
    melinda/:  well they are certainly quite forward
    /ms rich:  mmmm delicious, can i buy your code?
    Franzine:  interacting with these characters makes me quite sad
    /ms poor:  do you enjoy being sad. How sad?
    /ms rich: Sadness is only shifted from a heavy dose of stem cell therapy.
  /ms perfect: Im sick of this conversation, you are born what you are.
```

BEYOND HIERARCHY?

2000 INTERACTIVE ENVIRONMENT

E | The viewers entered the so-called Steigerhalle or payment centre of the former coal mine, "Zeche Zollern II" (now a museum of industrial labour), where they saw the images from BEYOND HIERARCHY? within the frieze of the atrium. These films or "moving murals" seem to be etched into the walls of the building. Here, six twentieth century worker-characters were virtually reconstructed in film segments. These characters were based on real research about workers in the Ruhr. They were Sophie, an ammunition factory-worker in 1918; Piotr, a Polish miner in 1932; Lotte, a miners' kitchen worker in 1952; Misha, a Czech car mechanic in 1971; Ahmet, a Turkish worker in the recycling industry in 1983 and Sabine, an electronic technician on a mobile phone assembly line in 1999. The script was based on research conducted in oral history archives and film archives of the Ruhr Region in Germany. What all six workers shared is their desire for better working conditions. I believe history is about ordinary people and their collective and shared desires and struggles. I admired these people, so I tried to capture their robust good humour as well as the difficulty of their working lives. Individual viewers can choose how much they want to see each character and how much they want to edit sequences together. These Ruhr-region workers can also meet "across time" in conversations set against documentary footage from demonstrations on the streets of Dortmund, Duisburg, Bochum and Essen. BEYOND HIERARCHY? attempts to take a critical Brechtian view of the future of industrial progress. It also tries to comment on the hierarchy within the Steigerhalle's architecture, as the workers used to collect their pay on the ground floor, while the upper floor housed the foremen's utilities. The aim was to subvert the hierarchy of the traditional use of the building, by placing the workers' films "on the top" of the building.

»AM EINDRUCKSVOLLSTEN IST DAS PROJEKT DER AUSTRALIERIN JILL SCOTT, DIE IN DER VERWALTUNG EINEN EIGENEN TRAKT GESTALTET. SIE PRÄSENTIERT DEM BETRACHTER AUSZÜGE AUS DEM LEBEN VON SECHS ARBEITERINNEN UND ARBEITERN IN FORM REKONSTRUIERTER FIGUREN. SO LERNEN DIE BESUCHER ZUM BEISPIEL SOPHIE, EINE ARBEITERIN IN DER MUNITIONSFABRIK IM JAHRE 1918 KENNEN. PROJIZIERT WERDEN DIE BILDER AUF DIE WÄNDE DES TREPPENHAUSES. DER BESUCHER KANN DIE INSTALLATION PER HEBEL BEEINFLUSSEN.« PETRA MECKLENBRAUCK

BEYOND HIERARCHY? 2000. VISION RUHR ZECHE ZOLLERN II. INDUSTRIAL LANDESMUSUEM DORTMUND, GERMANY. from left to right **1-6** | CHARACTERS AT WORK IN THE RUHRGEBIET. SOPHIE (AMMUNITIONS FACTORY WORKER 1900), PIOTR (POLISH COAL MINER 1930), LOTTE (KITCHEN WORKER AT THE MINE 1952), MISHA (CZECH CAR MECHANIC FOR OPEL 1969), AHMED (GARBAGE SORTER RE-CYCLING WORKER 1980) AND SABINE (ELECTRONIC ASSEMBLY-LINE WORKER – NOKIA 1990).

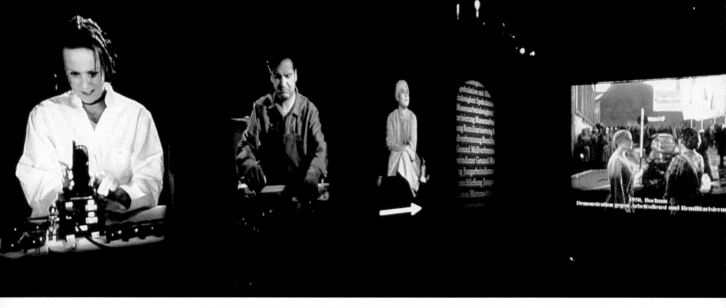

BEYOND HIERARCHY? 2000 VISION RUHR ZECHE ZOLLERN II. INDUSTRIAL LANDESMUSUEM DORTMUND, GERMANY. above **7-8** | THE INSTALLATION IN THE TOP OF THE PAYMENT CENTER. THE WORKERS SEE THEMSELVES TALKING TO EACH OTHER AT THE END OF THE HALL. below **9** | LINUX COMPUTER PROGRAM – SHOWING HOW THE JOYSTICKS MOVEAND HOW THE HANDSHAKE INTERFACE INTERRUPTS THEM. **10** | SKETCH OF THE HALL WITH EQUIPMENT.

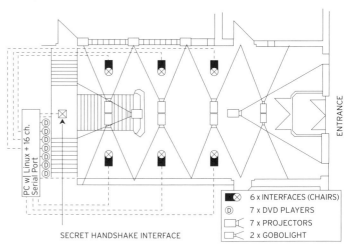

PC w/ Linux + 16 ch.
Serial Port

SECRET HANDSHAKE INTERFACE

ENTRANCE

6 x INTERFACES (CHAIRS)
7 x DVD PLAYERS
7 x PROJECTORS
2 x GOBOLIGHT

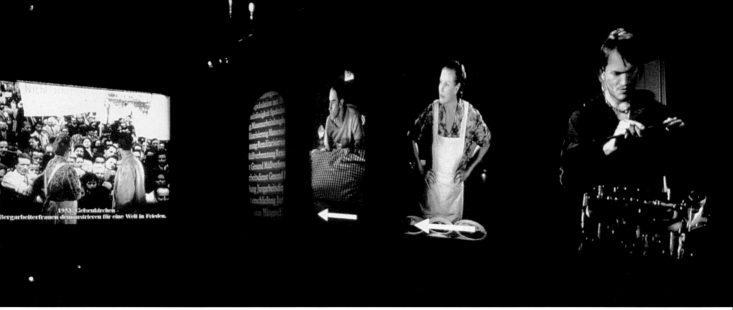

D | BEYOND HIERARCHY? 2000. Die BetrachterInnen betraten die sogenannte Steigerhalle oder Lohnaus-zahlungsstelle der früheren Kohlenzeche "Zeche Zollern II" (heute ein Museum für Industriearbeit), wo sie Bilder aus BEYOND HIERARCHY? als Fries in den Nischen des Atriums projiziert sahen. Diese virtuell rekonstruierten Filmsegmente oder "bewegten Wandmalereien" schienen wie in die Mauern der Gebäudes geritzt. Sie handelten von sechs Arbeiterfiguren des 20. Jahrhunderts, die auf der Grundlage einer Recherche über ArbeiterInnen im Ruhrgebiet entworfen wurden: Sophie, die Arbeiterin in einer Munitionsfabrik 1918; Piotr, ein polnischer Bergarbeiter 1932; Lotte, eine Arbeiterin aus einer Kumpelküche 1952; Misha, ein tschechischer Automechaniker 1971; Ahmet, ein türkischer Arbeiter in der Recyclingindustrie 1983, und Sabine, eine Elektrotechnikerin am Fließband für Mobil-telefone 1999. Das Drehbuch basierte auf Recherchen auch von erzählter Alltagsgeschichte und Materialien aus Filmarchiven im Ruhrgebiet. Allen sechs ArbeiterInnen gemeinsam ist der Wunsch nach besseren Arbeits-bedingungen. Meiner Auffassung nach sollte Geschichte grundsätzlich von gewöhnlichen Menschen und ihren kollektiven Wünschen und Kämpfen handeln. Ich bewundere diese Leute, und deshalb versuchte ich ihren robusten Humor, aber auch die Probleme ihres Arbeitsleben einzufangen. Der/die einzelne BetrachterIn kann auswählen, wieviel er oder sie von jeder Figur sehen will und wie die Sequenzen aneinanderhängen. Die porträtierten Arbeiterfiguren aus dem Ruhrgebiet können sich auch "über die Zeiten hinweg" in Gesprächen begegnen, die vor dem Hintergrund von Dokumentarfilmaufnahmen über Demonstrationen in den Straßen von Dortmund, Duisburg, Bochum und Essen ausgetauscht werden. BEYOND HIERARCHY? versucht eine kritische, Brechtsche Perspektive auf die Zukunft des industriellen Fortschritts einzunehmen. Zugleich kommentiert die Arbeit die hierarchische Architektur der Steigerhalle: Die ArbeiterInnen bekamen ihren Lohn nur im Erdgeschoss ausgezahlt, während die Einrichtungen der WerkmeisterInnen im oberen Stockwerk untergebracht waren. Indem ich die Arbeiterfilme "oben" zeigte, versuchte ich die traditionelle Ordnung des Gebäudes umzukehren.

»JILL SCOTT WILL MIT IHRER ARBEIT DIE HIERARCHI-
SCHE ARCHITEKTUR DER VERWALTUNGSHALLE UM-
KEHREN UND DIE IDEALE DER ARBEITER FEIERN. DURCH
DIE FIGUR DER SABINE AUS DEM JAHR 1999 KÖNNEN DIE
BETRACHTER AUCH EINEN BLICK INS NÄCHSTE JAHR-
HUNDERT WERFEN. HIER DEUTET JILL SCOTT AN, DASS
DAS RUHRGEBIET, WENN ES TATSÄCHLICH DEN WANDEL
VON DER INDUSTRIE- ZUR DIENSTLEISTUNGSREGION
VOLLZIEHEN MÖCHTE, AUCH NEUE, NICHT-HIERARCHI-
SCHE ARBEITSSTRUKTUREN BRAUCHT.« ANNEGRET WIEGERS

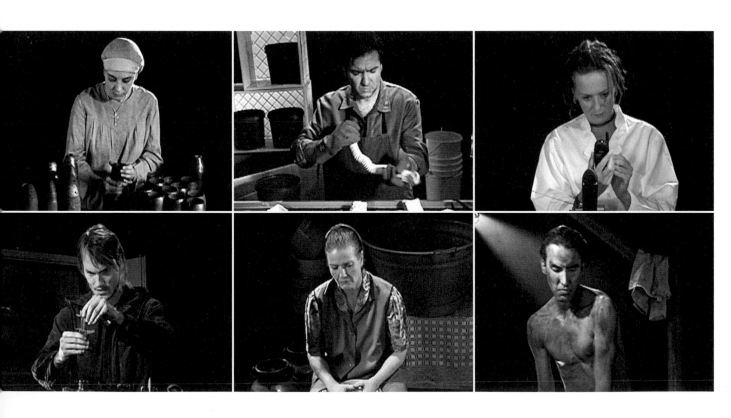

BEYOND HIERARCHY? 2000. VISION RUHR ZECHE ZOLLERN II. INDUSTRIAL LANDESMUSUEM DORTMUND, GERMANY. from left to right at top **11-14** | DETAILS OF THE MEDIA CHAIR, SET-UP IN THE HALL, THE CHAIRS FLIP BACKWARDS SO THE FEET ARE RAISED, THE SPEAKERS CAN BE ADJUSTED FOR EASY STEREO LISTENING, THE H-SHAPE IS EMBEDDED WITH A JOYSTICK THAT CONTROLS SCENES FROM THE FILM NARRATIVES from left bottom of page **15-20** | IMAGES FROM THE FILM NARRATIVES – WORKERS WORKING. **21** | ONE OF THE ORIGINAL SKETCHES OF THE CHAIRS.

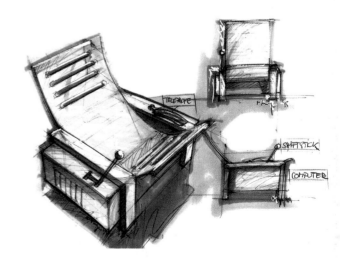

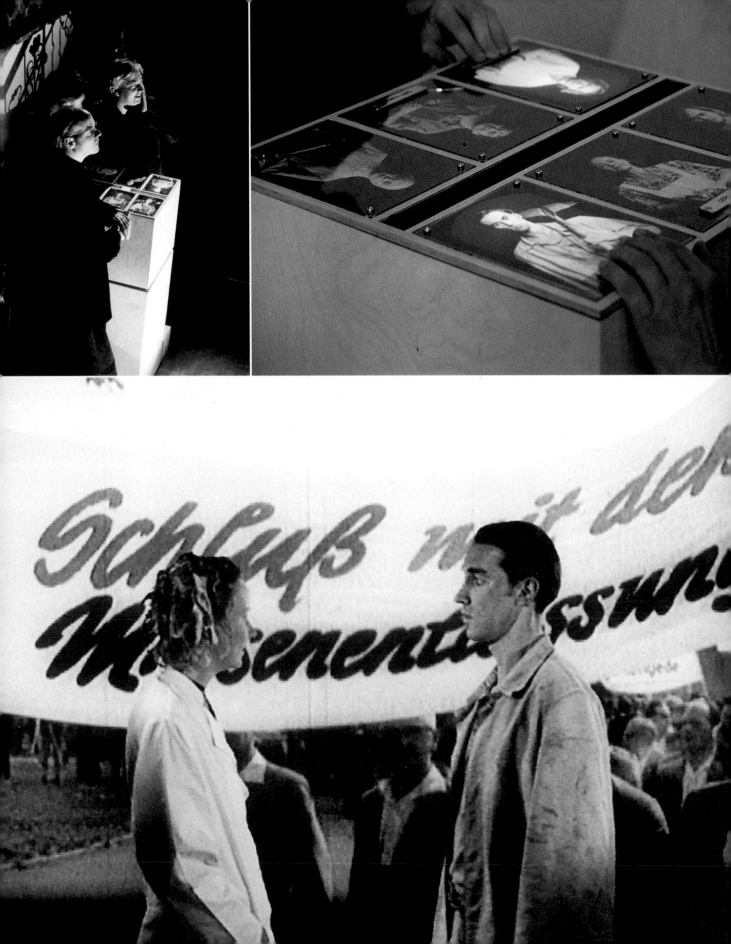

bottom left **24** |

IN 1962, PIOTR (1932) MEETS SABINE (1999) DURING A DEMONSTRATION AGAINST UNEMPLOYMENT.

SABINE Fahren Sie noch auf Schicht?

PIOTR (schaut sie von oben bis unten an) Sind Sie vom Zirkus?

SABINE (lacht)

PIOTR Ich habe Arbeit als Hauer.

SABINE Na, da schulen Sie besser jetzt schon mal um.

PIOTR Umschulen, was ist das?

BEYOND HIERARCHY? 2000. left page **22-23** | THE SECRET HANDSHAKE INTERFACE. **24** | EXAMPLE OF CONVERSATION - SABINE MEETS PIOTR. right page **25-26** | DIAGRAM OF INTERACTION AND PHOTO OF HANDSHAKE FROM THE ACTUAL INTERFACE. **27** | EXAMPLE OF CONVERSATION - SOPHIE MEETS LOTTE.

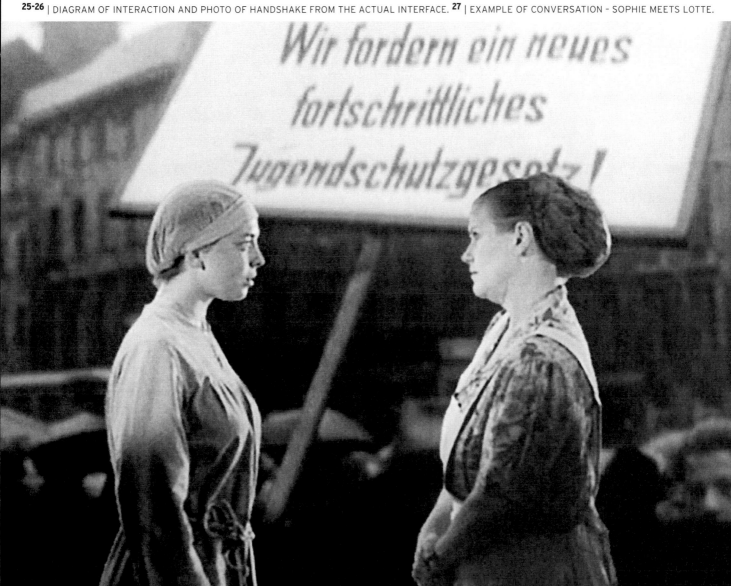

previous page bottom right **27** |

IN 1950, SOPHIE (1918) MEETS LOTTE (1952) IN BOCHUM AT A DEMONSTRATION FOR PEACE.
SOPHIE Lange kann ich nicht hier bleiben, ich habe ein krankes Kind zuhause.
LOTTE Oh, dat verstehe ich. Aber jetzt wollen sie schon wieder eine Armee in
Deutschland. Da musst du doch wat gegen tun.
SOPHIE Ja, wir haben genug Krieg gehabt.

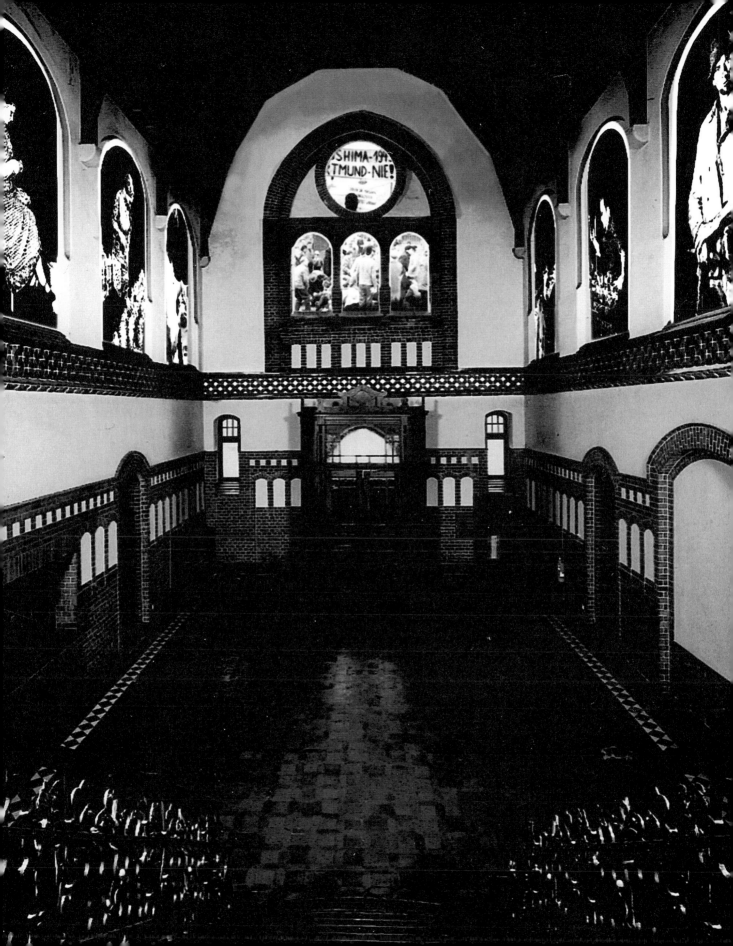

VIDEO - THE REFLEXIVE PERFORMANCE OF MEDIA IMAGES

AN ESSAY BY YVONNE SPIELMANN

E | In video performance, Jill Scott combines various aspects and developmental stages of performance art in a medium determined by reflexive characteristics. The concept of the video as a reflexive medium means that the electronic image radiates its presence at the place of the spectator. The electronic vocabulary of the video image is based on the direct and immediate transmission of signals, as is clearly demonstrated in feedback and closed-circuit processes, but also in the screening of the videotape on a monitor. The syntax of the monitor image transmitted is consequently determined by technical and apparative characteristics that generate a fluid type of image in constant motion on the surface of a screen. The transformatory character of the radiating and reflecting surface image inherent in this medium distinguishes it not only from the projective and light-generated image of film, but also from the digital and precisely numeric type of image.

D | Mit der Video-Performance verbindet Jill Scott verschiedene Aspekte und Entwicklungsstufen der Performance-Art in einem Medium, das durch reflexive Eigenschaften bestimmt ist. Der Begriff des Reflexionsmediums Video bedeutet, dass das elektronische Bild Präsenz ausstrahlt am Ort der BetrachterIn. Das elektronische Vokabular des Videobildes basiert auf der unmittelbaren und direkten Signalübertragung, was in Feedback- und Closed-Circuit-Verfahren exemplarisch deutlich wird, aber gleichfalls für die Ausstrahlung des Videobandes auf einem Monitor gilt. Die Syntax des ausstrahlenden Monitorbildes ist folglich durch technisch-apparative Eigenschaften festgelegt, die einen fließenden Bildtyp hervorbringen, der auf der Oberfläche eines Bildschirms in ständiger Bewegung ist. Der dem Medium eingeschriebene transformatorische Charakter des ausstrahlenden, also reflektierenden Oberflächenbildes unterscheidet dieses vom Projektionsbild/Lichtbild-Film und hebt es ebenso ab vom digitalen, genauer numerischen Bildtyp.

The immediate presence and transformatory character of the video image are suited in performance art to the direct transmission of simultaneous processes, self-control and monitoring of situations, as well as to the parallelism of spatially and temporally shifted perspectives, which can be introduced into a performance space. These aspects of the video medium come into their own especially where the electronic image is geared towards body-related performance. The use of video in an artistic framework of action rooted in the scenic-theatrical and space-related body-action works of the 1970s ultimately creates the context of body art and performance art. Like many performers and action artists who followed on from the works of Happening and Fluxus, Jill Scott, too, develops a body language based on her own psycho-social and physiological state, which she then extends to objects and media images.

Under the sign "body images", body art first and foremost describes the images of the artist's own body, but also the body as an image object. This can take on sculptural dimensions, as when Jill has herself affixed with adhesive tape, like an appliqué, to the facade of a warehouse. The "body" as object also means that in PARADISE TOSSED and MACHINEDREAMS the medially preproduced and stereotypical attitudes to the female body that prevail not only in advertising but also in art history are applied to household appliances and implements typically associated with women – such as a woman embracing a mixer and reaching out with similarly symbiotic intent to touch a typewriter or a telephone. With the lettering "Femmetech" inserted in these images like magazine titles, Jill Scott provides a programmatic response to her own question "where do we go from here?" Her notion of women and technology goes hand in hand with the visual setting of her own technological body fantasies through computer graphics and points in a new direction, with a ludic and temporary represention of the principle of blending in moving visual spaces of mixed realities.

Die unmittelbare Präsenz und der Transformationscharakter des Videobildes eignen sich in der Performance Art für Direktübertragungen gleichzeitiger Vorgänge, die Selbstkontrolle und Überwachung von Situationen, aber auch für die Parallelität von zeit-räumlich versetzten Perspektiven, die in einen Performance-Raum eingefügt werden. Solche Aspekte des Mediums Video kommen insbesondere dort zur Ausführung, wo das elektronische Bild auf körperbezogene Performance ausgerichtet ist. Der Einsatz von Video in einem künstlerischen Aktionsrahmen, der in den siebziger Jahren mit Körperaktionen in szenisch-theatralen und raumbezogenen Arbeiten seinen Ausgang nimmt, stellt schließlich den Kontext von Body Art und Performance Art her. Wie zahlreiche PerformerInnen und AktionskünstlerInnen in der Nachfolge von Happening und Fluxus entwickelt auch Jill Scott eine von der eigenen psycho-sozialen und physiologischen Befindlichkeit ausgehende Körpersprache, die sie dann auf Gegenstände und Medienbilder ausdehnt.

Body Art bezeichnet unter dem Stichwort Körperbilder zunächst die Bilder des eigenen Körpers, die die Künstlerin von sich macht, dann aber auch den Körper als ein Bildobjekt. Dies kann skulpturale Dimensionen annehmen, wenn sich Jill Scott mit Klebeband wie eine Applikation an der Außenfassade einer Lagerhalle befestigen lässt. Bildobjekt "Körper" heißt aber auch, dass in PARADISE TOSSED und MACHINEDREAMS medial vorproduzierte und stereotype Haltungen des weiblichen Körpers, wie sie nicht nur in der Werbung, sondern auch aus der Geschichte der Kunst vorliegen, an typisch weiblich konnotierten Haushalts- und Arbeitsgeräten eingenommen werden, so dass Frau einen Mixer umarmt und zu Schreibmaschine und Telefon in ähnlich symbiotischer Absicht greift. Mit den in diese Bilder wie Illustriertentitel eingefügten Schriften "Femmetech" antwortet Jill Scott programmatisch auf die selbst gestellte Frage "where do we go from here?" Denn ihre Vorstellung von Frauen und Technik geht mit der visuellen Setzung eigener technologischer Phantasien des Körpers durch Computergrafiken einher und weist in eine neue Richtung, die das Prinzip der Verschmelzung spielerisch und temporär in bewegten Bildräumen der Mixed Realities darstellt.

Taking the video image of the female body as her starting point, Jill Scott uses digital technology to alter the medium in order to bring other visual objects of variable and multiple bodies to the fore in interactive installations. On the one hand, this constitutes overcoming gender differences in the design of virtual figures no longer subject to the dual concept of Either-Or, but pursuing instead a multiple principle of As-Well-As and generating factually impossible identities (such as cyborgs and other virtual characters) through new correlations of characteristics. On the other hand, there is an intentional transhistorical approach to culturally and socially determined biographies, giving rise, in turn, to virtual characters embodied by real individuals or actors, that is to say figures whose interaction must be based on plausibility, but not necessarily on factual reality. In BEYOND HIERARCHY? six different biographies presented on parallel life-size screens can be involved in dialogue through additional interactive interfaces. In this way, the interaction takes on a transhistorical role, for the immediate presence of encounters that did not actually take place transfers fragments of past reality into virtually constructed aspects of the present that remain "alive" as long as the superstructure of the interaction is maintained.

In BEYOND HIERARCHY? the decisive factor is the transition from the filmically defined representation of documentary-fictional biographies to virtual presentation in a visual medium that underlines presence by virtue of the medial characteristic. Moreover, in addition to the intermedial transformation of film and video, there is also a further level of current interaction, which bridges the spatial and temporal differences underlying the individual portrayals. Strictly speaking, Jill Scott applies digital simulation as the superstructure that embraces the properties of film and video images in such a way that their characteristics become optional compositional traits within a hypermedial order. This means that filmic and videographic media images existing in linear order become integral aspects of a sequentially combinable visual structure.

Ausgehend vom Videobild des weiblichen Körpers wechselt Scott mit digitalen Techniken das Medium, um in interaktiven Installationen andere Bildobjekte von variablen und multipen Körpern hervorzubringen. Hierbei geht es zum einen um die Überschreitung von Gender-Differenzen im Entwurf virtueller Figuren, die nicht länger dem dualen Konzept des "Entweder-oder" unterliegen, sondern vielmehr einem multipen Prinzip des "Sowohl-als-auch" folgen und in der Neuzusammenstellung von Merkmalen auch faktisch unmögliche Identitäten (also Cyborgs und weitere virtuelle Charaktere) hervorbringen. Zum anderen geht es um einen intentional transhistorischen Zugang auf kultur- und sozialgeschichtlich determinierte Biografien, woraus wiederum virtuelle, aber von realen Personen/SchauspielerInnen verkörperte Charaktere entstehen, also Figuren, deren Interaktion auf Plausibilität, aber nicht notwendigerweise auf Faktizität beruhen muss. In BEYOND HIERARCHY? können sechs verschiedene Lebensläufe, die in der Videoprojektion auf parallelen Live-Size-Screens wiedergegeben werden, durch die zusätzliche interaktive Schnittstelle in einen Dialog gebracht werden. Hierbei kommt der Interaktion eine transhistorische Rolle zu, denn durch die unmittelbare Präsenz von historisch nicht stattgefundenen Begegnungen werden Wirklichkeitsausschnitte der Vergangenheit in eine virtuell konstruierte Gegenwärtigkeit transferiert, die solange "lebendig" bleiben, wie die Superstruktur der Interaktion aufrechterhalten bleibt.

Entscheidend ist in BEYOND HIERARCHY?, dass der Übergang von der filmisch definierten Repräsentation dokumentarisch-fiktionaler Biografien zur virtuellen Präsentation hier in einem Bildmedium erfolgt, welches qua medialer Eigenschaft Präsenz unterstreicht. Zur intermedialen Transformation von Film und Video tritt zudem eine weitere Ebene der aktuellen Interaktion hinzu, welche die in den einzelnen Darstellungen zugrundeliegenden zeit-räumlichen Differenzen überbrückt. Genau genommen setzt Jill Scott die digitale Simulation als die Superstruktur ein, welche die Beschaffenheiten von Film- und Videobildern in der Weise umschließt, dass deren Eigenschaften optionale Gestaltungsmerkmale in einer hypermedialen Anordnung werden. Dies bedeutet, filmisch-videografische Medienbilder, die in linearen Festlegungen existieren, werden Bestandteil einer sequentiell kombinierbaren Bildstruktur.

In a similar vein, Jill Scott's installation FRONTIERS OF UTOPIA outlines eight different female life-concepts on a filmic-narrative basis, linking them interactively, so that here, too, the combination of video and computer enables the spectator or user to intervene interactively (in the representation of fictional characters). Indeed, in both art works, the media difference between film and video is lucidly expressed by the fact that the portrayals fulfil the filmic function of representing an aspect of female cultural history in each of the individual biographies. However, the portrayal goes still further, for the character of video is especially evident in a form of portrayal which permits the direct and simultaneous presence of historically impossible partners in dialogue within a single image, supported by computergenerated selection. This concept of blending an electronic medium of presence with interactive processes becomes even clearer when the principle of filmic montage is entirely replaced by the electronic collage and when entirely non-narrative elements are digitally combined in INTERSKIN. The use of computer animated characters indicates the transition from linear video to non-sequential hypermedium, which also signifies a conceptual change from the virtual reconstruction of past and present figures towards futuristic corporeality and future bodies.

This means that the use of digital visual processes generates other potentials of imaging which is not based on the duality of image and the representational image relevant to recording media (film and video) and so frequently the subject of art historical debate. On the contrary, the digital image is fundamentally optional as a simulated image, being flexible and not determined by specific spatial and temporal parameters. Like the video image consisting of electronic signals, the digital image is unstable and non-fixed, but is also multidimensional and omnidirectional, as evidenced in the simulated movements and 3-D effects of virtual reality. Proceeding from body art and an intermedial approach to video as an interface to performance art, Jill Scott ultimately regards the possibilities of digital imagery as

In vergleichbarer Weise hat Jill Scott bereits in der Installation FRONTIERS OF UTOPIA acht verschiedene weibliche Lebensentwürfe auf filmisch-narrativer Basis konzipiert und interaktiv verschränkt, wobei auch hier die Verbindung von Video und Computer es den BetrachterInnen bzw. AnwenderInnen ermöglicht, nicht nur in die Repräsentation der fiktionalen Charaktere interaktiv einzugreifen. Vielmehr kommt in beiden Arbeiten die Mediendifferenz zwischen Film und Video dadurch anschaulich zum Ausdruck, dass die Darstellungen zwar die filmische Funktion erfüllen, in den individuellen Lebensgeschichten jeweils ein Stück weiblicher Kulturgeschichte zu repräsentieren. Darin erschöpft sich die Darstellung jedoch keineswegs, denn der Charakter von Video zeigt sich insbesondere in der Form der Darstellung, welche die unmittelbare und gleichzeitige Präsenz von historisch nicht möglichen DialogpartnerInnen in einem Bild erlaubt, unterstützt durch die computergesteuerte Auswahl. Deutlicher noch wird dieses Konzept der Vermischung von elektronischem Präsenzmedium und interaktiven Prozessen, wenn das Prinzip der filmischen Montage vollständig abgelöst ist durch die elektronischen Collage und in INTERSKIN von vornherein nicht-narrative Elemente in digitaler Kombinatorik zusammentreffen. Mit computeranimierten Charakteren zeichnet sich ein Übergang vom linearen Video zum non-sequentiellen Hypermedium ab, der auch einen konzeptuellen Wechsel von der virtuellen Rekonstruktion vergangener und gegenwärtiger Figuren zu futuristischer Körperlichkeit/Future Bodies bedingt.

Dies bedeutet, dass der Einsatz von digitalen Bildverfahren andere Potentiale von Bildlichkeit hervorbringt, die gerade nicht auf der kunsthistorisch stark diskutierten Dualität von Bild und Abbild beruhen, wie sie für die Aufzeichnungsmedien (also Film und Video) relevant ist. Im Gegenteil, das digitale Bild ist als Simulationsbild grundsätzlich optional, es ist flexibel und nicht durch bestimmte zeit-räumliche Parameter festgelegt. Wie das aus elektronischen Signalen bestehende Videobild ist auch das digitale Bild instabil und nicht-fixiert, es ist aber darüber hinaus auch multidimensional und omnidirektional, wie dies in simulierten Bewegungen und 3-D-Effekten der

media extensions of the body and its new visual syntax. In the virtual reality installation INTERSKIN the possible body forms and body images are not fixed, but, on the contrary, demand a performative activity on the part of the user as viewer, and vice versa, in order to combine visual objects to create an imaginary body. The interesting aspect here is the step towards interactivity in the sense that the spectators not only participate in the construction process of the visually simulated body, but also use various possible modules to produce an image-space-body in 3-D animation that presents, through selection, a different self-image whose form cannot be representative. Unlike the visual representations of the screen medium film, where the image can be permeable in respect of the object represented (the image appearing as a window on the world), but also in contrast to the monitor image of the video which "transmits" the line-written surface image into the viewer's space (the image appearing as a spatial inclusion in the space of the viewer), the interactive visual space opens up optional forms of portrayal through multiple choices in media surroundings that shift conventional media boundaries in several respects.

In digital image composition mode, the moving picture as object is not only a visual representation that alters three-dimensionally for the viewer, but the viewer or user is actually involved performatively in the process of transformation of a multi-layered visuality that blends elements of the static (photographic), the dynamic (filmic) and the sculptural (computer graphics). The effect of an immersive involvement is created by the construct of mixed realities. This consists in spaces that blend medially simulated and actual physical dimensions in such a way as to generate spatial surroundings in which the viewers coherently interact with physical reality and digitally coded reality. The resulting merger of different levels of portrayal cancels the representational function of images that portray something, and renders permeable the boundary between media surroundings and real surroundings in the interactive process. The viewer or user is involved in a constantly changing presentation of a performative environment. The fact that the viewer and the artist share the creative process with the computer as image-generating machine applies generally to the media surroundings of virtual reality. A typical aspect of Jill Scott's interactive installations, however, is that in the DIGITAL BODY AUTOMATA trilogy, bodies occur as image and object relating both to each other and to the spectator.

Virtual Reality deutlich wird. Jill Scott begreift ausgehend von der Body Art und einem intermedialen Verständnis von Video im Sinne einer Schnittstelle zur Performance Art schließlich die digitalen Bildmöglichkeiten als mediale Erweiterungen des denkbaren Körpers und seiner neuen Bildersprache.

In der Virtual Reality Installation INTERSKIN sind die möglichen Körperformen und -bilder gerade nicht fixiert, sondern erfordern im Gegenteil eine performative Aktivität der BenutzerIn (user) als ZuschauerIn (viewer) und vice versa, um visuelle Objekte zu einem imaginären Körper zusammenzufügen. Hierbei interessiert der Schritt zur Interaktivität in der Weise, dass die BetrachterInnen am Konstruktionsprozess des visuell simulierten Körpers nicht nur teilhaben, sondern einen Bild-Raum-Körper in der 3-D-Animation aus verschieden möglichen Bausteinen herstellen, der über Auswahl ein anderes Selbst-Bild präsentiert, dessen Form nicht repräsentativ sein kann. Im Unterschied zur visuellen Repräsentation des Screen-Mediums Film, wo das Bild auf den Gegenstand hin durchlässig werden kann (das Bild, das als Fenster zur Welt erscheint), aber auch unterschieden vom Monitorbild des Videos, welches das zeilengeschriebene Oberflächenbild in den Raum der BetrachterIn "ausstrahlt" (das Bild, das als räumlicher Einschluss in den Raum der BetrachterIn erscheint), eröffnet der interaktive Bildraum optionale Darstellungsformen durch multiple Wahlmöglichkeiten in Medienumgebungen, die gewohnte Mediengrenzen in mehrfacher Hinsicht verschieben.

Im Modus der digitalen Bildgestaltung ist das bewegte Bild als Objekt nicht nur eine visuelle Repräsentation, die sich für die BetrachterIn dreidimensional ändert, sondern vielmehr sind die BetrachterInnen/AnwenderInnen performativ in den Transformationsprozess einer vielschichtigen Bildlichkeit eingebunden, die statische (fotografische), dynamische (filmische) und plastische (Computergrafik) Anteile vermischt. Der Effekt einer immersiven Einbindung entsteht durch das Konstrukt von Mixed Realities. Darunter sind Räume zu verstehen, die medial simulierte und tatsächlich physikalische Dimensionen vermischen, und zwar so, dass räumliche Umgebungen erzeugt

The future bodies that can be combined out of unrelated elements in INTERSKIN thus address visions of a different corporeality, even a third gender, in the work of Jill Scott. As a counter-concept to the complete and perfect, healthy and youthful cyberbody connoted as the "ideal" body image in the sterile and symmetrical environments of most computer graphics, Scott's virtual body portrayals point to the limitations and imperfections of the real body when she works with ironic visual metaphors in the futuristic setting of computer animation. The visual vocabulary of DIGITAL BODY AUTOMATA suggests fluid transitions between medical models, pictograms and iconic signs from different cultural contexts.

The structural openness in the portrayal of digital figures (and their temporary interaction in A FIGURATIVE HISTORY) reflects, in whimsically utopian forms, the fundamental optional media character of digital visuality. At the same time, however, this optionality infers drifting on another level, for the serious confrontation with one's own imperfect body occurs in the context of illness. In the videotape CONTINENTAL DRIFT Jill Scott addresses her own experience of the unhealthy body when she uses the metaphors of water and machine to highlight issues of the life struggle. The thematic and visual centre of the work is the concept of transformation or, more precisely, control of transformation, which permits both the regeneration of the earth and the healing of the body. In an earlier video tape, AUSTRALIAN PARADOX, Scott also uses similar shots of moving water, fire and wind to correlate the transformatory powers of nature with our notions of functionality:

werden, in denen die BetrachterInnen mit der physischen Realität und der digital codierten Wirklichkeit zusammenhängend interagieren. Die hieraus entstehende Vermischung der Darstellungsebenen hebt die Repräsentationsfunktion von Bildern auf, die etwas darstellen, und macht im interaktiven Prozess die Grenzen zwischen Medienumgebung und realer Umgebung durchlässig. Viewer/User sind in eine ständig wechselnde Präsentation eines performativen Environment eingebunden. Dass BetrachterIn und KünstlerIn gemeinsam den kreativen Prozess mit der bildgenerierenden Maschine Computer teilen, gilt allgemein für die Medienumgebungen der Virtual Reality. Charakteristisch für die interaktiven Installationen von Jill Scott ist jedoch, dass in der Triologie DIGITAL BODY AUTOMATA, Körper als Bild und Objekt vorkommen, die sowohl aufeinander wie auf die BetrachterIn bezogen sind.

Die aus unverbundenen Elementen kombinierbaren Future Bodies in INTERSKIN teilen bei Jill Scott somit Visionen anderer Körperlichkeit, auch eines dritten Geschlechts mit. Im Gegenentwurf zum vollständigen und perfekten, gesunden und jugendlichen Cyberbody, wie er in der Überzahl der Computergrafik in aseptischen und symmetrischen Environments als idealer Bildkörper konnotiert ist, weisen Scotts virtuelle Körpervorstellungen auf die Begrenztheit und "Reparaturbedürftigkeit" des realen Körpers hin, wenn sie im futuristischen Setting der Computeranimation mit ironischen Bildmetaphern arbeitet. Zwischen medizinischem Modell, Piktogrammen und ikonischen Zeichen aus verschiedenen Kulturzusammenhängen sind im visuellen Vokabular der DIGITAL BODY AUTOMATA fließende Übergänge nahegelegt.

Die strukturelle Offenheit in der Darstellung digitaler Figuren (und auch ihrer temporären Interaktion in A FIGURATIVE HISTORY) reflektiert in spielerisch utopischen Formen zugleich den grundsätzlich optionalen Mediencharakter digitaler Bildlichkeit. Optionalität bedeutet aber auch noch "Driften" auf einer anderen Ebene, denn die ernsthafte Auseinandersetzung mit dem fehlerhaften eigenen Körper steht im Zeichen der Krankheit. In dem Videoband CONTINENTAL DRIFT

those ones rooted in the principle of the mechanical and the machine. The technical visual medium of the video has a dual function in these poetic works: on the one hand, it underlines the technological feasibility and achievements in cultural terms, while on the other hand self-reflexively indicating the mutability of elementary powers and states of disease through the transformatory quality of the medium.

For the medial convergences that are the benchmark of interactive video and computer installations, the potential for transformation constitutes the decisive prerequisite for the presentation of persuasive mixed realities. Initially, these comprise the complex levels of reality that arise through the intermedial fusion of historic-documentary and virtually simulated figures in imaginary visual spaces, and secondly, the interactive inclusion of the recipient in immersive visual environments. Even if recent interactive computer animations clearly express the creative potential of digital visuality in the composition of multiple interfaces, the validity of the electronic medium of video remains inviolate. This occurs above all where Scott grasps the immediate presence of fluid imagery as a structural framework in order to bring together filmic, performative and computer graphic elements on a single compositional level. In a further step, this results in the juxtaposition of film, video and computer animated visual forms in a performative setting in which interactive participation is extended into collaborative creativity. The starting point of this development lies in the early interaction of performance art and body art, where the approach to inter-medial spatial installations is initially grounded in the video transmission from inside to outside and from before to after.

verarbeitet Jill Scott eigene Erfahrungen des kranken Körpers, wenn sie über die Metaphoriken des Wassers und der Maschine Fragen des Lebenskampfes aufwirft. Im thematischen und visuellen Zentrum der Arbeit steht das Konzept der Transformation, genauer der Kontrolle der Transformation, welches sowohl die Regeneration der Erde als auch die Heilung des Körpers ermöglicht. Auch in dem früheren Videoband AUSTRALIAN PARADOX verwendet Scott ähnliche Aufnahmen von bewegtem Wasser, von Feuer und Wind, um transformatorische Kräfte in der Natur mit unseren Vorstellungen von Funktionalität abzugleichen, die – vor allem in der westlichen Kulturgeschichte – aus dem Prinzip des Mechanischen und Maschinellen hervorgehen. Das technische Bildmedium Video hat in diesen poetischen Arbeiten eine zweifache Funktion: Es streicht zum einen das technologisch Machbare und Gemachte in kultureller Hinsicht heraus, und es zeigt zum anderen die Veränderlichkeit von elementaren Kräften und Krankheitszuständen durch die transformatorische Qualität des Mediums selbstreflexiv an.

Für die medialen Vermischungen, wie sie in den interaktiven Video- und Computerinstallationen maßgeblich sind, bildet demzufolge das Transformationspotential die ausschlaggebende Voraussetzung, um überzeugende Mixed Realities präsentieren zu können. Diese umfassen zunächst komplexe Realitätsebenen, die aus der intermedialen Vermischung von historisch-dokumentarisch und virtuell simulierten Figuren in imaginären Bildräumen entstehen, dann aber auch die interaktive Einbeziehung des Rezipienten in immersive Bildumgebungen. Auch wenn die neueren interaktiven Computeranimationen das Potential digitaler Bildlichkeit in der Gestaltung multipler Interfaces pointiert zum Ausdruck bringen, so bleibt dennoch der Stellenwert des elektronischen Mediums Video erhalten. Dies geschieht vor allem dort, wo Scott die unmittelbare Präsenz fließender Bildlichkeit als Strukturrahmen begreift, um filmische, performative und computergrafische Elemente auf einer Gestaltungsebene zusammenzuführen. In einem weiteren Schritt ergibt das Zusammentreffen der Bildtypen Film, Video und Computeranimation ein performatives Setting, in dem interaktive Partizipation erweitert ist zur krea-

Scott uses video as a component part of performance in accordance with the notion of video as a medium of transmission, which prevailed in the 1970s. In live video performances, such as MOVED UP MOVED DOWN, she records her own movements and those of the audience in the manner of publicly installed surveillance cameras and juxtaposes monitors showing previously recorded footage and current images of the same situation. The transmission from the visual medium to the viewer in ACCIDENTS FOR ONE is such that one person in the room has to follow the instructions fixed on video tape and presented on a monitor, while the execution of these instructions is recorded live. In INSIDE OUT the surveillance function in the use of video as a transmission medium is even clearer. Here, inside and outside, before and after, are situated in spatially and visually discrete areas. The connection is created by a camera operating in the street in front of a cellar window and giving an insight into the performance in the cellar itself. However, the spectator can abandon the voyeuristic through-the-keyhole view of part of the performance and can cross the media boundary by entering the cellar personally and experiencing at first hand the overall situation of the performance which, like the two examples mentioned above, thematically addresses movement in space.

The deliberately theatrical aspects of Jill Scott's video performance undoubtedly have their origins in the body sculpture TAPED and culminate spectacularly in CONSTRICTION. In this latter video performance installation, various levels of performance are spatially linked by video. The videotape shows a stage-like space "inhabited" by a boa constrictor that devours white mice. This scene is contrasted with shots of the performer Jill Scott, lying under a thin box of glass and also attempting to catch, with her mouth, the mice running inside the glass box. This scene, in turn, is shown on a monitor allocated to the space of the boa constrictor, so that the performance takes place on various stages, which are medially interlinked. Video is defined here as the visual inclusion of theatrical performances integrated into another scene in the room. This work clearly illustrates the reflexive character of the video medium by introducing the media image into another room and at the same time referring back to the level of departure by way of the circular structure.

tiven Mitgestaltung. Ihren Ausgangspunkt nimmt diese Entwicklung in der frühen Verschränkung von Performance Art und Body Art, wo der Ansatz zur medienübereifenden Raum-Installation zunächst in der Videoübermittlung von innen nach außen und vorher zu nachher begründet ist.

Video als Bestandteil der Performance verwendet Scott gemäß der in den siebziger Jahren vorherrschenden Auffassung als ein Übertragungsmedium. In Live-Video-Performances wie MOVED UP MOVED DOWN zeichnet sie eigene Bewegungen und Bewegungen der ZuschauerInnen wie mit einer öffentlichen Überwachungskamera auf und stellt das zuvor aufgenommene Bildmaterial mit den aktuellen Bildern der gleichen Situation auf Monitoren gegenüber. Die Übertragung vom Bildmedium auf die ZuschauerIn erfolgt in ACCIDENTS FOR ONE derart, dass eine Person im Raum den auf Videoband fixierten Anweisungen eines Monitors folgen soll, während ihre Ausführungen dieser Vorgaben wiederum live aufgezeichnet werden. Mit INSIDE OUT wird die Überwachungsfunktion im Gebrauch von Video als Übertragungsmedium noch deutlicher. Denn hier sind innen und außen, vorher und nachher in räumlich und das heißt auch visuell getrennten Bereichen situiert. Die Verbindung stellt eine Videokamera her, die im Straßenraum vor einem Kellerfenster justiert ist und Einblick in die Live-Performance in diesem Kellerraum gibt. Allerdings können die ZuschauerInnen die voyeuristische Schlüsselloch-Perspektive auf einen Ausschnitt der Performance auch aufgeben und die Mediengrenze überschreiten, indem sie selbst in den Keller gehen und die Gesamtsituation der Performance erfahren, die sich thematisch – wie die beiden letztgenannten – mit Bewegung im Raum auseinandersetzt.

The medial extensions of body art into the field of video performance, the medial self-reflection of the video image, and the expansion of any given setting into different, linked rooms, are the kind of constant themes that characterise the way in which Jill Scott's video works have been anchored within the wider context of media art since the 1970s. In the field of video, a distinction is to be made, above all, between three main streams. Video regarded as an electronic medium that has certain technical and apparative qualities in common with television is used by political movement groups with the aim of creating an alternative form of television. The second group consists of visual artists seeking to integrate what was then the new medium of video into the gallery space as an extension of Happenings, Fluxus and Event Art, and who are the founders of the so-called art video. The third group emerged from the field of technical experimentation with electronic audio and visual signals, making a seminal contribution to the development of the visual language of the video medium.

In her DOUBLE DREAM installation based on videotape, Jill Scott experiments, against the backdrop of the media history of video, with half-image of video and renders visible the space between the electronically generated scan lines. In other words, she composes the duality of two portraits of women referring to different stereotypes of female beauty projected in advertising and television, placing them in a visual context that uses the video effects of the surface image to render visible deeper structures, both in technical and in cultural terms. DOUBLE SPACE also oversteps the principle of doubling, for in feedback the same female figure appears to multiply. Jill Scott's experimental use of effect appliances such as those developed for processes of layering, matte and mask (especially Blue Box) is motivated by her critical view of found patterns of representation and a seriously playful development of other visual, object and body worlds. In her futuristic video installation LIFE FLIGHT, the use of Blue Screen permits an "escape" into other visual spaces. Although

Die gezielt theatralen Momente in der Video-Performance von Jill Scott haben zweifelsohne ihren Ausgangspunkt in der Körperskulptur TAPED und finden einen weiteren spektakulären Kulminationspunkt in CONSTRICTION. In dieser Video-Performance-Installation sind verschiedene Aufführungsebenen per Video miteinander räumlich verbunden. Das Videoband zeigt einen bühnenartigen Raum, der von einer Boa Constrictor "bewohnt" wird, die weiße Mäuse auffrisst. Diese Szene ist kontrastiert mit Aufnahmen der Performerin Jill Scott, wie sie unter einer Glasplatte liegt und versucht, gleichfalls Mäuse mit dem Mund zu fangen, die über der Glasplatte laufen. Diese Szene wiederum ist auf einem Monitor zu sehen, der dem Raum der Boa zugeordnet ist, so dass das Staging der Performance auf verschiedenen "Bühnen" stattfindet, die medial verschachtelt sind. Video ist hier als der bildliche Einschluss theatraler Performances definiert, der in den Raum einer anderen Szene integriert ist. Diese Arbeit veranschaulicht den Reflexionscharakter des Mediums Video durch die Einfügung des Medienbildes in einen anderen Raum, welcher durch die zirkuläre Struktur gleichzeitig auf die Ausgangsebene zurückverweist.

Die medialen Erweiterungen von Body Art auf Video-Performance, die mediale Selbstreflexion des Videobildes, aber auch die Expansion eines Settings in verschiedene, verbundene Räume, solche durchgängigen Thematiken kennzeichnen die Verankerung der Videoarbeiten von Jill Scott in einem größeren Rahmen der Medienkunst seit den siebziger Jahren. Im Bereich Video sind hier vor allem drei Hauptströmungen zu unterscheiden. Video verstanden als ein elektronisches Medium, das mit dem Fernsehen technisch-apparative Eigenschaften teilt, wird von der Gruppe der politischen Bewegungen mit dem Ziel eines alternativen Fernsehens eingesetzt. Die zweite Gruppe sind bildende KünstlerInnen, die in der Weiterführung von Happening, Fluxus und Event Art das damals neue Medium Video in den Galerieraum zu integrieren versuchen und die Anfänge des sogenannten künstlerischen Videos begründen. Die dritte Gruppe geht aus dem Bereich technischer Experimente mit elektronischen Bild- und Tonsignalen hervor und trägt entscheidend zur Entwicklung der Bildsprache des Mediums Video bei.

Vor dem Hintergrund der Mediengeschichte von Video experimentiert Jill Scott in DOUBLE DREAM, einer auf Videoband basierenden Rauminstallation, mit den Halbbildern des Videos und macht den Zwischenraum der elektronisch geschriebenen Linien (scan lines) sichtbar. Das heißt, sie gestaltet die Dualität von zwei Frauenportraits, die auf unterschiedliche Stereotypen der Werbe- und Fernsehbilder von weiblicher Schönheit anspielen, hier in einem Bildzusammenhang, der Videoeffekte des Oberflächenbildes nutzt, um tiefere Strukturen in technischer, aber eben auch in kultureller Hinsicht zur Sichtbarkeit zu bringen. DOUBLE SPACE überschreitet dann das Prinzip der Doppelung, denn im Feedback-Verfahren erscheint dieselbe weibliche Figur vervielfacht. Der experimentelle Einsatz von Effektgeräten, wie sie für Layer-, Matte-, und Masken-Verfahren (insbesondere Blue Box) entwickelt wurden, ist bei Jill Scott motiviert durch Kritik an vorgefundenen Repräsentationsmustern und die ernsthaft spielerische Entwicklung anderer Bild-, Objekt- und Körperwelten. In der futuristischen Videoinstallation LIFE FLIGHT ermöglicht die Verwendung von Blue Screen die "Flucht" in andere Bildräume. Dieser virtuelle Garten, der nichts anderes als eine technologische Realität präsentiert, erhält, obwohl die Metapher des Paradieses in idealisierten Naturbildern gewollt strapaziert wird, eine poetische Qualität, die Effekte der Bildermaschine durchschlägt. Solchen Videoarbeiten aus den achtziger Jahren vergleichbar, zeugt auch eine komplex interaktive Installation wie MACHINEDREAMS einerseits von der direkten Aneignung technischer Effekte und andererseits von der ironisch-kritischen Perspektive auf Vorstellungen, die unser Verhältnis zu Technologie im Allgemeinen und das Verhältnis von Frauen und Technologie im Besonderen betreffen.

Dieser Ansatz ist in Videoarbeiten und den späteren digital codierten Körperbildern von Jill Scott dort prägend, wo die Überwachungs- und Kontrollmöglichkeiten des Mediums, also der Übertragungscharakter des Bildes und die reflexive Struktur im Video, unter dem Vorzeichen eines politisch verstandenen persönlichen Ausdrucks stehen. Ein wichtiger Aspekt bildet hierbei die Auseinandersetzung mit der Überwachungs- und Kontrollfunktion der öffentlichen Bilder ("public images"). Das Hinterfragen der technologischen Manipulation im "public image" führt Jill Scott zur Bearbeitung der Differenz von zuvor aufgenommenem Bild und Live-Übertragung in Video-Performances. Deren mediale Anordnung - Apparat, BetrachterIn, PerformerIn - dient dazu, die Parameter medial strukturierter

the metaphor of Paradise is deliberately overloaded in idealised images of nature, this virtual garden, which presents none other than a technological reality, possesses a poetic quality that penetrates the effects of the image machine. Comparable to the video works of the 1980s, a complex interactive installation such as MACHINEDREAMS bears witness, on the one hand, to the direct appropriation of technical effect and, on the other hand, to the ironically critical view of notions that affect our relationship to technology in general and the relationship between women and technology in particular.

This approach is formative in Jill Scott's video works and later her digitally coded body images, wherever the medium's possibilities of surveillance and control - (that is to say, the transmission character of the image and the reflexive structure in the video) are used under the sign of a politically conceived personal expression. An important aspect in this respect is the confrontation with the surveillance and control function of public images. Questioning technological manipulation in the public image has led Jill Scott to explore the difference between recorded footage and live transmission in video performances. Their medial alignments - apparatus, viewer, performer - serve to explore the parameters of medially structured reality more precisely. This occurs particularly in interim areas, which do not clearly separate the defined art context from the medial reality of public images. This is the field that Jill Scott occupies through video as a reflexive performance.

All in all, Jill Scott's video work is embedded within a dual context relating, on the one hand, through live performances to the public use of live surveillance cameras and oriented, on the other hand, towards body-related performance. The close connection since the 1970s between video and performance so typical of Jill Scott's work has been of interest to many women artists. This connection increasingly articulates feminist viewpoints and seeks out medially unused forms of expression in order to develop other/different views of the female body and its cultural determinations. In this respect, Scott's video works indicate conceptual parallels with the appropriation and analysis of self-image and the function of video technology, as in the work of Ulrike Rosenbach and Friederike Pezold. Given their intention of countering prevailing notions of femininity, female sexuality and the female body through visual aesthetics, the discursive analysis with the body image is a necessity for these artists. Whereas Pezold is interested in the difference between the recording and projection of the image and in addressing the control function of the monitor image self-reflexively in her body performance for the camera, such artists as Joan Jonas and Marina Abramovic concentrate more on the interface between performance and body art from the point of view of their own image and/as a public image.

Stronger similarities can be found in the video performances by Ulrike Rosenbach, in which the artist explores images of female body-poses she has recorded on video, contrasting them with fixed and supposedly natural body-poses in famous works of the history of painting (such as her 1975 "Glauben Sie nicht, dass ich eine Amazone bin" – Don't Believe I'm an Amazon – and her 1976 "Reflexionen über die Geburt der Venus" – Reflections on the Birth of Venus). The fact is that there is a crucial difference here between the concept of the "image" and its visual representation. This is an impor-

Wirklichkeit genauer zu ergründen. Dies geschieht insbesondere in Zwischenbereichen, die den definierten Kunstkontext und die mediale Wirklichkeit von "public images" nicht sauber trennen. Diesen Bereich hält Jill Scott mittels Video als einer reflexiven Performance besetzt.

Zusammengenommen steht Jill Scotts Videoarbeit in einem doppelten Kontext, der einerseits mit Live-Performances auf den öffentlichen Gebrauch von Live-Überwachungskameras bezogen ist, und sich andererseits orientiert an der Richtung der körperbezogenen Performance. Die enge Verbindung von Video und Performance, wie sie für Scott typisch ist, wird seit den siebziger Jahren für KünstlerInnen interessant, die zunehmend feministische Standpunkte artikulieren und nach medial unverbrauchten Ausdrucksmöglichkeiten suchen, um andere Ansichten, vor allem des weiblichen Körpers und seiner kulturgeschichtlichen Determinationen, zu geben. Diesbezüglich weisen die Videoarbeiten von Scott konzeptuelle Parallelen auf zur Aneignung und Auseinandersetzung mit dem eigenen Bild und der Funktion von Videotechnik, beispielsweise bei Ulrike Rosenbach und Friederike Pezold. In der Absicht, vorherrschenden Vorstellungen von Weiblichkeit, weiblicher Sexualität und weiblichem Körper bildästhetisch zu begegnen, ist für diese Künstlerinnen die diskursive Auseinandersetzung mit dem Bild des Körpers eine Notwendigkeit. Während Pezold an der Differenz zwischen Aufnahme und Wiedergabe des Bildes interessiert ist und die Thematisierung der Kontrollfunktion des Monitorbildes selbstreflexiv in ihre Körperperformance für die Kamera einbezieht, arbeiten beispielsweise Joan Jonas und Marina Abramovic stärker an der Schnittstelle von Performance und Body Art unter dem Gesichtspunkt ihres eigenen und/als öffentliches Bild.

Stärkere Gemeinsamkeiten weisen Video-Performances von Ulrike Rosenbach auf, in denen die Künstlerin einen Abgleich des selbst auf Video aufgenommen Bildes weiblicher Körper-

tant point of departure by video artists in various ways: a bid to render visible the reconstruction of the visual in aesthetic analysis. In her 1977 performance "Frauenkultur - Kontaktversuch" (Female Culture - Contact Attempt) Rosenbach takes photographs of women from different cultures, and places the images in a row on the floor. The fact that she herself lies on the floor and rolls past the photos creates, for the viewer, a visual difference between the image of the lined-up photographs and the rotating representation of these pictures.

What appears in the work of Rosenbach as a discrepancy between image and representational image through the self-reflexive appropriation and reiteration of images also contributes in Jill Scott's work to the constitution of an "image of one's own". This also means that, in the medium of the video, it is a question of highlighting the difference at the level of the medium itself. This also applies to the technical-apparative structure of the electronic medium in its transformatory possibilities. For this reason, Jill Scott is interested in the technical possibilities of intervention which, for her, do not merely arise from the concept of the performance, but can actually gain a performative quality themselves - above all in the interaction of videographic and digital imagery. In this respect, video is the consequential step in the development towards hybrid media images of virtual reality.

haltungen in Differenz zu den bildnerisch fixierten, vermeintlich natürlichen Körperhaltungen auf berühmten Gemälden der Kunstgeschichte sucht (z.B. "Glauben Sie nicht, dass ich eine Amazone bin", 1975 und "Reflexionen über die Geburt der Venus", 1976). Dass hier eine entscheidende Differenz zwischen dem Konzept von "Bild" und seiner visuellen Repräsentation vorliegt, haben Videokünstlerinnen verschiedentlich zum Ausgangspunkt genommen, in der ästhetischen Analyse die Rekonstruktion des Bildlichen sichtbar zu machen. In der Video-Performance "Frauenkultur - Kontaktversuch" (1977) nimmt Rosenbach mit der Kamera Fotos von Frauen aus verschiedenen Kulturkreisen auf, die in einer Reihe am Boden aufgestellt sind. Dadurch, dass sie selbst am Boden liegt und mit Drehungen um die eigene Achse an den Fotos vorüberrollt, entsteht für die ZuschauerInnen eine visuelle Differenz zwischen dem Bild der Fotos in Reihe und dem rotierenden Abbild dieser Bilder.

Was dort als Nicht-Übereinstimmung von Bild und Abbild durch die selbstreflexive Aneignung und Wiedergabe von Bildern bei Rosenbach aufscheint, trägt auch bei Jill Scott zur Konstituierung eines "image of one's own" bei. Dies bedeutet auch, dass es im Medium Video darum geht, die Differenz auf der Medienebene selbst zu verdeutlichen. Und dies betrifft nicht zuletzt die technisch-apparative Struktur des elektronischen Mediums in seinen transformatorischen Möglichkeiten. Jill Scott interessieren gerade deshalb die technischen Möglichen der Intervention, die für sie nicht bloß aus dem Konzept der Performance hervorgehen, sondern vielmehr selbst performative Qualität gewinnen können - und zwar vor allem in der Interaktion von videografischem und digitalem Bild. So gesehen ist Video ein konsequenter Entwicklungsschritt zu hybriden Medienbildern der virtuellen Realität.

D | Jill Scott ist ursprünglich ein Kind der sechziger Jahre. 1968 schleuderte sie als frühreifer Teenager Ziegelsteine in die Fensterscheiben der Honeywell Corporation in Melbourne und wurde deswegen kurzzeitig verhaftet. Honeywell lieferte damals Napalm für den Vietnamkrieg. Ihre linksradikale Einstellung war charakteristisch für viele aus ihrer Generation. Aber im Gegensatz zu den meisten anderen ist sie ihrem Idealismus und Aktivismus treu geblieben. Drei Jahrzehnte als Künstlerin und Frau – häufig nicht voneinander zu trennen – zeugen von ihrer sozialen Haltung und dem politischen Engagement, glücklicherweise in einer weniger destruktiven Form als man vielleicht nach ihrem jugendlichen Vandalismus gegen die Einrichtungen von Honeywell hätte befürchten können.

PROGRESSIVE IDEALS AND POLITICAL ENGAGEMENT IN JILL SCOTT'S ART

AN ESSAY BY ROBERT ATKINS

E | Jill Scott is a product of the sixties. As a precocious teenager she threw bricks through the windows of the Honeywell Corporation in Melbourne in 1968 - Honeywell supplied napalm for the war in Vietnam - and was arrested for it. Her leftist radicalism was typical of many members of our generation. But unlike most, she has maintained her idealism and activism. Three decades of her art and life - often inseparable - testify to her social commitment and political-engagement, thankfully in a less destructive fashion than her youthful vandalism at the Honeywell facility might have presaged.

To be clear at the outset, let me offer a simple definition of "political engagement": It is the awareness of - and concern for - the inequalities of power among individuals and among institutions. Transcending progressive analysis, it also encompasses action to alleviate those inequalities.

Um gleich zu Beginn eine eindeutige und verständliche Definition von politischem Engagement zu geben: es äußert sich im Bewusstsein und in der Unzufriedenheit über eine ungerechte Machtverteilung zwischen Individuen und Institutionen. Es geht über eine fortschrittliche Analyse weit hinaus und umfasst auch Aktionen und ethische Aspekte, um gegen diese Ungleichheit vorzugehen.

Jill Scott hatte früh erkannt, dass Kunst und Politik nicht voneinander zu trennen sind. Ihr Vater, von Beruf Industriedesigner, wurde nach dem Krieg Mitglied der Kommunistischen Partei. Er sprach immer wieder mit großer Begeisterung über moralische Fragen im Allgemeinen und besonders gegen den Krieg in Vietnam, an dem sich Australien mit Truppen beteiligte. Ihre Eltern waren viel gereist, und das Haus war ständig von interessanten Gästen aus dem Ausland bevölkert oder von TänzerInnen und SängerInnen, mit denen die Leidenschaft ihrer irischen Mutter für Kabarett und Bühne zum Ausdruck kam. Für Jill Scott gab es nie einen Zweifel daran, dass sie Künstlerin werden wollte. Sie erinnert sich, dass Schwester Raymond, ihre Kunstlehrerin an der Klosterschule, besonders großen Einfluß auf sie hatte: "Nach dem 2. Vatikanischen

Art and politics are linked, as Scott learned early. Her father, an industrial designer, was a Communist Party member after the war, and always spoke with animation about politics in general, and the Vietnam War, to which Australia sent troops, in particular. Her parents were well traveled and the house was filled with stimulating, foreign visitors as well as dancers and singers who reflected her Irish mother's obsession with cabaret and the stage. Scott never doubted that she would become an artist. She recalls one art teacher at her convent school, Sister Raymond, as especially influential: "After Vatican II, all the nuns went back to grad school and they became quite politicized. Sister Raymond was into Pop Art, which she interpreted as political art, a satirical reaction against American consumerism."[1] Later at the Prahran College of Art and Design, Scott made short films as well as produced satirical, Pop Art-style paintings from utopic Hollywood film stills of the depression.

It's difficult now to remember just how politically-inflected everyday activities and allegiances were three decades ago: In the U.S. we boycotted table grapes on behalf of Cesar Chavez's nascent Farmworkers' Union and Coors Beer for the reactionary views of the Coors family; we didn't trust people who dressed differently or - heaven help us - had reached the ripe old age of 30. (How could they possibly understand?) At Scott's art school, this impulse to live with consistency - another formulation of the notion that the personal is political - played itself out in the emergence of two student-cliques: the commodity-making painters and sculptors, and the anti-commodity film and installation makers.

Konzil kehrten viele Nonnen zur Hochschule zurück und sie wurden ziemlich politisiert. Schwester Raymond war begeistert von der Pop Art, die sie für politische Kunst als ironische Reaktion auf die amerikanische Konsumgesellschaft hielt."[1] Später, am Prahran College of Art and Design, drehte Jill Scott Kurzfilme und malte ironisch-satirische Bilder im Stil der Pop Art. Fotographien aus Hollywoodfilmen aus den dreißiger Jahren dienten dabei als Vorlagen.

Man kann sich heute, drei Jahrzehnte später, nur noch schwer vorstellen, wie stark politisiert der Alltag oder die Arbeit in Gruppen gewesen ist: In den USA riefen wir aus Loyalität zu Cesar Chavez und seiner gerade im Aufbau begriffenen Gewerkschaft der Landarbeiter zum Boykott von Tafeltrauben auf, oder gegen Coors Bier wegen der reaktionären Ansichten der Coors-Familie; wir trauten niemandem, der sich anders kleidete als wir oder - der Himmel steh uns bei - das reife Alter von dreißig erreicht hatte (Wovon hatten die schon eine Ahnung?). An der Kunstschule, die Jill Scott später besuchte, findet dieses Verlangen nach Konsequenz - eine andere Formulierung dafür, dass alles Persönliche immer auch politisch ist - im Entstehen zweier Gruppierungen unter den StudentInnen seine Entsprechung: die MalerInnen und BildhauerInnen, die eine verkäufliche Ware herstellten, sowie die Film- und InstallationskünstlerInnen, die das vehement ablehnten.

Jill Scott fühlte sich der letzteren Gruppe, die eher konzeptionelle Ansätze in der Kunst verfolgte, zugehörig. 1973 arbeitete sie zusammen mit anderen StudentInnen für Christo bei dessen Projekt "Wrapped Coastline" und las begeistert Essays wie Lucy Lippards "The Dematerialization of the Art Object".[2] Sie empfand die Aussichten, die ihr die Kunstwelt bieten konnte, als nicht besonders verlockend und begann deshalb Kunst an einer fortschrittlichen Steiner-Schule zu unterrichten. 1974 öffnete ihr eine Gruppenausstellung, an der sie teilgenommen hatte, die Augen: "Ich sah die Arbeiten der

Jill Scott was one of the latter groups, attracted to conceptually-oriented art approaches. She joined students who worked with Christo on his "Wrapped Coastline" project of 1973, and avidly read such works as Lucy Lippard's "The Dematerialization of the Art Object."[2] She found the prospects the art world offered unappealing and taught art at a progressive Steiner school. A 1974 group exhibition in which her work was included was a revelation: "I saw the others' art objects with prices attached," she recalls, "And I almost got sick. What's the point I thought?" To discover the point, she yielded to wanderlust, that Australian fact of life. She traveled in Asia and Europe. In 1975, she moved to San Francisco to attend graduate school and upon arriving stood at the celebrated corner of Haight and Ashbury Streets. It's an emblematic moment, even though, post Watergate, the revolutionary phase of Hippie movement was already a memory. But could there be a better symbol of the anti-capitalist, art-life unity Scott sought than the aestheticized and ritualized lifestyle of the countercultural sixties?

SAN FRANCISCO, 1975: Coincidentally Scott and I arrived and left San Francisco within a few months of one another in 1974-75 and 1982. For me, the anti-materialism and social connectedness of the contemporary art scene in the San Francisco Bay Area had replaced politics in the conventional sense. Against the backdrop of the emerging age of the yuppie (young urban professional), artists lived like Bohemians, on the cheap. Scott occupied a converted, heatless shed in South of Market, the hub of performance and installation art activities in the city, until she gradually transformed it into a working studio. And while there's nothing especially noble about poverty, at least a low-cost existence was possible then in pregentrified San Francisco. We were, as Scott put it, "a generation that had the luxury to fiddle around on $150 a month."

anderen, an denen die Preisschilder klebten", erinnert sie sich, "und ich wurde fast krank davon. Ich dachte, worum geht es hier eigentlich?" Um sich darüber klar zu werden, worum es wirklich ging, gab sie der Wanderlust, einer typisch Eigenschaft der AustralierInnen nach. Sie unternahm Reisen nach Asien und Europa. 1975 zog sie für ihr Hochschulstudium nach San Francisco, und als sie dort ankam, stand sie direkt an der berühmten Kreuzung von Haight und Ashbury Street (siehe INSIDE OUT). Das hatte Symbolcharakter, obgleich, nach Watergate, die revolutionäre Phase der Hippiebewegung schon Geschichte war. Aber konnte es einen besseren Ausdruck geben für die von Jill Scott angestrebte Einheit von antikapitalistischer Haltung und künstlerischem Leben als den ästhetisierten und ritualisierten Lebensstil der gesellschaftskritischen sechziger Jahre?

SAN FRANCISCO, 1975: Jill Scott und ich gingen zufälligerweise im Abstand von wenigen Monaten 1974-75 beide nach San Francisco und verließen die Stadt im gleichen Jahr, 1982. Die antimaterialistische Haltung und die sozialen Bindungen der zeitgenössischen Kunstszene in der Bay Area von San Francisco hatten für mich Politik im herkömmlichen Sinne ersetzt. Als Antwort auf die damals gerade aufkommenden Yuppies (Young Urban Professionals) lebten die KünstlerInnen möglichst bescheiden, wie Bohemians. Jill Scott besetzte einen umgebauten Schuppen ohne Heizung in South of Market, im Zentrum der Aktivitäten von Performance- und Installationskunst in der Stadt, und baute ihn nach und nach zu einem Atelier um. Natürlich ist Armut nicht gerade vornehm, aber es war damals, bevor die Besserverdienenden Einzug hielten, zumindest möglich, mit relativ wenig Einkommen in einer Stadt wie San Francisco seine Existenz zu bestreiten. Wir waren, wie Jill Scott es ausdrückte, "eine Generation, die sich den Luxus erlauben konnte, es mit $ 150 im Monat ruhig angehen zu lassen."

South of Market war eine geradezu klassische Avantgardegemeinde entstanden. Sie sorgte für permanenten sozialen Austausch, suchte nach formellen oder informellen Orten für Ausstellungen und Performances und setzte sich aus einem

South of Market was a classic avant-garde community. It provided constant social contact, formal and informal venues for exhibitions and performances, and an audience primarily comprised of artists. (The latter is an aspect of the avant-garde that historian Leo Steinberg incisively discusses in his classic article of 1962, "Contemporary Art and the Plight of its Public.")[3] This community's ideals were perhaps epitomized by the artist-curator-organizer Tom Marioni's ongoing and self-consciously Beuysian social sculpture, The Museum of Conceptual Art. Marioni also ran a weekly Salon ("Drinking Beer is the Highest Form of Art" was an ongoing work by Marioni) as well as showing installations and actions (the term performance had not yet entered the art parlance). His publication, "Vision", chronicled the work of artists from abroad. Scott knew of Marioni's activities before coming to San Francisco and especially appreciated his internationalism and his interest in sound and video.

This openness to non-visual media was typical of the Bay Area and an aspect of life there that many of us have come, in retrospect, to cherish. Scott went to poetry readings organized by Carla Harryman and Barret Watten, who also operated the multi-cultural "THIS Press".[4] She attended the ritual actions of Terry Fox, performance spectacles by Jock Reynolds/Suzanne Hellmuth, Snake Theater and Soon 3, as well as the electronic music offerings produced by musician Paul de Marinas. at Mills College in nearby Oakland. In 1980 she performed with the punk band Anglosheen.

Scott also experienced social ferment – the ongoing revolution of feminism and the emergence of the gay scene in San Francisco. (She would "come out" as a Lesbian in 1986 and sees the exploration of intimacy with women as an extension of the political maxim that the personal is political.) Although Marioni's Salon was a bit of a boys' club, Scott also quickly became involved in feminist art activities. She belonged to a women's

Publikum zusammen, das vorwiegend aus KünstlerInnen bestand. Den letzteren Aspekt der Avantgarde streicht der Historiker Leo Steinberg in seinem berühmten Essay "Contemporary Art and the Plight of its Public" von 1962 besonders heraus.[3] Die Ideale dieser Community mag man in abgeschwächter Form auch bei Tom Marioni wiedererkennen, einem Künstler/Kurator/Ausstellungsmacher, und seinem Museum of Conceptual Art, einer zeitlich nicht begrenzten und bewusst auf Beuys und Duchamp verweisenden sozialen Skulptur. Marioni führte auch eine Art wöchentlichen Salon ("Drinking Beer is the Highest Form of Art – Biertrinken ist die höchste Form der Kunst" hieß ein laufendes Projekt von Marioni) und zeigte Installationen und Aktionskunst (der Begriff Performance war noch nicht in den Sprachgebrauch der Kunst aufgenommen worden). Seine Publikation "Vision" veröffentlichte regelmäßig Arbeiten von KünstlerInnen aus dem Ausland, einschließlich Osteuropa. Jill Scott hatte bereits von den Aktivitäten Marionis gehört, bevor sie nach San Francisco gekommen war, und schätzte vor allem seine internationale Orientierung und sein Interesse an Sound- und Videokunst.

Diese Aufgeschlossenheit für nicht-visuelle Medien war charakteristisch für die Bay Area und ein Aspekt des täglichen Lebens, der für viele von uns, wenn wir zurückschauen, besonders wichtig war. Jill Scott ging zu DichterInnenlesungen, die von Carla Harryman und Barret Watten, der auch das multikulturelle Magazin "THIS Press" herausgab, veranstaltet wurden.[4] Sie nahm an den rituellen Aktionen von Terry Fox teil, sah spektakuläre Performances von Jock Reynolds und Suzanne Hellmuth, dem Snake Theater sowie Soon 3, oder besuchte Aufführungen elektronischer Musik, produziert von dem Musiker Paul de Marinas am Mills College im nicht weit entfernten Oakland. 1980 trat sie selber mit der Punkband Anglosheen auf.

Zudem wurde Jill Scott mit gesellschaftlichen Protestbewegungen konfrontiert – der sich gerade entwickelnden feministischen Revolution und dem Entstehen der Schwulenszene in San Francisco. Sie selbst erlebte 1986 ihr "Coming Out" und betrachtete die Erkundung weiblicher Intimität als Steigerung der Maxime, dass das Persönliche immer politisch sei. Obwohl Marioni's Salon stets etwas von einem Männerclub ausstrahlte, wurde Jill Scott schnell in die Aktivitäten feministischer Künstlerinnen einbezogen. Sie gehörte zu einer ausschließlich aus Frauen bestehenden marxistisch-feministisch orientierten

artists' group with a Marxist-Feminist slant that brought together artists such as Judith Barry, Theresa Cha, Lynn Hershman Suzanne Lacy and the writer Moira Roth. She participated in an exchange show of artists in 1976, "Bay Area Artworks", held at the Women's Building in Los Angeles, and, inspired by Marioni's curatorial efforts, she organized "Contemporary Australian Art – A Survey" and "Contemporary Bay Area Art – A Survey, Touring Show" in 1979, that helped bring her back to Australia for a decade.

She would go on to curate and organize shows including "The San Francisco-Berlin Exchange Show" in Berlin together with Judith Barry (1981, Franz Mehring Galerie) and Audioeyes (1983) in Sydney with Allessio Calivario. Currently she is organizing a feasibility study for a potential Artists in Residence program for Artists to spend time in Swiss Science laboratories. In addition to such curatorial activities, from 1978-82 she directed Site/Cite/Sight, an alternative space in San Francisco featuring installation work, which she "inherited" from artist Allan Scarritt, and she founded (and for four years directed) the Australian Video Festival in 1985. It presented innovative, thematic programs that eschewed the prevailing formalist, curatorial approach of the day.

She has also operated outside the usual art sphere by teaching video to aboriginal groups through Metro Television and Open Channel, access groups dedicated to community television as an empowering political tool. Inspired by this experience she visited the Australian outback and the Aboriginal TV station (EVTV, Ernabella). Finally, one current project, based in Singapore and Germany, comprises a network of cyberfeminists focused on the ethical issues of biotechnology and breast cancer.

Gruppe, die Künstlerinnen wie Judith Barry, Theresa Cha, Lynn Hershman, Suzanne Lacy und die Schriftstellerin Moira Roth zusammenbrachte. 1976 nahm sie an der "Bay Area Artworks" teil, einer Austauschausstellung von Künstlerinnen im Woman's Building in Los Angeles. 1979 organisierte sie, angeregt durch die Projekte von Marioni als Kurator, die beiden Ausstellungen "Contemporary Australian Art – A Survey" sowie "Contemporary Bay Area Art – A Survey", Diese beiden Reiseausstellungen waren letztendlich der Auslöser für ihre Rückkehr nach Australien.

Sie kuratierte und organisierte weitere Ausstellungen, unter anderem "The San Francisco – Berlin Exchange Show" zusammen mit Judith Barry 1981 in der Galerie Franz Mehring in Berlin sowie Audioeyes (1983) bei Artspace in Sydney zusammen mit Allessio Calivario. Gegenwärtig ist sie damit beschäftigt, ein Gutachten für ein geplantes Programm zu erstellen, in dem GastkünstlerInnen für einige Zeit in wissenschaftlichen Einrichtungen in der Schweiz arbeiten können. Zusätzlich zu diesen kuratorischen Tätigkeiten leitete sie 1979-82 site.cite.sight.inc., einen alternativen Ausstellungsraum in San Francisco und zeigte dort hauptsächlich Installationen, die sie von dem Künstler Allan Scarritt "geerbt" hatte. 1985 gründete sie (und leitete dann vier Jahre lang) das Australian Video Festival. Das Programm bestand aus innovativen, eher thematisch ausgerichteten Filmen, die sich den damals vorherrschenden formalistischen Ansätzen der meisten KuratorInnen widersetzten.

Sie hat sich in ihrer Arbeit auch außerhalb des gewohnten Terrains von Kunst begeben, indem sie in lokalen Fernsehsendern (Metro Television) und im Offenen Kanal (Open Channel) Videokurse für Aborigines abhielt, mit dem Ziel, diesen sozialen Gruppen öffentliches Fernsehen zugänglich zu machen und ihnen so ein Instrument für politische Meinungsäußerung zu verschaffen. Inspiriert durch diese Erfahrungen besuchte sie das australische Hinterland (Outback) und die Fernsehstation der Aborigines: Ernabellas EVTV. Schliesslich befasst sich ein gerade laufendes Projekt, das seine Basis in Singapur und Deutschland hat und aus einem Netzwerk für "Cyber-Feministinnen" besteht, vor allem mit ethischen Fragen von Biotechnologie und Brustkrebs.

Critic John Perreault has written that "To tamper with categories is to tamper with power."[5] Scott has spent her entire career tampering with categories and blurring the boundaries of discipline, media and modus operandi that represent the status quo. Like Scott's activism, her art is hybrid and multi-dimensional, whether assuming the form of action, performance, video, installation or public artwork. Her varied output defies the stultifying modernist ethos or category of the "signature style," which depends on instant visual, rather than intellectual, recognition. Perhaps it's not the recommended career path for any artist set on appearing in the Venice Biennale!

During the first or San Francisco phase of Scott's career - which rather neatly divides into three decades, concerns and locations - she was already ranging widely. She had created a series of actions in 1975 including TAPED, BOXED, TIED and STRUNG that used her body as an object; taped to the wall, packed in a shipping crate, and the like. The series was intended to focus attention on the objectification of women and the art historical veneration for the male-produced art object. When she was released from bondage in these pieces, the effect was extremely dramatic, to say the least.

Scott believes that dislocating audience members - in Bertold Brecht's terminology producing the "alienating effect" that blurs life and art - is the first step in altering consciousness.[6] It is an approach that underlies much of her work. It first surfaced overtly in a series of San Francisco installations including ACCIDENTS FOR ONE (1976), ACCIDENTS FOR FOUR (1976), EXTREMITIES (1977), MOVED UP MOVED DOWN (1978), INSIDE OUT (1978) and CHOICE (1979). Those disruptions of expectations presciently raised issues of authorship and collaboration. In ACCIDENTS FOR ONE, for instance, her friends videotaped sets of movement-related instructions for Scott to carry out, which she did while

Bei dem Kritiker John Perreault heißt es, "Veränderung von Kategorien bedeutet Veränderung von Macht".[5] Jill Scott hat sich in ihrer gesamtem Karriere mit dieser Überschreitung von Kategorien beschäftigt, mit dem Ziel, die Grenzen der einzelnen Disziplinen, Medien und des Modus Operandi, welche den Status quo repräsentieren, aufzuheben. Genauso wie ihr Aktivismus ist auch ihre Kunst hybrid und multi-dimensional, gleich ob sie nun die Form von Aktion, Performance, Video, Installation oder von Kunst im öffentlichen Raum annimmt. Die unterschiedlichen Resultate treten dem lähmenden Ethos der Moderne oder der Kategorie von "Signatur und Stil", die eher auf eine unmittelbare visuelle als auf intellektuelle Wiedererkennbarkeit zielt, entgegen. Das ist nicht unbedingt der richtige Weg für eine KünstlerIn, die darauf aus ist, an der "Biennale" in Venedig teilzunehmen!

Während der Zeit in San Francisco, in den ersten Jahren ihrer künstlerischen Laufbahn - die sich relativ leicht in drei Jahrzehnte, Interessensgebiete und Orte aufteilen lässt - hatte Jill Scott bereits viele ihrer Themen vorweggenommen. 1975 entwickelte sie eine Reihe von Aktionen, unter anderem TAPED, BOXED, TIED and STRUNG, bei denen sie ihren Körper als Objekt benutzte; sie ließ sich an eine Wand kleben oder in eine Transportkiste verpacken usw. Die Serie sollte die Aufmerksamkeit auf die Objektifizierung der Frau und die einseitige kunsthistorische Verehrung für das vom Mann geschaffene Kunstwerk lenken. Als man sie während dieser Aktionen von ihren Fesseln befreite, hatte das eine äußerst dramatische Wirkung, um es vorsichtig auszudrücken!

Jill Scott betrachtet Dislozierung von TeilnehmerInnen aus dem Publikum als ersten Schritt einer Bewusstseinsveränderung - analog zu Bertolt Brecht's Terminologie des "Verfremdungseffekts", der die Grenze zwischen Leben und Kunst aufhebt. [6] Dieser Ansatz lässt sich auf einen großen Teil ihrer Arbeit übertragen. Zum ersten Mal wird er sichtbar in einer Reihe von Installationen in San Francisco, unter anderem bei

moving across red, dust-covered sheets of paper that became documentary artworks in themselves. She soon moved on to installation works employing surveillance cameras that forced every visitor to make choices in order to experience the work. For the straightforwardly named CHOICE (1979), visitors had to choose either a left or right entrance to the space. Meanwhile, Scott was situated inside, receiving video feedback of the exhibition goers at the crossroads, from which she made drawings.

Although the process tended to be tightly controlled, such works offered viewers new experiences and embodied the conceptualist belief that art is completed by its audience. With their concern for the body, the participation and representation of the audience, and the creation of documentary artworks as by-product, these works operate squarely within the late-seventies zeitgeist of the Bay Area. By contrast, the final, larger-scaled, theatrical performances (rather than actions) that Scott staged before leaving San Francisco - OUT THE BACK (1978-80), THE HOMECOMING (1978), PERSIST, THE MEMORY (1980), SAND THE STIMULANT (1980), ORDER THE UNDERFIRE (1981), DESIRE THE CODE (1981) - are entirely her own. They mark not only Scott's coming of age, but also the waning of the modernist era, the philosophical equivalent of the demolition of the Berlin Wall.

They are also among the most personal body of work in Scott's oeuvre. Her rejection of the so-called "universalism" and "purity" of modernism was a defining characteristic of feminist artists who began to employ narrative and autobiography in their art during the seventies. The

ACCIDENTS FOR ONE (1976), ACCIDENTS FOR FOUR (1976), EXTREMITIES (1977), MOVED UP MOVED DOWN (1978), INSIDE OUT (1978) und CHOICE (1979). Hier widersetzt sie sich den Erwartungen, indem sie Fragen nach der Autorschaft und der Kooperation mit dem Publikum vorwegnimmt. In ACCIDENTS FOR ONE nahmen zum Beispiel ihre Freunde Videotapes mit Bewegungsanweisungen auf, die Jill Scott ausführen sollte, was sie dann auch tat, während sie rote, staubbedeckte Papierbahnen überquerte, die dadurch selbst zu dokumentarischen Kunstwerken wurden. Daraus entstanden nicht viel später Installationen, in denen die BesucherInnen mit Hilfe von Überwachungskameras aufgefordert wurden, sich zwischen bestimmten Optionen zu entscheiden, um die Arbeit erleben zu können. In der Installation mit dem bezeichnenden Titel CHOICE (1979) mussten die BesucherInnen entweder den rechten oder linken Eingang des Raumes betreten, während sie gleichzeitig auf einem Brett balancierten. Währenddessen saß Jill Scott im Innern des Raumes und sah die Reaktionen der AusstellungsbesucherInnen vor dem Eingang als Video-Feedback, wovon sie dann Zeichnungen anfertigte.

Obgleich der Ablauf offensichtlich unter aufmerksamer Beobachtung stand, vermittelten Arbeiten dieser Art der BetrachterIn neue Erfahrungen und verkörperten den konzeptualisierten Anspruch, dass Kunst sich erst durch das Publikum vollendet. In ihrem Interesse an dem Körper, der Partizipation und Repräsentation des Publikums und auch, sozusagen als Nebenprodukt, an der Realisierung dokumentarischer Kunstwerke entsprechen diese Arbeiten genau dem Zeitgeist der siebziger Jahre in der Bay Area. Im Gegensatz dazu erscheinen die letzten, raumgreifenden Theaterperformances (eher als die Aktionen), die Jill Scott aufführte, bevor sie San Francisco verließ - OUT THE BACK (1978-80), THE HOMECOMING (1978), PERSIST, THE MEMORY (1980), SAND THE STIMULANT (1980), ORDER THE UNDERFIRE (1981), DESIRE THE CODE (1981) - als vollkommen eigenständig. Sie stehen nicht nur dafür, dass Jill Scott erwachsen geworden ist, sondern auch für ein Ermatten der Moderne, das im Fall der Berliner Mauer seine quasi-philosophische Entsprechung findet.

Außerdem gehören sie zu den persönlichsten Arbeiten im Gesamtwerk von Jill Scott. Ihre Ablehnung des sogenannten "Universalismus" und "Purismus" in der Moderne wurde zu einem entscheidenden Merkmal feministischer KünstlerInnen, die in den siebziger Jahren begannen, Erzählung und Autobiographie in ihre Kunst einzubeziehen. 1979 erhielt Jill Scott durch ihre Reise nach Australien im Zusammenhang mit der von ihr organisierten Ausstellung von Video- und Konzeptkunst aus der San Francisco Bay Area zusätzliche Impulse. Sie thematisierte die Situation ihrer Rückkehr in einer Performance namens THE HOMECOMING, in der Ruine eines Wohnhauses in Noosa Heads, einem Touristenort in Queensland. Zu

series was also prompted by Scott's visit to Australia in 1979 connected with the travelling show of San Francisco Bay-area video and conceptual art that she had organized. She marked the occasion of her return with a performance called THE HOMECOMING, staged in a ruined residence in the tourist town of Noosa Heads, Queensland. The performers included her parents, her sister and nephew. This ritual included a telling of the story of "the transient lifestyle of a girl who had traveled in Africa and Asia," of course Scott herself. The sound emanating from unusual sources, including pouring water, crushed eggs, and a jewsharp, would become an increasingly central feature of her performances.

In contrast to this private ritual in Australia, nostalgia for Australia permeated the series of solo works Scott subsequently presented in San Francisco. Extremely multi-media, they encompassed video (real-time and recorded), carefully chosen settings and seating (the range extended from revolving stools to a sandy, chairless floor), recorded, mostly natural sounds (bees buzzing, crickets chirping, and sand poured through a funnel to evoke the desert landscape of the Outback), as well as Scott herself performing tasks, activating sound elements, and playing the digeridoo, an Aboriginal instrument which requires circular breathing. Theatricality pervaded every element of these pieces. In PERSIST, THE MEMORY the audience was led in by attendants with flashlights and Scott began and ended the work by riding a horse in and out from behind a giant portrait of herself as a child with a pony. "I wanted to change the space, the time and the audience," as Scott now recalls the work of this period. She succeeded. At the time I described the related, contemporary piece, SAND THE STIMULANT as hypnotic, evoking "the power and persistence of a (Borgesian) dream."[7]

den DarstellerInnen gehörten auch ihre Eltern, ihre Schwester und ihr Neffe. Die rituelle Handlung erzählte unter anderem eine Geschichte über "den unbeschwerten Lebensstil eines jungen Mädchens, das durch Afrika und Asien reist", womit natürlich Jill Scott selbst gemeint war. Die Töne, hervorgerufen durch ungewöhnliche Quellen wie fließendes Wasser, zerschlagene Eier und eine Maultrommel werden zunehmend zu einem zentralen Teil in ihren Performances.

Im Gegensatz zu diesem privaten Ritual in Australien war die Reihe von Soloaufführungen, die Jill Scott nachfolgend in San Francisco zeigte, von Sehnsucht nach Australien geprägt. In ihrer konsequent multimedialen Auslegung umfassten sie Video (in Echtzeit und als Aufzeichnung), eine sorgfältig ausgesuchte Einrichtung des Raumes sowie Sitzgelegenheiten (das ging von Drehstühlen bis zu einem sandigen Fußboden ohne Stühle), aufgezeichnete, meist natürliche Geräusche (Bienensummen, das Zirpen der Grillen oder Sand, der durch einen Trichter rinnt, als Simulation der Wüstenlandschaft im Outback), außerdem Jill Scott selbst, die bestimmte Handlungen ausführte und dabei die Komponenten, mit denen die Geräusche erzeugt wurden, aktivierte sowie auf einem Didgeridoo spielte, einem Instrument der Aborigines, das eine Art kreisförmige Atemtechnik erfordert. Theatralik durchdrang jedes Element dieser Stücke. Bei PERSIST, THE MEMORY wurden die BesucherInnen von HelferInnen mit Taschenlampen begleitet. Jill Scott kam am Anfang und am Ende der Aufführung auf einem Pferd hereingeritten und verschwand wieder hinter einem riesigen Selbstporträt von sich als Kind mit einem Pony. "Ich wollte den Raum, die Zeit und das Publikum verändern", erinnert sich Jill Scott heute an die Arbeit aus dieser Phase. Das ist ihr gelungen. Damals habe ich das verwandte SAND THE STIMULANT als ein hypnotisches Werk der Gegenwartskunst beschrieben, "das die Kraft und Zeitlosigkeit eines (Borges'schen) Traumes" evoziert.[7]

SYDNEY, 1982: Die frühen achtziger Jahre wurden für Jill Scott zu einer Übergangsphase, was auch für die westliche Gesellschaft generell zutraf. Sie war zu einem Zeitpunkt schwindelerregender politischer Veränderungen, wie sie es ausdrückte, dabei, "durchzustarten". Die erzkonservativen Regierungen von Reagan und Thatcher waren entschlossen, den öffentlichen Bereich zu privatisieren, öffentlicher Raum und Kultur eingeschlossen. Jill Scotts marxistisch-feministische Analyse schien nicht mehr zu genügen im Zeitalter der Massenmedien und Informationsgesellschaft. Sie war vertraut mit Theoretikern wie Marshall McLuhan oder dem jungen Ökologen James Lovelock und las begeistert sozialkritische Romane, in denen sich ein gemeinsames Interesse für zeitliche und räumliche Dislozierung, Feminismus, narrative Strategien und Technologie offenbarte (u.a. Borges, Angela Carter, Margret Atwood, Ursula Le Guin und Philip K. Dick). Aber erst der Aufenthalt

SYDNEY, 1982: The early eighties were a period of transition for Scott, as well as for Western society at large. She was, as she put it, "starting over" at a moment of dizzying political change. The radically conservative Reagan- and Thatcher regimes were bent on privatizing the public sector, including public space and cultural expression. Scott's Marxist-Feminist analysis no longer seemed sufficient for the mass media/information age. She was familiar with theorists like Marshall McLuhan, the new ecologist James Lovelock, and an avid reader of socially-acute fiction mirroring her overlapping interests in temporal or spatial dislocation, feminism, narrative strategies and technology (Borges, Angela Carter, Margaret Atwood, Ursula Le Guin and Philip K. Dick, among others.) But it was a visit to Australia in 1983 by Jean Beaudrillard that helped galvanize Scott's interest in contemporary theory. She dove into the work of Beaudrillard, Jacques Lacan, Michel Foucault, Roland Barthes, and others.

Her videotapes and installations reflected those theoretical influences: the Orwellian sounding DOUBLE DREAM (1984), a tape and installation about the supposedly cool medium of video versus the hot medium of film, interrogates McLuhan. MEDIA MASSAGE (1989), a short tape and installation set among the satellite transmission towers of the desert, similarly tips its hat to the seminal Canadian media theorist. DOUBLE SPACE (1986) was inspired by Robert Graves's "The White Goddess" and involved women artists sharing – and later performing as – their favorite animals. With their music and pop cultural imagery, these works are hardly dry or theoretical. DOUBLE DREAM represented "hot" and "cool" media with images of a blonde and a dark goddess appropriated from sexy, daytime television commercials. Australian MTV included the four-minute MEDIA MASSAGE in its line-up.

Scott's re-inventing herself included an early immersion in the new – and newly accessible – digital technology of the personal computer, which arrived just as Scott returned to Australia. She was a fast learner. Her mid-eighties' series of videos about women's mythology, (DOUBLE DREAM, DOUBLE SPACE, DOUBLE TIME) was shot in a blue screen studio and post-produced on the then state-of-the-art Fairlight system. In 1986, the

von Jean Baudrillard 1983 in Australien weckte wirklich Jill Scott's Interesse an der Theorie der Gegenwart. Sie tauchte geradezu ein in das Werk von Baudrillard, Jacques Lacan, Michel Foucault, Roland Barthes und anderen.

Ihre Videoarbeiten und Installationen reflektierten diese theoretischen Einflüsse: Das an Orwell erinnernde DOUBLE DREAM (1984) besteht aus einem Tape und einer Installation über das eigentlich "kühle" Medium Video im Gegensatz zum "heißen" Medium Film und beschäftigt sich intensiv mit McLuhan. Die Videoinstallation MEDIA MASSAGE (1989), errichtet zwischen den Masten eines Satellitensenders mitten in der Wüste, kommentiert auf ähnlich ironische Weise den einflussreichen kanadischen Medientheoretiker. DOUBLE SPACE (1986) war von "The White Goddess" von Robert Graves inspiriert und zeigte Künstlerinnen zusammen mit ihren Lieblingstieren, die sie dann später nachzustellen versuchten. Mit der musikalischen Untermalung und den Bildern aus der Popkultur lassen sich diese Arbeiten wohl kaum als spröde oder theoretisch bezeichnen. DOUBLE DREAM stellte die "heißen" und "kühlen" Medien dar, mit aufreizenden Bildern einer blonden und einer dunkelhaarigen Göttin, die den tagsüber ausgestrahlten Fernsehspots entsprungen sein konnten. MEDIA MASSAGE, insgesamt 3 Minuten lang, ist später im australischen MTV gelaufen.

Der Versuch einer Neu-Erfindung beinhaltete für Jill Scott eine frühzeitige Immersion in die neue – und erst seit kurzem zugängliche – digitale Technologie des Personal Computers, genau in dem Augenblick, als Jill Scott nach Australien zurückkehrte. Sie lernte schnell. Mitte der achtziger Jahre drehte sie eine Serie von Videos über weibliche Mythologien (DOUBLE DREAM, DOUBLE SPACE, DOUBLE TIME) in einem Blue Screen-Studio und verwendete für die Nachbearbeitung das Fairlight System, das damals als der neueste Stand der Technik galt. 1986 wurde sie von der Firma Video Paint Box in Melbourne und Sydney als Gastkünstlerin eingeladen, sicher eine Anerkennung ihres technischen Knowhows.[8]

Video Paint Box Company of Melbourne and Sydney invited her to be artist-in-residence, an acknowledgement of her technical acumen.[8]

Scott's mid-eighties' work with community television and sophisticated but far from inexpensive digital video processing – along with her exposure to postmodern theory – forced her to gradually rethink her relationship to her audiences. She had always seen her audience as a small group of informed artists and feminists. She had experienced the waning days of the rebellious, modernist avant garde in San Francisco, which was epitomized by the Zen-Fluxus, collapse-art-into-life philosophy of Tom Marioni and Terry Fox, an important installation artist who nurtured Scott's interest in sound and ritual. Sydney offered a socially engaged and well-supported video and media scene, but not a geographically concentrated artists' community as San Francisco had. And the post-sixties' climate had changed everywhere. For Scott, the eighties called for a far more public view of media artists in general and her own role in particular.

Consider the difference between two, feminist-themed works. THE SHOCK OF THE STILL (1985), an interactive video installation inspired by Naomi Wolf's "The Beauty Myth", which assaulted oppressive cultural standards of female beauty, and Lacan's notions of self-recognition. The installation visitor saw his/her reflection, like Narcissus, projected onto water through surveillance cameras providing background images of a tremendous splash. When s/he touches the water, the viewer's face is distorted. Evocative and metaphorical, THE SHOCK OF THE STILL is not the stuff of mass audiences. Then in 1989, Scott completed WISHFUL THINKING, a slickly-produced, 30-minute pilot for a television mini-series, intending to reach an audience of girls provided with few televisual role models of intelligence and initiative. With its narrative about a female replicant who travels to earth from the eco-paradise of Planet X to meet earthlings and comic book heroes, the entertaining piece plays with stereotypes and the conventions of the Sci-Fi and action genres. As is so often the case with artist-made, mass media products, the Australian Broadcasting Commission passed on the proposed series, even though high-school presentations of the work were very successful.

Die Kooperation mit lokalen Fernsehsendern und das hochentwickelte, aber noch recht kostspielige digitale Videoverfahren veranlassten Jill Scott – zusammen mit ihrer Affinität zu postmoderner Theorie – Mitte der achtziger Jahre, die Einbindung der BesucherInnen nachhaltig zu überdenken. Für sie hatte das Publikum stets aus einer Kleinen Gruppe informierter KünstlerInnen und FeministInnen bestanden. Die Tage einer rebellischen, modernistischen Avantgarde in San Francisco waren gezählt, was sich im kleinen in einer an Zen und Fluxus erinnernden Philosophie des Übergangs vom Leben in die Kunst bei Tom Marioni und Terry Fox widerspiegelte, letzterer ein wichtiger Installationskünstler, der Jill Scott's Interesse für Sound und Rituale weckte. In Sydney existierte eine sozialengagierte und überaus inspirierende Atmosphäre für Video und Medien allgemein, aber keine an einem Ort konzentrierte Künstlergemeinde, wie das in San Francisco der Fall war. Auch hatte sich im Anschluss an die sechziger Jahre das Klima überall verändert. Für Jill Scott artikulierte sich in den achtziger Jahren das Bedürfnis nach einer weitaus größeren öffentlichen Beachtung als MedienkünstlerIn generell und vor allem ihrer eigenen Arbeit und erforderte auch ein Überdenken ihrer eigenen Rolle.

Bemerkenswert ist die Verschiedenheit von zwei Arbeiten, die feministische Themen behandeln, THE SHOCK OF THE STILL (1985) und WISHFUL THINKING (1989). THE SHOCK OF THE STILL, eine interaktive Videoinstallation, verwies auf "The Beauty Myth" von Naomi Wolf, eine Attacke auf repressive kulturelle Standards weiblicher Schönheit, sowie die Anmerkungen von Lacan über das Wiedererkennen des Selbst. Die Besucher der Installation konnten vor dem Hintergrund eines gewaltigen Wasserfalls – wie Narziss – ihr eigenes Spiegelbild erkennen, das u.a. mit Hilfe von Überwachungskameras auf das Wasser projiziert wurde. Sobald er/sie das Wasser berührte, verzerrte sich das Gesicht der BetrachterIn. THE SHOCK OF THE STILL ist in seiner provozierenden und metaphorischen Wirkung nicht gerade für ein Massenpublikum geeignet. 1989 realisierte Jill Scott WISHFUL THINKING, eine eher konventionelle 30-minütige Fernsehproduktion, als Pilotfilm für eine Miniserie, mit der sie ein Publikum von jungen Mädchen ansprechen wollte, welche im Fernsehen bisher kaum intelligente oder aktive Rollenvorbilder zur Orientierung hatten. Die Geschichte über eine Replikantin, die aus dem Ökoparadies Planet X zur Erde reist, um dort ErdbewohnerInnen und HeldInnen aus Comicbüchern zu treffen, spielt auf unterhaltsame

As much as anything else, it is Scott's thematic concerns for ecological sustainability and women's health that characterize her work of the late-eighties. At the end of the decade, Scott was stricken with breast cancer. She produced a remarkable videotape, CONTINENTAL DRIFT (1990), based on her own experiences with the disease and so-called alternative medical cures. Lyrical and upbeat, but not sentimental, it metaphorically equates excavation of the earth's crust to the process of medical diagnosis and treatment, linking the health of the body and of the planet. It has been seen by cancer support groups and Scott continues to seek broader distribution.

Discussing the Australian Cancer Council's lack of interest in supplying the tape to its affiliated organizations, Scott wistfully noted that socially-engaged work is "much more welcome in the U.S. than anywhere else." Although she had left the US in the early eighties, Scott was, of course, aware of the epochal contributions of progressive American artists, critics and institutions in response to the AIDS crisis and related issues of identity politics during the late eighties and early nineties. This movement followed hard on the heels of artists protesting American involvement in Central America during the early eighties, but the late-modernist options of that day included only the citizenly efforts of raising money and consciousness, rather than the possibility of centering an art practice on such causes, despite exceptions like Leon Golub or the Group Material collective. The proliferation of their aggressive approaches largely awaited the mid-decade post-modernism of influential artists such as Barbara Kruger and Jenny Holzer, who helped popularize more direct, non-gallery forms of audience address. Much of the most memorable work of the later eighties, from the performative agit prop of the Gran Fury collective to the violently sublime object or media/performance work of David Wojnarowicz and Felix Gonzalez-Torres (among literally countless others), was created as a powerfully direct response to the social crisis of AIDS. American artists – unlike their European counterparts – have generally been relegated to outsider status. With little

Weise mit Stereotypen und den Konventionen der Genres von Science Fiction und Actionfilmen. Wie das so häufig mit Filmen geschieht, die von KünstlerInnen für die Massenmedien produziert werden, setzte die Australian Broadcasting Commission die Serie vorzeitig ab, obwohl sie bei Testvorführungen an verschiedenen High-Schools viel Beifall erhalten hatte.

In gleichem Maße ist Jill Scotts Werk in den späten achtziger Jahren von der thematischen Auseinandersetzung mit dem ökologischen Gleichgewicht und der individuellen Gesundheit von Frauen gekennzeichnet. Ende der achtziger Jahre wurde bei Scott Brustkrebs festgestellt. Sie produzierte die bemerkenswerte Videoarbeit CONTINENTAL DRIFT (1990), in der sie sich mit ihren eigenen Erfahrungen mit der Krankheit und sogenannten alternativen Heilungsmethoden befasst. Auf lyrische und optimistische, aber nicht sentimentale Weise setzt das Video metaphorisch den Eingriff in die Natur – wie die Zerstörung der Erdoberfläche - mit dem Eingriff in den Körper – dem Prozess der medizinischen Diagnose und Behandlung – gleich, indem es die Gesundheit vom Körper und vom Planeten der Erde thematisch miteinander verknüpft. Jill Scott hat die Videoarbeit Selbsthilfegruppen für KrebspatientInnen zur Verfügung gestellt und bemüht sich um weitere Aufführungsmöglichkeiten.

In der Diskussion darüber, dass das Australian Cancer Council kein besonders großes Interesse daran zeigte, das Tape in seinen angeschlossenen Organisationen in Umlauf zu bringen, bedauert Jill Scott, soziales Engagement in der Kunst sei "in den USA weitaus willkommener als anderswo". Obwohl sie die

social status to lose, they have tended to remain free to comment on social conditions. Perhaps Scott sacrificed her associations with these groups by returning to Australia, where the arts, as in Europe, are publicly funded!

In 1991 CONTINENTAL DRIFT was followed by a performance of the same name. Upon entering the performance site, viewers were asked to choose a weak organ in their bodies and to sit on a floor cushion signifying that organ. Scott appeared wearing a small surveillance camera on her wrist, and attached to a video monitor that trailed her like an intravenous drip on a mobile, hospital stand. A scientist appeared prerecorded on video. With an awareness of her specialized art audience, Scott could take a more symbolic approach to the examination of the contrasts between East and West, intuition and logic, than she did on the videotape. The pair of works reminds us that contemporary artists, attracted to both sorts of audiences, need not choose between them.

SAARBRÜCKEN, 1992: In 1992, the German artist, Ulrike Rosenbach, invited Scott to be a guest professor at the Art Academy in Saarbrucken. Scott was ready for a change and soon decided to accept this invitation to Germany, signifying a third, European phase of her career. Just before she left Australia, she completed MACHINEDREAMS (1991), an interactive sound installation with virtual recognition, that would typify her works to come: Interactive, didactic and technologically complex installations that engage contemporary issues through the lens of history.

MACHINEDREAMS examines the relationship between women and technology, specifically the technology associated with "women's work". A discussion among the women of the Scott family catalyzed the installation: Scott's grandmother had been a seamstress, her mother a typist, her older sister a Sunbeam Mixmaster saleswoman and Scott, herself, works with communications technology. In the installation, each of the related

USA in den frühen achtziger Jahren verlassen hatte, kannte sie selbstverständlich die bahnbrechenden Beiträge progressiver, amerikanischer KünstlerInnen, KritikerInnen und Institutionen als Reaktion auf die Gefahr durch AIDS und verwandte Themen der Frage nach Identität in den späten achtziger und frühen neunziger Jahren. Diese Bewegung war eng verknüpft mit KünstlerInnen, die gegen die amerikanische Verstrickung in Zentralamerika in den frühen achtziger Jahren protestierten. Aber damals zielten die spätmodernen, bürgerlichen Anstrengungen eher auf das bloße Sammeln von Geld oder auf Bewusstseinsbildung, als dass solche Themen im Mittelpunkt künstlerischer Arbeiten standen, trotz Ausnahmen wie Leon Golub oder das KünstlerInnenkollektiv Group Material. Diese kämpferischen Initiativen, die sich rasch ausbreiteten, hatten Mitte der achtziger Jahre nur auf postmoderne und dabei sehr einflussreiche KünstlerInnen wie Barbara Kruger und Jenny Holzer gewartet, die dabei halfen, außerhalb von Galerien direktere Formen der Einbindung des Publikums populär zu machen. Viele der wichtigsten Arbeiten der späteren achtziger Jahre, vom performativen Agit-Prop des Kollektivs Gran Fury zu den äußerst sublimen Arbeiten der Objekt- oder Medien/Performancekunst von David Wojnarowicz und Felix Gonzalez-Torres (unter buchstäblich zahllosen anderen), kommentierten auf anschauliche und direkte Weise die durch AIDS entstandenen gesellschaftlichen Probleme. Amerikanische KünstlerInnen sind in ihrem Status – im Gegensatz zu den europäischen – generell zu Outsidern erklärt worden. Weil der soziale Status eine untergeordnete Rolle spielte, konnten sie sich die Freiheit bewahren, auf gesellschaftliche Bedingungen einzugehen. Vielleicht opferte Jill Scott sogar ihre Zugehörigkeit zu diesen Gruppen, als sie nach Australien zurückkehrte, wo die Kunst, ähnlich wie in Europa, in größerem Umfang mit öffentlichen Geldern gefördert wird.

1991 folgte auf CONTINENTAL DRIFT eine weitere Performance mit dem gleichen Titel. Bei Betreten des Raumes wurden die ZuschauerInnen aufgefordert, ein schwaches Organ in ihrem Körper auszuwählen, sich dann auf ein Kissen auf dem Boden zu setzen und auf dieses Organ zu zeigen. Daraufhin erschien Jill Scott, die eine kleine Überwachungskamera an ihrem Handgelenk trug, angeschlossen an einen Videomonitor, den sie hinter sich herzog wie ein mobiles Infusionsgerät aus dem Krankenhaus. Eine Wissenschaftlerin erschien auf dem Videobild, das vorher aufgezeichnet worden war. Im Bewusstsein eines interessierten Kunstpublikums gelang es Jill Scott, einen stärkeren symbolischen Ansatz zu finden für ihre Untersuchungen über die Gegensätze zwischen Ost und

machines was exhibited and emitted sounds when electronic sensors detected the approach of viewers. Images of the scientific advances responsible for these machines and of the women in Scott's family were also exhibited, creating a contextualizing environment about "women's work" in the twentieth century.

With the programming possibilities available in Saarbrucken, Scott continued to work on another piece she had begun in Australia, PARADISE TOSSED. An amusing and highly-interactive installation, it complimented the feminist inquiry of MACHINEDREAMS Coupling the history of twentieth century design and "Lifestyles of the Rich and Famous," the work allows viewers to examine up-to-date, techno-filled domestic environments that are as seductive as the new 3-D animation software Scott employed in their creation. Popular cultural images of design and gesturing hands enabled the viewer to easily navigate the work at an early stage of laser-disc technology.

Scott concluded what she considers a trilogy of works about technology and idealism with FRONTIERS OF UTOPIA (FOU, 1995). It joins MACHINEDREAMS and PARADISE TOSSED as part of a trio dealing with the theme Scott calls "unreachable Utopias". FOU is however far richer and more politically pointed than the other two; the characters symbolizing "unreached" - perhaps more than unreachable - utopias. Scott's modus operandi is dependent on time travel, as are those of writers of historical fiction, science fiction, or history itself, all of whom she resembles at times.

Political idealism and activism occupy the foreground of FRONTIERS OF UTOPIA (1995). Chronicling nine decades of labor history, the viewer meets eight very different women workers, whose roles range from an

West, Intuition und Logik, als das bei den reinen Videoarbeiten möglich war. Diese Arbeiten erinnern uns daran, dass GegenwartskünstlerInnen, die beide Formen der Rezeption durch das Publikum anstreben, sich nicht zwingend zwischen ihnen entscheiden müssen.

SAARBRÜCKEN, 1992: Die deutsche Künstlerin Ulrike Rosenbach holte 1992 Jill Scott als Gastprofessorin an die Kunsthochschule Saarbrücken. Für Jill Scott war die Zeit für eine weitere Veränderung gekommen, und sie entschloss sich umgehend, die Einladung nach Deutschland anzunehmen, mit der eine dritte, die europäische Phase ihrer Karriere begann. Kurz bevor sie Australien verließ, vollendete sie MACHINEDREAMS (1991), eine interaktive Klanginstallation mit virtuellen Charakteren, die ihre folgenden Arbeiten vorwegnehmen sollte: interaktive, didaktische und technologisch komplexe Installationen, die sich mit Themen der Gegenwart aus historischer Sicht beschäftigen.

MACHINEDREAMS untersucht das Verhältnis von Frauen zu Technologie, insbesondere wenn diese mit "der Arbeit von Frauen" assoziiert wird. Eine Diskussion unter den Frauen in Jill Scotts Familie diente als Katalysator der Installation: ihre Großmutter war Näherin gewesen, ihre Mutter Stenotypistin, ihre ältere Schwester Verkäuferin bei Sunbeam Mixmaster und Jill Scott selbst arbeitet mit Kommunikationstechnologie. In der Installation wurde jeder der Frauen das passende Arbeitsgerät zugeordnet, welches Geräusche von sich gab, sobald elektronische Sensoren die Nähe einer BesucherIn anzeigten. Außerdem waren in der Ausstellung Abbildungen der wissenschaftlichen Errungenschaften, die diese Geräte erst hervorgebracht hatten, und Bilder von den weiblichen Mitgliedern der Scott-Familie zu sehen, die ein kontextualisiertes Environment über die "Arbeit der Frau" im 20. Jahrhundert entstehen ließen.

Mit den in Saarbrücken verfügbaren Möglichkeiten der Programmierung setzte Jill Scott ihre Arbeit an einem anderen Projekt fort, mit dem sie schon in Australien begonnen hatte, nämlich PARADISE TOSSED. Die unterhaltsame und in hohem Maße interaktive Installation vervollständigte die feministi-

Aboriginal maid of the thirties to a pro-democracy physicist from nineties Hong Kong, all expertly played by professional actors. The chronological milestones of 1900, 1930, 1960 and 1990 are each represented by two actors. With FRONTIERS the notion of interactivity gained real meaning from Scott's use of the most up-to-date technology: It allowed visitors to examine any of the characters' suitcases or transport them across time to a virtual dinner party at which they converse.

The innovative design of this complex installation comprised an "interactive photograph," four "interactive" suitcases", five computers, and five laserdisc players. Although she had begun research for it in New York in 1989, FRONTIERS was the first work she exhibited at ZKM, the groundbreaking media arts research center in Karlsruhe, Germany. She came to the attention of the director Hans-Peter Schwarz after he saw PARADISE TOSSED, which won an award at the 1994 Ars Electronica Festival. At ZKM, she was engaged half-time as artist in residence, and half-time as a technical research co-ordinator for the Media Museum. The extraordinarily rich technical resources of ZKM allowed her to refine her audience-friendly approach to her historical works of the nineties, as well as her virtual-reality project, INTERSKIN, about the ethics of biotechnology and the body that extends the concerns of CONTINENTAL DRIFT into the realm of the disembodied virtual. The video-and data-base driven installations produced at ZKM (they also served as the art practice portion of her doctoral program in the Center for Advanced Inquiry in the Interactive Arts (or CAiiA-STAR) at the University of Wales), feature in-depth research, pop-cultural looking interfaces and an approach that can be slyly humorous within Scott's overall framework of unapologetic didacticism. "History", she says, "is a net full of holes".

schen Untersuchungen von MACHINEDREAMS. Sie verknüpfte die Geschichte des Designs im 20. Jahrhundert mit "dem Lebensstil der Reichen und Berühmten", so dass sich der/die BetrachterIn in hochmodernen, vollkommen technisierten häuslichen Umgebungen bewegen konnte, die ebenso verführerisch wirkten wie die neuartige 3-D-Animationssoftware, die Jill Scott für die Realisierung verwendete. Abbildungen von Design aus der Popkultur und von gestikulierenden Händen ermöglichten es bei diesem frühen Beispiel von Laserdisk-Technologie der BesucherIn, die Arbeit leicht zu bedienen.

Die Trilogie der Arbeiten über Technologie und Idealismus wurde abgeschlossen mit FRONTIERS OF UTOPIA (1995). Diese Arbeit beschäftigt sich als letzter Teil genauso wie MACHINEDREAMS und PARADISE TOSSED mit dem Thema der nach Jill Scott "unerreichbaren Utopien". FRONTIERS OF UTOPIA ist jedoch im Gegensatz zu den beiden anderen viel umfassender und politisch auf den Punkt gebracht; die Charaktere verkörpern aber eher "unerreichte" als unerreichbare Utopien. Eine Reise durch die Zeit bestimmt den Modus Operandi von Jill Scott, was mitunter an SchriftstellerInnen von historischer Literatur, Science Fiction oder Geschichte erinnert.

Politischer Idealismus und Aktivismus bilden die vordergründige Ebene von FRONTIERS OF UTOPIA. In einer chronologischen Auflistung einer Geschichte der Arbeit aus neun Jahrzehnten lernt der/die BetrachterIn acht sehr verschiedene Frauen und ihre beruflichen Tätigkeiten kennen, von einer Dienstmagd der Aborigines der dreißiger Jahre bis zu einer prodemokratischen Physikerin im China der neunziger Jahre, großartig dargestellt von professionellen Schauspielerinnen. Jede der Szenen im chronologischen Ablauf, 1900, 1930, 1960 und 1990, wird von zwei Schauspielerinnen gespielt. Mit FRONTIERS OF UTOPIA gewann der Begriff der Interaktivität für Jill Scott erstmals wirkliche Bedeutung durch die Benutzung modernster Technologie: sie ermöglichte den BesucherInnen, den Koffer jeder einzelnen Darstellerin zu untersuchen oder die Charaktere quer durch die Zeit zu einer virtuellen Dinnerparty zu begleiten, wo sie sich miteinander unterhalten konnten.

Didacticism has not been much appreciated in the art world since the nineteenth century. A more detached stance reflected the artist's alienation from society, usually expressed through modernist tropes such as irony. Nor is "accessibility" necessarily a complement in contemporary art discourse. Many artists cling to romantic ideas of avant-gardism, although not to the desirability of living an impoverished life in a garret. It is fitting, then, that BEYOND HIERARCHY? (2000), sited in the sort of non-art setting that tends to escape the notice of the mainstream artworld and art press, is the most recent work chronicled in this book.

Commissioned by the curator Axel Wirths for the "vision.ruhr" exhibition at Dortmund's new Industrial Landes Museum, BEYOND HIERARCHY? is sited in the vast, classicizing atrium of the former payment center of the Zeche Zollern II – once a coal mine. Video is projected within huge arched openings at the top of the cavernous volume, reversing the hierarchy of the foremen who controlled their fiefdom from above. BEYOND HIERARCHY? presents the twentieth-century industrial history of the Ruhr region through the lives of six historical characters. As with FRONTIERS OF UTOPIA viewers can interact with characters, have them meet, and determine how much history they would like to learn. It includes documentary footage from demonstrations that provides a view of history from below that is sometimes sanitized in public works.

Die innovative Gestaltung dieser komplexen Installation umfasst eine "interaktive Photographie", vier "interaktive Koffer", fünf Computer und fünf Laserdiskplayer. Obwohl sie mit den Recherchen schon 1989 in New York begonnen hatte, wurde FRONTIERS zur ersten Arbeit, die sie am ZKM, dem führenden Forschungszentrum für Medienkunst in Karlsruhe, zeigte. Der Direktor des Medienmuseums, Hans-Peter Schwarz, war 1994 auf dem Festival Ars Electronica auf sie aufmerksam geworden, wo sie für PARADISE TOSSED einen Preis erhalten hatte. Vom ZKM wurde sie als Gastkünstlerin eingeladen, und sie übernahm zusätzlich die Projektleitung für Interface Design am Medienmuseum. Die hochentwickelte technische Ausstattung am ZKM brachte sie dazu, den publikumsfreundlichen Ansatz ihrer historisch angelegten Arbeiten aus den neunziger Jahren weiterzuverfolgen. Darüberhinaus realisierte sie das Virtual Reality-Projekt INTERSKIN, das sich mit ethischen Aspekten im Verhältnis von Biotechnologie und Körper auseinandersetzt und die Thematik von CONTINENTAL DRIFT in den Bereich einer körperlosen virtuellen Realität ausdehnt. Die am ZKM entstandenen – auf Video und digitalen Daten basierenden – Installationen dienten auch als praktischer Teil ihrer Dissertation am Center for Advanced Inquiry in the Interactive Arts – kurz CAiiA-STAR – an der Universität von Wales. Die Arbeiten basieren auf eingehenden Recherchen, sie benützen Interfaces in Anlehnung an die Popkultur und zeigen einen unterschwelligen Humor in der allgemeinen Grundstruktur eines nicht apologetischen Didaktizismus. "Geschichte", erklärt Jill Scott, "ist wie ein Netz voller Löcher".

Der Didaktizismus hat in der Kunstwelt seit dem 19. Jahrhundert nicht besonders viele AnhängerInnen gefunden. Die Entfremdung der KünstlerIn von der Gesellschaft spiegelte sich in einer eher distanzierten Haltung wider, gewöhnlich fand sie in der Moderne ihren bildlichen Ausdruck zum Beispiel in Ironie. Ebensowenig ist "Zugänglichkeit" ein notwendiger Bestandteil im Diskurs von Gegenwartskunst. Viele KünstlerInnen klammern sich an romantische Ideen der Avantgarde, doch sie wollen kein Leben in Armut in einer Dachkammer führen. Passenderweise wird BEYOND HIERARCHY? (2000), realisiert an einem Ort, der ursprünglich nicht für Ausstellungen vorgesehen war und deshalb der Beachtung im Mainstream der Kunstwelt und Kunstmagazine leicht zu entgehen droht, als aktuellste Arbeit in diesem Buch vorgestellt.

Auf Einladung von Axel Wirths, Kurator der Ausstellung "vision.ruhr" im Industriemuseum Dortmund, ist BEYOND HIERARCHY? in der Zeche Zollern II - einem ehemaligen Bergwerk - im riesigen klassizistischen Atrium, das früher als Halle für die Lohnauszahlung diente, installiert worden. Videobilder werden in die großen gewölbten Öffnungen im oberen Teil des dunklen Raumes projiziert, in Umkehr der gewohnten Hierarchie, in der die Vorarbeiter ihren Machtbereich von oben herab

kontrollierten. BEYOND HIERARCHY? lässt die Industriege-schichte im Ruhrgebiet des 20. Jahrhunderts in den Lebens-läufen sechs historischer Charaktere sichtbar werden. Wie bei FRONTIERS OF UTOPIA können die BesucherInnen mit den DarstellerInnen interaktiv kommunzieren, Begegnungen zwi-schen den Charakteren arrangieren und selbst bestimmen, wieviel sie über ihre Geschichte erfahren wollen. Zusätzlich vermitteln persönliche Kommentare und dokumentarisches Filmmaterial von Demonstrationen einen Blick auf Geschichte von unten, was in öffentlichen Projekten gelegentlich eher vernachlässigt wird.

Jill Scott, of course, was selected for her approach and, given the nature of the institution, perhaps for her poli-tics as well. It was a perfect coupling of artist, thematic content and technological savy. But media-art commis-sions on this scale are relatively few. This points to the nature of media art itself, with its need for up-to- date technology and large budgets, forcing the media artist to collaborate with institutions. Scott's facility with such collaborations suggests the distance she has traveled from brick-throwing demonstrator to installation buil-der. Her political views of the necessity for genuine redistribution of power and for ethical behavior remain the same, but her means could hardly differ more fully. "I never used to believe in resistance from within," she told me with a chuckle. "Now I want to infiltrate every-thing, especially the male world of technology. In the West, the days of battling from the outside are over." Scott is a bracing role model for a too-often-elitist art-world that naively maintains a steadfast belief in its own progressive outlook.

Natürlich wurde Jill Scott wegen ihres allgemeinen Ansatzes ausgesucht, und wenn man sich die Institution vor Augen führt, vielleicht auch im Hinblick auf ihren früheren marxisti-schen Hintergrund. Das Ergebnis war ein perfektes Zusam-menspiel aus künstlerischer Arbeit, inhaltlichen Bezügen und technologischem Wissen. Aber Medienkunstprojekte dieser Größenordnung sind relativ selten. Das liegt in der Natur von Medienkunst an sich begründet, die auf modernste Technolo-gie und große Budgets angewiesen ist, was die Medienkünstle-rInnen zwingt, die Zusammenarbeit mit Institutionen zu su-chen. Das vermittelt uns einen Eindruck von Jill Scott's Geschick bei solchen Kooperationen und davon, welchen Weg sie zurückgelegt hat von einer Steine werfenden Demonstran-tin zu den von ihr realisierten themenorientierten, interaktiven und hybriden Umgebungen. Ihrem politischen Bekenntnis zu der Notwendigkeit einer wirklichen Umverteilung von Macht und ethischer Verhaltensweisen ist sie treu geblieben, aber ihre Methoden könnten kaum unterschiedlicher sein. "Ich habe früher nie an einen Widerstand von Innen heraus geglaubt," bemerkt sie mit leisem Lächeln. "Heute möchte ich am lieb-sten alles unterwandern, besonders die männliche Welt der Technologie. Im Westen sind die Tage für einen erfolgverspre-chenden Kampf von Außen für ein Erwirken von Veränderun-gen Vergangenheit." Jill Scott stellt ein inspirierendes Vorbild in einer vorwiegend elitären Kunstwelt dar, die auf naive Weise den festen Glauben in ihre eigene progressive Haltung zu bewahren sucht.

1 All comments by Jill Scott are from a series of interviews between her and the author, conducted in Zürich, Switzerland, July 17-July 20, 2002. **2** Lippard, L. R. 1973. "Six Years: The De-Materialization of the Art Object". Reprinted in: L. R. Lippard. 1976. Performance Art From the Center: Feminist Essays on Women's Art. New York: Dutton, pp. 21-35. **3** Leo Steinberg, Contemporary Art and the Plight of its Public, Oxford University Press, New York, 1972, pp. 3-16. First published in Harper's Magazine, March 1962, and based on the first of three lectures given at the Museum of Modern Art, NY, in the spring of 1960. **4** Most of these early publications like Vision and THIS press are now out of print. However one can find them in the archives of the Museum of Modern Art, San Francisco. **5** John Perreault, "It's Definitely Global, But is it Art?". Ceramics: Art and Perception, No. 47, 2002, pp. 75-79. **6** The idea of the alienating effect runs through so much of Bertolt Brecht`s work, as Walter Benjamin has pointed out. See BENJAMIN, W. 1973. The Author as Producer, Understanding Brecht. London: NLB. **7** Atkins, R. "Sand the Stimulant" at 80 Langton St., San Francisco, Artforum, September 1982, pp. 84. **8** For more information about Scott's immersion in high technology, see my interview with her, "Of Continents and Decades, Bodies and Technology," in the beginning of this book.

	1970's	1980's	1990's
CONTENT	parallel worlds	pluralistic metaphors	paradigms of mixed realities
MEDIUM	video/photo montage	video/TV	computer
ART FORM	performance art	video art	interactive art
CHARACTERS	analog figures	digital beings	mediated nomads
AUDIENCE	viewers	participants	collaborators

above [1] | DIAGRAM. A LINEAR DESCRIPTION OF THE CHANGES IN RELATION TO MEDIA ART OVER THE LAST 3 DECADES – JILL SCOTT, 2001.

below [2] | DIAGRAM. MEDIA MODEL – THE TRANSFORMED STAGE OF MIXED REALITY – JILL SCOTT, 2001.

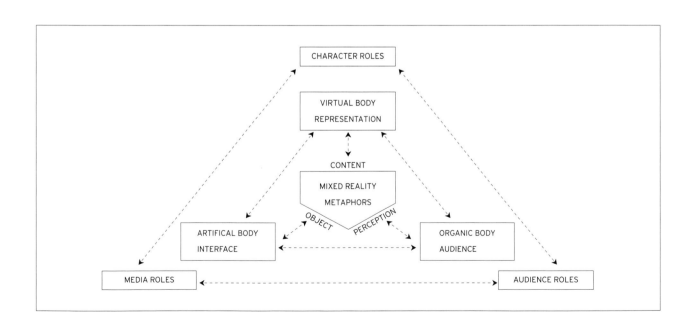

BIOGRAPHY JILL SCOTT

Born 1952 in Melbourne, Australia - http://www.jillscott.org
Agents: 235 Media, Cologne, Germany and Roslyn Oxley Gallery, Paddington, Sydney, Australia.

EDUCATION

1995-98 | Doctorate in Media and Philosoph, Center for Advanced Inquiry into the Interactive Arts, University of Wales, Great Britain. **1976-77** | Masters Degree in Fine Art and Communications, San Francisco State University, California, USA. **1974** | Diploma of Education, Melbourne Teachers College, Melbourne University, Australia. **1970-73** | Degree in Art and Design, Prahran College of Advanced Education, Melbourne, Australia.

EXHIBITIONS

2002| E-Phos Media Art Festival, Athens, Greece. **2001** | Konferenz "Future Bodies", Köln, Germany. | VIPER New Media Festival Basel, Switzerland. **2000** | "Vision Ruhr", Zeche Zollern II, Industrial Museum, Dortmund, Germany. | WRO Media Festival Fundacia, Wroclaw, Poland. | "History of the Future", Franklin Furnace Archives, New York, USA. **1999** | Roslyn Oxley, Sydney, Australia. **1998** | "Directions in New Media", St. Pollin, Austria. **1997** | Zentrum für Kunst und Medientechnologie – ZKM, Medienmuseum, Karlsruhe, Germany. | Virtual Art – Plural Reality, Museo de Monterrey, Monterrey, Mexico. | "The Performing Body", Film and Video Program, Art Gallery of New South Wales, Sydney, Australia. | Zentrum für Kunst und Medientechnologie – ZKM (Artist in Residence), Karlsruhe, Germany. **1996** | "The Body Remembers" - Solo Retrospective, Experimenta and The Australian Center for Contemporary Art, Melbourne, Australia. | "Virtual Territories", DEAF Rotterdam, Media Festival, Holland. | "Ich und Du" Museum of Art and Design, Zürich, Switzerland. | Images Du Futur, Montreal, Canada. | ZKM (Artist in Residence), Karlsruhe, Germany. **1995** | "The Multimediale", Medienmuseum, ZKM, Karlsruhe, Germany. | Siggraph '95 Virtual Communities, Los Angeles, California, USA. | ISEA, Montreal, Canada. | The Mediamu Festival Helsinki, Finland. | "Endurance" Exit Art, New York, USA. | "Australian Video", Podeville, Berlin, Germany. | "Digital Images", Rauma Art Museum, Finland. | "Technothelyalogia", Monash University, Melbourne, Australia. | Roslyn Oxley Gallery, Sydney, Australia. | VIPER Video Festival Luzern, Switzerland. | "Image Forum", Video Festival, Tokyo, Japan. | Sarr Lor Lux Videofestival, Saarbrücken, Germany. | ZKM (Artist in Residence), Karlsruhe, Germany. **1994** | Kunst- und Ausstellungshalle der Bundesrepublik Deutschland, Bonn, Germany. | "25 Years of Australian Performance Art", Ivan Dougherty Gallery, Sydney (Touring Show). **1993** | "WHERE DO WE GO FROM HERE", Stadt Gallerie, Saarbrücken, Germany. | Roslyn Oxley Gallery Sydney, Australia. | "The Frozen Gesture", Leverkusen, Germany. | "Shared Techlines", Artspace, Auckland, New Zealand. | "Interactiva" Multimedia Festival, Köln, Germany. | "Elderado", Antwerp 93, ICC Antwerp, Belgium. **1992** | "Selected Works" Montbelliard Video Festival, France. | Siggraph '92

Art and Design Show, Chicago, USA. | "III. International Concillo de Vigo", Vigo, Spain. | "Electronic Theatre" TISEA, Sydney, Australia. | "Strangers in Paradise", AGNSW - Art Gallery of New South Wales, Sydney. Australia. **1991** | Siggraph' 91 Art and Design Show, Las Vegas, USA. | Roslyn Oxley Gallery, Sydney, Australia. | The Sao Paulo Video Festival, Brazil. | The Sydney Biennale, Sydney, Australia. | "Virtual Dreams" Dance Theatre Workshop, New York, USA. | "Dissonance" Artspace, Sydney, Australia. | The Performance Space, Sydney, Australia. | The Victorian Centre for Photography, Melbourne, Australia. | The Melbourne Film Festival, Melbourne, Australia. | "Virtual Landscapes", Artspace, Sydney, Australia. | Ausgraph Computer Art Exhibition, Melbourne, Australia. | "A Matter of Refraction", Performance Space, Sydney, Australia. **1989** | Heidelberger Kunstverein (in conjunction with The German American Institute), Heidelberg, West Germany. | Utopias Downtown Community TV, New York, USA. | Roslyn Oxley Gallery, Sydney, Australia. | Ausgraph Computer Animation Show, Sydney Australia. | New Animation, M.I.M.A. Melbourne, Australia. | Ars Electronica, Vienna, Austria. | Fujiko Video Biennale, Tokyo Japan. | Australian Video, The New Museum, New York, USA. | Locarno Film and Video Festival, Locarno, Switzerland. | "Narrative and Fiction", Taormina Video Festival, Italy. | Artspace, Sydney, Australia. | "Figure it out", Performance Space, Sydney, Australia. | "Structures of Necessity" First Draft Gallery, Sydney, Australia. | Special Australian Selection of the Montbelliard Television Festival, Montbelliard, France. | "Quick Draws" The Animation Tour, Melbourne, Sydney; Brisbane; Adelaide; Australia. **1988** | "Looking with the Whole Body", Six International Video Installations, Artspace, Sydney, Australia. | Women and the Media, Performance Space, Sydney, Australia. **1987** | ACCA - The Australian Center for Contemporary Art, Australian Video, Melbourne, Australia. | The Art Gallery Of New South Wales, Sydney, Australia. | "Chaos" Roslyn Oxley Gallery, Sydney, Australia. | The Australian Video Festival, Sydney Australia. | JAPAN 87, Video Television Festival, Tokyo, Japan. **1986** | Video Scan Gallery, Tokyo, Japan. | The Australian Video Festival, Sydney, Australia. | "Video Installations", Australian Centre for Contemporary Art, Melbourne, Australia. | Australian Video Festival Installations at the Art Gallery of New South Wales, Sydney, Australia. | The French - Australian Exchange, Paris, France. **1985** | Govert/Brewster Art Gallery, New Plymouth, New Zealand. | Roslyn Oxley Gallery, Sydney, Australia. | The Performance Space (Artist in Residence), Sydney, Australia. | The International Video Biennale, Vienna, Austria. | "A Sense of Australia" Tour in England. | ANZART, Australian. - New Zealand Exchange, Auckland, New Zealand. | "Scanlight" The Australian Centre for Photography, Sydney, Australia. | PERSPECTA 85, Art Gallery of New South Wales, Sydney, Australia. **1984** | Mannheim Kunstverein, Mannheim, West Germany. | Avago Miniature Gallery, Sydney, Australia. | Montreal Video Festival, Montreal, Canada. | Belgrad Video Festival, Belgrad, Yugoslavia. **1983** | Roslyn Oxley Gallery, Sydney, Australia. | International Cultureel Centrum, Antwerp, Belgium. | "Continuum", Australian Artists in Japan, Tokyo, Japan. | AUSTRALIA at ZONA, Australian Artists In Florence, Italy. **1982** | 80 Langton Street, San Francisco, USA, International Cultreel Centrum (Artist in Residence), Antwerp, Belgium. | "New Imagery", The Museum Of Modern Art, New York, USA. | The Sydney Biennale, Sydney, Australia. | The Art Gallery of New South Wales, Sydney, Australia. | "Sound Corridor", P.S.1., Queens, New York, USA. | "Act 3-10 Australian Performance Artists", Canberra, Australia and Italy. | ANZART, Australian - New Zealand Exchange, Hobart, Australia. | "Audioeyes" Audio Visual Exhibition, Artspace, Sydney, Australia. | "Sound Sculpture" Maquarie Gallery, Sydney, Australia. **1981** | London Video Arts, AIR Gallery, London, Britain. | Los Angeles Contemporary Exhibitions, LA, USA. | The Video Bank, Amsterdam, Holland. | "The San Francisco - Berlin Exchange Show", Amerika Haus, Berlin, Germany. | "Sound Sculpture", Sound Art, Rimney, Milano, Italy. | "Video Works from Australia", The Video Bank, Amsterdam, Holland. **1980** | Tour: Name Gallery, Chicago; 80 Langton Street, San Francisco; Los Angeles Institute for Contemporary Art, LA, USA. | "A Decade of Women's Performance", Chicago Art Institute, Chicago, USA. | "Audioworks", The Franklin Furnace, New York, USA. | "Art Talks", KPFA Radio, San Francisco, USA. **1979** | Performance-tour: The Franklin Furnace, New York; Maryland College of the Arts, Baltimore, Maryland, USA. | The Institute of Modern Art (Artist In Residence), Brisbane, Australia. | "Contemporary Australian Art - A Survey", Touring Show: The Franklin Furnace, New York; Washington Project for the Arts, Washington DC; Maryland College for the Arts, Baltimore; 80 Langton Street, San Francisco; Site, Cite, Sight Inc., San Francisco; L.A.I.C.A., Los Angeles, USA. **1978** | The University of California, Davis, California, USA. | The Farm, Crossroads Community (Artist In Residence), San Francisco, USA. | "Contemporary Bay Area Art - A Survey" Touring Show: The Institute of Modern Art, Brisbane; The Experimental Art Foundation, Adelaide; The Sculpture Centre, Sydney, Australia. | The Ewing and George Patton Galleries in Melbourne, Australia. **1977** | The Women's Building, Los Angeles, USA. | Video Free America, San Francisco, USA. | "The Global Space Invasion Show", Museum of Modern Art, San Francisco, USA. | "Artists Tapes", Channel 34 Cablevision, San Francisco, USA. **1976** | The Neighbourhood Arts Foundation, San Francisco, USA. | "Bay Area Artworks", The Women's Building, Los Angeles, USA. | "Open Studio", South of Market Series, San Francisco, USA. **1975** | "Open Studio", South of Market Series, San Francisco, USA. **1974** | "Free Forms", The Ewing and George Patton Galleries, Melbourne, Australia.

PRIZES

1993 | Prix Ars Electronica – Interactive Multi Media Award for PARADISE TOSSED, Linz, Austria. **1990** | Prix Ars Electronica, Interactive/Honorable Mention, MACHINEDREAMS, Linz, Austria. **1990** | Australian Video Festival-Video Art Prize for WISHFUL THINKING, Sydney, Australia. **1989** | The Australian Video Award, LIFE FLIGHT, Sydney, Australia.

COOPERATIONS, DIRECTIONS/ASSOCIATIONS/POSITIONS (not including papers and panels).

2002 | Professor: Media Department, Bauhaus University Weimar, Germany (Since 1998). | Adjunct Professor: Cultural Studies, University of Art and Design, Zürich, and Consultant Contract for Reformprojekt 2004, Hochschule für Gestaltung und Kunst, Zürich. | Adjunct Professor: Media Art, University of Applied Science, Aargau, Switzerland. | External Assessor: Australian Research Counci, Australia. **2001** | Consultant, Swiss Peer Review, International Assessment of Swiss Design and Media Education, Switzerland. **1998-2002** | Director of FUSION (Internet Real-Time On-Line-Festival with point to point student collaboration between three international universities (UCLA, Los Angeles, USA – COFA, Sydney, Australia – Bauhaus University Weimar, Germany). **1995-97** | Artist in Residence: ZKM, Media Museum, Karlsruhe, Germany. | Research Consultant "Interactive Applications", OTC Telecom, Australia. **1992-95** | Guest Professor: Computer Animation, University of Art and Design Saarbrücken, Germany. **1988-92** | Assistent Professor: Time Based Arts, College of Fine Art. University of New South Wales, Sydney, Australia (from 1983-91). **1986-88** | President and Curator of The Australian Video Festival, Sydney. **1980-1982** | Director and Curator SITE, CITE, SIGHT Alternative Art Space, San Francisco, USA. | Board of Artistic Directors, San Francisco Art Institute, USA. **1978-1980** | Part Time International Relations Manager, Video International Company, San Francisco, USA. **1976-1978** | Part time Assistant Producer for Cable TV, San Francisco. USA.

TECHNICAL MEDIA EXPERIENCE

2000-2002 | Linux driving multiple custom interfaces. PC and DVD players | Research project: Ubiquitous Computing, Microchip technologies, Smart Sculptures. **1994-2000** | Research: Biotechnology. Artist in Residence, ZKM Medienmuseum- Interface design and electronics with Allen Giddy and Martin Häberle. | VR (c++) with Andreas Schiffler and Sabine Hirtes (SoftImage. Flock of Birds Performer) and ethernet (servers and linux programming) and internet (www html and web cam) | CD-ROM production. **1992-94** | Started working with Jens Müller on Macro-Media Director, Lingo (then called Macro Mind Director) Saarbrücken. **1990** | First computer-based interactive work – MACHINEDREAMS, Sydney Biennale Worked with Simon Veetch, an innovative security camera detector called The 3 DIS System, PC based Dos, security cameras. **1990-91** | Started a Computer Animation Company called Lumagraph-Sydney. (Lumina, and an animation program called Cystal from Time Arts using Targa Graphic Cards). **1989** | Research: Interactive computer-laserdisc technologies and human cognition. In New York worked as Commercial Painbox-Harry editor at Edital USA. **1985-87** | Research: Astronomy and Physics. | Video paintbox- Harry, Digital Compositing and basics in 3D Computer Animation, – Australian Video Fesival, Australian Film and Television School and the Video Paint Brush Company. **1982-85** | Research: digital sound effects. First MacIntosh Computers-Mac Paint and Macwrile at the Alexander Mackey School of Art, International Slow-scan experiments, Fairlight Computer Music and Video Instruments, Band- The Dynabytes. **1979-82** | Research: Analog Effects. | Grass Valley Vision Switcher. Video editing at the Community editing facilities in Australia and in San Francisco. **1978-79** | Acoustic instrument building and multi-track recording. **1975-78** | Student assistent: San Francisco State University. | Practical experience: Bay Area Video Coallition. **1974** | Lecturer in Video. Cockpit Theatre, London.

PUBLISHED WRITINGS

BY JILL SCOTT

NEW SCREEN MEDIA. 2002, Cinema/Art/Narrative, Ed. Martin Reiser and Andrea Zapp, British Film Institute Publishing, "Crossing and Collapsing Time", UK, p. 195-208. | **OBN CYBERFEMINIST CONFERENCE PROCEEDINGS.** 2002, "Bioethics ", Ed. von Oldenburg, H. und Reiche, C., Hamburg, Germany. | **MEDIATED DRAMA - DRAMATISED MEDIA.** 2000, Vol no. 7, "Recasting the Human Form on a Transformed Stage", Ed. Bernhard Reitz and Eckart Voigts-Virchow, Pub. Wissenschaftlicher Verlag Trier, Germany, p. 31-43. | **VISION.RUHR.** 2000, ed. 235 Media, Hatje Cantz Verlag, "Beyond Hierarchy?", p. 126-136, Germany. | **CONSCIOUSNESS REFRAMED.** "Body as Interface", CAiiA Conference Proceedings 1998, University of Wales, UK. | **DIGITAL BODY AUTOMATA.** 1998, Ph.D Thesis with CD-ROM's and additional Hypertextbook, CAiiA- Star, UK (Available at University of Wales, College of Arts, UK). | **MESH. THE FIFTH EXPERIMENTA MEDIA ARTS FESTIVAL.** 1996, "Re-possessing the Body" from the retrospective "The Body Remembers", Interview by Josephine Starrs, Melbourne, Australia. | **KUNSTFORUM.** 1995, "Die Digitale Körperethik" in "Die Zukunft des Körpers II", no. 133, February-April, Köln, Germany, p. 172-178. | **MEDIA ART PERSPECTIVES.** 1995, "If Memory Then Multimedia Fantasy" in Perspectiven der Medienkunst, Editor ZKM, Cantz Verlag, Pub. Heinrich Klotz, Germany, p. 207. | **ARS ELECTRONICA.** 1993 "Paradise Tossed or Lost?" in Prix Ars Electronica 93, Internationales Kompendium der Computerkünste, Ed. Hannes Leopoldseder, Austria, p. 108-111. | **TIGHTROPE MAGAZINE.** 1994, October, "Technosharmanism, Reality or Nonsense?" in Tightrope, Ed. Jens Geelhaar, Saarbrücken, Germany, p. 72-73. | **SIGGRAPH INTERACTIVE COMMUNITIES.** 1995, "Where are the Frontiers of Utopia" in The Art and Interdisciplinary Programs of Siggraph, Visual Proceedings, Ed. Ken O'Connell, pub. ACM Siggraph,USA, p. 123. | **TIGHTROPE MAGAZINE.** 1995, "Collective Intelligence" in Tightrope, Vol. 2, Ed. Jens Geelhaar, Publisher Hochschule der Bildenden Kunst Saarbrücken, Germany, p. 8-9. | **SEEING AUSTRALIA - VIEWS OF ARTISTS AND ART WRITERS.** 1994, "Personal Interaction with Art and Technology", Ed. Graeme Sullivan, Pub. Piper Press, Sydney, Australia, p. 166. | **FUTURE VISIONS, TECHNOLOGIES OF THE SCREEN.** 1993, "Virtual Reality, Beyond Cartesian Space" in British Film Institute Publication, Co-Writer Sally Pryor, Ed. Phil Hayward and Tanya Wollen, UK, p. 166-179. | **FRAMES OF REFERENCE, ASPECTS OF FEMINISM IN ART.** 1991, "The Panopticon Project" in Artspace, Ed. Sally Couacaud, Publisher NSW Ministry for the Arts, Australia Council, Australia, p. 74-76. | **VIRTUAL REALITY.** 1990, OTC Conference Proceedings, Telcom Australia. | **AUSGRAPH.** 1989, "The Nature of Interactivity" Conference, Melbourne. Australia. | **THE AUSTRALIAN VIDEO FESTIVAL.** 1987, Artlink Magazine, Ed S. Britton Adelaide, Australia. | **VIDEO FROM JAPAN, THE PERFORMANCE SPACE, THE FIRST AUSTRALIAN VIDEO FESTIVAL.** 1986, Curator Jill Scott. Publisher The Australian Film Commission. | **AUSTRALIAN MYTHOLOGICAL - SITES, CITES, SIGHTS.** 1986, "Double Space" in Third Degree, Ed. C. Payne, P. Mc Carthy, K. Brereton, Pub. University of Technology, Sydney, p. 21. | **80 LANGTON STREET.** 1980, "Sand, the Stimulant" in the June 1979-April 1980 Publication of the 80 Langton Street Corp., San Francisco, USA, p. 70. | **CHARACTERS OF MOTION.** 1980, "Performance Work", Ed. Jill Scott with Interview by Robert Atkins and Introduction by Moria Roth, Straw Man Press, San Francisco, USA.

ABOUT THE WORK OF JILL SCOTT (not including newspaper reviews).
PVC PERFORMANCE VIDEO COMPUTER CLIP CLUB. 2002, Interview from 1996 with Jill Scott by Gerhard Johann Lischka, Ed. Gerhard Johann Lischka, ZKM Digital Arts Edition, Pub. Hatje Cantz. | **WOMEN, ART AND SCOIETY.** 2002, Ed. Witney Chadwick, Pub. Thames and Hudson, London. | **FORMEN INTERAKTIVER MEDIENKUNST.** 2001, Ed. Peter Gendolla, Norbert M Schmitz, Irmela Schneider und Peter Spangenberg, Suhrkamp, Siegen, Germany. | **CAST 01.** 2001, "Living in Mixed Realities", Conference proceedings, Pub. Mars Exploratory Media Lab, Fraunhofer Institute, Germany. | **STEVEN WILSON INFORMATION ARTS, INTERSECTIONS OF ART, SCIENCE AND TECHNOLOGY.** 2000, Ed. Steven Wilson, Chapter 2.7, Computer - Media Deconstruction and Feminist Critiques of Cultural Trends, MIT Press. | **TECHNOLOGY WITH CURVES, WOMEN RESHAPING THE DIGITAL LANDSCAPE.** 2000, Pub. J. Napier, D. Short, E. Smith. Harper Collins, Canada. | **DER ELEKTRONISCHE RAUM, 15 POSITIONEN ZUR MEDIENKUNST.** 2000, "Der kodierte Körper und die weibliche Sicht der Dinge" by Söke Dinkla, Ed. Kunst- und Ausstellungshalle Bonn, Hatje Cantz, Germany, p. 50-61. | **ARTE VIRTUAL - REALIDAD PLURAL.** 1998, Museo de Monterrey, Curator Karin Ohlenschlager, Mexico. | **MEDIA ART HISTORY.** 1997, Essay by Hans Peter Schwarz, Media Museum, ZKM, Center for Art and Mediatechnology, Karlsruhe, Germany, Pub. Prestel, p. 87, 136 and 140. | **MESH, THE FIFTH EXPERIMENTA MEDIA ARTS FESTIVAL.** 1996, "The Body Remembers" by Zara Thornhope, Melbourne, Australia. | **MULTIMEDIALE - MEDIENKUNST FESTIVAL DES ZKM.** 1995, Karlsruhe, "Grenzen der Utopie" by Hans Peter Schwarz, Hatje Cantz, Germany, p. 62. | **ICH UND DU, KOMMUNIKATION UND NEUE MEDIEN.** 1996, ed. Erika Keil, Museum für Gestaltung und Kunst, Zürich, Switzerland, p. 33. | **VOYAGE VIRTUAL !! UNE EXPOSITION DES TROIS SUISSE.** 1995, ed. Les Virtualistes, Numerise Utopic, Paris, France, p. 13. | **VIPER '95.** 1995, Internationales Video and Multimedia Festival Lucerne, October,

Ed. Mirrella Wepf, Switzerland, p. 164-165. | **KUNSTFORUM.** 1994, October-December 94 International, (no. 128) "Zwischen Erinnern und Vergessen", Review of Machinedreams by Andreas Denk, Germany, p. 401. | **BODY AND SELF, PERFORMANCE ART IN AUSTRALIA.** 1993, Ann Marsh, Oxford University Press, UK, p. 156-159. | **SHARED TECHLINES.** 1993, Video Art from the Pacific Rim, Pub. Pricilla pitts. Artspace, Auckland, New Zealand. | **TECHNOLOGICA.** 1992, "Technology by and of Women", Curator and Ed. Zara Stanhope, Monash University Gallery, Melbourne, Australia, p. 10. | **CULTURE TECHNOLOGY AND CREATIVITY IN THE LATE TWENTIETH CENTURY.** 1992, "Negotiating Presence - Performance and New Technologies" by Andrew Murphie, Ed. Phillip Hayward, Pub. John Libbey, London, p. 209. | **THE FROZEN GESTURE.** 1992, " Beyond the Mirror", essay on Jill Scott by Helen Michaelse in "Junge Digitale Bilderkunst", Exhibition Catalog, Pub. Volkshochschule Leverkusen, Germany. | **CIDE DE VIGO.** 1991, Festival International de Video, Jan Alborada Productions Pub. Artes Graphics, Doya SL, Spain. | **THE 6TH AUSTRALIAN VIDEO FESTIVAL.** 1991, "Continental Drift", Curator and Ed.Brian Langer, Sydney, Australia, p. 12. | **FOLLOW ME MAGAZINE.** May 1990, "Continental Drift", Artists at Play, Document of Performance by Anne Howell, Sydney, Australia. | **SCAN* MAGAZINE.** 1990, The Fifth Australian International Video Festival, November Issue no 5., by Brian Langer, Pub. EMA, Ed. John Conomos, Australia, p. 33. | **8TH BIENNALE OF SYDNEY, ART IS EASY.** 1990, "Document of Machinedreams", Curator Rene Block, Pub. The Biennale of Sydney, MCA, Australia, p. 392. | **INTERVALLI.** 1989, tra Film, Video, televisione, Sellerio Editore (Pub) Palermo, by Jean Paul Feagier, p. 78, Italy. | **SIGN OF INDEPENDENCE, TEN YEARS OF THE CREATIVE FILM DEVELOPMENT FUND.** 1988, "Wishful Thinking", Ed. Megan McMurchy and Jennifer Stott, Pub. Australian Film Commission, Australia, p. 127. | **TAORMINA ARTE VIDEO FESTIVAL.** 1988, "Gli Inseparabili", Taormina, Italy, p 75. | **FOLLOW ME MAGAZINE.** 1988, Aug.-Sept., Issue, Advertisement for Video Festival with review of Jill Scotts Work, Pub. Follow Me Publications, Sydney, Australia. p. 40. | **THE MELBOURNE FILM FESTIVAL.** 1988, "Wishful Thinking", Catalogue Australian Video, Pub. Ellikon Printers, Melbourne, Australia, p. 70. | **QUICK DRAWS, THE AUSTRALIAN INTERNATIONAL ANIMATION FESTIVAL.** 1987, Pub. British Council and AFI, Ed. Amanda Falconer, Australia, p. 3. | **TAKING CARE OF BUSINESS, A PRACTICAL GUIDE TO INDEPENDENT FILMMAKING AND VIDEO PRODUCTION.** 1988, "Two Video Artists" by Sue Charlton, Ed. John Cruthers, Pub. Australian Film Commission, Australia, p. 59-68. | **EXPERIMENTA.** 1988, "Wishful Thinking by Jill Scott", Melbourne MIMA, Ed. Adrian Martin, p. 44. | **STRUCTURES OF NECESSITY.** 1987, First Draft Gallery, Ed Liz Coates, Rotary Offset Press, Pub. Australia Council, Visual Arts Crafts Board, Sydney, Australia. | **ARTLINK SPECIAL ISSUE ART AND TECHNOLOGY.** 1987, Volume 7, no. 2 und 3, "A Video Feast - Review of the Australian Video Festival" by Jill Scott, p. 54+55 and also in the same issue photos "Catwoman Series", Ed. Stephanie Britton and Fracisca de Rimini, Pub. Artlink Inc., Australia, p. 64. | **PERFORMANCE.** 1986, Australian Performance July/August 86 - no. 42, "Jill Scott, a Science Fiction Videomaker" by Rob La Frenais, Ed. La Frenais, Pub. Steve Rogers, London, UK, p. 25. | **NATURE AND TECHNOLOGY IN RECENT AUSTRALIAN ART.** 1985, Ed. George Petelin and Michael Milburn, Sanctury Cove, Art Council, Queensland, Australia, p. 10. | **A:U:S:T:R:A:L:I:A AT Z:O:N:A.** 1983, SPRING no 11, Exhibition Critiques Review by Judith Blackall, Pub. Network Publications, P/L October, Italy, p. 45. | **ACT 3 CANBERRA, TEN AUSTRALIAN PERFORMANCE ARTISTS.** 1982, Canberra School of Art Gallery, "Constriction, an investigation in four parts" by George Allexander, Canberra (six page fold out) Curator and Ed. Ingo Kleinert, Australia. | **BIENNALE OF SYDNEY 1982 - VISION IN DISBELIEF.** 1982, "Constriction", Curator and Ed. William Wright, p. 174. | **VIDEO INSTALLATION, INTERNATIONAL CULTREEL CENTRUM.** 1982, Antwerp, Belgium. Curator Hilde Van Leuven, "Sand the Stimulant" and "Constriction", Catalogue no 20, Pub. Ministerie van Nederlandsee Cultuur, Holland, p. 10-18. | **HIGH PERFORMANCE, ALL PHOTO ISSUE, PUBLISHER ASTRO ARTS.** 1980, Issue 20, Ed. Linda Fry Burnham, Los Angles, USA, p. 8. | **THE AMAZING DECADE, WOMEN IN PERFORMANCE ART IN AMERICA (1970-1980).** 1980, by Moria Roth. Astro Arts Los Angeles, USA. | **PEFORMANCE ANTHOLOGY.** 1980, Pub. Contemporary Arts Press, San Francisco, USA.

BIOGRAPHIES

ROY ASCOTT Founder and Director of CAiiA-STAR, Roy Ascott is the Prof. of Interactive Art at the Univ. of Wales College Newport, the Prof. of Technoetic Art at Univ. of Plymouth, and Adjunct Prof. in Design, Media Arts at the Univ. of California. L.A. His project for a Planetary Collegium is in development. A pioneer of cybernetics and telematics in art, he has shown internationally at a number of major cultural events and exhibitions. He has a special interest in the syncretic culture of Brazil, and has spent time with the Kuikuru people in the Xingu River area of the Mato Grosso. He is the founding editor of the international journal Technoetic Arts, and serves on the editorial boards of Leonardo, Leonardo Electronic Almanac, Convergence, Digital Creativity, and the Chinese language online journal Tom.Com. He has served on many intern. bodies including UNESCO, and the CEC, Brussels. He was Dean of San Francisco Art Institute, California. His publications include "Art & Telematics: Toward the Construction of New Aesthetics". (Japanese trans. E. Fujihara). NTT, Tokyo, 1998. Since 1998 he has convened the international Consciousness Reframed conference, and edited two books: "Art Technology Consciousness" (2000) and "Reframing Consciousness" (1999 – Intellect Books, Portland or/and Bristol). Forthcoming publications include the Univ. of California Press. "Telematic Embrace" edited by Edward Shanken.

ROBERT ATKINS is a New York and California-based art historian, activist, and writer. A professor of art and media, he is a Fellow at the STUDIO for Creative Inquiry at Carnegie Mellon Univ. and the author of the best-selling "ArtSpeak: A Guide to Contemporary Ideas, Movements and Buzzwords," its companion "ArtSpoke: A Guide to Modern Ideas, Movements and Buzzwords 1848-1944," and "From Media to Metaphor: Art About AIDS." A former columnist for The Village Voice, he has contributed to more than 100 int. publications. He received awards from the National Endowment for the Arts, Manufacturers Hanover Bank and the Penny McCall Foundation. In 1995 he founded the City Univ. of NY-sponsored TalkBack! A Online Forum for Critical Discourse (http://talkback.lehman.cuny.edu/tb), the first American online journal about online art and was media-arts editor for The Media Channel (http://www.mediachannel.org) and editor/producer of Artery: The AIDS-Arts Forum (http://www.artistswithaids.org/artery). He is also the initiator of 911-THE SEPTEMBER 11 PROJECT: Cultural Intervention in Civic Society (http://rhizome.org/911) and a founder of Visual AIDS, the group that originated Day Without Art and the Red Ribbon. He may be reached through (http://www.robertatkins.net).

MARILLE HAHNE (Editor) is a leading experimental film researcher in the field of Digital Cinema in Switzerland and the Co-Director of the Studienbereich Film at the Univ. of Art and Design, Zürich. In 1978, she completed a Degree in Precision Tool Engineering and Optics at the University of Applied Engineering in Munich, Germany. In 1979, she was the recipient of a Fulbright Grant to study at the Univ. of Colorado, in Boulder USA, and in 1983 she was awarded a MFA in Film at the School of the Art Institute, Chicago, USA. Since then she has produced experimental and documentary film works and these have been shown internationally. From 1984 to 1992 she was Assistent Professor at the Univ. of Applied Science in Dortmund, Germany, and currently she is consultant for a new institute for Art and Media in Switzerland. She specializes in the blend between Art and Science and is also a freelance editor of texts and the kinetic image.

ANNE MARSH is an art historian and critic. She is currently deputy head of the School of Literary, Visual and Performance Studies at Monash Univ. Her first major historical survey "Body- and Self-Performance Art in Australia 1969-1992" was published in 1993 by Oxford Univ. Press. She has written many articles in books based on the democratisation and dematerialization of the art object, re-configuring the body and body-political contexts as well as the liberation of the senses and the relationship between the artist and society. Currently she is working on a new book about the performative roles inherent in the history of photography entitled: "The Darkroom: Photography and the Theatre of Desire" (forthcoming).

YVONNE SPIELMANN is Prof. of Visual Media at Braunschweig School of Art, Germany. Previously she was Assistant Prof. of Media, Studies at the Univ. of Siegen. Her fellowships have included the Getty Center, Santa Monica and the Society for the Humanities at Cornell Univ. She is author of "The Concept of the Avant-Garde" (Peter Lang Press, 1991), "Intermediality. The Systems of Peter Greenaway" (Wilhelm Fink Press, 1998) and editor of "Art and Politics of the Avant-Garde" (syndicat anonym, 1989), "Image-Media-Art", together with G. Winter (Wilhelm Fink, 1999), and co-editor of the special issue "Intermediality of the Convergence" (winter 2002) as well as numerous articles on the experimental and avant-garde history and theory of visual media, aesthetics in the 20th century; intermediality and visual culture. The book "Video – the Reflexive Medium" is forthcoming.

INDEX AND CREDITS MEDIAWORKS (in the order of this book)

PP. 040-093, ANALOG FIGURES
TAPED 1975|p.048 Photos: Bryan Hillstrom | Assistants: Mark Gilliland, Al Nodel (1975) Bryan Zulaikha, Thomas Bishop (1988 - Artspace Sydney) | Sponsorship: 3M. San Francisco. Collection: The Franklin Furnace, New York. **BOXED 1975|p.052** Photos: Bryan Hillstrom | Sponsorship: The Handy Jack Moving Company, San Francisco. **TIED, STRUNG 1975|p.054** Photos and Assistant: Bryan Hillstrom. **ACCIDENTS FOR ONE 1976|p.056** Camera: Mark Gilliland | Flute: Carla Harryman | Video "Almorative Dance" produced at the Bay Area Video Coalition. **ACCIDENTS FOR FOUR 1976|p.058** Photos: Bryan Hillstrom | Sponsored by the Neighbourhood Arts Foundation. San Francisco. INSIDE OUT 1976 | Photos: Bryan Hillstrom | Sponsorship: Marin Community Video and Video International, San Francisco. **EXTREMITIES 1977|p.060** Photos: Jock Reynolds| Sponsored by: Video International and The San Fransisco State University. Photos: Bryan Hillstrom. **MOVED UP MOVED DOWN 1978|p.062** Curator: Barbara Smith, Photos: Terry Hanlon | "A Beat in Step" Videotape - Editing: Jill Scott, Camera: Mark Gilliland | Funded by The Women's Building, Los Angeles. Sponsorship: Video International | Collection: Mediathek of The Zentrum für Kunst und Medientechnologie ZKM, Karlsruhe, Germany. **INSIDE OUT 1978|p.064** Photos: Bryan Hillstrom | Sponsorship San Francisco State University. **OUT, THE BACK 1978|p.066** Curator: Jackie Apple | Photos: Sam Schoenbaum | Assistant: Larry Fox | Baltimore repeat in 1979: Curator and Photos : Kirby Malone | Sponsorship: University of Baltimore. Maryland and The Bay Area Video Coalition-San Francisco. **THE HOMECOMING 1978|p.068** Photos: Robert Mercer | Performers: Lance Scott, Margaret Scott, Mary-Lou Little and Scott Ramsay. **CHOICE 1979|p.070** Photos: Ian Smith | Assistant: Robert Mercer | Funded by the Institute of Modern Art, Brisbane - Artist in Residence Program with support from the Australian Council. **SAND THE STIMULANT 1980|p.074** Photos: Tom Marioni | Curator: Rene Pritican | Funded by the Bay Area Video Coalition and Langton Street Arts. **PERSIST, THE MEMORY 1980|p.078** Photos: Tom Marioni | Assistant: Marilyn Scarritt | San Francisco Artist in Residence Program at The FAR | Funded by the National Endowment for the Arts, Washington DC, USA. **ORDER THE UNDERFIRE 1981|p.080** Photos: Mike Henderson | Funded by the Visiting Artists Program of the Universtiy of California at Davis, USA. **DESIRE THE CODE 1981|p.082** Documentation: Mark Samuelson | Sound: Allan Scarritt and Jill Scott | Sponsors: The Bay Area Video Coalition and Site, Cite, Sight Inc. San Francisco. **THE MAGNETIC TAPES 1981|p.084** Editing and Camera: Jill Scott | Actor: Sarah Yakira| Sponsorship: Video Free America, San Francisco. **CONSTRICTION PART ONE. 1982|p.085** (Videotape), Funded by the Bay Area Video Coalition | Collection: The Art Gallery of New South Wales, Australia, The Art Gallery of Queensland, Australia and Video Scan Gallery, Tokyo. **CONSTRICTION PART TWO. 1982|p.090** Photos: Janet Delany | Funded by the International Cultureel Centrum, Antwerp, Belgium.

PP. 094-141, DIGITAL BEINGS
CONSTRICTION PART THREE. 1983|p.102 Photos: Bonita Ely | Funded by the Visual Arts Board of the Australia Council | Sponsorship: JVC Australia - Canberra Security Division. **DOUBLE DREAM 1984|p.106** Actors: Hot-Sara Woods, Cold-Ronda Mowat | Sound: The Dynabytes (Jill Scott, Vineta Lagzdina, Jade McCutcheon) | Vision Switcher: Peter Butterworth, Camera: Ann Graham, Costumes: Helena Keirluf, Technician: Steven Jones, Lighting: Nick Tsoutas, Assistance: Piotr Olszanski | Funded by the Performance Space, Sydney and the Artist in Residence Program of The Visual Arts Board of the Australia Council | Sponsored by the University of Technology, Sydney, Brigg Electronics, Radio Rentals, Metro Television, Fairlight Instruments Ltd. Sydney. **THE SHOCK OF THE STILL 1985|p.110** Photos: Jill Scott | Assistant: Cathie Vogan | Sponsorship: JVC Australia and The Video Paint Brush Company, Sydney. **DOUBLE TIME 1985|p.112** Actors: Astronaut-Bonita Ely and Aquarius-Hillary Mais | Sound: The Dynabytes | Video Mix: Peter Butterworth | Sponsorship: The University of Technology and Fairlight Instruments Ltd. Sydney. **MAGNIFICENT DESOLATION 1985|p.114** Photos: Robert Randell | Actor: Moon Goddess, Jill Scott and Astronaut, Niel Armstrong | Curator: Wendy Miller | Photos: Robert Randell | Sponsorship: The Video Paint Brush Company, Sydney and The University of Technology Sydney. Australia. **DOUBLE SPACE 1986|p.115** Photo: Cathie Vogan | Actors: Cat-Julie Rrap, Bird-Vineta Lagzdina, Horse-Ann Graham, Fish-Jade McCutcheon, Wolf-Janet Laurence, Snake-Jill Scott | Music: The Dynabytes | Assistance: Sue Maslin, Video Mix: Peter Butterworth | Sponsored by Fairlight Instruments Ltd. Sydney | Collection: Art Gallery of New South Wales Sydney, Australia. **THE GREAT ATTRACTOR 1988|p.119** Curator: Sally Couacaud | Sponsorship: The Video Paint Brush Company, Sydney, JVC Australia, The North Shore Astronomy Shop | Collection: The Astronomical Society, Australia. **MEDIA MASSAGE 1989|p.120** Dancer: Sarah Cathcart | Music: The Dynabytes | Graphics: Jill Scott, Sally Pryor | Tech: David Booth | Sponsorship: The Video Paint Brush Company and the Australian Film and Television School | Funded by The Womens Film Fund of the Australian Film Commission | Collections: WDR Germany and Griffith University, Brisbane, Australia. **WISHFUL THINKING 1989|p.124** Actors: Zira, Sarah Cathcart, Jane, Sher Ghul, Father - Ian Mortimer, Mother - Deborah Piper, Son - Scott Bartle, Daughter - Mellissa Marshall, Wonderwoman - Kristan Robson, Ms. Tree - Sher Cuhl, Catwoman - Angela Toohey | Music: Director and Composer, Andrew Quinn | Script Editor: Helen Grace | Production Assistant: Bernadette Flynn | Casting and Workshoping: Kerry Dwyer | Sets: Janet Laurence, Trish Ryan, James Hughes | Camera: Chris Frazer | Lighting: Tony McDonnald | CCD-operator: Bob Forster | Ultimatte Consultant: Bill Fitzwater | Digital effects and Computer Graphics: Jill Scott | Facilities: AFTRS Sydney, Open Channel Melbourne and The Video Lab Sydney | Funded by The Womens Film Fund of the Australian Film Comission, The Video Paint Brush Company and the Australain Film and Television School as well as The Art and Technology Program of the Australia Council. **LIFE FLIGHT 1989|p.128** Photos: Bill Seamen | Edit: Jill Scott | Assistant: Steven Jones | Sound: Andrew Quinn | Sponsorship: The Video Paint Brush Company and Heuristic Video, Sydney. **CONTINENTAL DRIFT 1990|p.130** (Videotape), Actors: Jill Scott, Cathie Wong | Edit: Jill Scott | Sound: Andrew Quinn | Sponsorship: The Australian Network for Art and Technology and The Communcations Department of the University of New South Wales, Sydney | Collection: Mediathek of The Zentrum für Kunst und Medientechnologie ZKM, Karlsruhe, Germany. **CONTINENTAL DRIFT 1991|p.132**

(Performance), Curator: Nick Tsoutas, Photos: Regan Cameron | Assistant: Vineta Lagzdina | Sound: Andrew Quinn | Sponsorship: The Australian Network for Art and Technology and JVC Professional Division, Australia. **MACHINEDREAMS 1991|p.136** Photos: Jill Scott | Music: Andrew Quinn | Programmer: Simon Veetch | Sponsorship: Perceptive Security Systems, Melbourne | In Bonn in 1996 – Programmer: Andreas Schiffler | Funded by the Australian Film Commission and the Visual Arts/Crafts Board of the Australia Council.

PP. 142-201, MEDIATED NOMADS

PARADISE TOSSED 1993|p.150 Photos: Josephine Grieve | Interactive Programming: Jens Muller | Animators: Don Ezard, Simon Gresham, Jill Scott and Isabelle Delmotte | Music: Andrew Quinn | Produced with the assistance of the Australian Film Commission, Sponsorship: Mikros Image, Paris, France, Animal Logic, Australia and Sony Australia. **FRONTIERS OF UTOPIA 1995|p.158** Photos: C.Moore Hardy, Stephan Harms | Actors: Emma-Clare Grant, Mary-Genevieve Lemon, Miner-Ross Pangallo, Margaret-Karen Colston, Pearl-Lillian Crombe, Gillian-Lizzy Falkland, Maria-Rosie Lalavich, Farmer-Geoff Parr. Zira – Sarah Cathcart, Ki – Cindy Pan, Ki's Husband-Scott Buxton | Programming: Monitor Information Systems and Jens Mueller | Original Music: Andrew Quinn | Graphics and Interface Design: Jill Scott, Ralf Pfeiffer, Allan Giddy, Martin Häberle.| Designer: Trish Ryan, Acting consultant: Andrea Lemon, Research: Bronwyn Coupe, Production Manager: Margot Oliver | Camera, Lighting, Sound: The Australian Film and TV School Crew | Produced in conjunction with Monitor Information Systems Ltd, Laura Tricker | Funded by the Australian Film Commission. Collection: Zentrum für Kunst und Medientechnology, ZKM- Medienmuseum. Karlsruhe Germany. **A FIGURATIVE HISTORY 1996|p.168** Photos: Stephan Harms | Animators: Sabine Hirtes, Jill Scott, Jan Stoltz, Matthias Whittman and Oliver Seiter | Researcher: Paul Charlier | Interfaces: Allan Giddy, Martin Häberle | Programming: Jens Mueller | Sound: Frank Schweitzer, Mix: Institut für Musik und Akustik | Travelling Version: Natalie Mueller and Andreas Schiffler | Sponsorship: Filmakademie Baden-Würtemberg Ludwigsburg | Construction: Schwab Engineering, Silkscreen Images: Carter Hogdkins | Collection: Zentrum für Kunst und Medientechnologie, ZKM- Medienmuseum, Karlsruhe, Germany. **INTERSKIN 1997|p.176** Graphic Construction: Andreas Schiffler, Sabine Hirtes, Lucas Romeik, Jill Scott | Researcher: Jennifer Schiffler and Dr. med. Mattias Tenholt in co-operation with the Institute for Biomedical Technology-University of Karlsruhe | Commissioned by the ZKM | Sponsored by the Filmakademie Baden-Württemberg Ludwigsburg. Construction: Schwab Engineering, Silkscreens: Carter Hogdkins | Collection: The Zentrum für Kunst und Medientechnology, ZKM- Medienmuseum, Karlsruhe, Germany. **IMMORTAL DUALITY 1997|p.184** Programming: Andreas Schiffler and Robert Chong | Graphic Construction: Sabine Hirtes, Jill Scott | Co-operation: Dynamax, Paris, France | Sound: Frank Schweitzer, Construction Swab Engineering, Silkscreens: Carter Hogdkins | Commissioned by the ZKM Medienmuseum | Collection: The Zentrum für Kunst und Medientechnology, ZKM-Medienmuseum, Karlsruhe, Germany. **FUTURE BODIES 1999|p.190** Sketches: Marion Meyer | Programming: Andreas Schiffler and Guillaume Stagnaro | Sponsorship: The Bauhaus University, Weimar, Germany and UCLA Los Angeles | Online link: www.jillscott.org. **BEYOND HIERARCHY? 2000|p.192** Photos: Wolfgang Burat | Actors: Sophie – Catherine Bode, Piotr – Kai Betterman, Lotte – Claudia Burckhardt, Misha – Herbert Schäfer, Ahmet – Tüne Denizer, Sabine – Heidrun Grote | Assistant Director: Marille Hahne, Script | Editor: Susanne Düllmann, Archival | Research: Karin Lauerwald | Kamera: Ludger Hennig, Licht: Martin Koenig, Sound: Stephan Schädlich | Props: Karin Lauerwald, Heiko Petersen | Soundmix: Gregg Skerman | Edit: Marille Hahne, Jochen Gerand | Programming: Andreas Schiffler | Interfaces: Andreas Krach, Jill Scott | DVD-Egli Films, Zürich | Supported by the Kunsthochschule für Medien Köln, HGK Zürich, Filmakademie Baden-Württemberg Ludwigsburg, Frau Dr. Gilhaus, Zeche Zollern II, Paul Hofmann, Kinemathek im Ruhrgebiet, Stiftung Westfälisches Wirtschaftsarchiv, Museum für Kunst and Kultur, Dortmund | Sketches : Marion Meyer, Tanja Gompf and Silke Altvater | Curator: Axel Wirths | Commissioned by Kultur und Projekte, Dortmund | Collection: Museen der Stadt Dortmund.

Thank you to the following institutions who contributed to the production in this book: The Australia Council | ZKM, Germany. | Kulturbetriebe Stadt Dortmund. | ANAT, Australia. | NEA America. | The Australian Film Commission. | Hatje Cantz, Germany.

QUOTES AND SOURCES

PP. 009-029, OF CONTINENTS AND DECADES, BODIES AND TECHNOLOGY

SIGMUND FREUD 1936. Civilization and Its Discontents. Kelley, trans. New York: Oxford University Press. **JACQUES LACAN** 1977. Ecrits, A Selection. The mirror stage as formative of the I as revealed in Psychoanalytic Experience. Trans. A.Sheridan. New York: W.W. Norton. **VILÉM FLUSSER** 1990. On Memory (Electronic or Otherwise). Leonardo, 23 (4), pp. 397 - 399. **ROLAND BARTHES** 1975. Mythologies. New York: Hill and Wang.Ibid Lacan. **JEAN FRANÇOIS LYOTARD** 1984. The Postmodern Condition: A Report on Knowledge. Manchester: Manchester University Press. **ALLAN KAPROW** 1975. A happening conversation with Allan Kaprow. DATA, 16/17. New York. Ed.-M. Bandin. **BRENDA LAURELL** 1988. Computers as Theater. Los Angeles: Addison Wesley Press. **GILLES DELEUZE** and **FELIX GUATTARI** 1987. A Thousand Plateaus: Capitalism and Schizophrenia. Trans. B. Masumi, Minneapolis: University of Minnesota Press | **LUCY LIPPARD** 1973. Six Years: The De-Materialization of the Art Object. Reprinted in 1976. Performance Art From the Center: Feminist Essays on Women's Art. New York: Dutton. **EVELYN FOX KELLER** 1990. From the Secrets of Life to the Secrets of Death. In. Jacobus, M. Keler, M. F. and Shuttleworth, S. Body Politics: Women and the Discourses of Science. New York: Routledge. **DONNA HARAWAY** 1991. A Manifesto for Cyborgs, Science, Technology, and Socialist Feminism in the Late Twentieth Century. In. Haraway, D., ed. Simians, Cyborgs and Women: The Reinvention of Nature. London: Routledge.

PP. 040-093, ANALOG FIGURES

MARTHA WILSON 1985 for the Franklin Furnace Archive. **JUDITH BARRY** 1979 "Performance Anthology - Source Book for a Decade of California Performance Art", Contemporary Arts Press, San Francisco. **JORGES LOUIS BORGES** 1995 (1964) Other Inquisitions 1937-1952. Trans. Ruth M.C .Sims. Austin. University of Texas. **MORIA ROTH** The Amazing Decade. Woman and Performance Art in America. 1970-80 A Source Book. Ed. Moria Roth. Astro Arts. LA. p. 132. **ROBERT ATKINS** 1981 Art Forum, New York, p. 84. **BARBARA LONDON** 1982. Press Release for the exhibition "New Image Video" MOMA. NY. USA. **HILDE VAN LEUVEN** 1982. Catalogue for the Exhibition "Video Installations". ICC. Antwerp Belgium.

P. 094-141, DIGITAL BEINGS

GEORGE ALEXANDER 1993. Catalogue ACT III Canberra. **MARGARET WIRTHEIM** 1985, Follow me Magazine, No 3, Sydney. **ADRIAN MARTIN** 1988, Film News, Sydney Australia No 22 p. 7. **ROSS GIBSON** in 1989 "Signs of Independents - Ten Years of the Creative Development Fund" - Australian Film Commission. **SALLY COU-ACAUD** 1988. "Scan+Vol. 1 - Magazine for Video and Time Based Art" Paddington, Australia. **BETH JACKSON** spring 1991. "Women and Technology - a Foucaldian Feminism or a new Humanism in Eyeline East Coast Contemporary Visual Art Nr. 16", Queensland, Australia. **ANNE MARSH** 1993 Body and Self. Performance Art in Australia. Oxford University Press. p. 159. **COLLEEN CHESTERMAN** 1990 Refractory Girl: a feminist Journal No 35. May Reviews p. 48-49. **ANDREAS DENK** 1994 Kunstforum International Bd. 128 Okt.EDez 1994" Jill Scott: "Machinedreams" p. 401.

PP. 142-201, MEDIATED NOMADS

MARGARET MEAD. 1964 reprint 1999, Continuities in Cultural Evolution. New Brunswick - NJ. USA Transaction Press. **STEVEN WILSON** 2000 Information Arts Intersections of Art, Science and Technology, MIT Press, Leonardo Series Cambridge. Mass. **HANNES LEOPOLDSEDER** 1993. Der Prix Ars Electronica'93 - Internationales Komdendium der Computer Künste. ORF. Austria. **HANS PETER SCHWARZ** 1997 Medienkunst Geschichte. ZKM. Prestel. p. 137. **HANS PETER SCHWARZ** 1995 Catalogue Multimediale 4, ZKM, Karlsruhe Germany. **URSULA FROHNE.** 1997. Extracted from an interview at the ZKM for the CD-Rom version of Digital Body Automata, CAiiA-STAR. Univ. of Wales. UK. **SÖKE DINKLA** 1998. Der elektronische Raum - 15 Positionen zur Medienkunst. Kunst und Ausstellungshalle der Bundesrepublik Deutschland. Bonn. Cantz Verlag. **DONNA HARAWAY** 1997. Modest_Witness@Second Millenium, Female Man._c Meets_OcoMouseTM New York, London, p. 39. **LIZ GROSZ** Space, Time and Perversion: The Politics of Bodies. New York Routledge. **PETRA MECKLENBRAUCK** 12.5.2000 Westfälische Nachrichten, Münster, Germany. **ANNEGRET WIEGERS** 17.8.2000. WAZ Westdeutsche Allgemeine Zeitung, Dortmund, Germany.

EDITOR/HERAUSGEBERIN Marille Hahne. **TEXTS/TEXTE** Roy Ascott (UK), Robert Atkins (US), Anne Marsh (Australia), Jill Scott (AUS/D), Yvonne Spielmann (D). **TRANSLATION/ÜBERSETZUNG** Michael Elsen, Ishbel Flett, Marille Hahne, Susanne Hofmann, Roger Buergel-Noack. **COPY EDITING/LEKTORAT** Tom Sperlich, Mark Kyburz. **GRAPHIC DESIGN, LAYOUT, TYPESETTING/GRAFISCHE GESTALTUNG, HERSTELLUNG, SATZ** Claudia Stöckli, Stefanie Herrmann. **COVER ILLUSTRATION/ UMSCHLAGGESTALTUNG** Claudia Stöckli. **GRAPHIC ASSISTANT/GRAFISCHE ASSISTENZ** Annie Wu, Efrain Folgin, Claudia Bach, Sonja Rössler. **ADVISORS/RATGEBER** Ursula Frohne, Christian Hügin, Sam Schoenbaum, Annie Wu. **REPRODUCTION/REPRODUKTION** Repromayer, Reutlingen. **PRINTED BY/GESAMTHERSTELLUNG** Dr. Cantz'sche Druckerei, Ostfildern-Ruit, Germany. **DVD: CO-EDITORS/MONTAGE** Marille Hahne, Marcel Lenz. **DVD-AUTHORING** Marcel Lenz, Bauhaus University Weimar, Germany.

PUBLISHED BY/ERSCHIENEN BEI Hatje Cantz Publishers, Senefelderstraße 12, 73760 Ostfildern-Ruit, Germany, Tel. +49-711-440 50, Fax +49-711-440 52 20, www.hatjecantz.de. **DISTRIBUTION/VERTRIEB US** D.A.P., Distributed Art Publishers, Inc., 155 Avenue of the Americas, Second Floor, New York, N.Y. 10013-1507, USA, Tel: +1-212 6 27 19 99, Fax: +1-212 6 27 94 84, dap@dapinc.com. **AUSTRALIA** Tower Books Pty. Ltd., Unit 2/17 Rodborough Road, Frenchs Forest, NSW 2086, Tel: +61-2-99 75 55 66, Fax: +61-2-99 75 55 99, towerbks@zipworld.com.au

English/German
240 pp., 400 illus., 200 in color
20 x 25 cm, hardcover
with DVD

ISBN 3-7757-1272-0
Printed in Germany